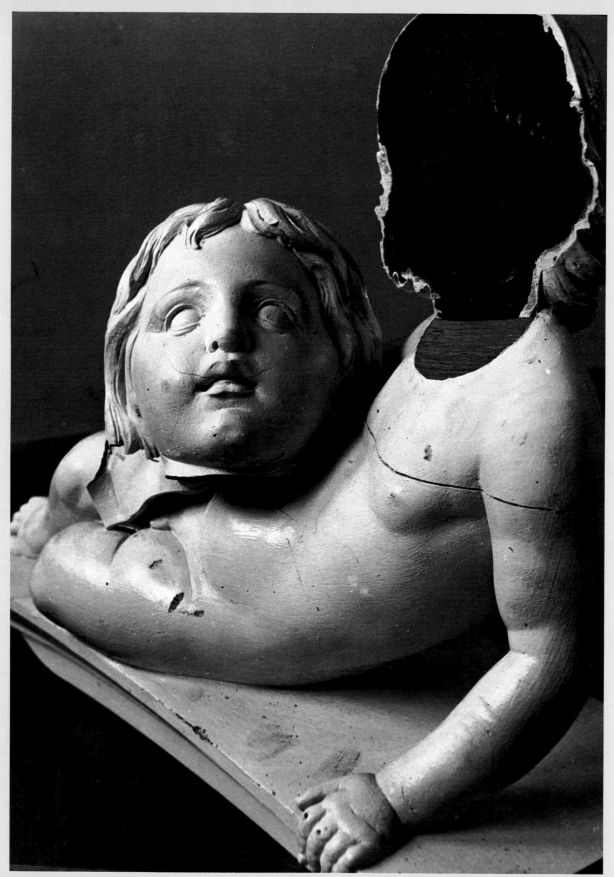

1
Broken cast;
12 July 1935

EDWIN SMITH

Photographs 1935–1971

with 254 duotone plates
and an Introduction by Olive Cook

THAMES AND HUDSON

On the half-title page Edwin Smith, photographed in Venice in 1962
by Monica Pidgeon

Printed and bound in The Netherlands by Druckerij de Lange/Van Leer

ONE AFTERNOON in October 1959 a photographer was at work in the Naples Museum; another photographer, the subject of these pages, who was waiting for permission to set up his own camera, watched him. The *maestro* was a small man jauntily dressed in cycling breeches with straps that stuck out like rococo ribbons echoing the sharp horizontal accents of the projecting straps of his sandals. The connecting verticals, the thin legs, were pale blue. A young woman waited for a wave of the master's hand to reload the camera as the films were used; another assistant ticked off the photographed items on a long list; while a grinning electrician held photographic lamps in what seemed to the observer most unsuitable positions. A group of visitors gaped at the proceedings. The onlooker was horrified by the fatuous performance. 'This is what success with Professor Maiuri will mean for me,' he wrote, describing the scene; 'Why on earth do I want it, I do earnestly ask myself why.'

Edwin's reactions on this occasion are characteristic: they indicate his strong aversion to any sort of parade and the curious ambivalence of his attitude to the work in which he excelled. He liked to speak of himself as an architect by training, a painter by inclination and a photographer by necessity. Like Eugène Atget, with whose work he felt a profound sympathy from the moment he first saw reproductions of it in *The Architectural Review* soon after the photographer's death in 1927, he never really accepted his role in life. As late as 1966 he was still talking of himself as 'misrouted'. Painting was his avowed concern, and the fact that Atget's preference was also for painting must have increased his importance for Edwin. Edwin's workroom was that of a painter and print-maker, and the amount he managed to produce was phenomenal – never less than two drawings a day, even when he was most pressed by demands for his photographs. He kept a stock of canvases and boards, copper plates, wood blocks, lino, paper, powder colours, inks, brushes, pencils and engraving tools big enough to set up a shop and his knowledge of techniques was exhaustive. He edited two works on the subject, Ralph Mayer's *The Artist's Handbook* and Hilaire Hiler's *Technique of Painting.*

For his photographic equipment, on the other hand, he outwardly appeared to care little: he seemed to begrudge money spent on it, he would use antiquated cameras (though I suspect that the choice was both deliberate and, in his case, wise), and for many years he had no proper darkroom. When at last he did install a darkroom he avoided full commitment to photography by refusing to have running water brought to it. Only in 1967 was it furnished with sink and tap. And it was not until 1971 (paradoxically, the year of his death), in a talk given to students at Bristol, that Edwin actually admitted to being a professional photographer. Yet no-one who knew him or saw him at work could doubt the seriousness of his involvement with the camera or his dependence on it as a vital means of expression. Just as Atget's tireless absorption in the techniques of his craft, his pleasure in the results and in the appreciation of his friends belied his proclaimed dissatisfaction with his vocation, so Edwin's dedication once he had embarked on a project, his enthusiasm when he felt he had captured the quintessence of a subject and an experience, his unobtrusive but thoroughgoing interest in the latest technical innovations, alert to anything that might further his specific ends, and the fact that he seldom took even the shortest walk without a camera, all argued that he recognized and secretly rejoiced in his calling.

The photographs that follow represent a minute fraction of Edwin's vast output of more than sixty thousand negatives, but they embrace most of his preferred themes and testify to his unmistakable style, adumbrated in the work of the 1930s and consistent from about 1950. The selection covers the whole of his working life: it includes pre-war pictures, of which only a few have so far been seen and even fewer have been reproduced, and many later photographs that have not been published and so will be unfamiliar to owners of his books.

Those who are acquainted only with the large gravure plates of those books, displaying the grandeurs and intimacies of architecture and nature, may perhaps be surprised by the contrast in subject-matter and feeling between the early photographs and the later work. And there is of course a difference, the reasons for which will

emerge. Yet some of the most distinguishing qualities of his work can already be discerned. The winter trees at *89* sunset photographed in 1939 have so evidently been seen by the same nostalgically selective and romantic eye as the landscapes of the sixties; Edwin's life-long affection for humble versions of the domestic shell is already *130* expressed, and the remarkable Camden Town bedroom scene, one of his earliest photographs – a picture of strange, thievish shadows defying the brightness falling from the window and engulfing the objects in the room – already bears the hallmark of his mature style: his painter's sense of composition, his instinctive understanding of the histrionic power of chiaroscuro, and the feeling of life and warm humanity which he imparted to every picture, often most strikingly when no figure was present.

Edwin was born on 15 May 1912, the only child of an unhappy marriage that ended after some twelve years, in a house which no longer stands in St Paul's Road, Camden Town. Except for the four years of World War I when his father was in France and he and his mother were living with his aunt and grandmother at Ponder's End, he spent the whole of his childhood and adolescence in two small first-floor rooms in St Pancras Way without even the convenience of cold water. But it was not until he was a teenager that he was aware of any disadvantages. His aunt described him as an exceptionally merry amusing little boy, and Edwin himself, though acutely conscious that his parents were at odds, always spoke of his robust and austere Camden Town childhood as enjoyable. He played boisterous games with cousins who lived opposite and by the time he was ten had explored most of North London on roller skates.

Edwin left school, the LCC elementary school in Great College Street, at the age of twelve to learn the building crafts – bricklaying, carpentry, plumbing and decorating – at the Northern Polytechnic in Holloway. He thus escaped the disciplines of academic training which so often stifle creativity and for which he had shown no aptitude. It was not until almost the end of his time at the elementary school that a possible reason for his lack of application occurred to his teachers. His eyes were tested and he was found to be extremely short-sighted. He often recalled the rapture and amazement with which he first saw the world through spectacles, and he never lost his sense of wonder at being able to see clearly. His approach was naturally heartfelt and instinctive but his continued appreciation of the miracle

of sight must have enhanced his gift for catching a subject almost unawares at the very moment when all its significance was revealed. Edwin's near sight was always preternaturally sharp and he could see details which to others were invisible without a magnifying glass. He would often remove his glasses to peer closely at something which excited him and always pushed them up onto his forehead when he was adjusting the lens in front of a subject. The abnormal clarity of his near vision may well have been in part decisive for the precise detail of his negatives which increased with enlargement.

The building trade was much more to Edwin's liking than the conventional classroom. He excelled in all its branches and soon became passionately interested in the art they served. His instructors were impressed by his intelligence and ability and in 1928 he was transferred to the Architectural School of the Polytechnic. Now he suddenly became a reader, never an omnivorous one, though he discovered two of the writers who were always to mean a great deal to him – Blake and Stendhal. He also took violin lessons and was playing in the college orchestra by the time he left the Polytechnic. It was now too that he began to acquire his comprehensive knowledge of Schubert, to whom he felt especially close.

In 1930 Edwin won a scholarship to the Architectural Association, where one of the teachers, James Burford, became a dear friend. Another life-long friend made at this time was Oswell Blakeston, a writer of sparkling promise and originality whose taste for architectural follies and visual oddities of all kinds drew an enthusiastic response from the boy of eighteen.

Despite his acknowledged talent Edwin had to abandon the architectural course in 1932 before fully qualifying. His mother, alone for the past eight years, found the strain on her purse too great. Whatever disappointment he may have felt, Edwin resigned himself uncomplainingly to the situation, and it was all the easier to accept because although he had not completed his degree James Burford helped him to a job with Marshall Sisson. But it was not long before he decided that office life, regular hours of work and a monotonous daily journey were quite unacceptable. More important, after a few months Edwin was wholly disenchanted by the commercialism of modern architectural practice. He made the drawings for an oppressively functional box-like house in Cambridge and resigned. 'I want to design St Paul's', he said, explaining his reasons. For a time he worked as an

assistant to an eccentric and individual architect and designer, R. Myerscough-Walker, spending one or two mornings a week in Chelsea setting up elaborate perspectives of historical buildings. He also collaborated with Myerscough on the building of a house of swelling curves in Nottingham which has recently been listed as a notable example of domestic design of the thirties. His employer, recalling that period, said that Edwin was a 'beautiful and extremely capable draughtsman . . . of all the people I have been in contact with Edwin shines through as being one of the purest and finest.'

Meanwhile, warmly interested as he was in every form of visual expression, Edwin had already been attracted by photography as a unique means of transfixing the marvellous and fascinating sights of everyday life which besieged his responsive eye and clamoured for immortality. All he had was a little Kodak box camera acquired by collecting coupons given away with packets of cornflakes. But with it he took the photograph of the Camden Town bedroom described earlier. A friend's timely present of a good but damaged camera encouraged Edwin's interest. It was a Contax II designed to work with interchangeable lenses, and while repairing it Edwin mastered its mechanism and formed some idea of its potential. It occurred to him that photography might become a profitable sideline, leaving him time to paint while providing the necessary keep. The problem was urgent, for by this time Edwin was married (a marriage later dissolved) and had moved to Hampstead, a district where he continued to live until he settled in Saffron Walden in 1962. The Contax took 35mm pictures such as Edwin later absolutely rejected. But this and another camera of the same Zeiss Ikon group, a Tenax producing a $2 \times 2\frac{1}{2}$ inch negative, were what he used for the most characteristic work of the pre-war years.

The writer Rayner Heppenstall, himself fleetingly drawn to photography in the late 1930s, in his novel *Satyricon* published a telling description of Edwin (thinly disguised as 'Aloysius Smith') at work with the Contax. Rayner had invited him to share a model:

He lay on his back and photographed half vertically up mighty columns of leg. He leaped on top of the desk and photographed an upward-looking face with a perspective of body receding down to absurdly diminished feet. He was in every corner of the room at once, so that if he demanded Pat Mallard's face she did not know in which direction to look. He tossed her bits of drapery and photographed her as she

caught them. He handed her a guitar or a Japanese sword or such other properties as I had been able to find, or snatched them away and recorded the turn of a bewildered arm and shoulder. Even visually woman is inexhaustible in her variety, but that evening every detail of a superb body was, if not made captive, yet momentarily, lyrically acknowledged.

I recognize in this account the same concentration and energy with which in the 1950s and 1960s Edwin went about photographing a church, a barn, a great house or an historic garden – but not the violent action. The theme of the nude too is not one which admirers of Edwin's work would ever associate with him. But at that time there was scarcely a branch of his new craft that he did not explore. Between 1935 and 1938, always with the Contax or the Tenax, he made his unique records of the fairground and circus, and in the summer of 1936 he photographed the mining community of Ashington in Northumberland and the life of the docks and the quays of Newcastle. And all the time he was taking pictures of cats, always cats, pictures of the familiar London streets, precious documents now of localities obliterated by sweeping change, pictures of urban houses of every type, of suburban parks and gardens with their amusing and niminy-piminy sculpture, of trees and plants, of music halls and the theatre and ballet, of pubs and coarse, exuberant pub glass, and of shop fronts mysteriously haunted by the forms and faces of passers-by reflecting and dissolving in the windows. Some of these photographs are so closely related in subject-matter to those which Atget took in Paris that I think it must have been the French photographer's example which suggested them to Edwin. It must be more than a coincidence that the pictures Edwin saw in *The Architectural Review* included photographs of the Cirque Zanfretta, the windows of a tailor's and a milliner's shop, a fishmonger's slab and a workman's room. More subjects of this kind as well as plant studies are reproduced in *Atget, photographe de Paris*, published in 1930; this was one of the first books Edwin bought and the only book on the work of another photographer that he ever did buy.

Edwin's photographs of clowns, music hall artists and fairground entertainers relaxing behind the scenes and of the Newcastle miners and their homes illustrate an aspect of his personality which contributed much to the eloquence of these and many later pictures – his gift for establishing a warm sympathetic relationship after the briefest encounter. Though all his photographs of the

148, 149

17, 19–30

41–45

16

Ashington and Tyneside colliers were taken in the space of a fortnight, Edwin had wholly won the confidence of the pitmen; he was invited into their homes and even became the guest of one of them. The photographs were taken for Sir Arnold Wilson after Edwin had heard him lecture on the conditions of the Geordie coal miners.

Shortly after acquiring the Contax Edwin was unexpectedly befriended by Paul Nash, whom he had met by chance at a party and who had happened to see a few of his photographs. At the time Edwin was relying on the local chemist to process his 'snaps', a frustrating and occasionally embarrassing situation. Paul Nash arranged for him to use the darkrooms in the offices of the publishers Lund Humphries and so to teach himself the crafts of printing and enlarging. The painter also introduced the young photographer to the editress of *Vogue*. Although Edwin found fashion photography uncongenial and his association with the magazine was shortlived, the work he did for it was noticed and requests for his photographs snowballed. On the strength of what had already been published he was offered a job as staff photographer to a London advertising agency. He took pictures of aeroplanes, furniture, machinery and other odd subjects, for which he cared as little as for fashion, and as little as for the copies in colour of paintings which he was now and then asked to make at later stages in his career.

The work at the agency was not arduous. Edwin came and went as he liked and in addition to taking photographs he enjoyed making an occasional drawing or typographical design. He even wrote a simple-hearted slogan or two. Years afterwards in moments of particularly high spirits he would chant one of these:

> Rich Uncle Joe in the back of beyond
> Will be glad of a letter on Basildon Bond.

Among those who singled out Edwin's work at this time was the photographer Francis Bruyguiere; he included a picture of a fairground helter-skelter in an anthology of 1935–36, *Modern Photography*, which he was editing. Asked to describe his approach as part of the introduction to the book, this is what Edwin wrote:

Photographically one year old. Having an incurable preference very early in life for the two-dimensional image rather than its three-dimensional counterpart, it was inevitable that I should discover the camera. Camera-eye has revealed a new visual sphere for my habitation; much that was before visually incomprehensible has become, in the presence of the camera, significant. A divining rod finding its own peculiar

water with myself a passive diviner. And how much remains to be divined!

That image of the divining rod and the passive diviner is crucial: Edwin's photography of whatever period is conspicuous for his self-effacing approach, for the absence in it of all flamboyance. His view of his own and the camera's role remained unchanged until the end of his life. In a passage he added in 1971 to a book he had written in the late thirties and was then revising he confirms and complements the youthful attitude expressed in the sentences just quoted:

The man who lives in his eyes is continually confronted with scenes and spectacles that compel his attention or admiration and demand an adequate reaction. To pass on without pause is impossible, and to continue after purely mental applause is unsatisfying. Some real tribute must be paid. Photography, to many of its addicts, is a convenient and simple means of discharging this ever-recurring debt to the visual world.

Photography is a way of offering praise in the form of an objective record, not of flaunting the photographer's brilliant originality and skill. Edwin spoke of being intoxicated with the privilege of being permitted to pay a glorious building the homage of his craft, and it was not for nothing that the word 'adorable' was so often on his lips. He literally meant it.

It comes as a surprise to discover the title of the book in which the above definition occurs – *All the Photo Tricks*. The theme seems altogether alien to Edwin's conception of what photography is about. But the book was written to order. First published in 1940, many times reissued and still in print, it was one of five photographic handbooks commissioned from Edwin by the Focal Press in the latter half of the thirties. *All the Photo Tricks* and *Photo Tips on Cats and Dogs* are full-length manuals; the remaining three, *Better Snapshots*, *All About the Light*, and *All About Winter Photography*, are short paperbacks. All five are illustrated by the work of various photographers, but the technical details are explained by means of the author's own amusing pen-and-ink drawings. The reader is at once impressed by two things: the writer's easy mastery of his subject and the clarity with which he imparts his knowledge. The style is already enlivened here and there by the unexpected turn of phrase, the unusual rhythm of the sentences and the humour which so distinguish every scrap of writing, every letter of his mature years, and which make his last contribution on photographic

technique, the chapters he wrote for *The Graphic Reproduction and Photography of Works of Art*, so much more than a practical account.

All the Photo Tricks appeared after the outbreak of war, which coincided with a period of change and turbulence in the photographer's life. His job with the advertising agency came to an abrupt end. Opportunities for photography were few, and for a year or two he worked as a camouflage artist. Another commission was to photograph some objects from the British Museum: for this work Edwin bought his first stand camera, second-hand, accommodating plates measuring 3 × 4 inches.

During what was a time of great personal unhappiness and isolation, Edwin sought consolation in his possessions, in the collection of printed ephemera he had started long before such habits became fashionable, in his few fine pieces of country pottery and glass, his already considerable library, his records and his E.M.G. Hand-Made gramophone with the elephantine yet graceful horn. This retreat from nightmarish reality was encouraged by what was almost his only social contact. He had made friends with Kokoschka, who was then living in Hampstead. The great painter had his being in a realm of wild fantasy, absorbed in himself and totally relieved of the practical demands of everyday life by his devoted wife. Once at least each week Edwin visited him, listening to the vivid fabrications this old magician with the captivating peasant face and huge ears conjured up from distorted memories of his agitated youth, admiring the intense, impetuous paintings and making his own contribution to the flights of fancy engendered by some of the objects in the small, over-heated and ill-lit room – a remarkably naturalistic paper cobra about to strike, a flint heart, a toy tiger from China whose head and tail were in perpetual, hypnotic motion.

Like even the worst of haunting dreams the experience of the war years, once it was over, lost its horror. It seems only to have confirmed the characteristics which all Edwin's friends admired: the calm radiance of his personality, his ready sympathy, his unfailing good humour and the tolerance which allowed no stronger condemnation of an arch villain than that he might perhaps be 'a bit of a rascal'.

Edwin had never lacked confidence in his work but now he was more certain of his aims. He knew what he wanted of the photographic medium and what he must

do to achieve it. He discarded all the aspects of the craft which no longer moved him. He had, for instance, experimented with colour photography in the early years and he worked with it again to please his publishers. But now it was on the severe convention and wide range of the black-and-white image that he wished to concentrate. In all colour work, the processing of which, because of its complication, had to be performed under controlled laboratory conditions by the manufacturers or their agents, the creative element was minimal. Returning to black-and-white after having taken a number of commissioned colour pictures Edwin once remarked on the relief he felt: 'Intelligence is re-introduced at almost every step.'

He did not altogether abandon the subjects which had earlier attracted him, for he still received requests for them. Leonard Russell, creator and first editor of *The Saturday Book*, was a particular admirer of the early work and gave Edwin and the writer (whom he was soon to marry) the opportunity of devising many delightful features for the annual. But this was more in the nature of a light-hearted diversion. Edwin's serious photographic interests were becoming more specialized. He had never been more than occasionally drawn to the nude and he never attempted the subject again in the post-war years. Portraiture too was not for him. Though he loved the idiosyncrasies of the human face, a sense of delicacy about privacy held him back from revealing the irregularities of feature, the blemishes and frailties he found so peculiarly expressive. The rare portraits taken at the entreaty of friends usually horrified the sitters, they were so frankly unflattering. Edwin never went to a circus or music hall again after the forties and added little to his documentation of the fairground, while his obsession with cats merged into the affection he felt for all animals. A cat might enliven a landscape or an architectural scene, but only three sat for their portraits after 1950.

Edwin had always delighted in buildings and landscapes, his training had strengthened his inclination, and he now began to gravitate towards these themes almost exclusively. Chance, in which he wholly trusted, presented him just at this time with a splendid opportunity. In 1950 Thames and Hudson commissioned the first of a series of books on architectural and landscape subjects for which Edwin took the photographs. It was a decisive event in his career, for the work concentrated his attention on his chosen field. The subject of *English Parish Churches*,

121

9

moreover, was particularly congenial to him. When he embarked on the book, Edwin's first-hand knowledge was limited to the churches of London and of perhaps a dozen villages. By the time he had completed the work there was hardly a church with which he had not become familiar. It was a transporting experience, and for none of the world-famous churches and cathedrals of other countries which he came to know did Edwin ever feel so strong an attachment. 'For me photography in a good village church is unalloyed bliss', he wrote; 'the visual pleasures and surprises of visiting country churches have been among the most vivid and poignant of my life.' The English village church was often his touchstone when appraising some celebrated building in a foreign land. A letter from Aachen notes his reactions to the cathedral: 'The interior was as dark as night and not at all convincing. Much retouched and added to, it is perhaps as good as St Bartholomew the Great, to be generous. And as far below a good English parish church as a starling to a curlew.' At Vézelay (where the scrubbed capitals seemed so 'got up to be looked at' that 'the sense of discovery, of seeing them when they are not seeing you, is impossible') 'the view of the interior . . . is wonderful, in three clear tones – tympanum, nave and choir – but not worth changing for a decently neglected, dusty and secretive English parish church.'

The photography of churches demanded a camera very different from the Contax, which was most suited to constantly changing subjects such as people and animals in motion. The stand camera Edwin already possessed approached more nearly to his needs but its scope was limited. He acquired a heavy half-plate bellows camera of mahogany and brass with a truly massive mahogany tripod. It had been made by Thornton Pickard of Altrincham in 1904 and was called 'The Ruby'. The sight of it in action usually drew a smile if not an exclamation from the casual observer. It seemed ridiculously primitive, a joke. In fact the Ruby was perfectly attuned to Edwin's temperament and requirements. It was a camera of the utmost manoeuvrability and, as Edwin said, this veteran was antique only in its articulation: the negative material at one end and the lens at the other were completely up-to-date. It produced large negatives, the prints from which were sharper than those from a small light camera could ever be and at the same time more subtle in tone. The developers it was possible to use for such a negative furthermore yielded a print of smooth forms and no grain, or the minimum of graininess, which was essential

for the kind of picture Edwin wanted. The Ruby remained his favourite camera and accompanied him on all but the last of his many travels in Europe despite the formidable labour of transporting it. The $2\frac{1}{4} \times 3\frac{1}{4}$ inch hand camera, an Autorange 820, used when quick action was necessary and the 9×6 cm plate camera, an adapted Sanderson, which was more easily carried when a subject was only accessible after strenuous walking or climbing, though constantly in demand, were regarded as the Ruby's auxiliaries. The big camera was never wholly abandoned until 1970, when Edwin acquired a relatively modern instrument, a versatile Linhof producing $2\frac{1}{2} \times 4$ inch contact prints. He must have provided the inhabitants of many a city, London and Edinburgh, Bath and Bristol, Athens, Venice and Rome, Vienna and Amsterdam, with their last glimpse of a photographer huddled under a black cloth behind a ponderous wooden tripod as he focused on some light-dappled façade, a vista of iron railings, a finely chiselled keystone or a graceful fanlight. His manner of working differed as radically from that of the photographer in Rayner Heppenstall's description as did the potential of the Ruby from that of the Contax.

Edwin himself described his preliminary exploration of his subject, in a short piece included in the new edition of *English Parish Churches* published by Thames and Hudson in 1976. Calmly, deliberately, discreetly he would walk round a church, a garden or a great house relating the needs of the camera to his own visual responses and only starting work when he was certain of the possibilities of the material and the natural lighting. Nearly always he was conscious of mounting excitement as he walked and looked and when at length he set up the camera it was with an expression of rapt intentness. While making the exposure he would gaze fixedly at the subject, sometimes smiling encouragingly at it. Edwin seldom used a meter and could frequently be heard to measure the passage of the seconds with a whispered incantation: 'Cat one, cat two, cat three . . .' Reliance on exposure meters often, he thought, led to under-exposure; experience alone enabled exposure times to be correctly judged. To this end Edwin kept log books of all his exposures with the plate cameras and the conditions under which they were made, giving details also of the type of glass or film negative used and of the lens focal length and aperture, and briefly indicating the quality of the result. Occasionally he would also comment lightly in pencil on the back of the finished print: 'Should and *can* do better.' Edwin was unusually

dismayed when he mislaid the last of his log books early in 1971. He felt it was an omen, all the more portentous because he discovered the loss immediately after a memorable experience: he had spent the best part of the previous night alone in the arching dusk of Westminster Abbey, his only companions the effigies of the royal and illustrious dead. He had been able to work in blissful immunity from all disturbance, using the available electric light and an occasional 500 watt photographic lamp.

Normally, working during hours of daylight Edwin preferred to accommodate to the existing light conditions and he used lamps only when photographing isolated or two-dimensional works of art. He would now and then have recourse to the flash bulb or electronic flash but always sought to disturb the given lighting as little as possible. So interiors, especially of churches, necessitated long exposures, seldom of less than 10 seconds and often of as many minutes. Edwin's pictures of the dim Saxon interior of St Lawrence, Bradford-on-Avon, resulted from an exposure of $27\frac{1}{2}$ minutes! There could scarcely be a method of working more opposed to the quick reportage of the modern miniature camera. Whereas the users of those little instruments shoot whole picture sequences at the rate of several exposures a second in an endeavour to transfix the essence of some dynamic, animate subject, Edwin, confronting a static theme, placed all his trust in a single exposure. 'Co-operating with the inevitable', he called it; and this was his guiding principle in art as in life. He never attempted to impose his will on a subject, but always adapted to the situation he found. It was an attitude which again and again was justified by conditions which perfectly accorded with the photographer's own mood and with what he felt to be the spirit of his subject. Again and again he seemed to find himself in just the right place at just the right time and because he had the talent to grasp his good fortune he often achieved brilliant success. One of the most astonishing instances of this is the electrifying 249 photograph of the ambulatory of the crypt at Canterbury. A shaft of light was streaming across the narrow passage. The eye behind the lens recognized the unexpected and magical pictorial effects of this effulgence and a $\frac{1}{2}$-minute exposure captured the coruscation of luminous pattern on the short thick piers and arches and created a beautifully composed and mysterious image as hallucinatory as one of Piranesi's prison labyrinths, and quite unintentionally recalling the monk Gervase's account of the 'wonderful and awful'

light of the wind-fanned flames flickering about pillar and vault when the cathedral choir caught fire in 1174. Just as fortuitous was the emergence in the park at 188 Benrath of a small figure dressed and shod entirely in white passing in front of a screen of giant trees to give them scale and enhance their deep, romantic shade at the very moment when the lens was focused upon them. Just as opportune was the appearance of a single rough moorland pony beneath a waning moon when the camera was concentrated on the bare, ancient expanse of 110 Goldsborough Pasture.

English Parish Churches was followed by *English Cottages and Farmhouses*, which like the first book involved the photographer in a theme which became a life-long passion. His feeling for humble vernacular buildings was evident in photographs of cottages and cottage interiors he had taken on his rare visits to the 113 country in the thirties. He now made a most moving record of English traditional buildings in all their astonishing variety, vividly evoking the life of man and animal within them and the landscape which was their matrix. These photographs are all the more valuable because they were taken at a time when local tradition was still unselfconscious, scarcely touched by the social change which has since disrupted where it has not totally destroyed it. *Scotland* and *England* which were Edwin's next commissions testified as impressively to the photographer's sensitive and sympathetic perception of the spirit of place and his skill in conveying it.

From the late fifties onwards Edwin was deluged with requests to illustrate books on architectural and landscape subjects of all kinds. By 1971 he had completed some thirty volumes, and others came out after his death. No less than seventeen of these books were crowded into the sixties, most of them showing aspects of historic cities, the face of a whole land, the splendours and revealing details of great houses, and the poetry of great gardens.

The work meant of course extensive travelling and often considerable discomfort, especially for a man who always left home reluctantly. Noisy hotel rooms and sleepless nights interfering with work were the worst hazards. Before the blessed invention of 'Boules Quies' earplugs Edwin several times had to protect his sensitive ears with candlewax, and once slept in a hen-house to escape the din of a main road. But with his habit of living absolutely in the present and of using every minute to the utmost he was soon absorbed by the visual pleasures and the strange and stimulating experiences

which all his commissions brought him. There was not a day without its ecstatic moments during the many weeks he spent in Venice translating its shimmering exotic fabric into two-dimensional images, becoming familiar with the masonry and the life of dark little *calle* and canals where no tourist set foot, and at last, at the time of the great flood, left in a city half under the sea and lit only by candles. At Herculaneum, alone there in the very early morning and too disappointed by the over-trim restoration to start work, Edwin stumbled almost accidentally, at the very lowest level of the excavations, into a tiny forum, then lower still he found the half-blocked entrance to a dripping pillared hall only just emerging from the lava. Faint light from high above dimly revealed a classical head on a pedestal in front of a marble basin and a door standing half open, an actual wooden door, slightly askew and propped up by a bastion of brown rock-like earth not yet cleared. Through the door lay a room decorated with stucco figures of warriors and putti, parchment-coloured and stained with green. Beyond that, through another opening the door to which, warped and blackened, lay on the floor, Edwin could make out a sunken bath with a carved marble rim. It was partially filled with water and drops of water were plopping into it from the roof. He was clearly not intended to see all this. 'But I have encountered the real thing. This was utterly magic.'

Edwin's capacity for work was phenomenal. When away from home he usually rose at about 6 o'clock and worked, with only short breaks, until dusk. He became adept at smoothing the inevitable difficulties – the irritating conditions laid down by bureaucracy, the obstinate refusals to open certain rooms or permit the use of a tripod, the demands for extortionate fees – which beset every photographer of historical sites, especially in foreign parts. Most officials quickly succumbed to his charm and gentle manner, but his success in overcoming all obstacles was just as much due to a steely resolve not to be thwarted.

He would generally arrive at a site armed with lists provided by his author, but after a preliminary inspection of the suggested subjects invariably rejected a number of them as 'ridiculously unpictorial'. Edwin would only photograph what moved him and always had a keen and affectionate eye for details which were irrelevant to the art historians whose work he was supposed to be illustrating – the nettles forcing their virulent way through the slats of a garden seat at Rousham; the old-fashioned telephone casting a freakish shadow and the gardening gloves and plant in the deep embrasure of a tiny window in the entrance hall at Egeskov; Vita Sackville-West's boots carelessly left by the stairs at Sissinghurst; a cast iron-stove bearing the name 'WARM MORNING' yet vainly attempting to dispel the chill of Stupinigi's splendours. 'Bonuses' Edwin called them. Another bonus conferred by travel, one of a different kind, was Edwin's enjoyment of the 'gorgeous risk' of not knowing how successful he had been until, after a long and hard-working absence, he returned home with a huge suitcase crammed with undeveloped plates and films and entered the darkroom.

The pictures taken while Edwin was working for various publishers between 1950 and 1971, including the large number which were not reproduced in any of the commissioned books, are probably his most significant contribution as a photographer. His practical appreciation of the subject, his classical sense of composition combined with deep romantic feeling, give his photographs of architecture, whether of palace, cathedral or cottage, a peculiarly resounding, vibrant quality. His pictures of interiors, especially, do more than tell about structure and texture: they uncover secret overtones and aspects of those forms which our own eyes looking at the reality fail to apprehend. The photograph of the King's Bedroom at Knole is astir with ghostly life. We look across the King's bed, as we have surely never looked when standing with visitors in that room, into a tapestry that seems to be another chamber, a picture within a picture, as draped, as muffled in heavy gold and silver hangings and faded tapestries as the royal apartment, but occupied: a majestic robed figure sits with his back towards us, confronted by a wild-eyed monk pointing at an object hidden from our gaze. And had we ever, before looking at the photograph, been so aware of the strange, surreal effect of Hoogstraaten's painted perspective at Dyrham, receding behind the dream-like ziggurat forms of the giant Delft tulip vases? Had we ever in the *salone* of Palazzo Labia been fully conscious of the uneasy disposition of the mirror repeating the elaborate décor of the room but hanging too high behind a strikingly realistic marble bust to include it in the reflection? The photograph, stressing the isolation of the white, emphatic head and shoulders in the foreground of the composition but conspicuously absent from the glass, is redolent of all its sophistication and decadence.

Edwin's sensitive response to the drama and endlessly varied and subtle manifestations of landscape was

5,6,11, 140, 231

119

182

112

118

113

141

140

encouraged and developed through the work he did for such books as *Ireland*, *England* and *Scotland*. It found increasingly more evocative and more exact means of expression as the photographer strove to render what moved him in nature – the sense of infinity. In his Bristol lecture he at last acknowledged that in his view photography was a proper vehicle for this tremendous task.

It is perhaps not surprising that the marriage of Edwin's two dominant interests, architecture and landscape, in the sophisticated gardens of the Renaissance and the eighteenth century should inspire some of his most ravishing and eloquent photographs. The whole spirit of the great garden of cascades and fountains on the hillside of Tivoli is embodied in *180* Edwin's unique interpretation of the Neptune Fountain as a composition of nothing but rock and thunderous water, wild elemental forces austerely shaped and controlled by art. The image actually seems to partake of the visionary dream that prompted the design of this artificial landscape. Nothing suggests the present and the tourism that so tarnishes such a glorious creation. Not that Edwin was blind to the litter lying at the feet of sphinxes or to the scratched and written obscenities on the very faces of marble goddesses and dryads. The way he looked and saw beyond the degradation of our century is vividly illumined by a letter he wrote from Versailles. Eager to begin work as soon as possible, he went to the Park at 6 o'clock on the morning after his arrival. Its vast acres were deserted, but

every foot-print in the dusty sand, every empty cigarette or film carton seemed important evidence of previous occupation, like a newly excavated Pompeii . . . The vistas stretch away for miles and convey a sensation of desperate dismay to the heart. 'Have I to walk so far?' is one's reaction to the temptation of every prospect. A few steps and one's shoes are thick with dust, the sight of them distresses the eye and almost at once parches the throat. The dust is sometimes so dense that the terrain resembles some sordid children's play-pit, indeed some of the quincunxes resemble exactly those poor pieces of earth in a municipal park that has been worn down to below mere bareness and where the earth has now the quality of ash. I could not bring myself to tread in them though I admired the white termae that surrounded them, smiling or gesturing – but thought how wise of them to be without feet . . . How much one regrets the lost simplicity and innocence of even such sophisticated places as this . . . Now there are dark green floodlights hidden in the trees, every prominent statue has

somewhere its light and wire, the pools have pipes as well as lighting troughs, the terraces are studded with searchlights in groups of three – as absurdly obtrusive as three chamber pots in a drawing room. Not to mention the waste paper bins and the notices not to step on the grass. Scarcely anywhere can one look without an effort not to notice something grotesque.

Yet soon he is writing,

the statues are a joy and raise one's spirits every few yards, so that however one flags one makes progress. And the three hundred yards of the Tapis Vert, the narrow lawn that joins the Palace Terrace to the distant canal, are a great experience. The trees that confine it have been constantly trimmed for half their great height so that the foliage, chestnut, clings dense and tight like our pollarded sycamore. Above, the trees spread out full and bosky to give a cover of deep shade for the goddesses, gods and giant urns below. The urns are superb, so huge in mass, so fragile in their whiteness and shallow relief, and to walk beside them – one way, up to the distant chateau – the other, towards a glittering vista of water – is all the present magic of the garden.

187 It is that magic which wholly informs the photographs. Nowhere does a searchlight or a litter basket intrude. The statues are unencumbered, the paths scarcely trodden, the expanse of water is frank and untroubled. How is it that the objective lens has seen with the poetic eye of the writer of the last half of that quotation rather than with the critical, graphic eye of the author of the first half? What has become of the photographer's conception of himself as a passive diviner and of the camera as a mere recording device? Somehow the lens which of itself can do nothing but respond with complete impartiality to unalterable optical laws has been persuaded to collaborate with a discerning and sympathetic eye and an ardent imagination. All Edwin's photographs, but especially those of the fifties and sixties, are more than statements of documentation: like any work of art they are the result not only of vision but of skilful manipulation of the medium. They depend on the choice of lens, the use of filters, the length of the exposure, the selection of a paper of suitable gradation and above all on the way in which the tone is controlled during processing. Despite his reluctance ever to intrude upon the scene, we are conscious of Edwin's presence in every photograph, conscious that we are looking through his bespectacled eyes, enriched through them with new and unimagined ways of seeing.

TOWN

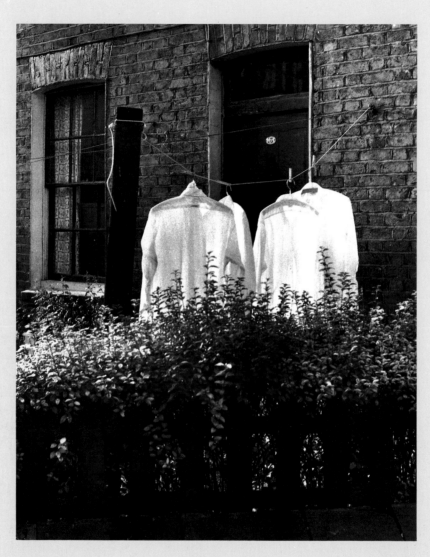

*2
Camden Town, London;
9 October 1960*

*3
Naples; April 1961*

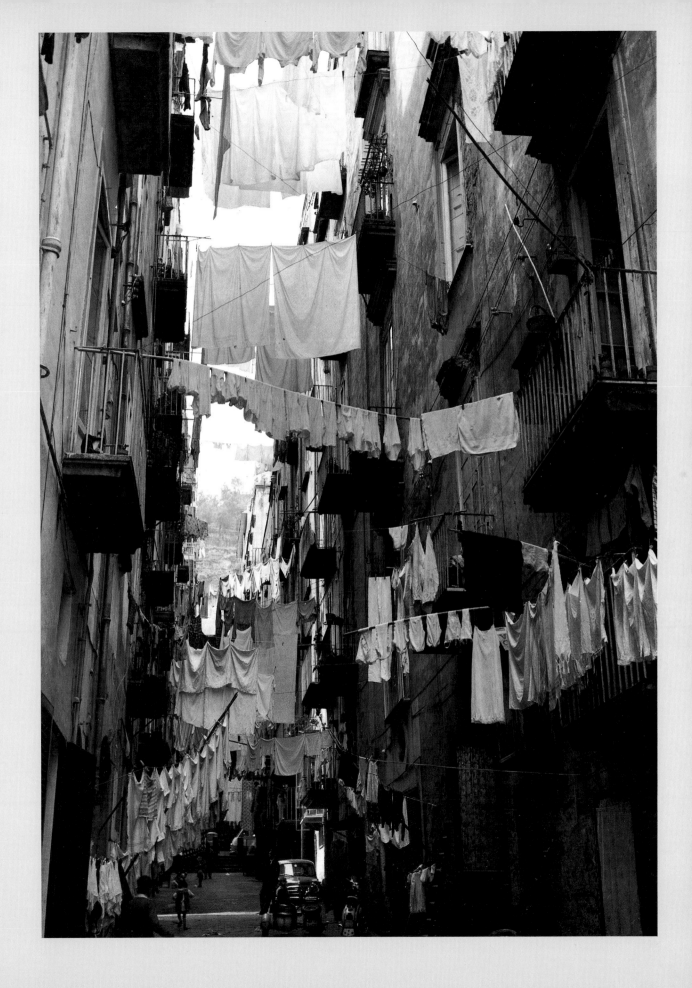

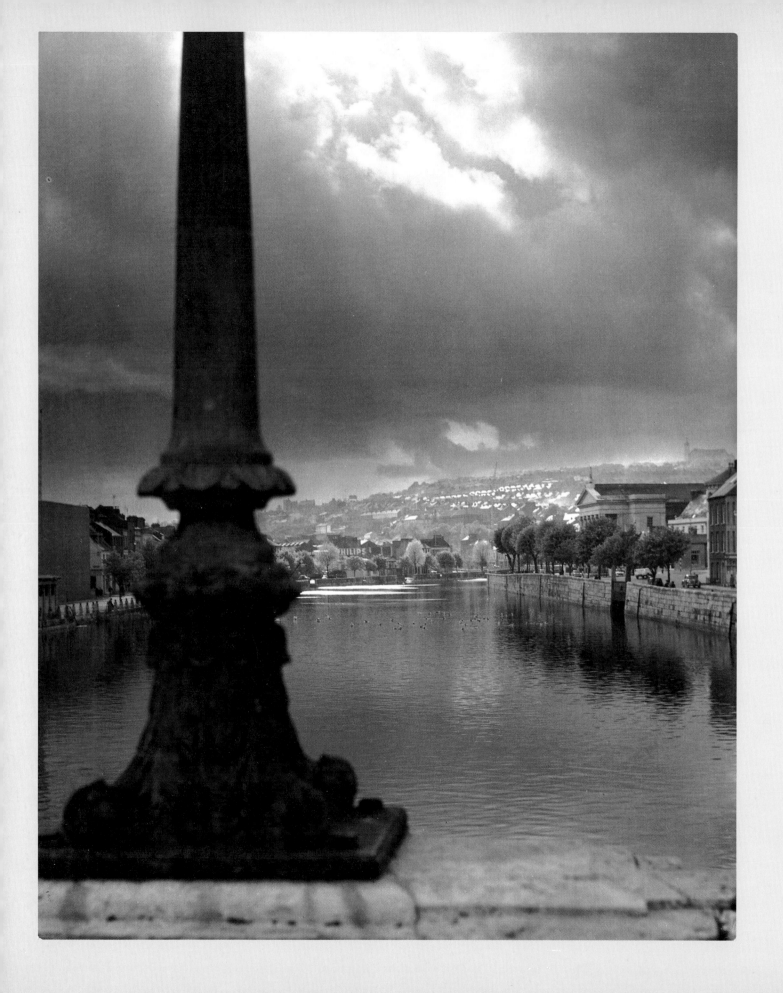

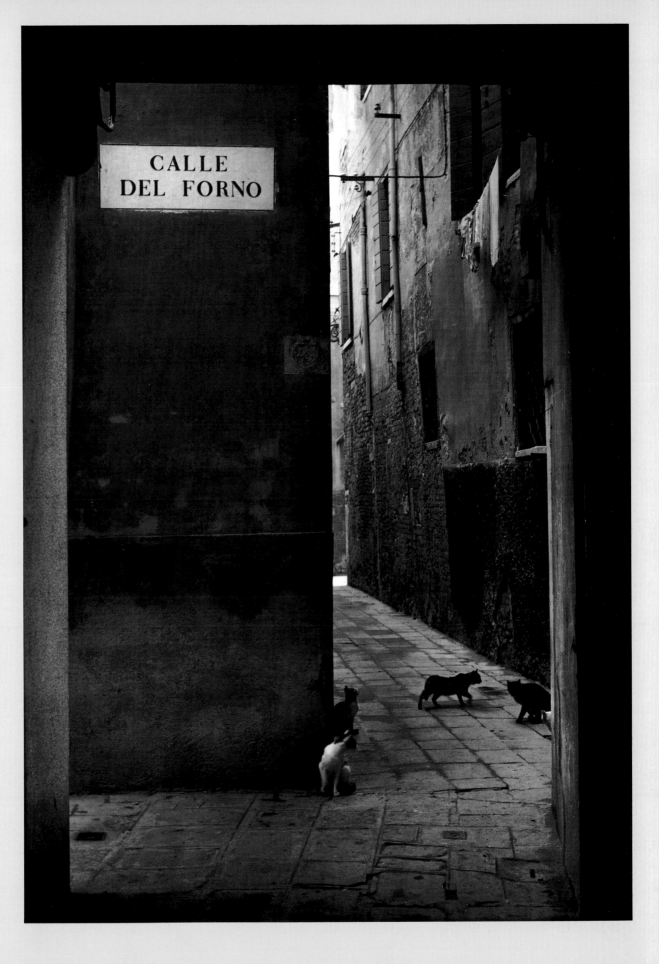

4
From St Patrick's Bridge,
Cork, Ireland;
May 1965

5
Venice; 16 September 1961

6
Corte del Volto Santo, off the Rio Terrà della Maddalena, Venice;
16 September 1961

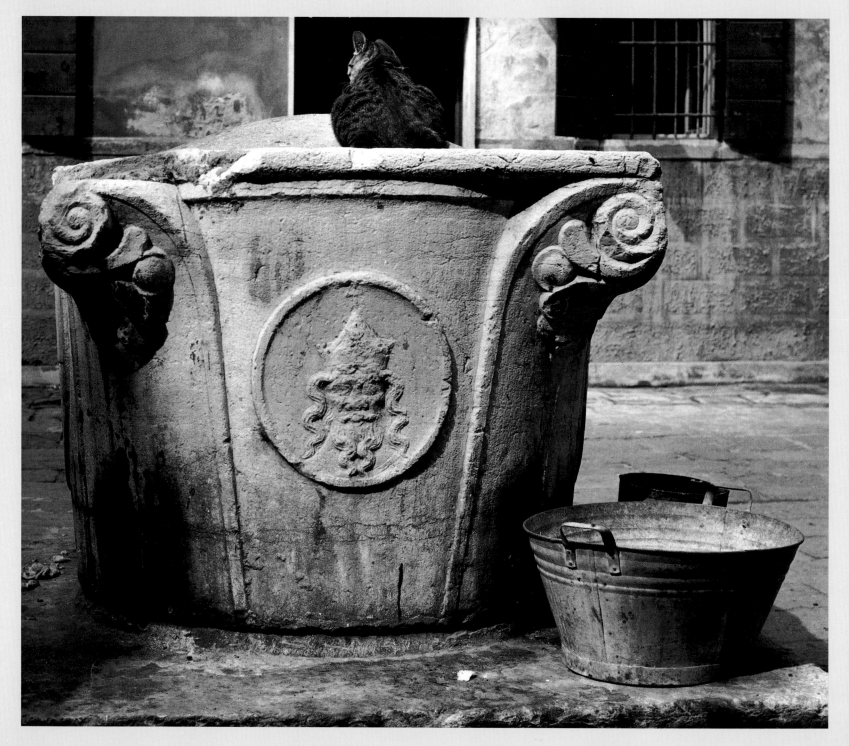

7
Corner of Marshall and
Cross Streets, Soho,
London;
5 August 1962

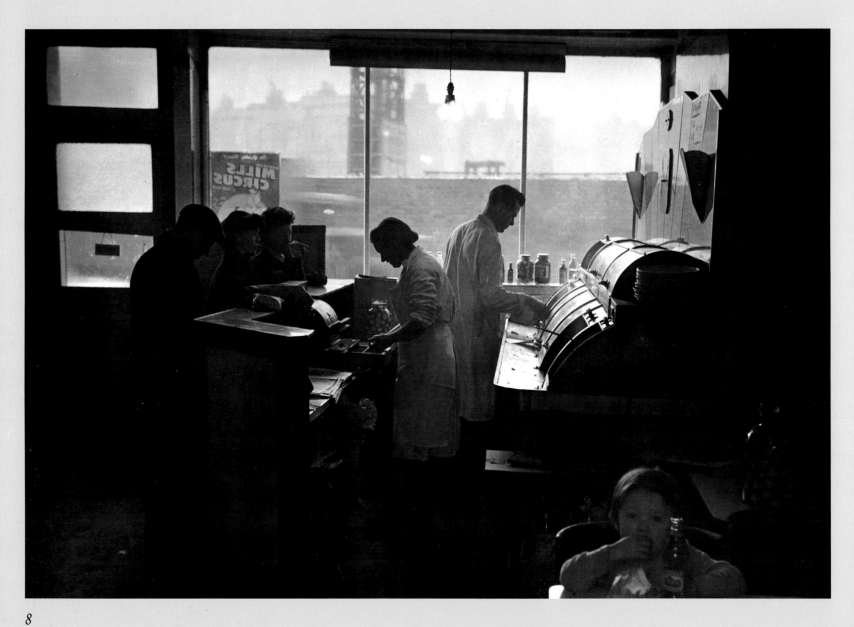

8
Fish and chip shop, Walworth, London;
6 March 1959

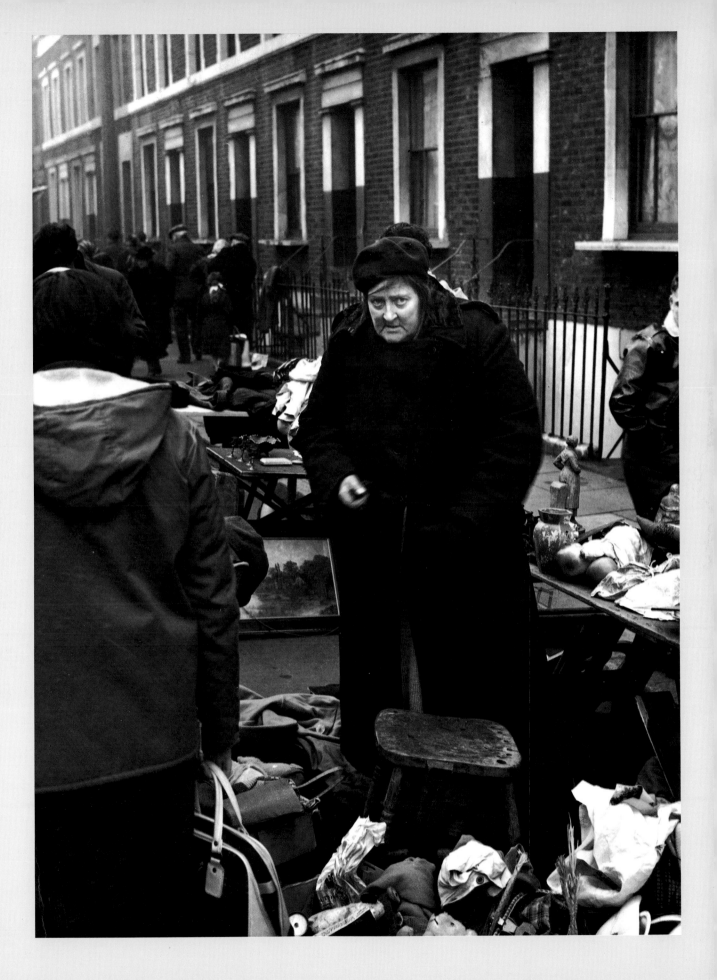

9
Street market,
Douglas Way, Deptford,
London;
7 December 1960

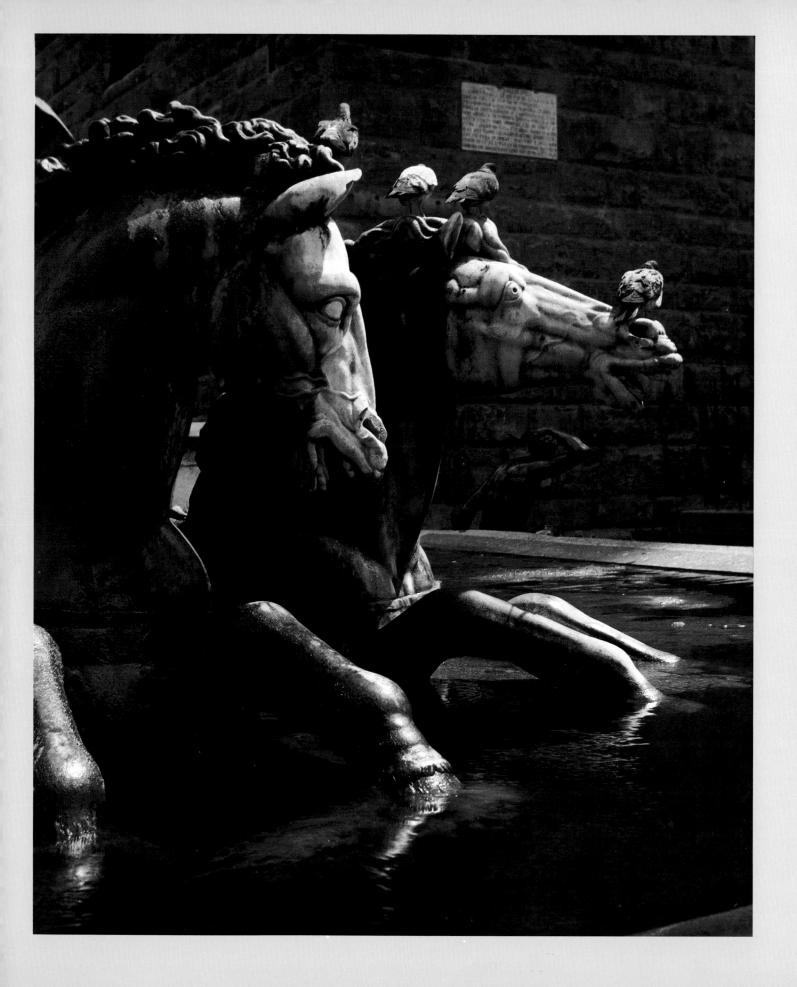

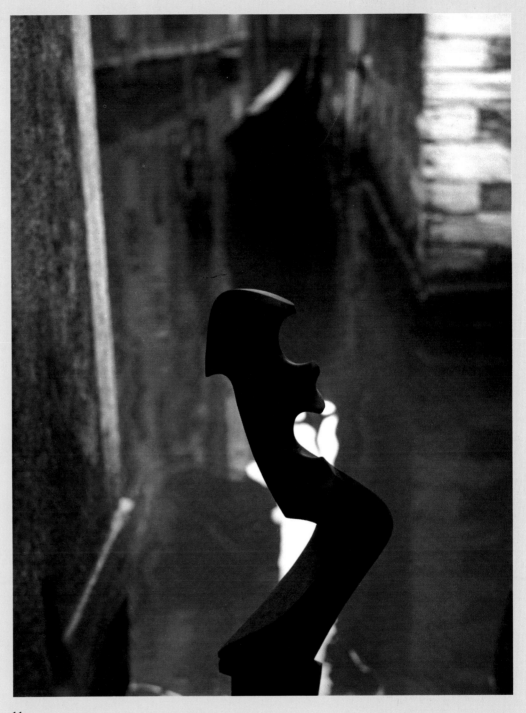

11
Gondola rowlock, Venice;
15 September 1961

10
Piazza della Signoria, Florence;
1 May 1962

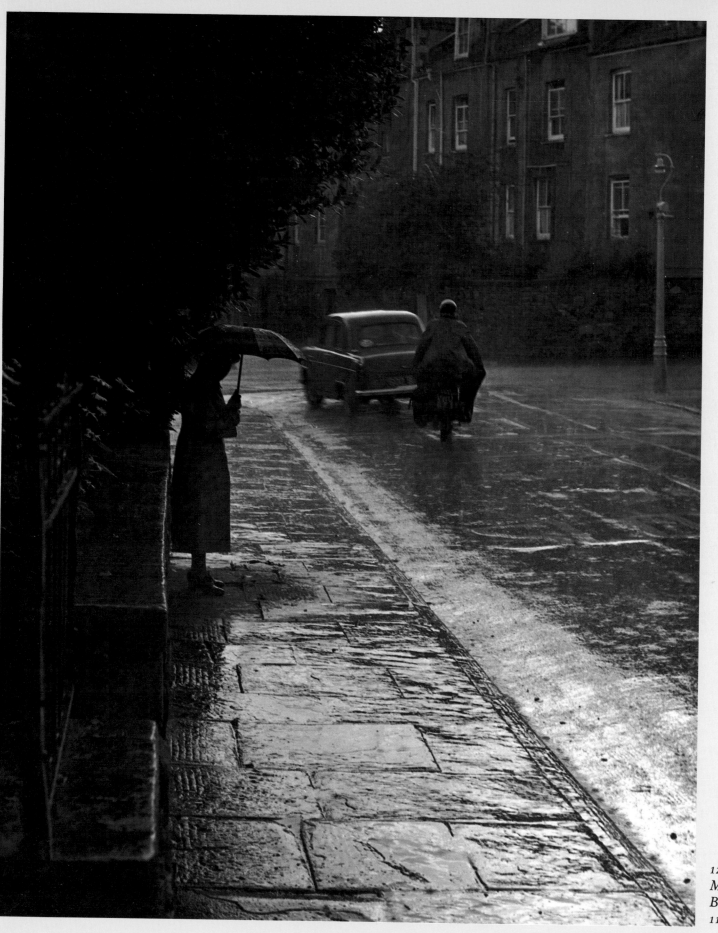

12
Manilla Road,
Bristol;
11 July 1961

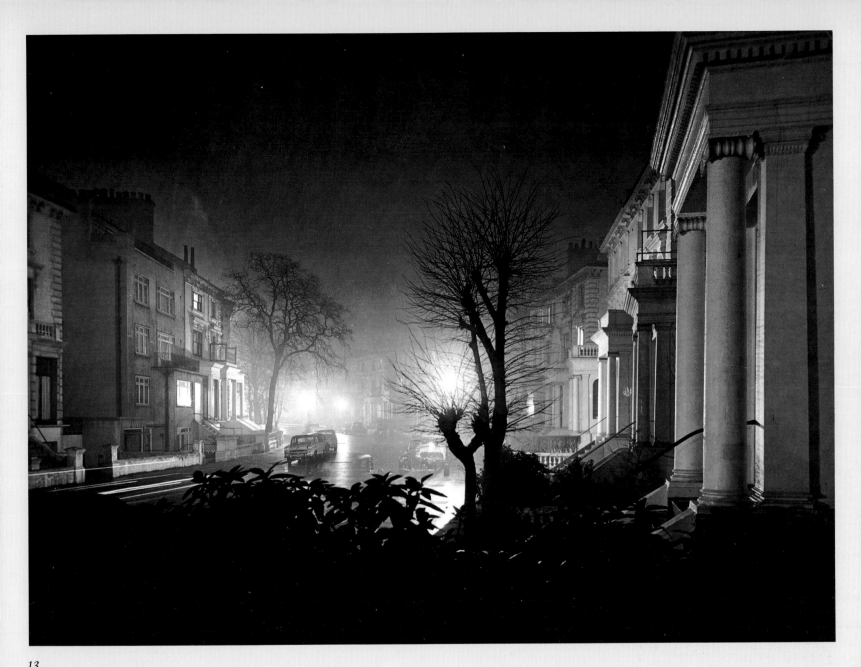

13
Buckland Crescent, London;
31 December 1961

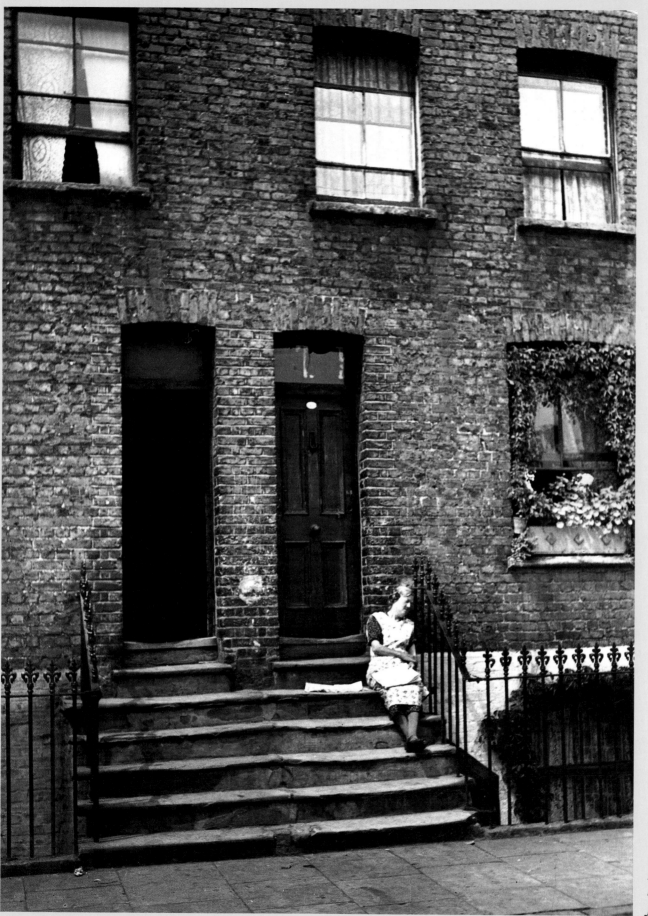

14
Somers Town, London;
June 1936

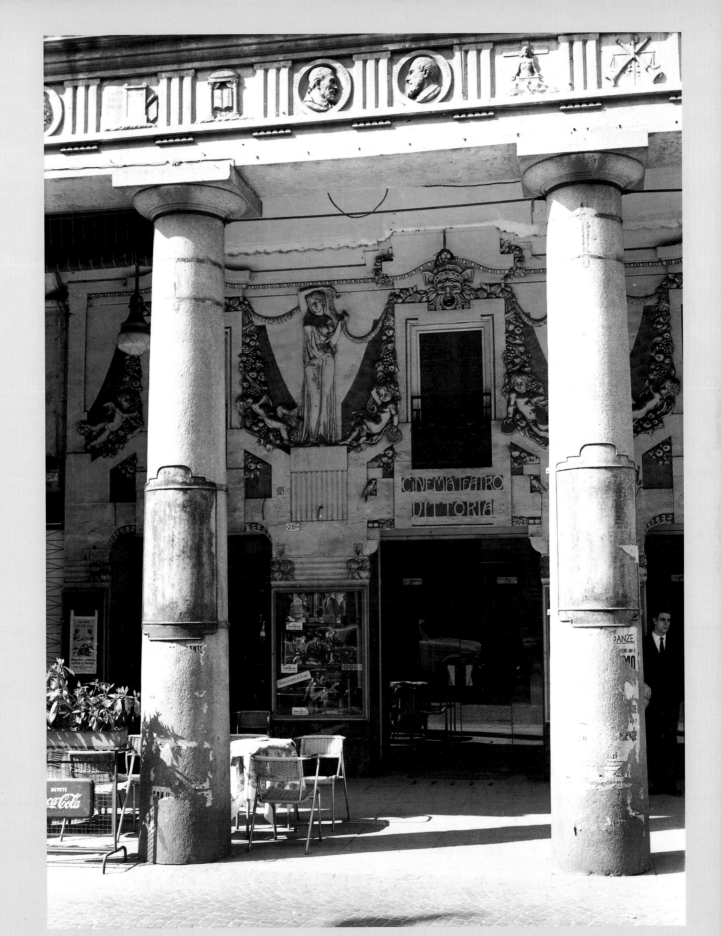

15
Cinema, Novara, Italy;
May 1963

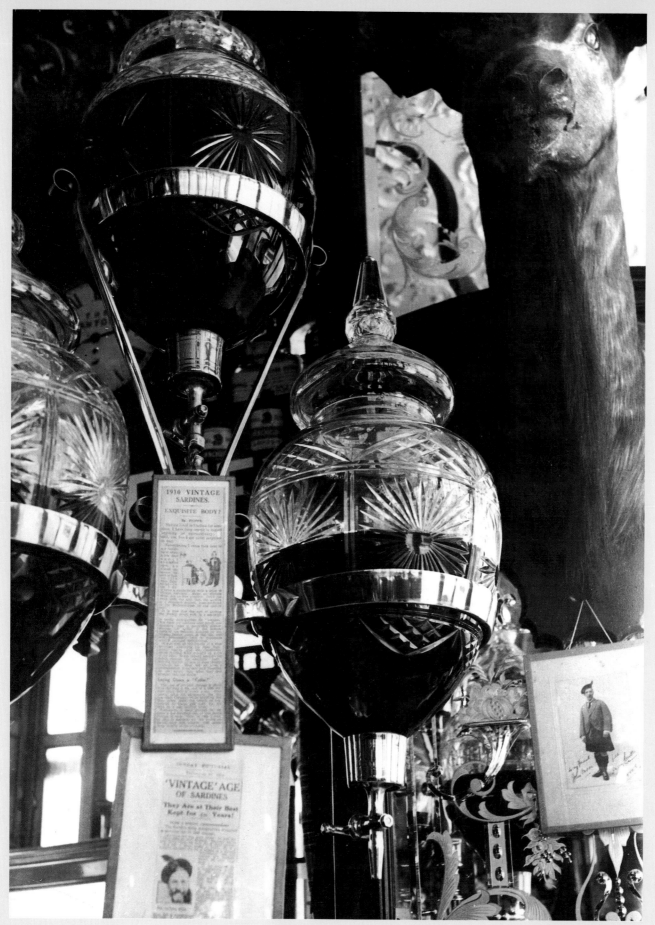

16
Decanters in the Salisbury,
St Martin's Lane,
London; June 1935

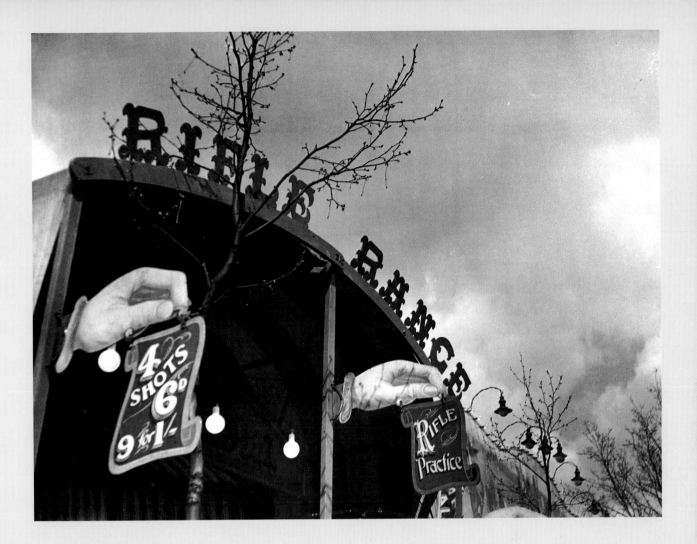

17
*Fairground rifle range,
Hampstead, London;
June 1938*

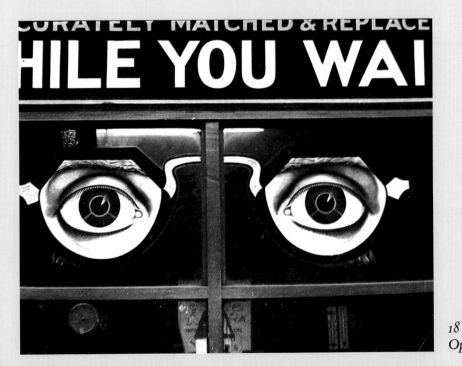

18
Optician, London; May 1935

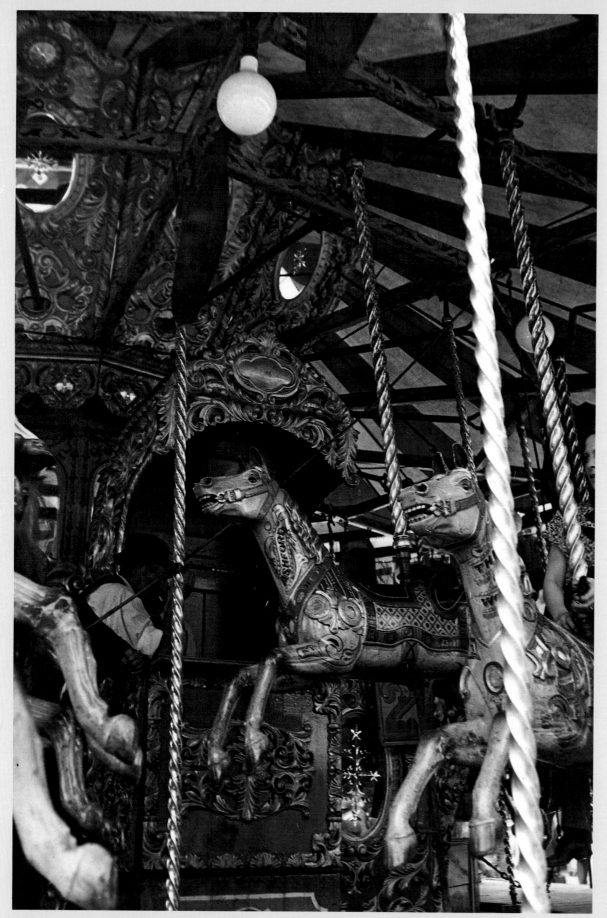

19
Grey's Roundabout,
Hampstead, London;
August 1935

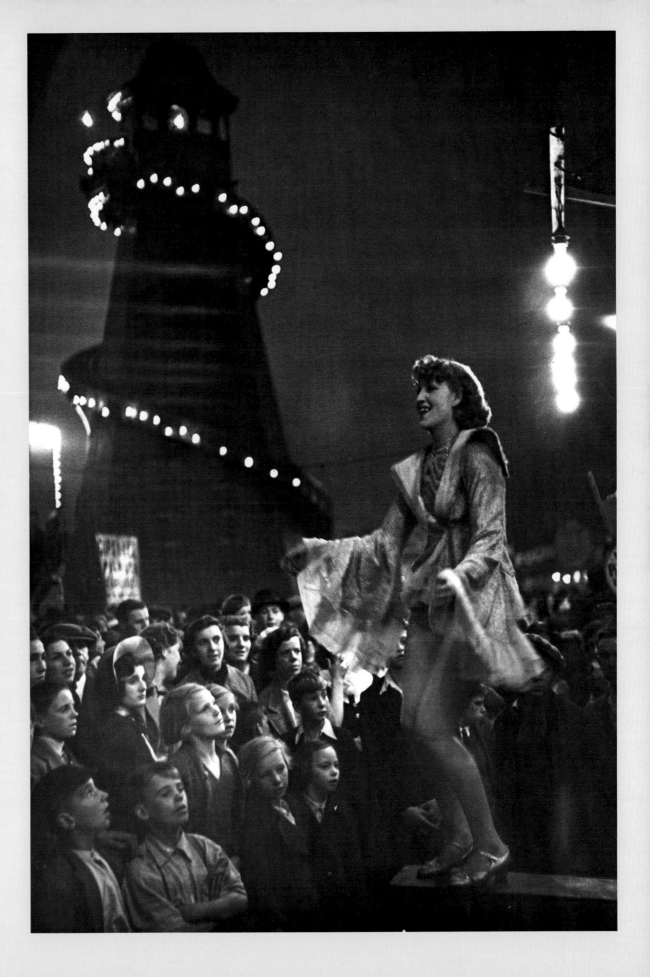

20
Fairground entertainer,
Mitcham, Surrey;
August 1938

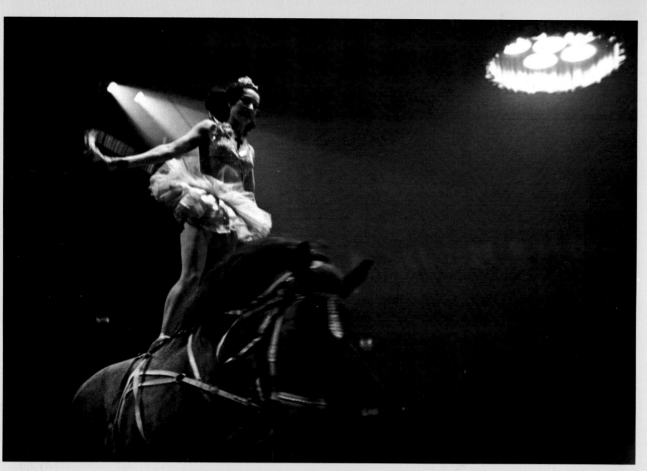

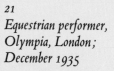

21
Equestrian performer,
Olympia, London;
December 1935

22
Circus horses,
Olympia, London;
December 1938

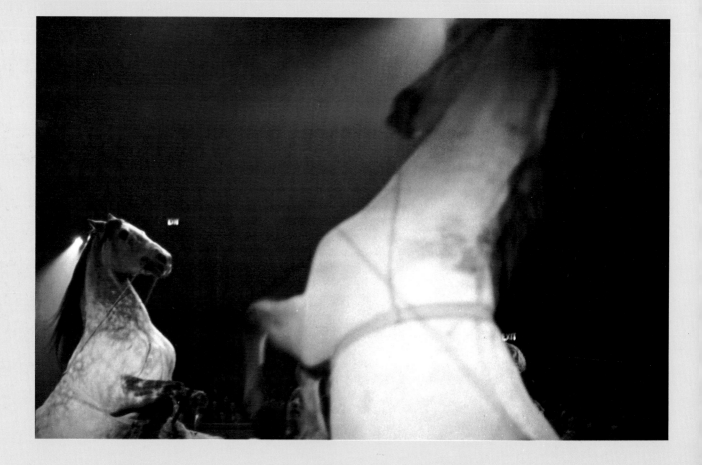

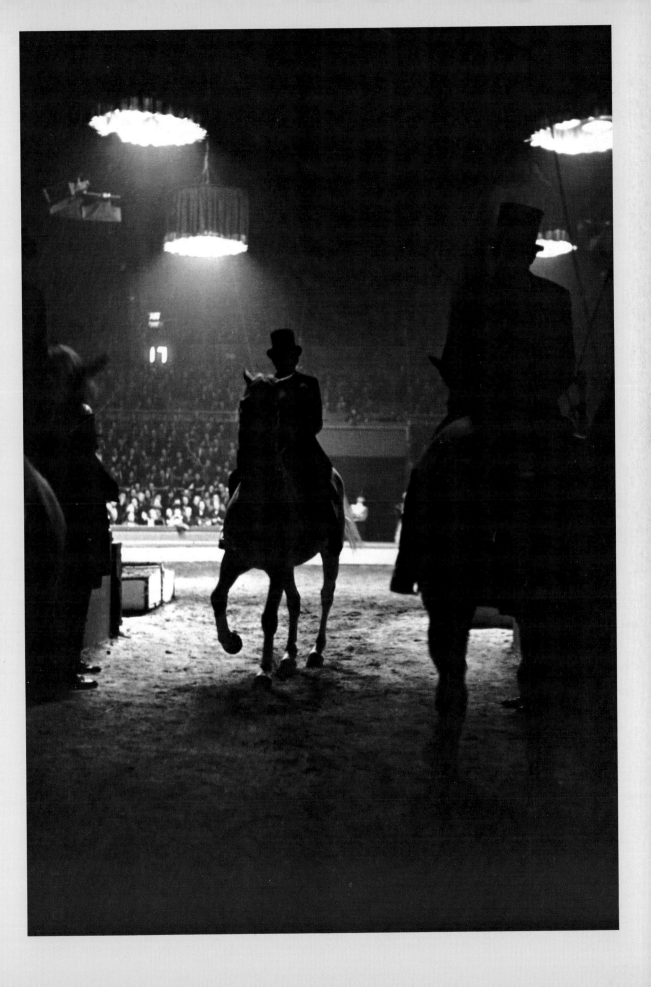

23
Ring Master and
riders, Althoff's
Circus, Olympia;
24 January 1938

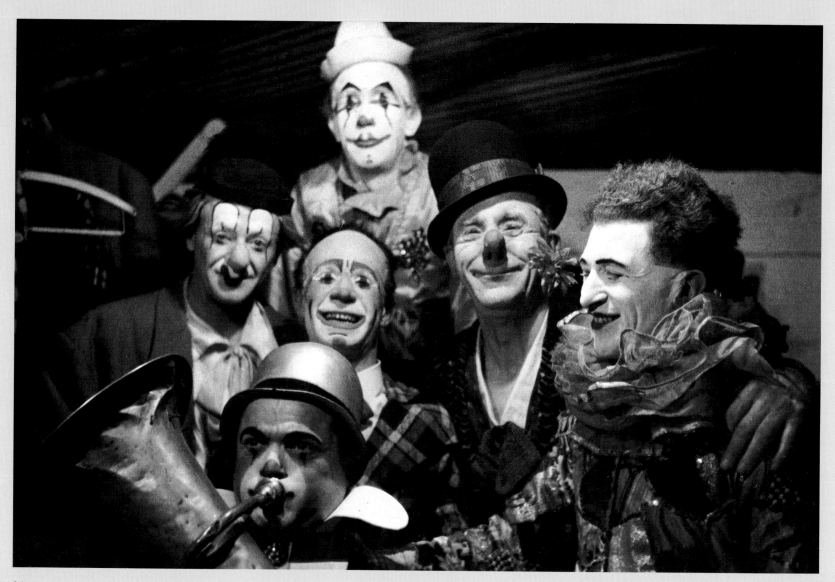

24
Clowns at Olympia, London; January 1936

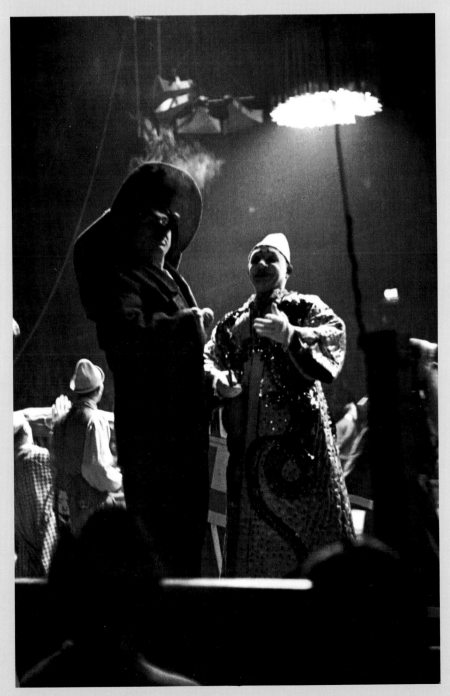

26
*Two of the Pleiss Brothers reading
letters of congratulation at
Bertram Mills's Circus, Olympia;
January 1936*

25
Clowns at Olympia, 24 January 1938

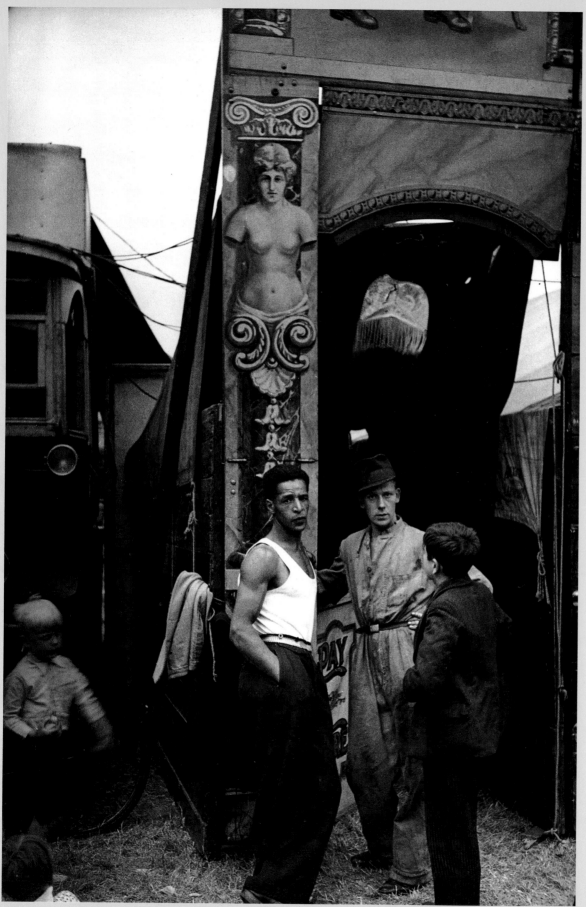

27
Fairground, Mitcham, Surrey;
August 1935

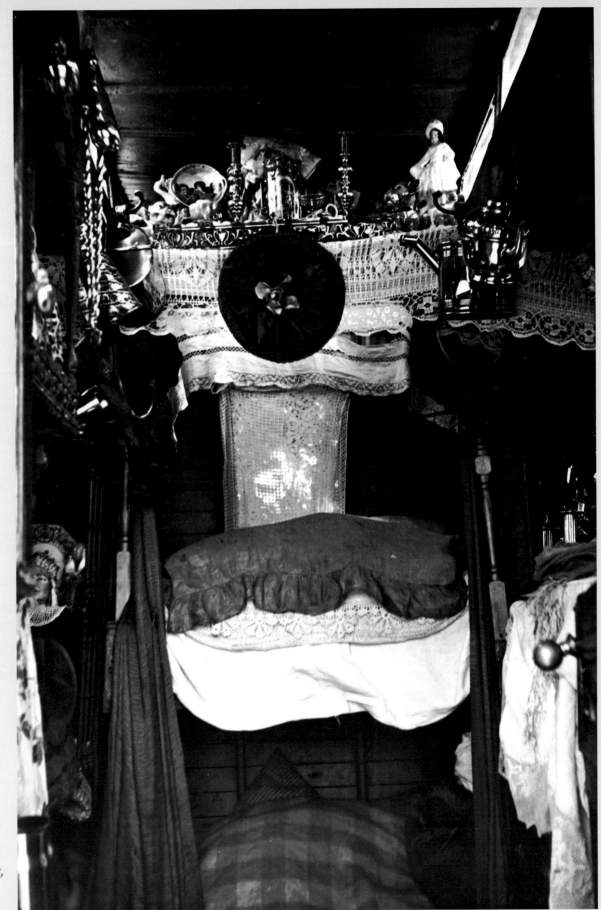

28
Gipsy caravan interior,
Epsom, Surrey;
1 June 1937

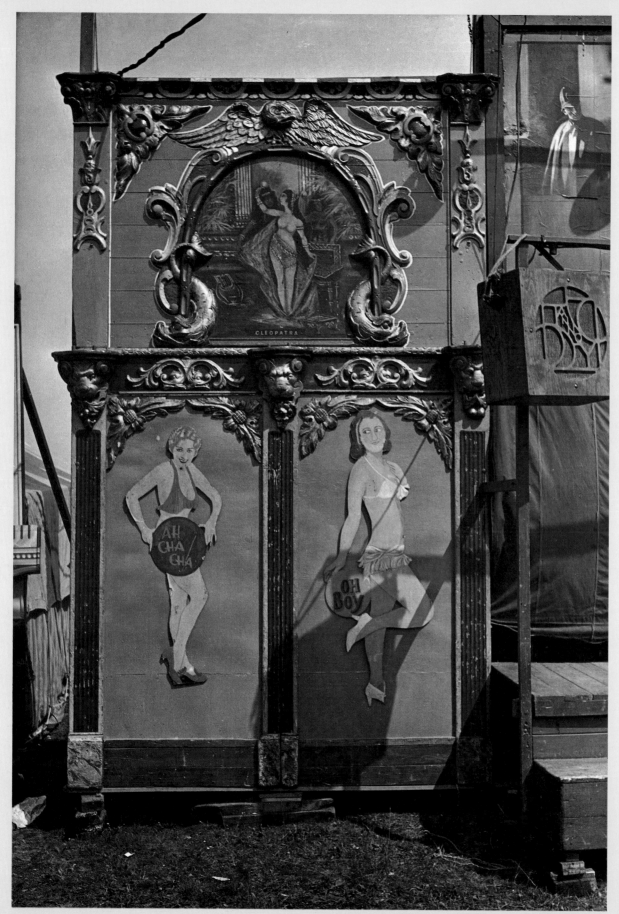

CLEOPATRA

AH CHA CHA

OH BOY

29
Fairground booth,
Epsom, Surrey;
May 1936

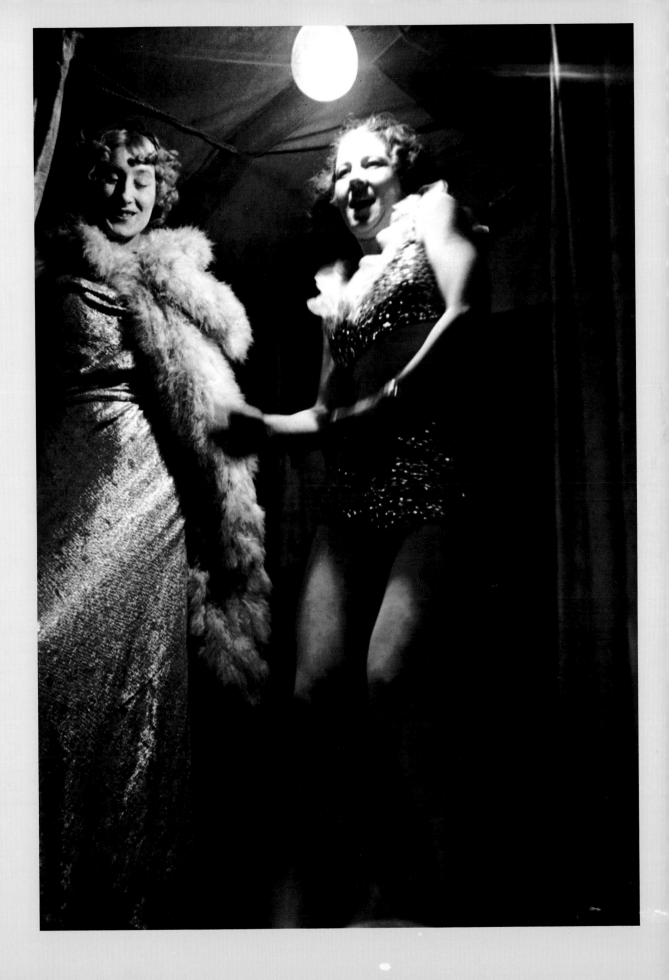

30
Fairground entertainers,
Hampstead;
6 June 1938

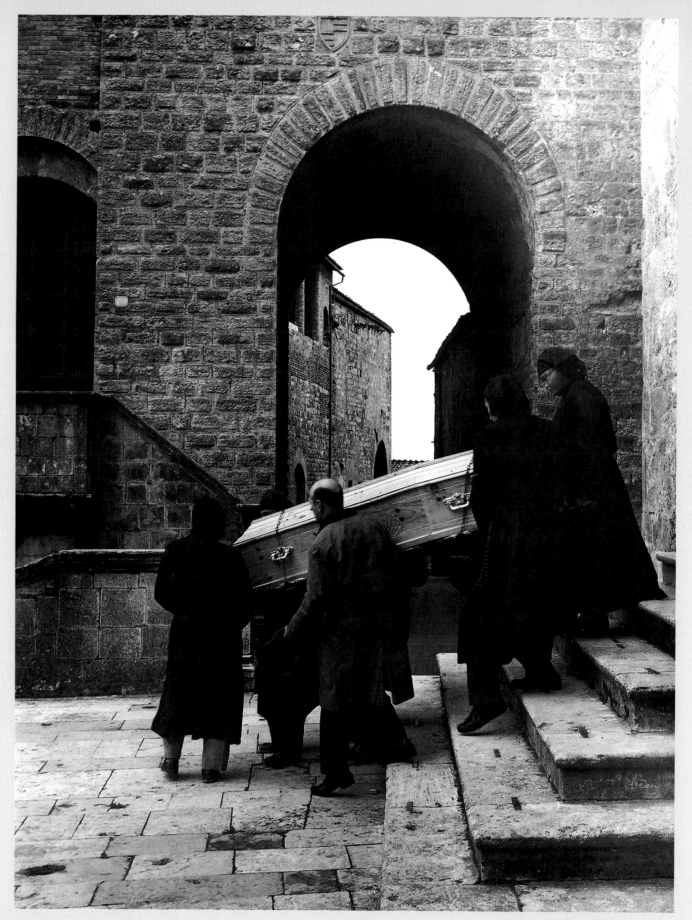

31
San Gimignano,
Italy;
April 1963

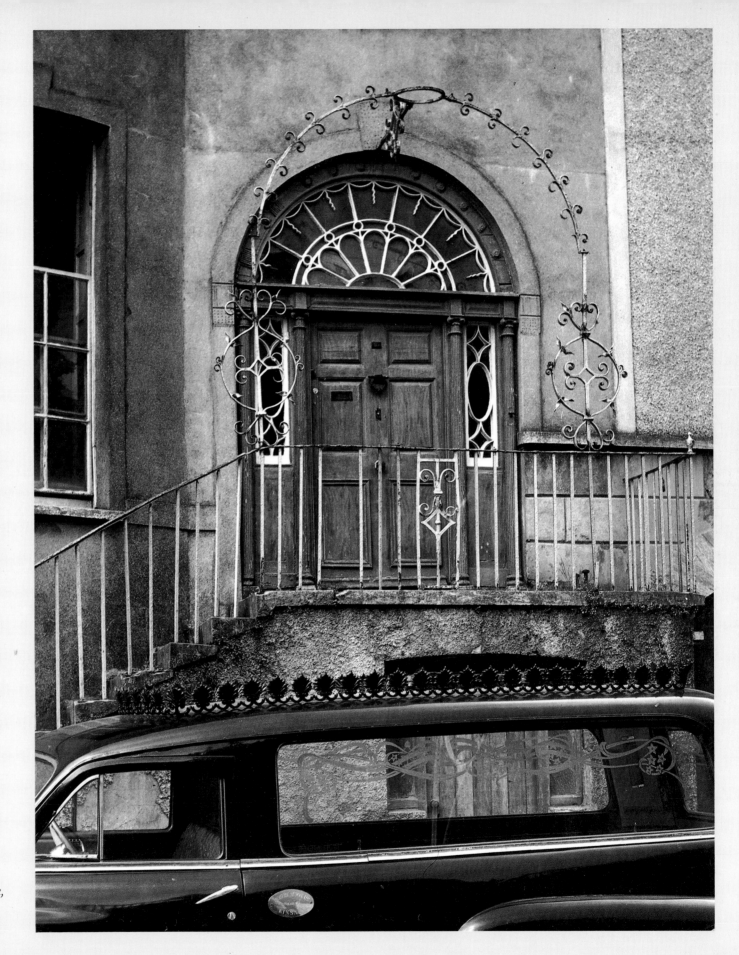

32
*Kinsale, Co. Cork,
Ireland;*
17 May 1965

33
Florence; May 1962

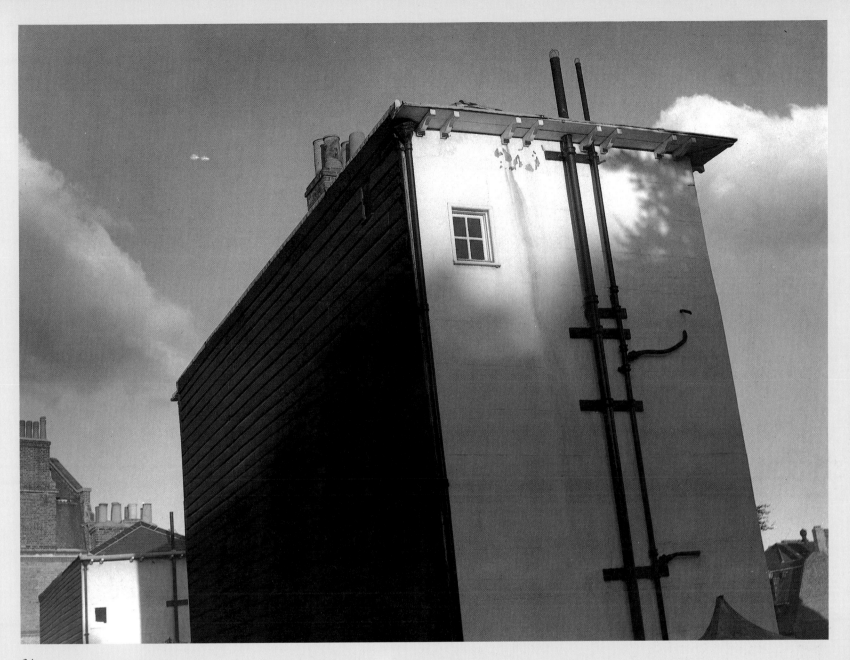

34
Benham's Place, Hampstead, London;
August 1960

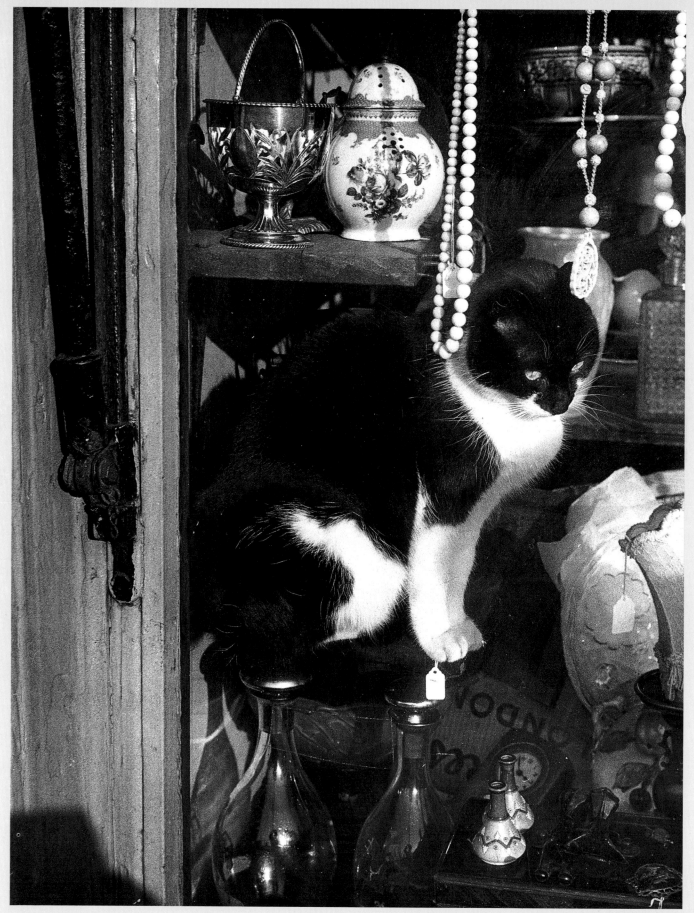

35
*Shop at Swiss
Cottage, London;
December 1961*

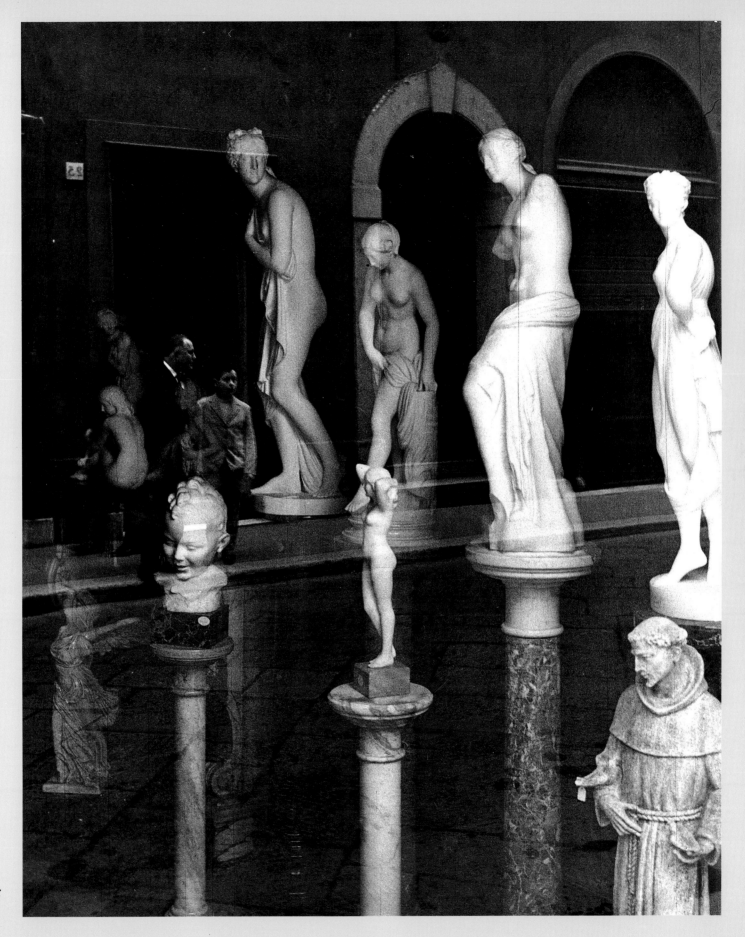

36
Shop in Florence;
May 1963

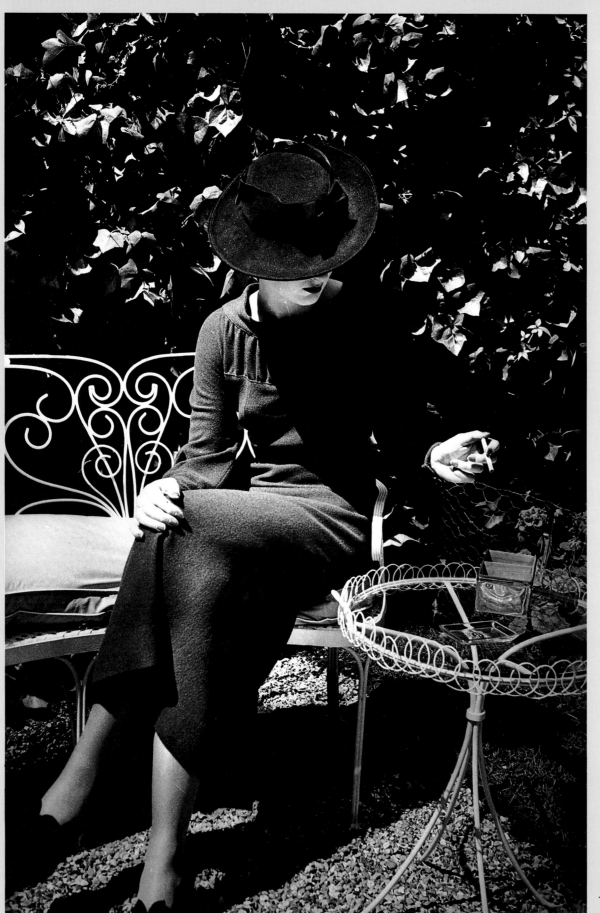

37
*Fashion photograph
for 'Vogue';
22 July 1935*

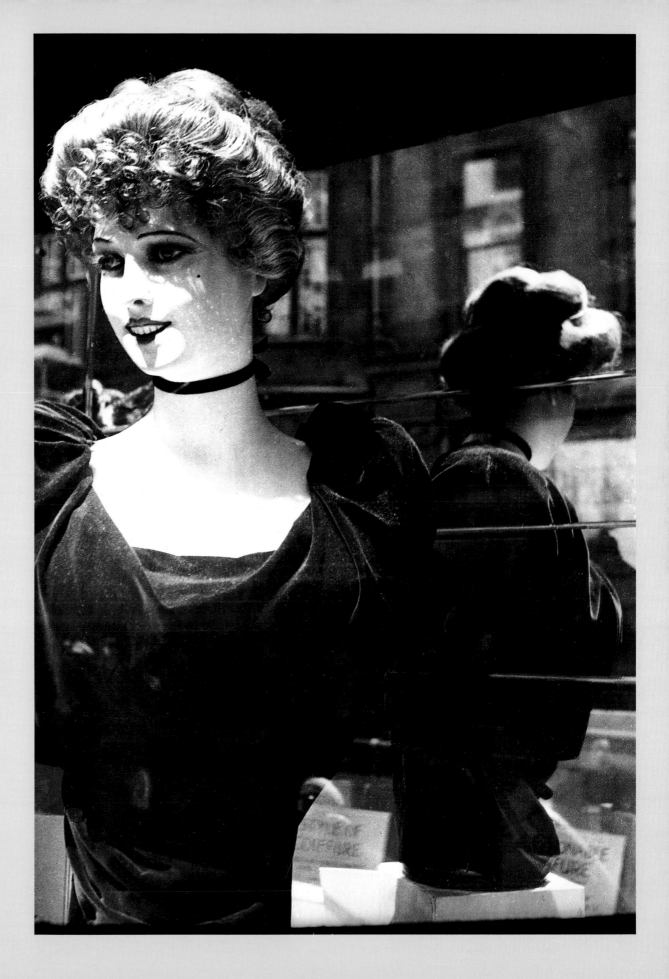

38
'Court Hairdresser',
Dover Street, London;
June 1935

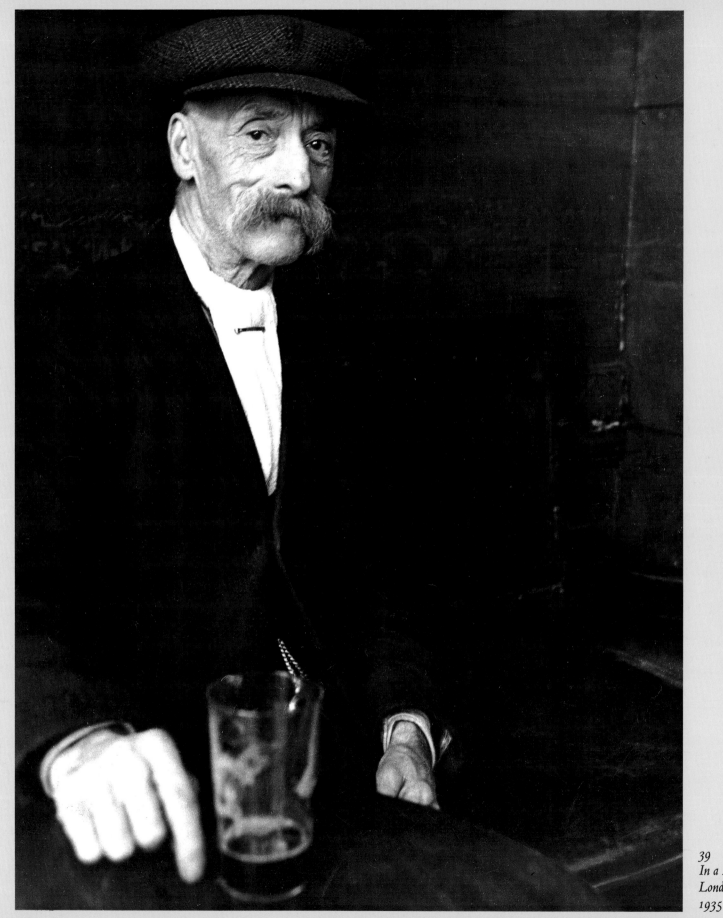

39
*In a Bermondsey pub,
London; Jubilee Day,
1935*

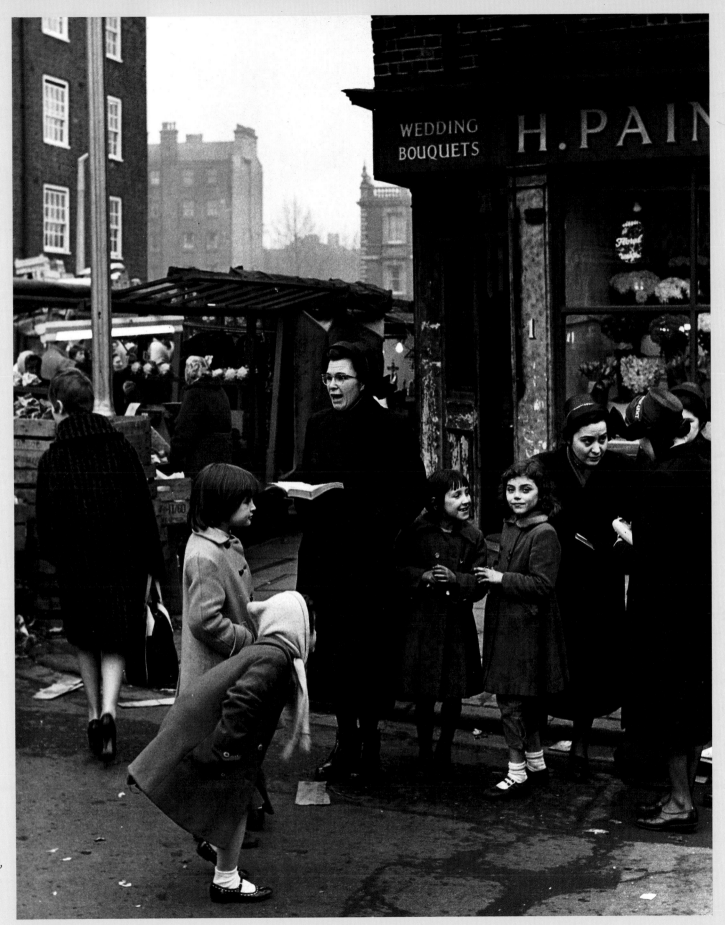

40
East Street Market,
Walworth,
London;
14 January 1961

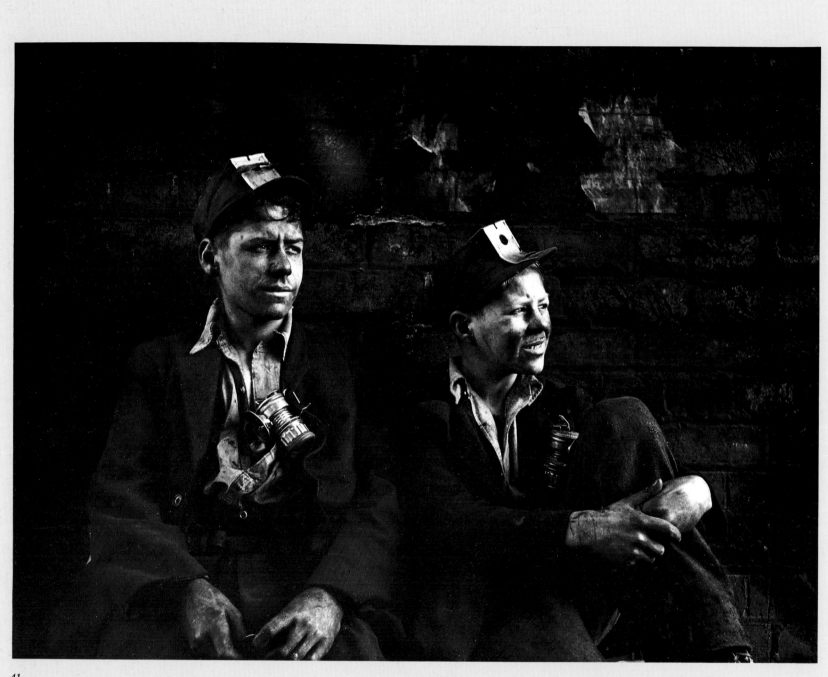

41
Colliers, Ashington, Northumberland;
August 1936

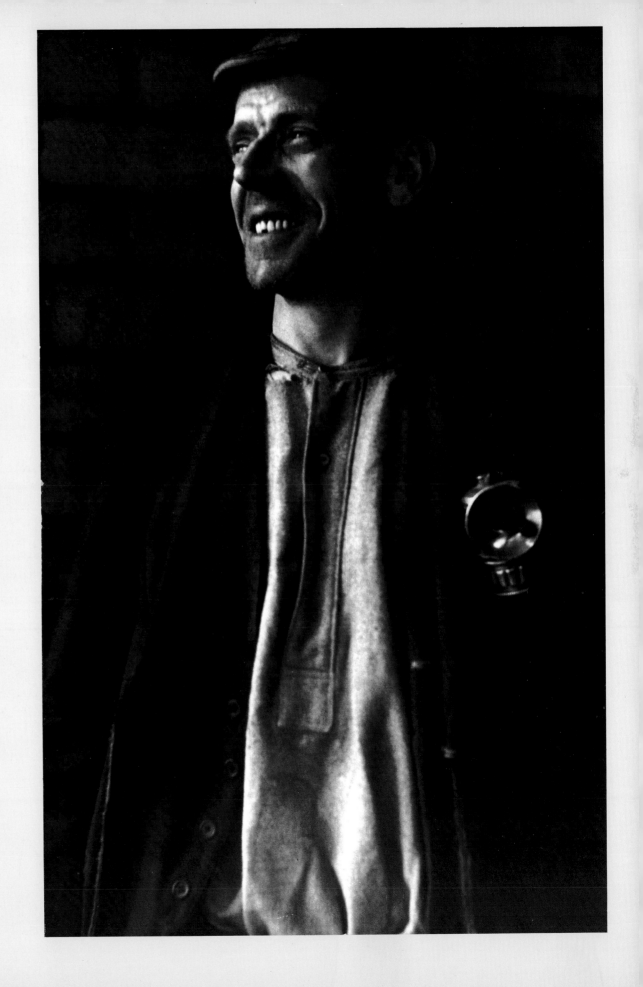

42
Miner, Ashington Colliery,
Northumberland;
August 1936

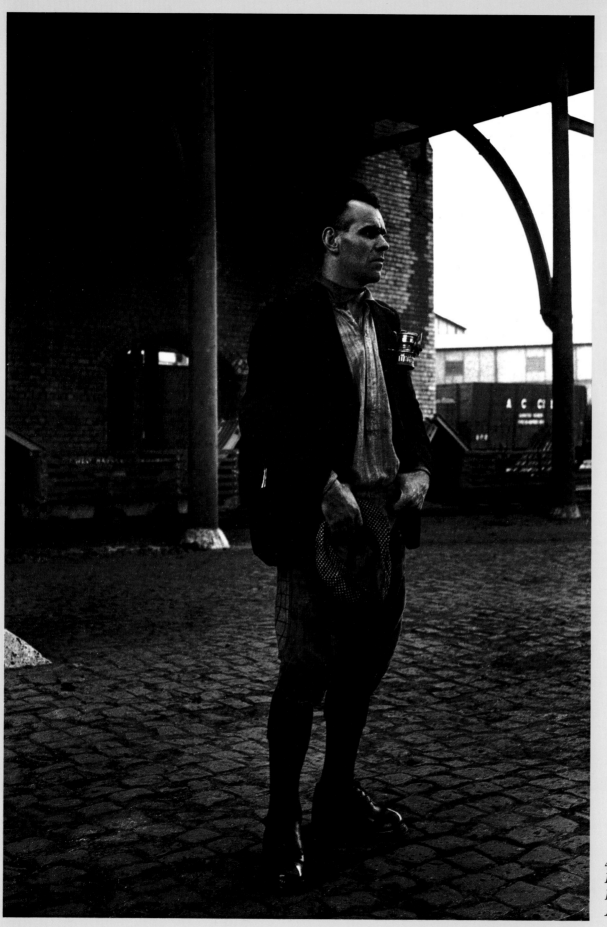

43
Foreman, Ashington Colliery,
Northumberland;
August 1936

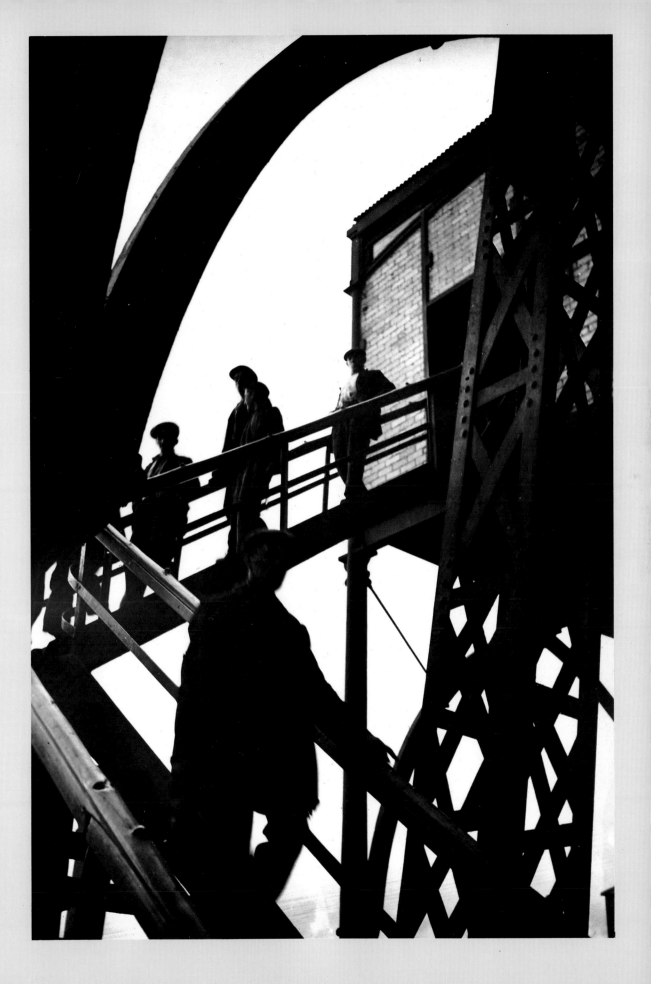

44
Pithead, Ashington Colliery,
Northumberland;
August 1936

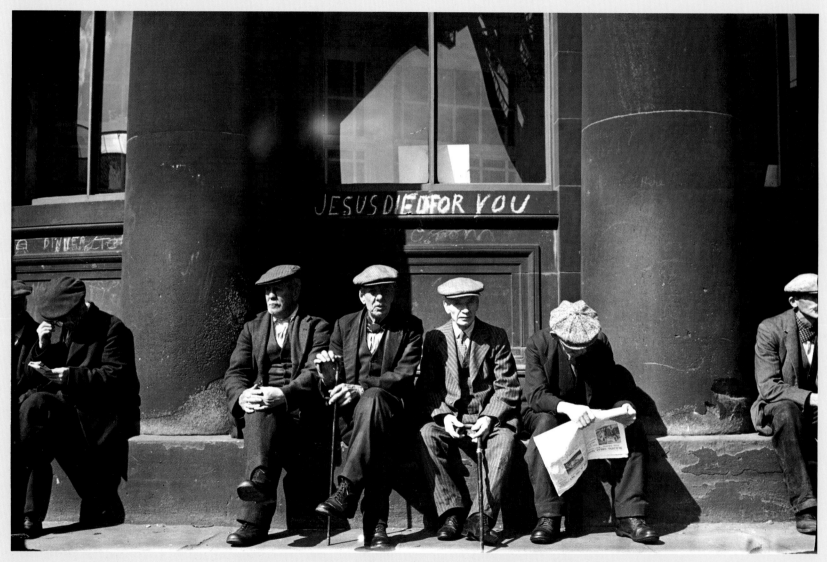

45
Outside the Guildhall, Newcastle;
August 1936

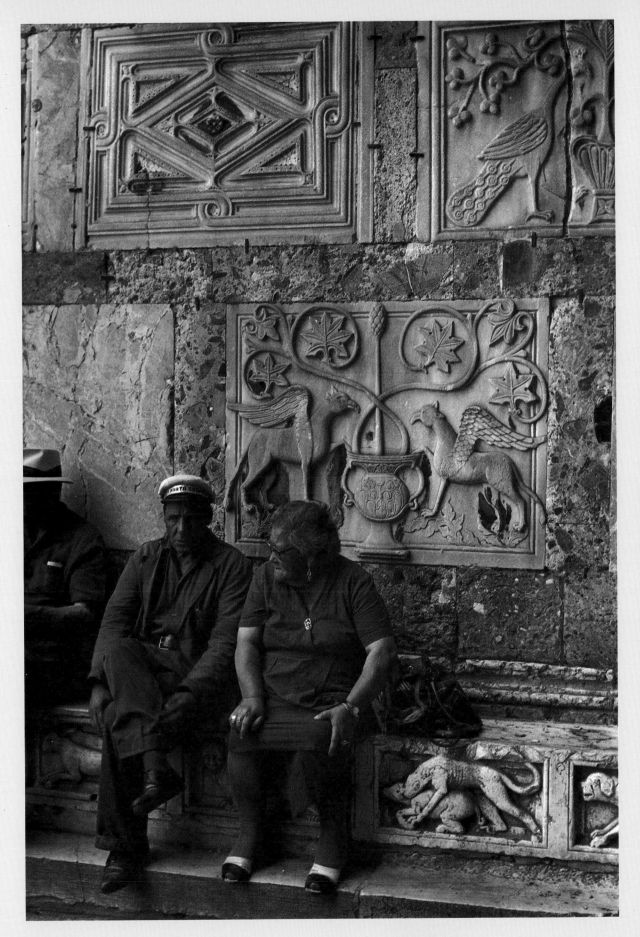

46
Outside St Mark's Treasury, Venice;
2 September 1961

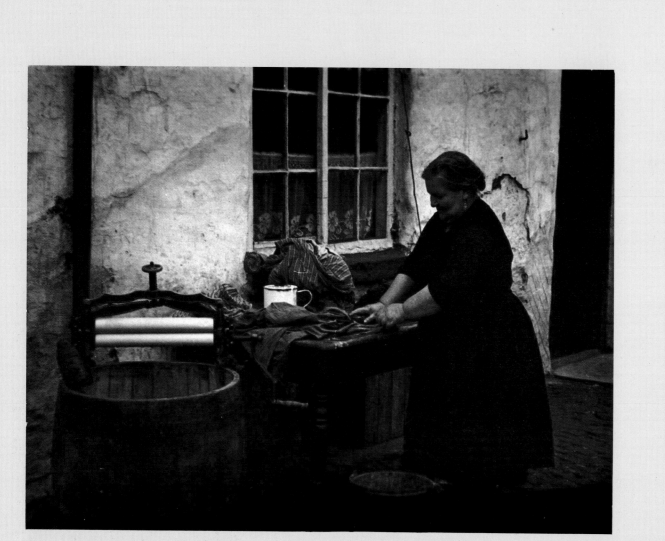

47
South Shields,
Co. Durham;
August 1936

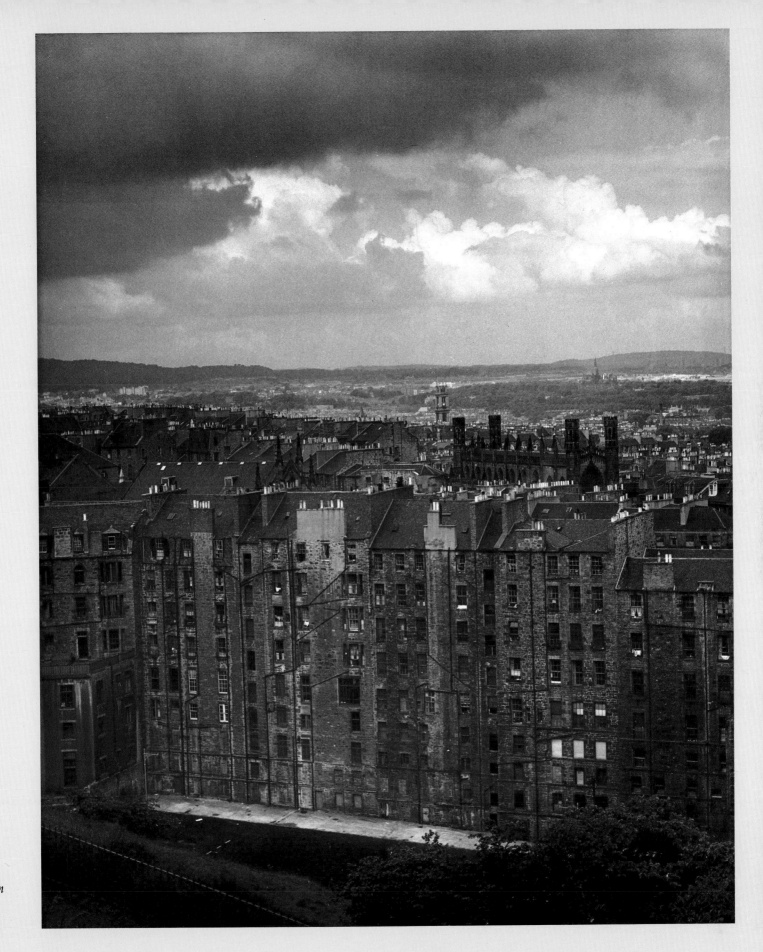

48
*Edinburgh from Calton Hill;
June 1963*

RAILWAYS AND IRON

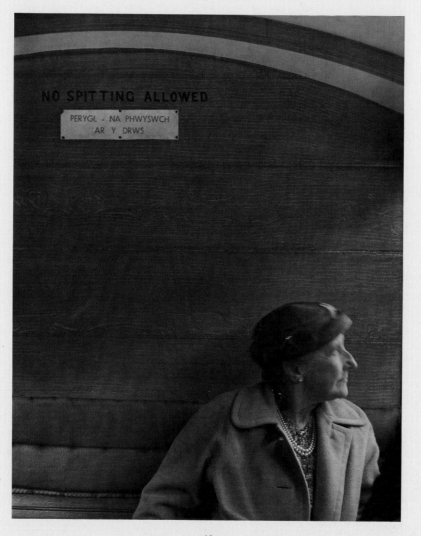

49
Talyllyn Railway, Wales;
25 September 1959

50
Printer's Antique, Southwold, Suffolk;
2 September 1957

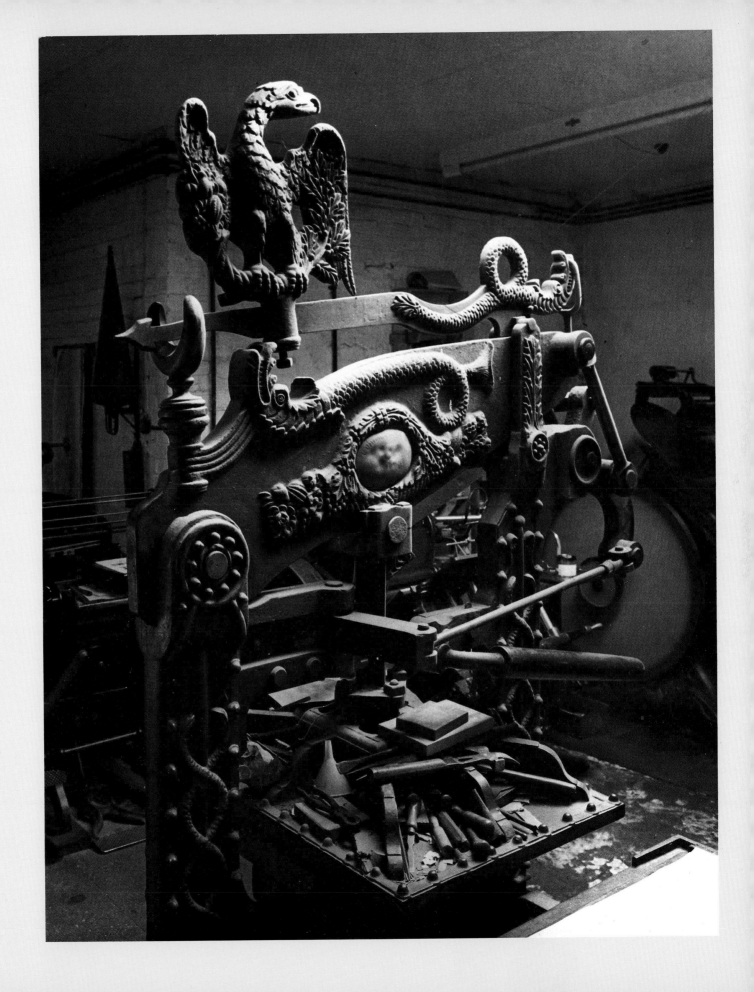

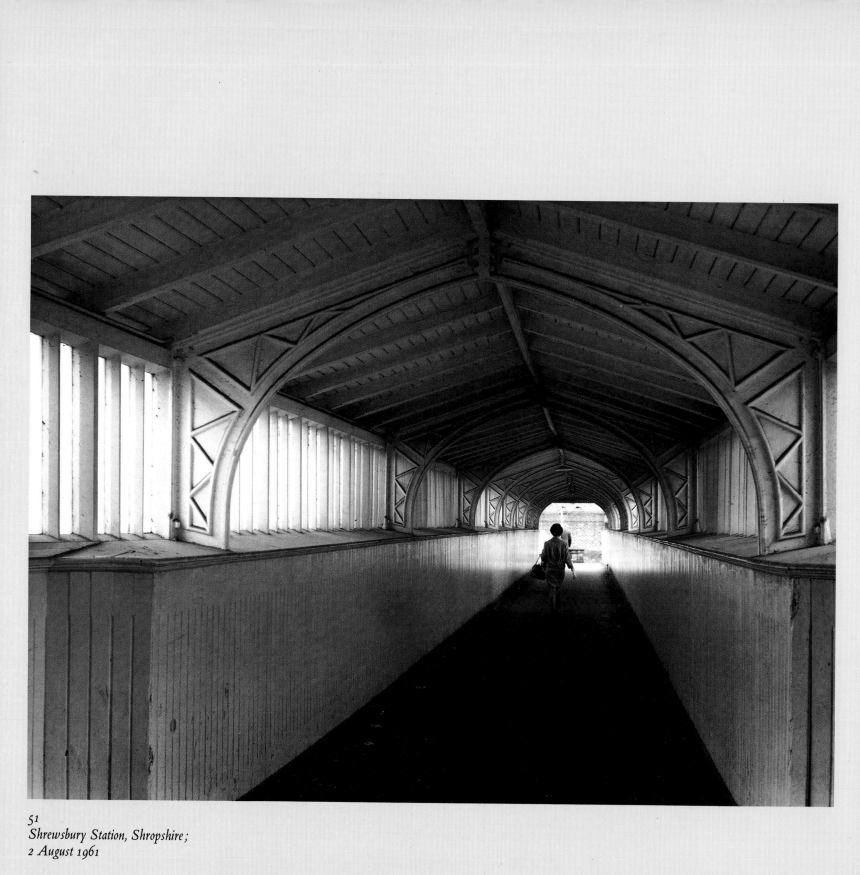

51
Shrewsbury Station, Shropshire;
2 August 1961

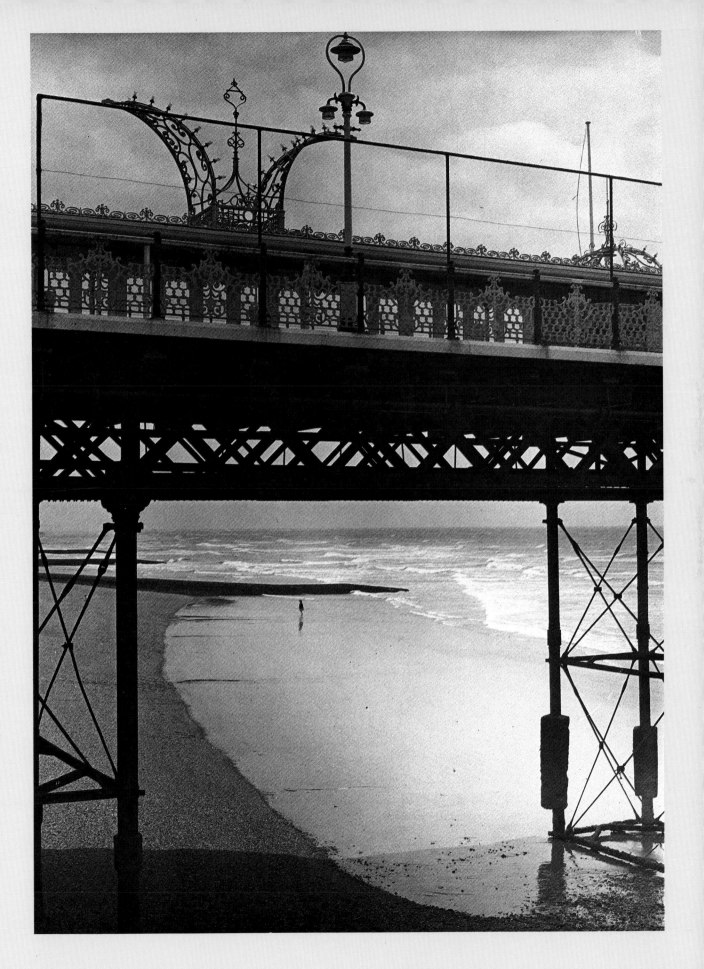

52
Palace Pier, Brighton;
13 October 1952

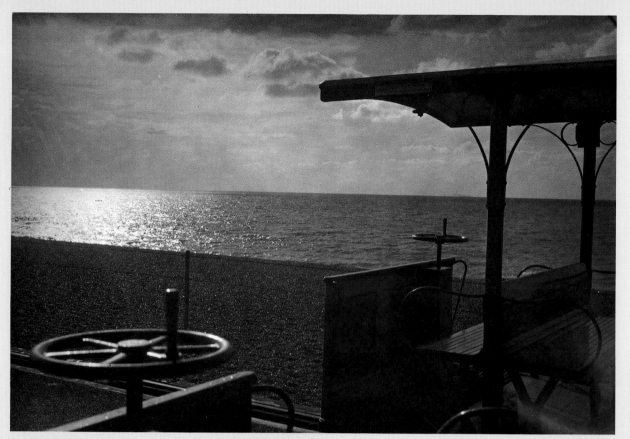

53
Beach railway,
Brighton;
11 October 1952

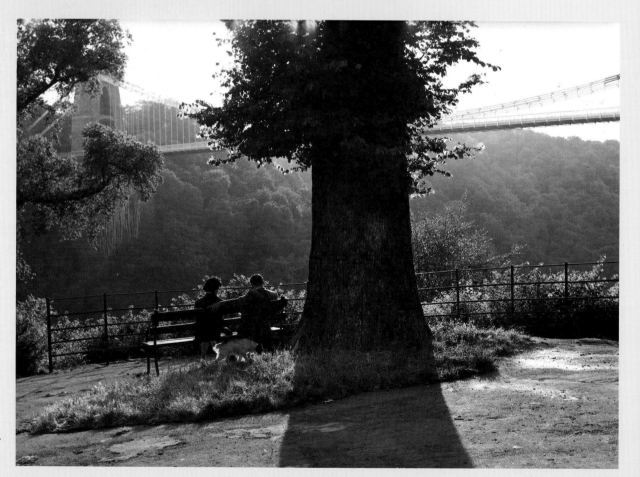

54
Clifton, Bristol;
11 July 1961

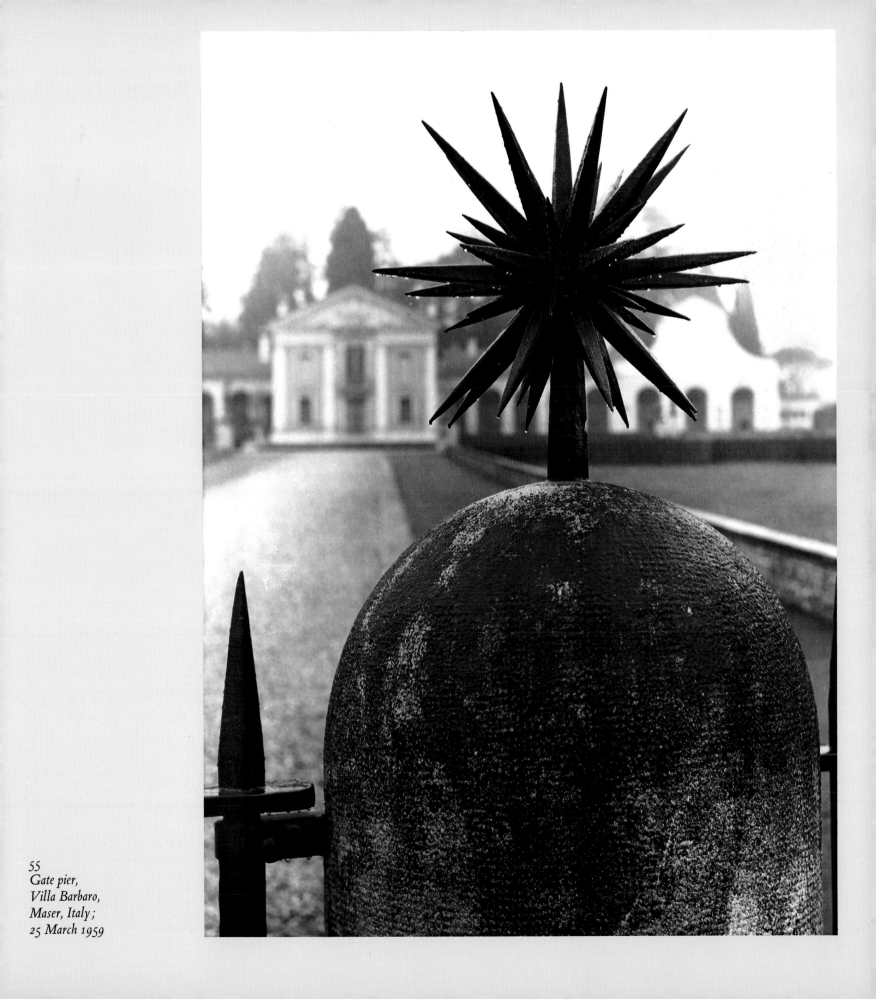

55
Gate pier,
Villa Barbaro,
Maser, Italy;
25 March 1959

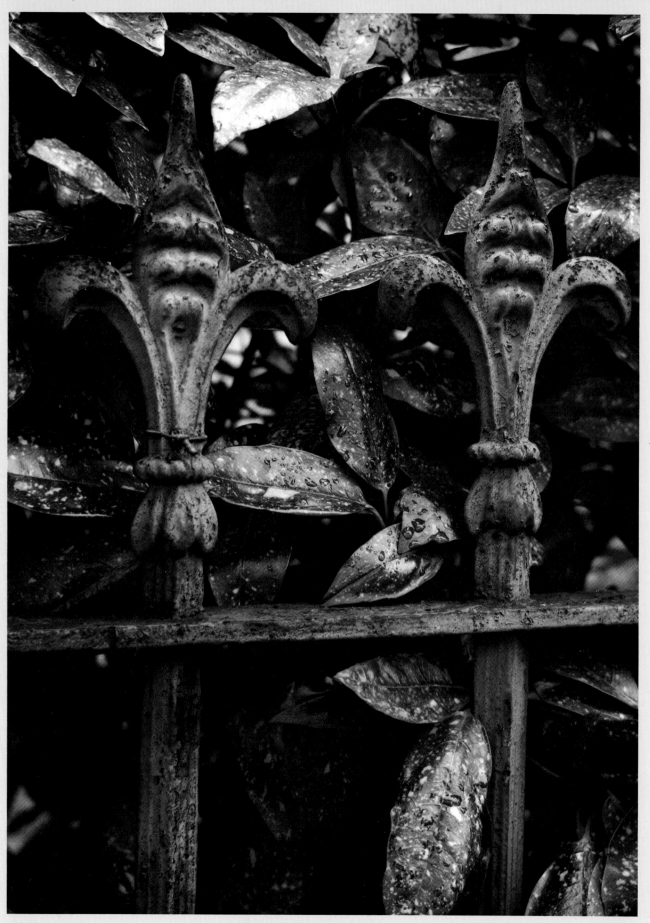

56
Back garden cast iron
railing above
the Water of Leith,
Edinburgh;
13 October 1964

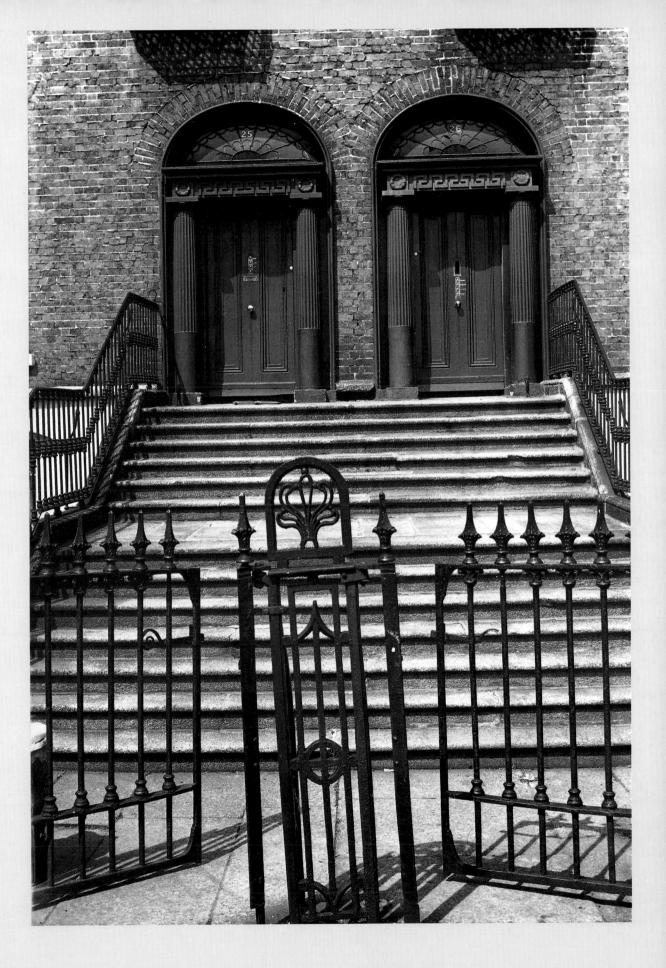

57
Herbert Place, Dublin;
10 May 1965

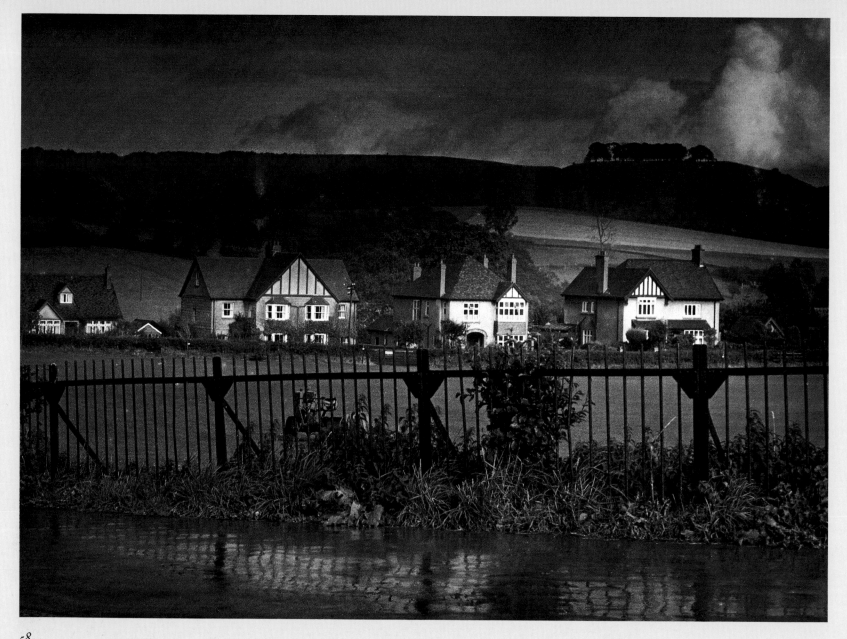

58
Dursley, Gloucestershire;
14 September 1955

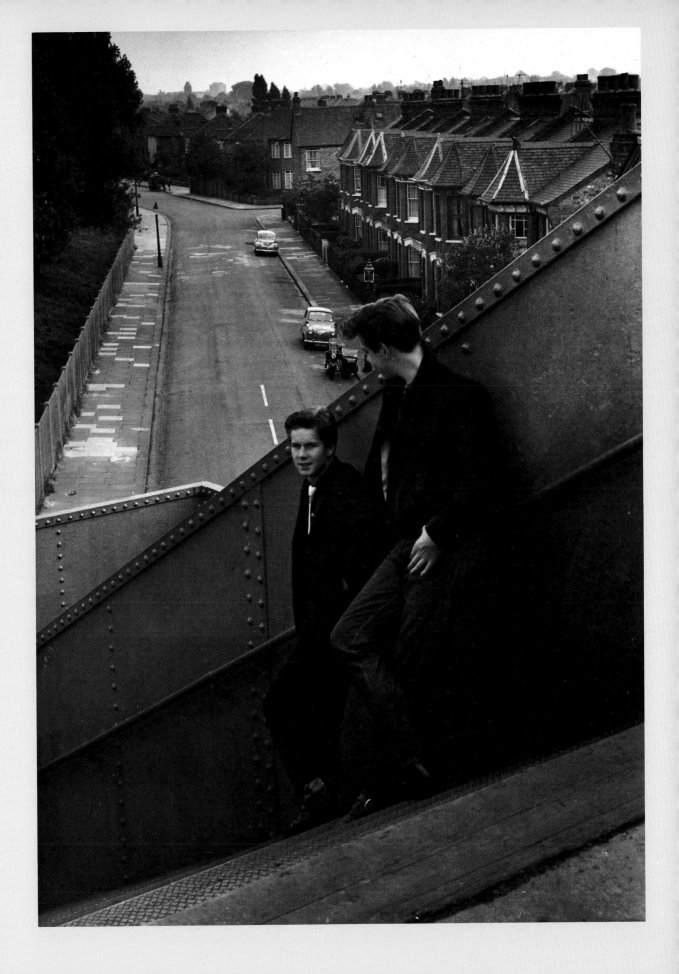

59
Dollis Hill, London;
11 June 1961

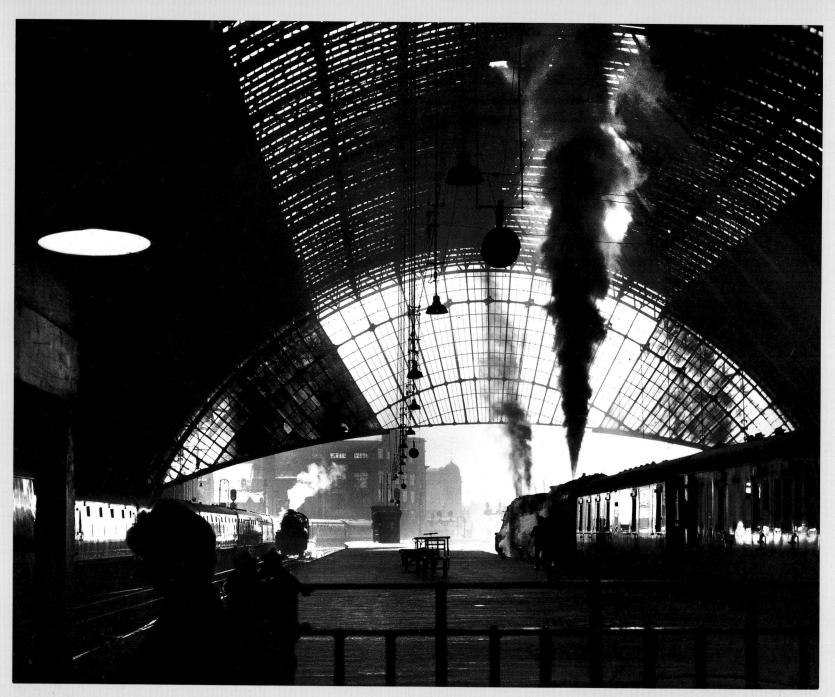

60
St Enoch's Station, Glasgow;
6 July 1961

61
Kentish Town Station, London;
28 October 1936

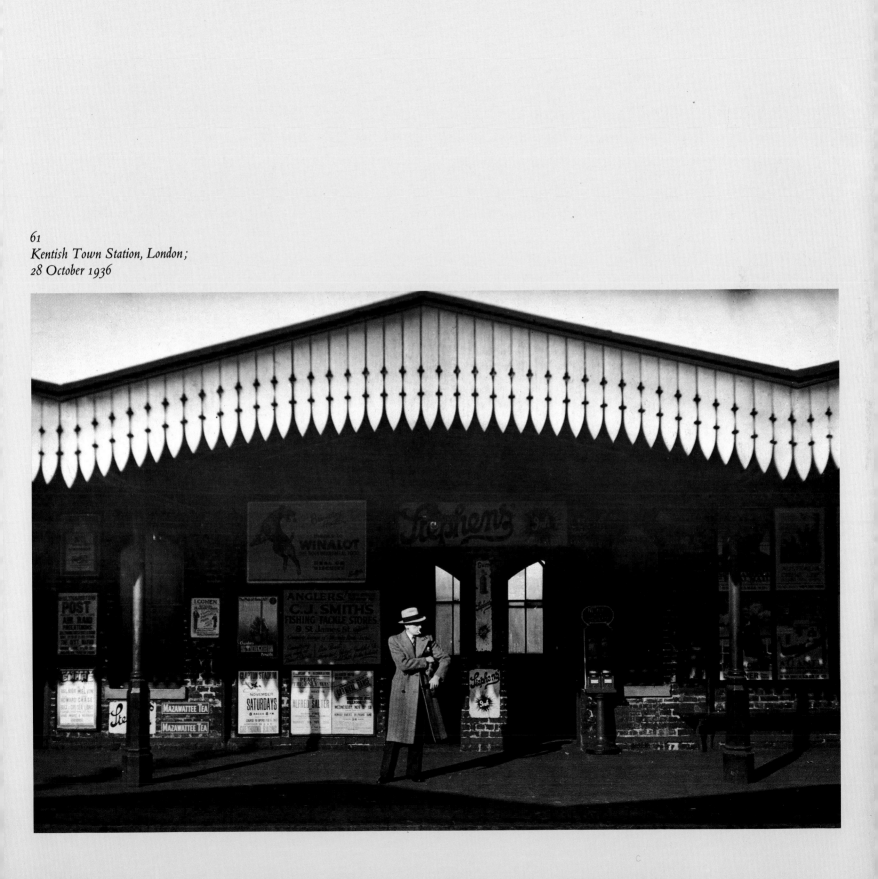

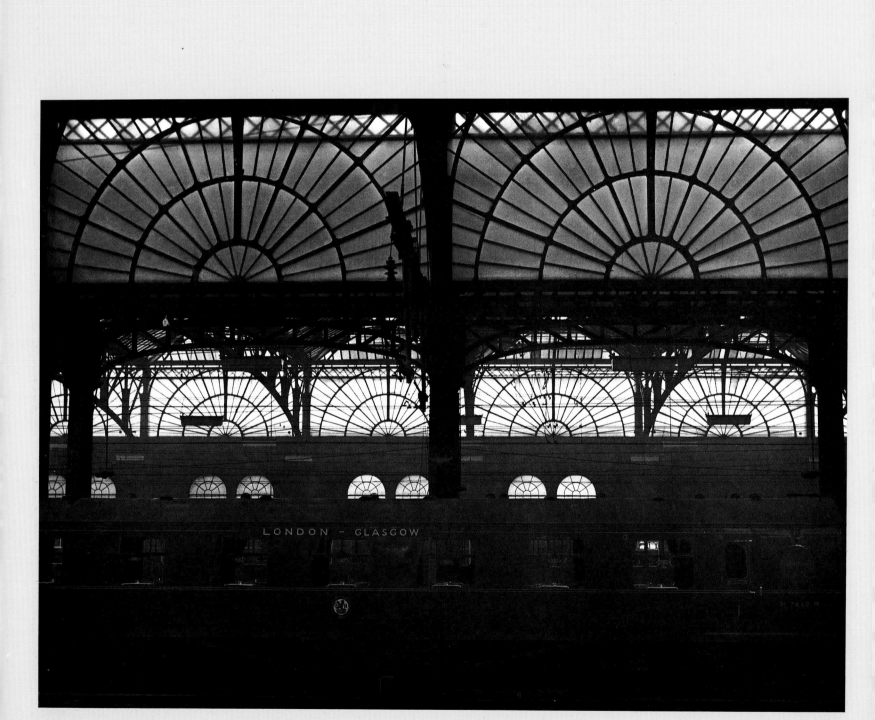

62
Central Station, Glasgow;
7 July 1961

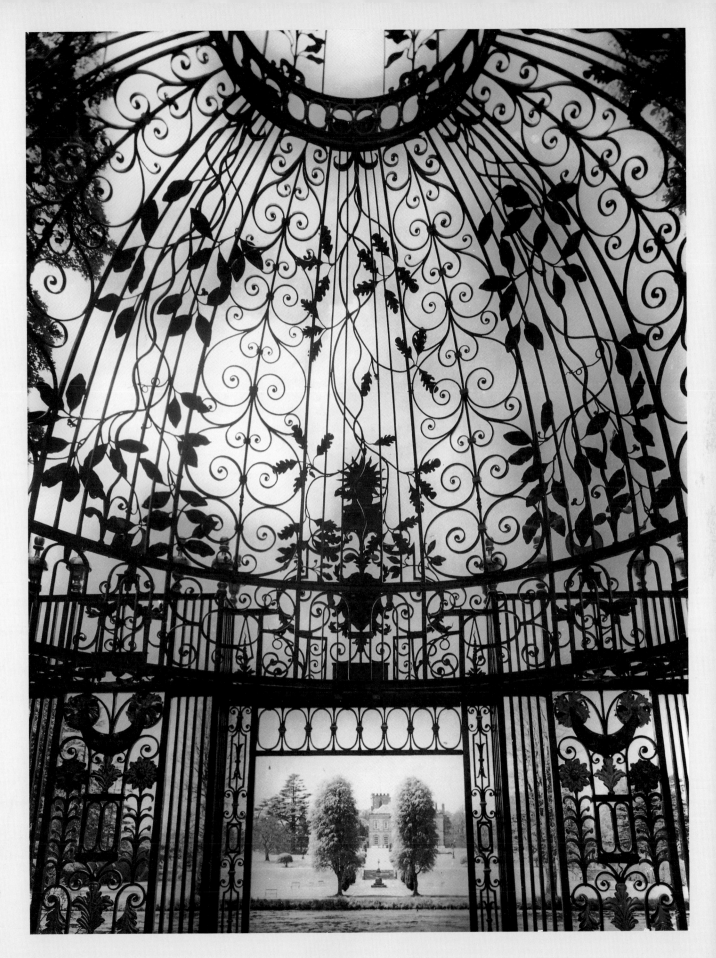

63
The Arbour, Melbourne Hall, Derbyshire; 3 June 1963

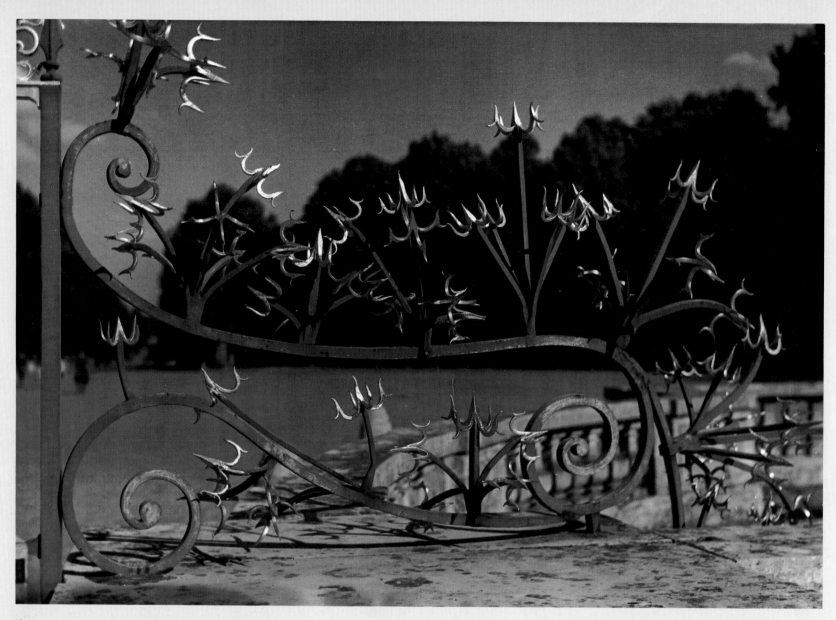

64
Versailles;
30 June 1960

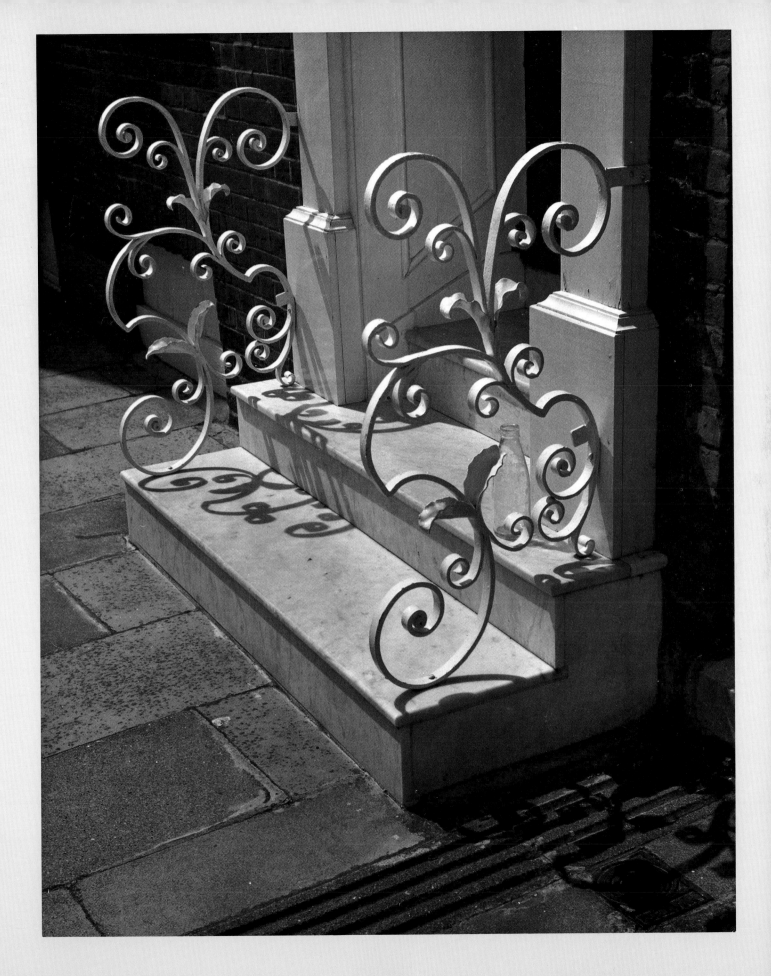

65
Portsmouth,
Hampshire;
20 June 1968

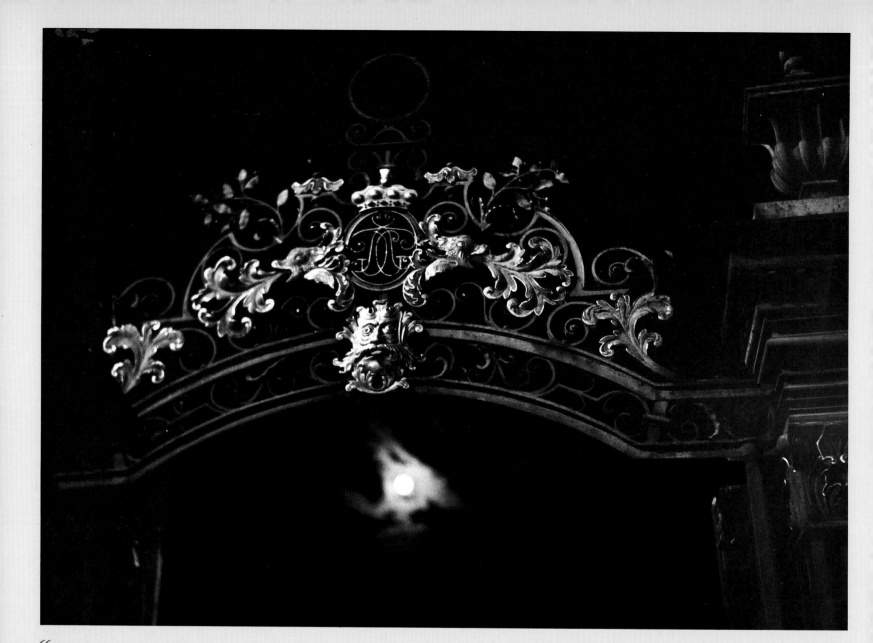

66
The gates of Tewkesbury Abbey,
Gloucestershire; 11.30 p.m.,
2 August 1958

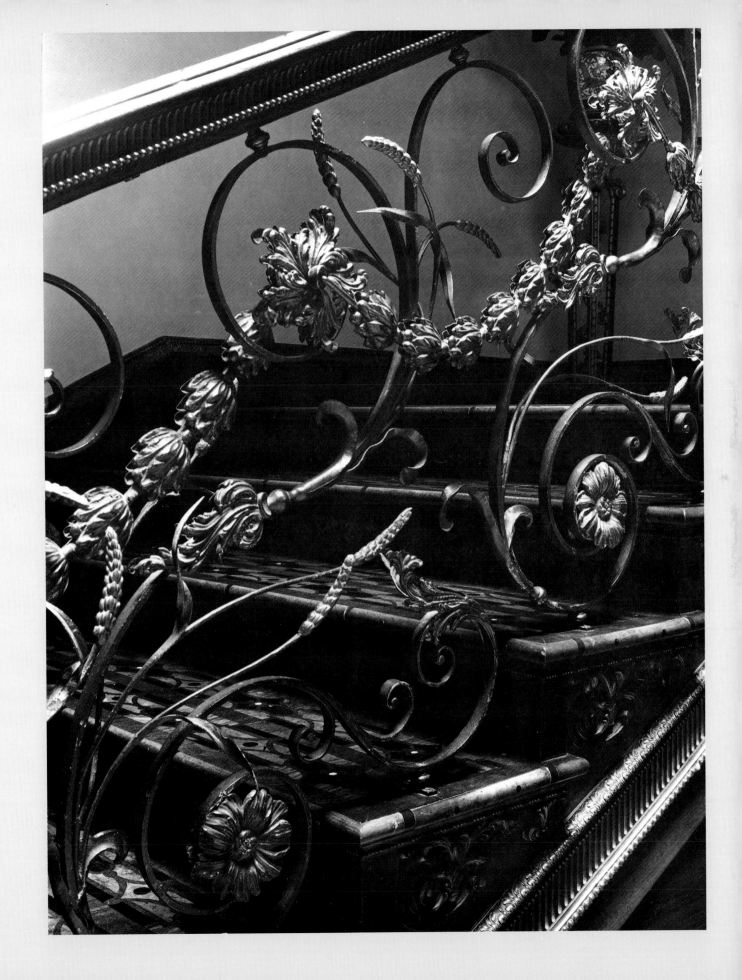

67
The staircase,
Claydon House,
Buckinghamshire;
16 September 1958

COUNTRY

68
*Date stone in the porch,
Bingham's Melcombe, Dorset;
20 August 1965*

69
*The Giant's Causeway,
Co. Antrim, Ireland;
14 June 1965*

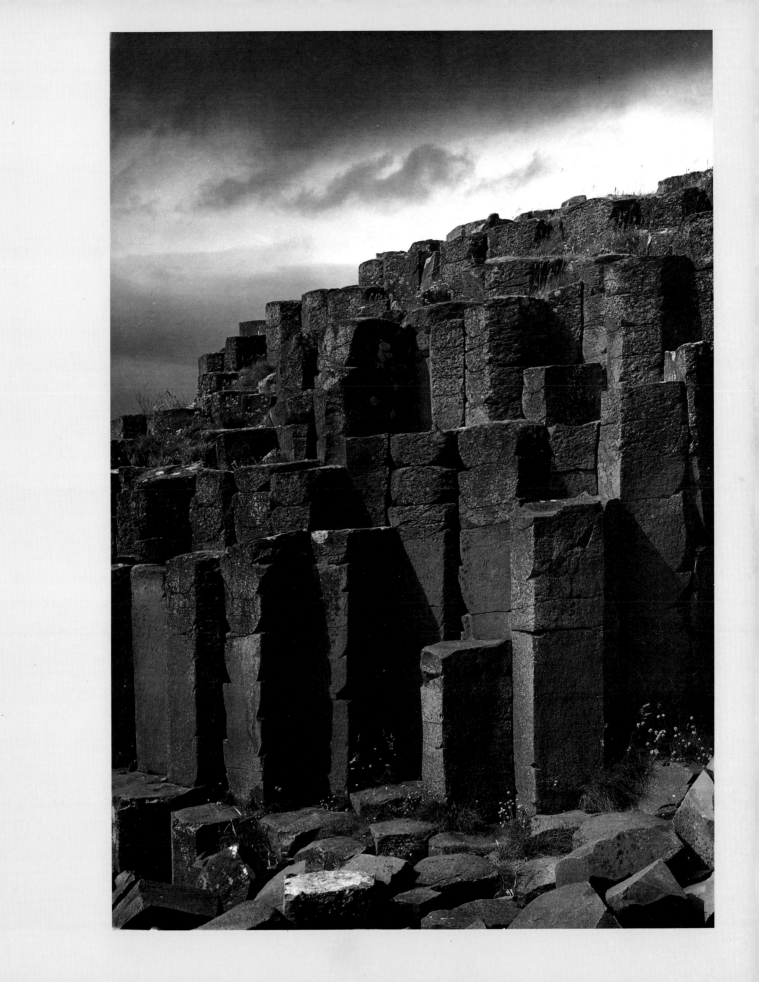

Arbor Low, Derbyshire ;
8 February 1967

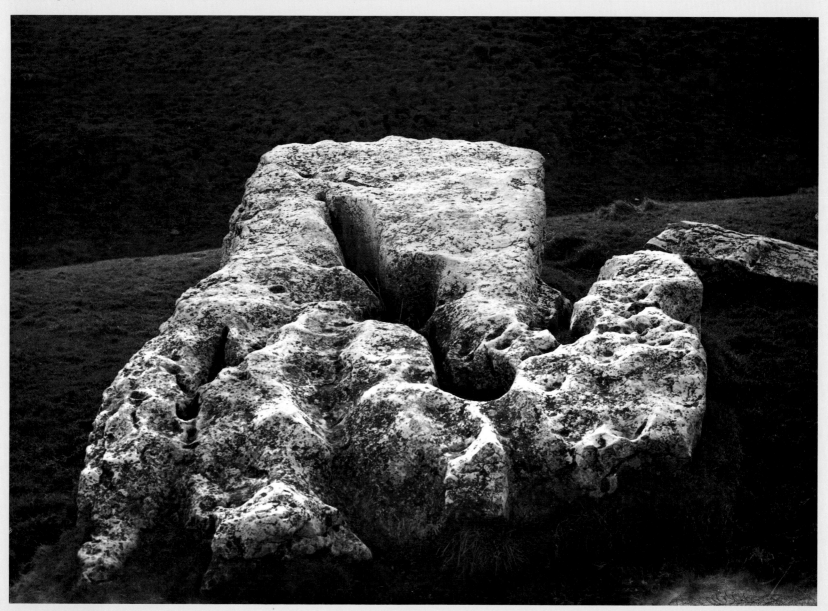

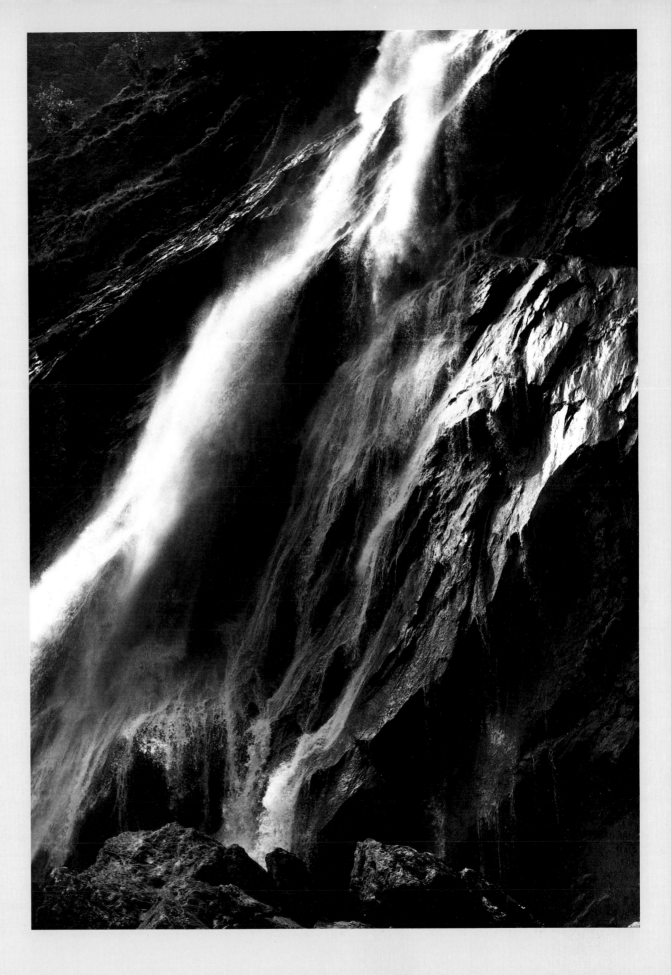

71
Waterfall at Powerscourt,
Co. Wicklow, Ireland;
7 May 1965

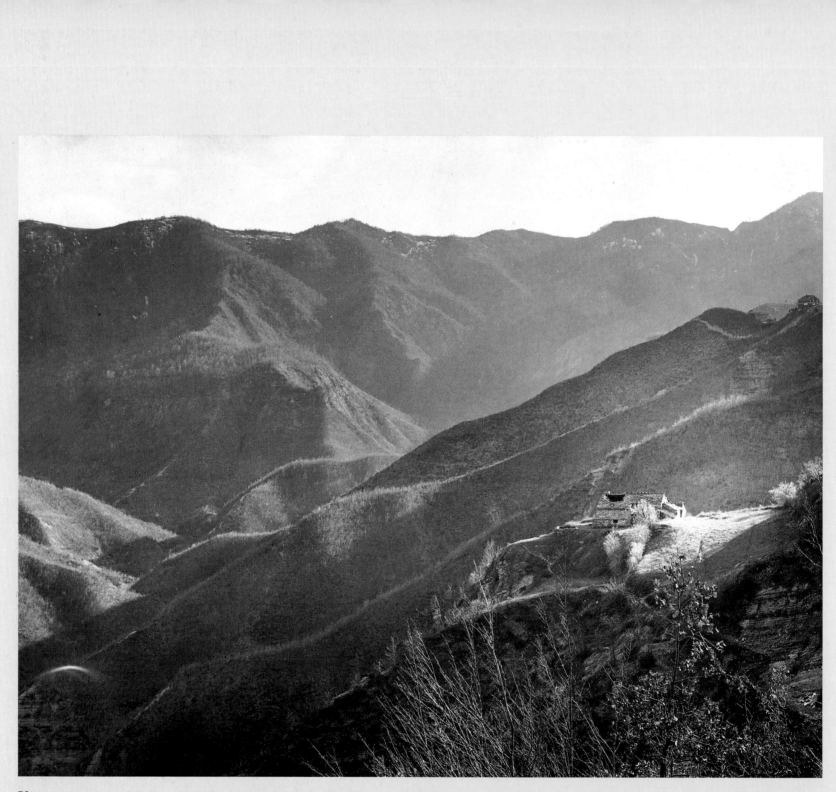

72
Pass between Poppi and Ravenna, Italy;
13 April 1963

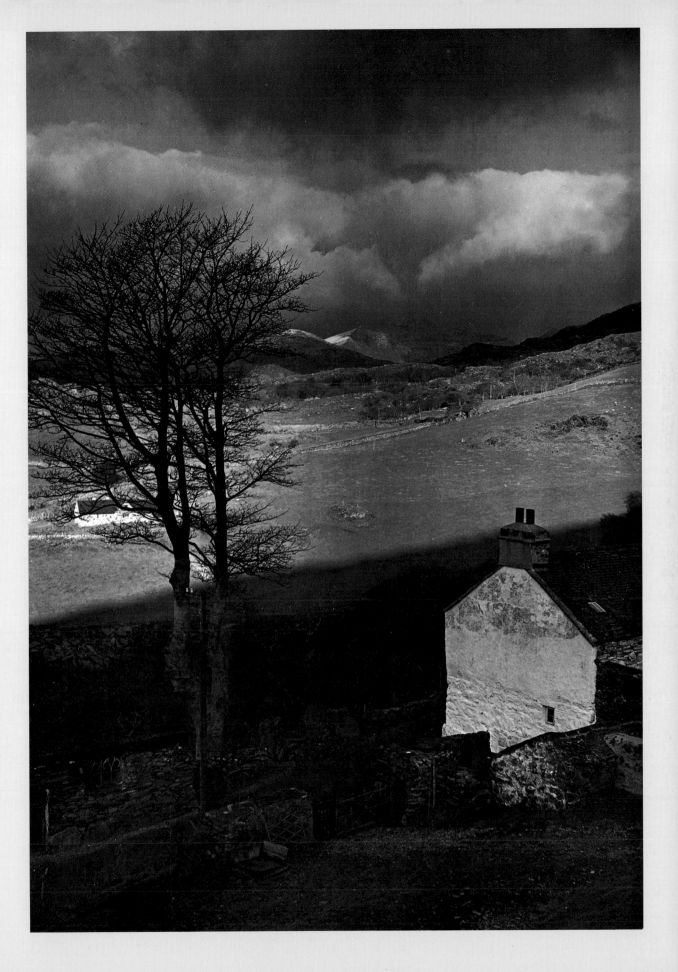

73
*The Snowdon Range
from Bewdy Newydd,
Merioneth, Wales;
30 December 1955*

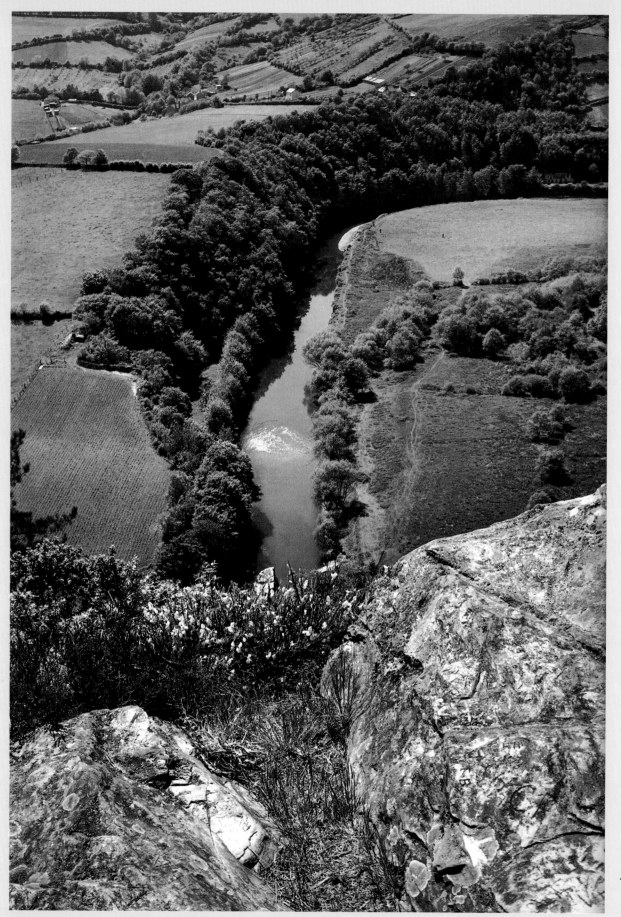

74
*The River Tamar
from Morwell Rocks,
Devon;
29 May 1956*

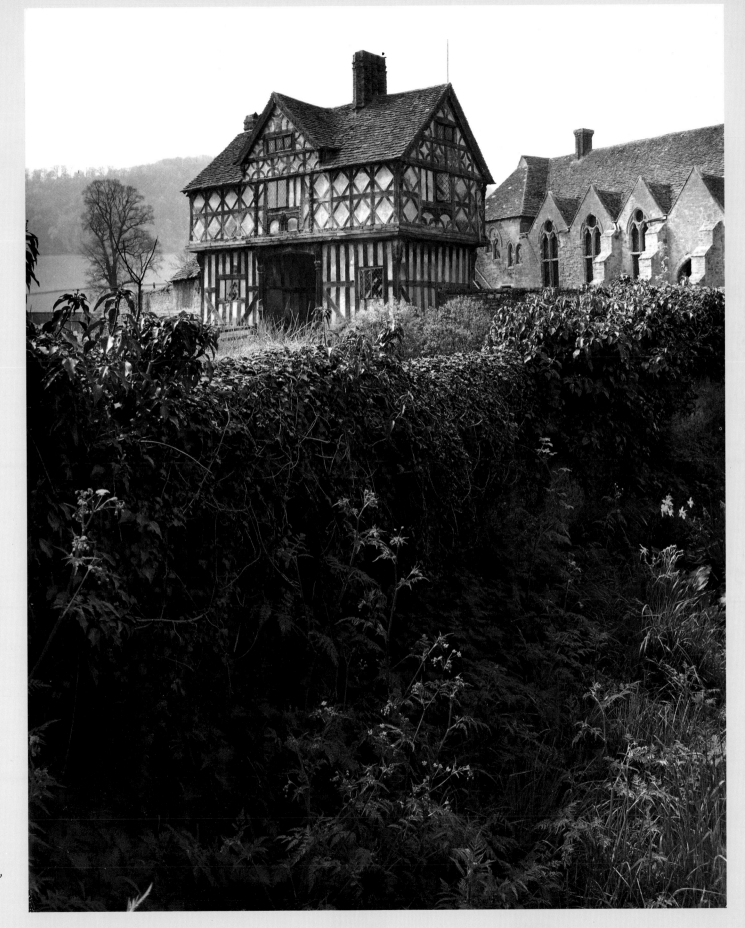

75
Stokesay Castle,
Shropshire;
23 April 1959

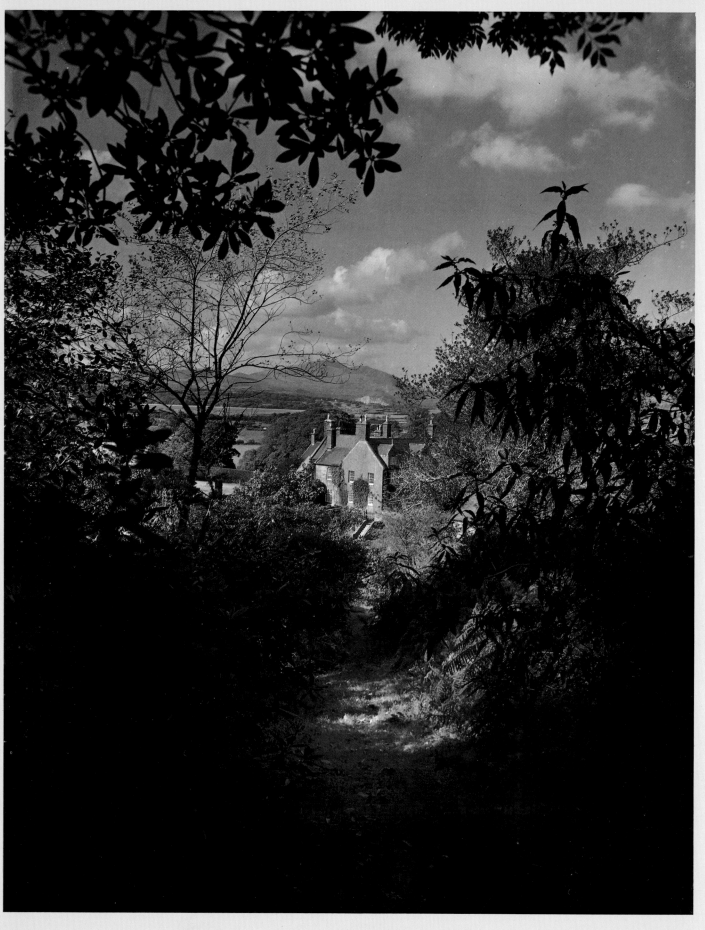

76
Glyn, Talsarnau,
Merioneth, Wales;
26 September 1959

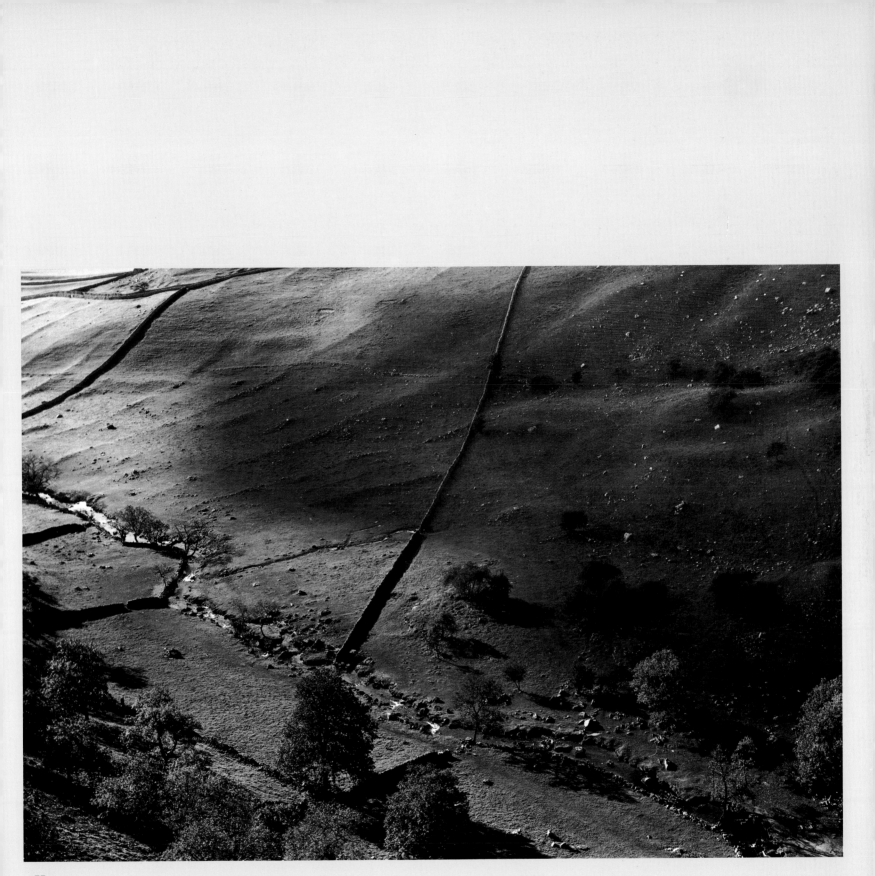

77
View from Malham Cove,
West Yorkshire;
September 1969

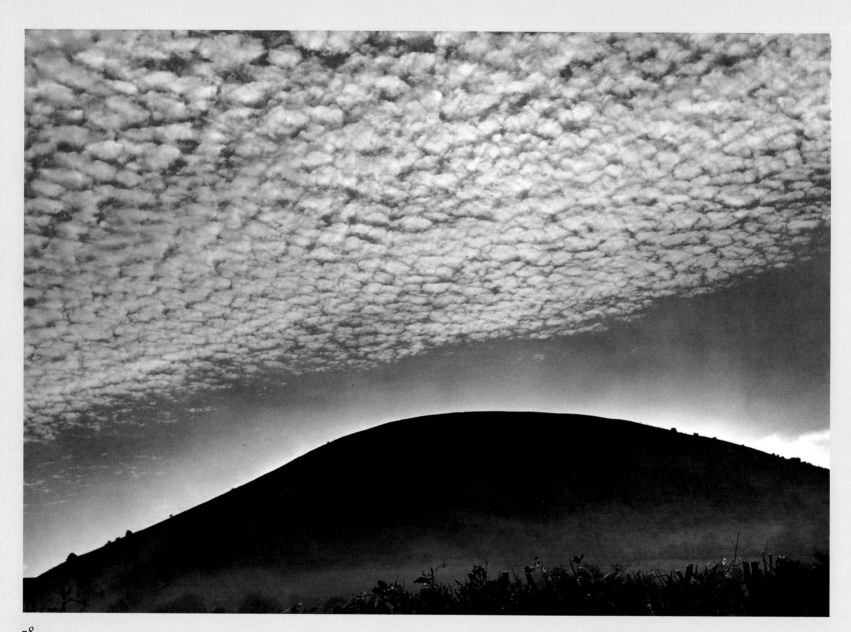

78
The Black Mountains, Llanthony,
Monmouthshire, Wales;
10 October 1969

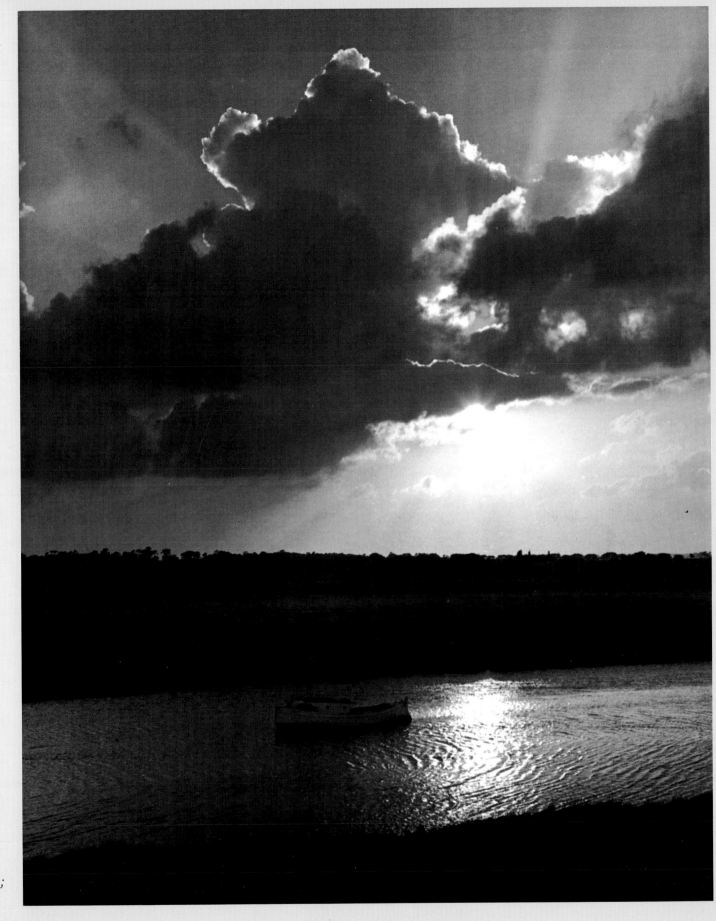

79
Blackshore,
Southwold, Suffolk;
September 1960

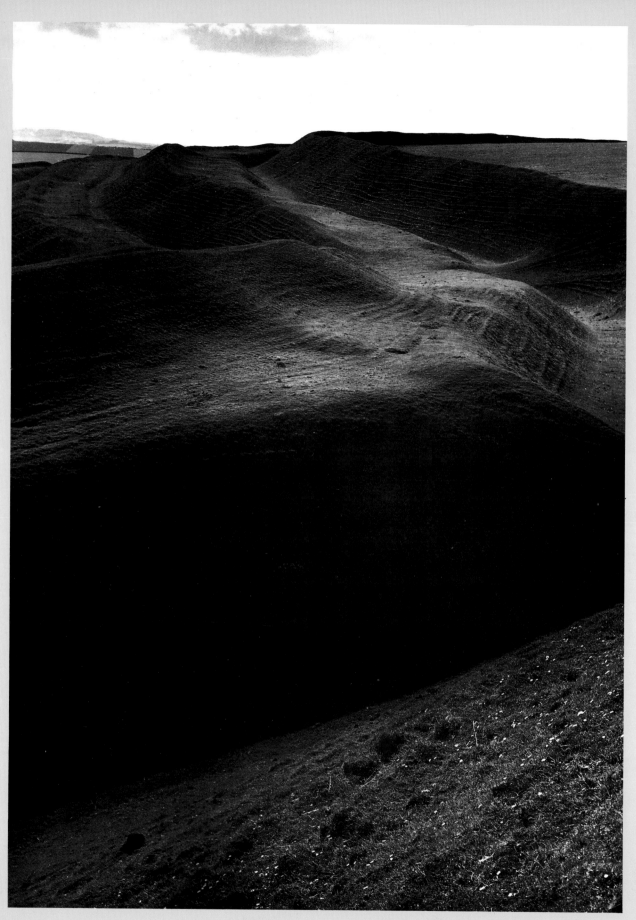

80
Maiden Castle, Dorset;
17 May 1956

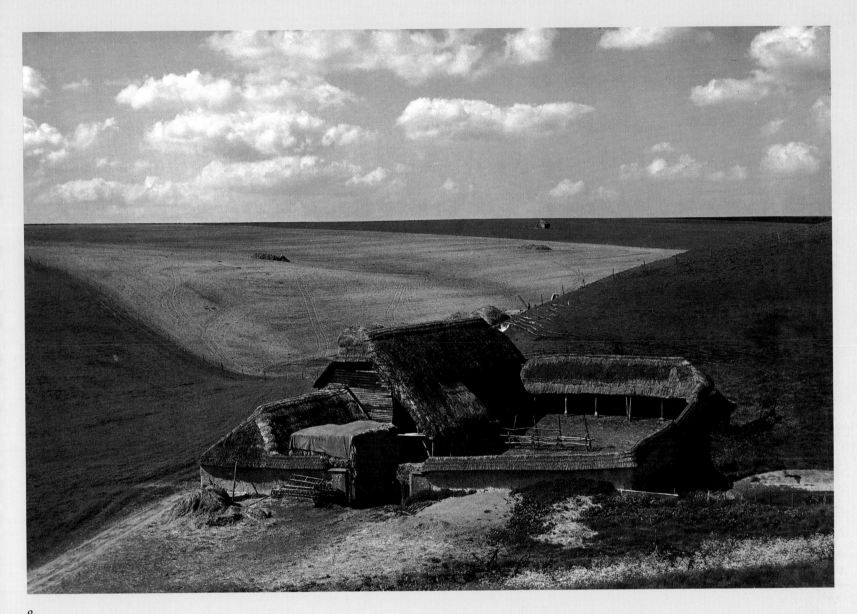

81
Looking north near Deptford,
Wiltshire;
28 May 1956

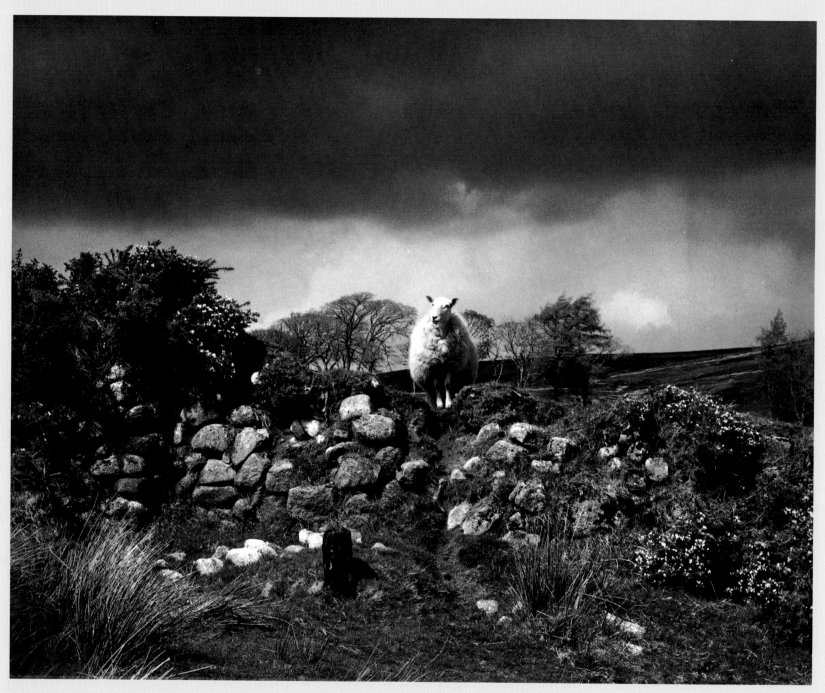

82
In Co. Wexford, Ireland;
15 May 1965

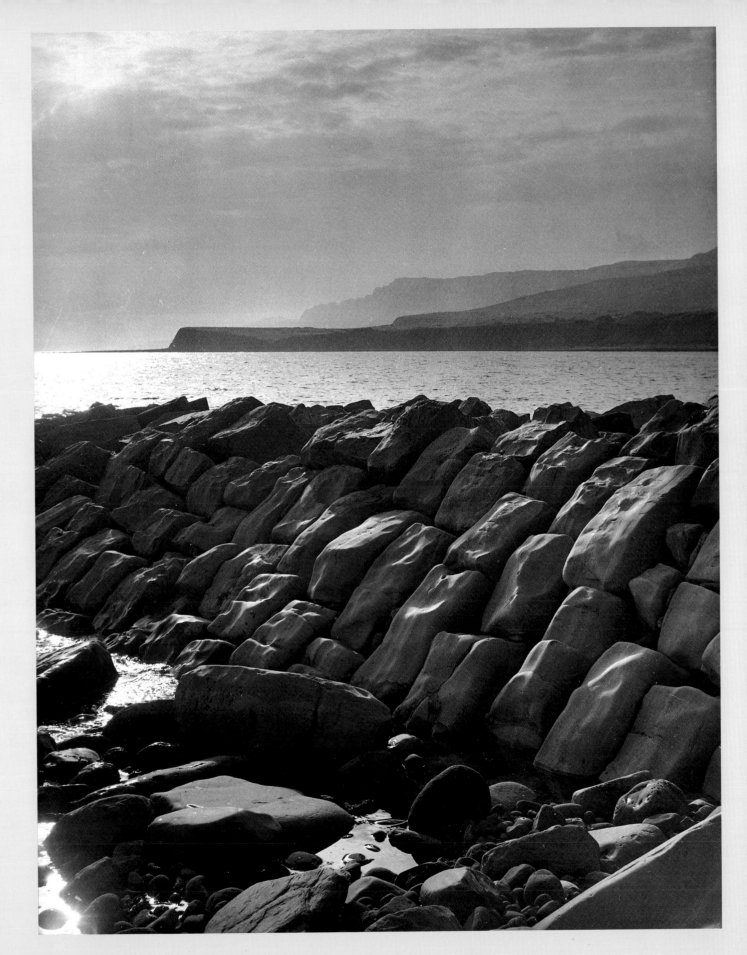

83
*Kimmeridge Bay,
Dorset;
16 May 1956*

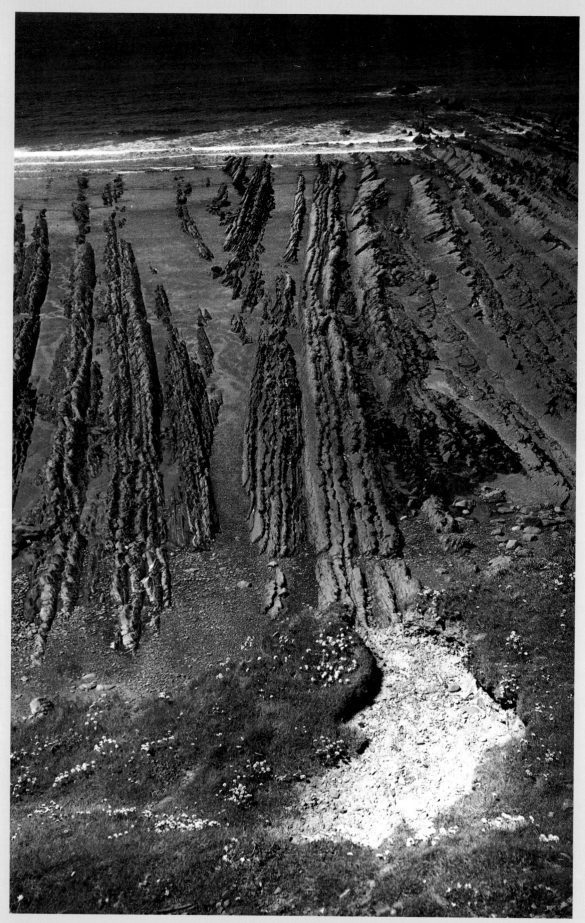

84
Welcombe Gap, North Devon;
21 May 1956

85
Malham Cove, West Yorkshire;
24 September 1969

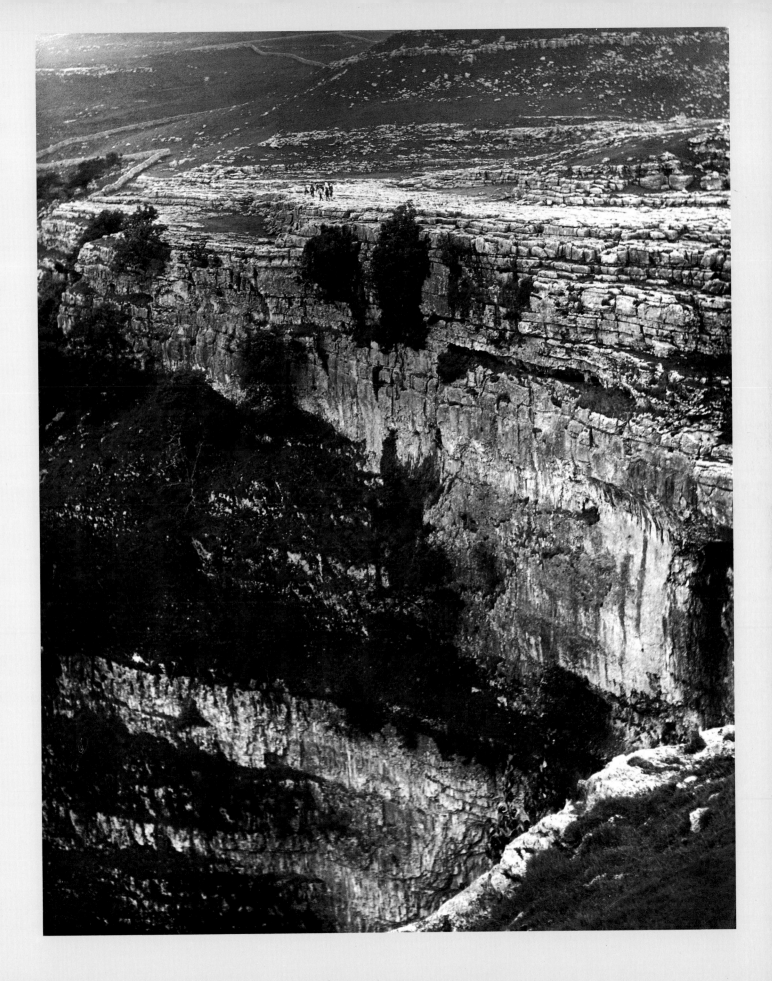

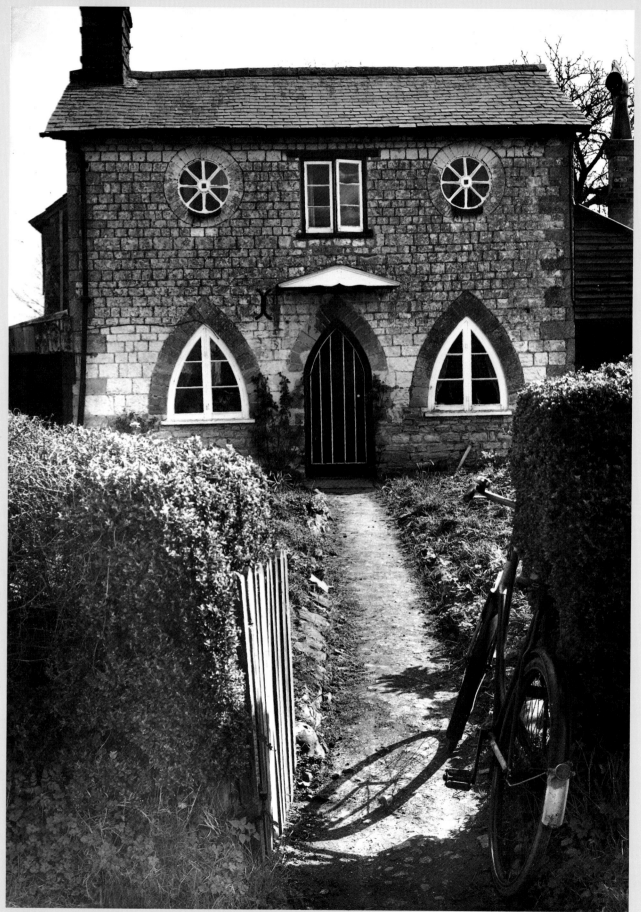

86
Wylye, Wiltshire;
27 March 1967

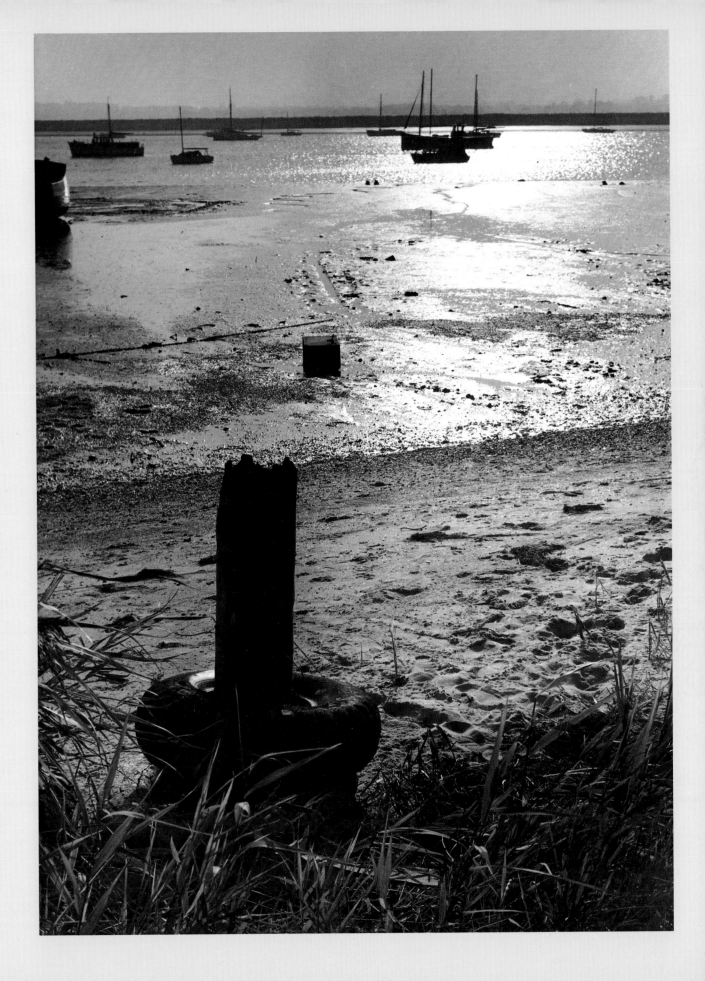

87
*The River Deben
at Ramsholt, Suffolk;
October 1965*

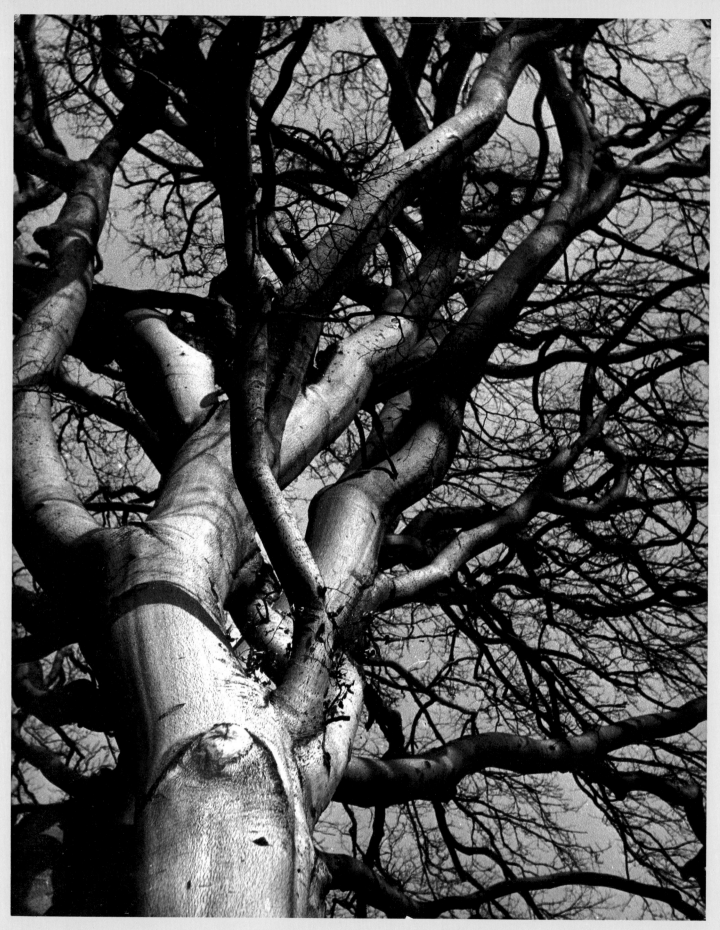

88
Beech, Kenwood,
Hampstead, London;
November 1935

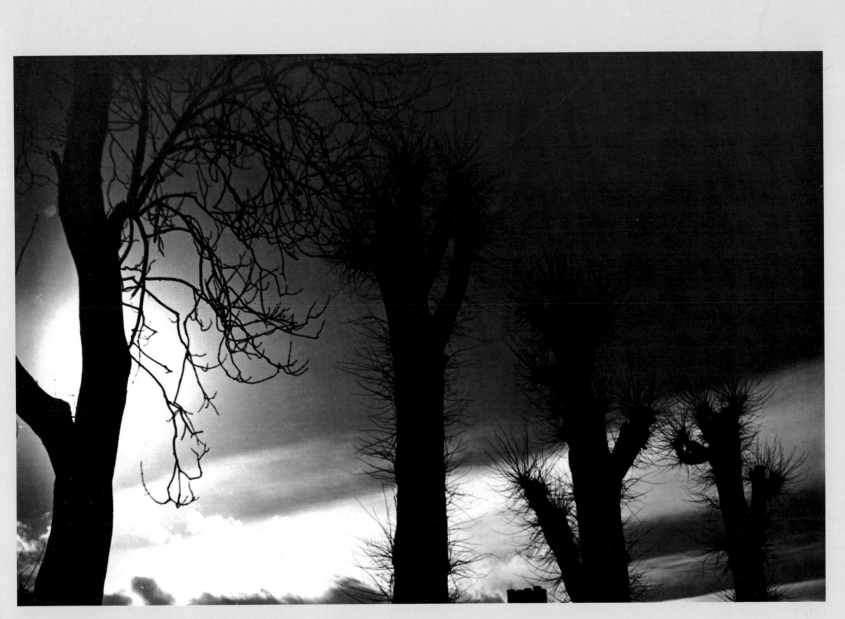

89
Hampstead, London; winter 1939

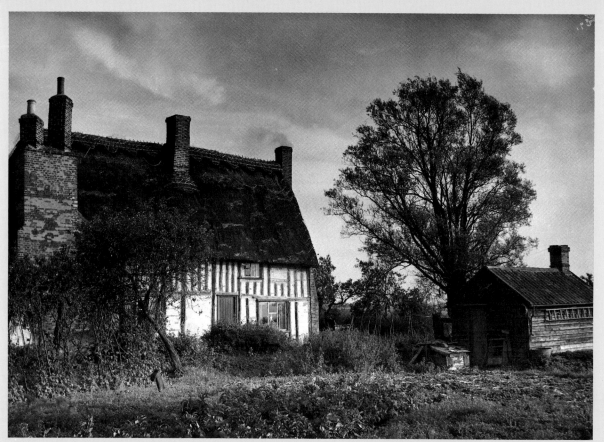

90
Fenstead End,
Boxted, Suffolk;
24 September 1955

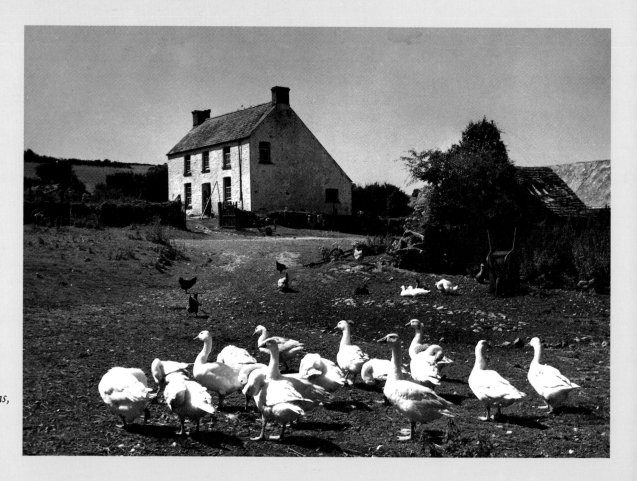

91
'Mountain Cott',
Trefgarn,
Prescelly Mountains,
Pembrokeshire,
Wales;
11 August 1953

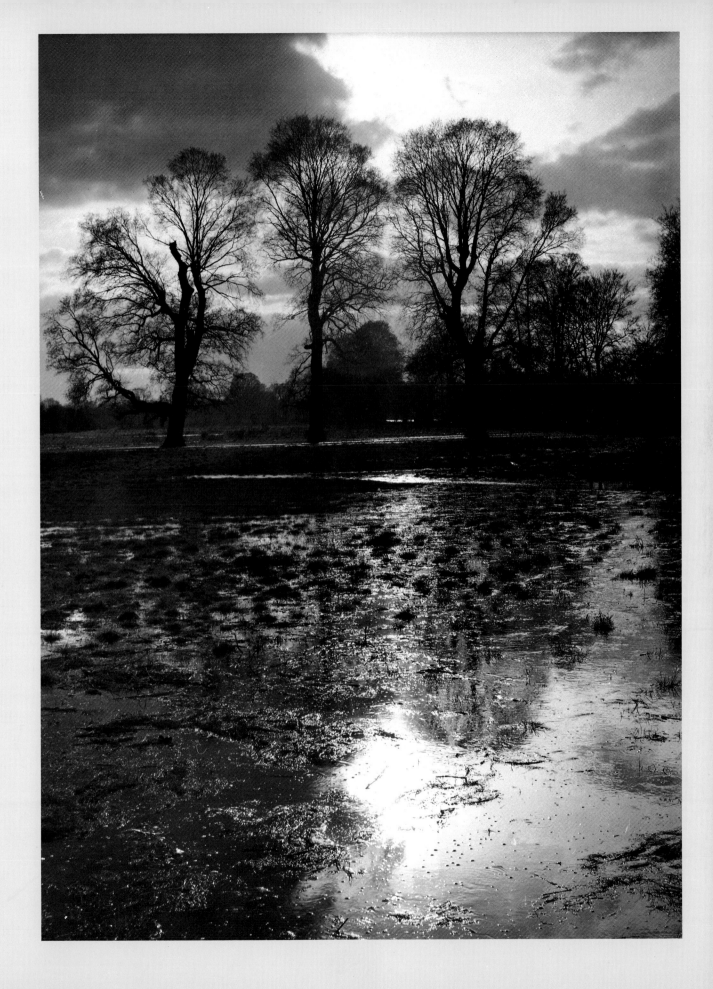

92
The Thames at
Twickenham;
26 March 1959

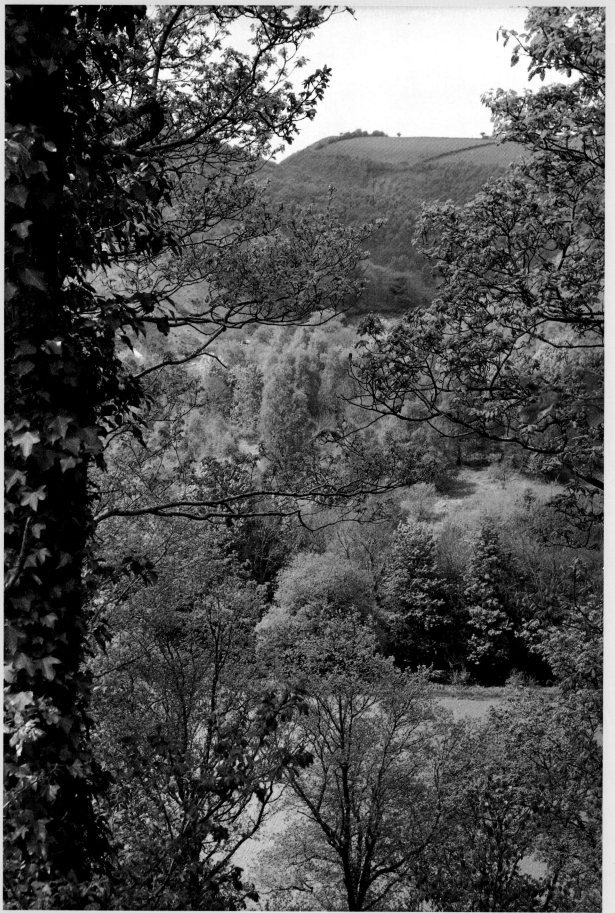

93
Cod Wood, near Boyland,
South Devon;
19 May 1956

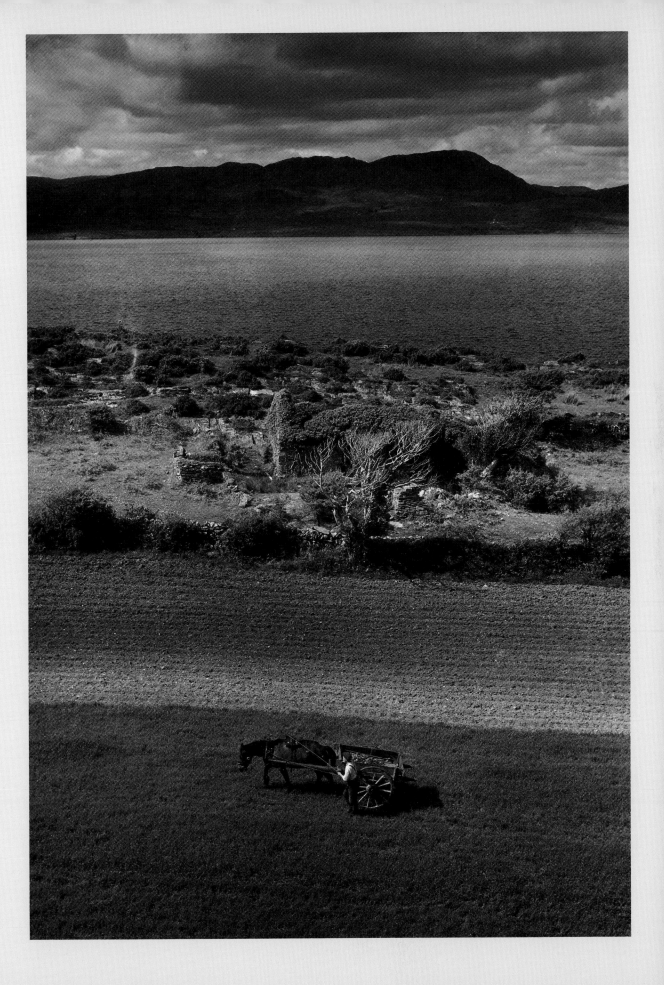

94
Bantry Bay,
Co. Cork, Ireland;
18 May 1965

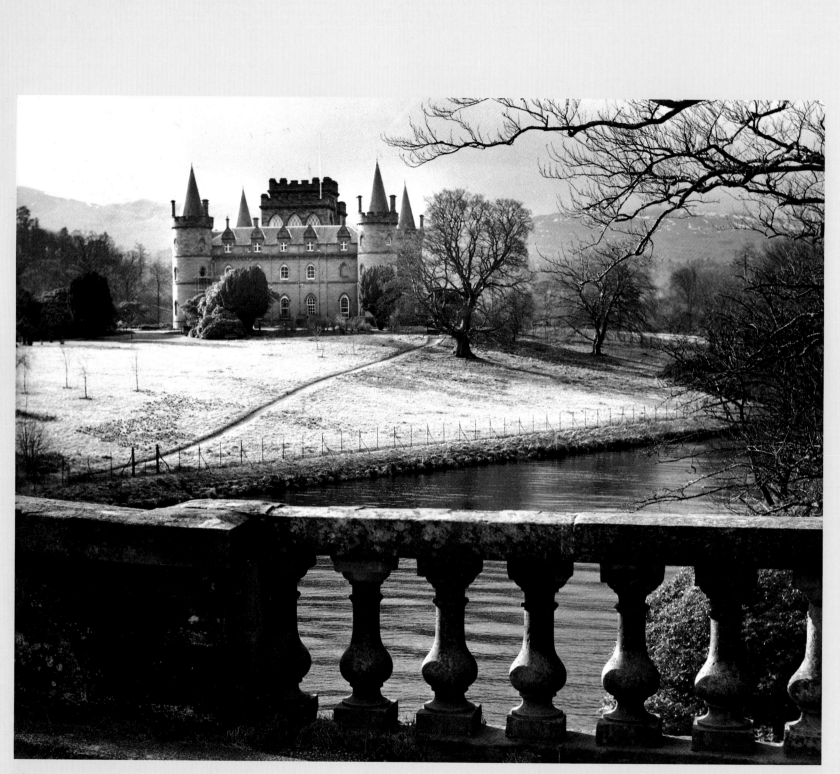

95
Inverary, Argyllshire, Scotland;
April 1962

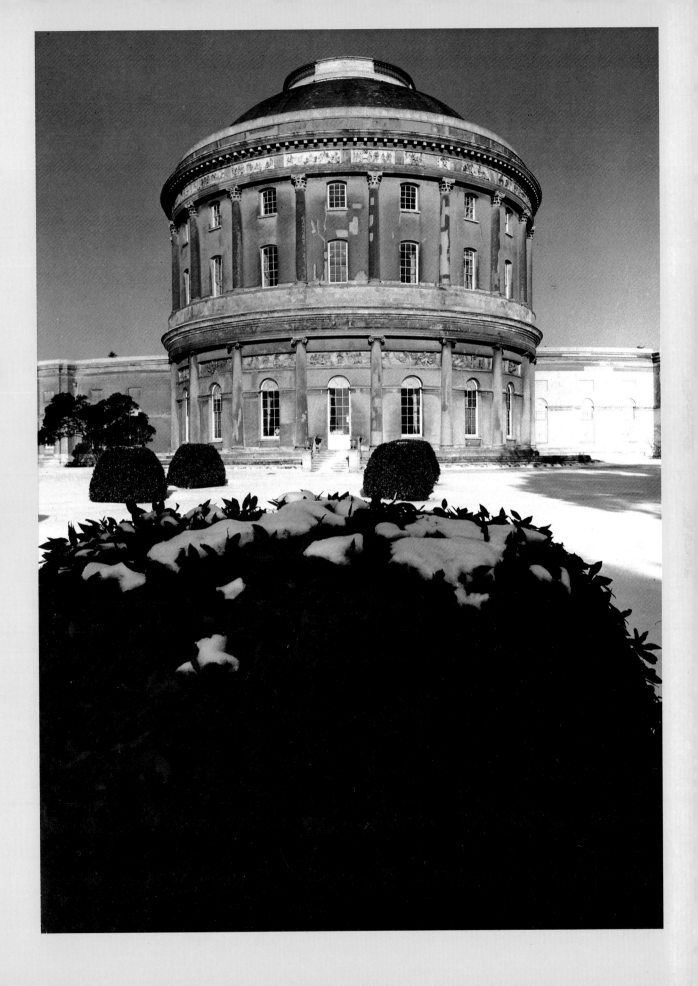

96
Ickworth House,
Suffolk;
22 January 1963

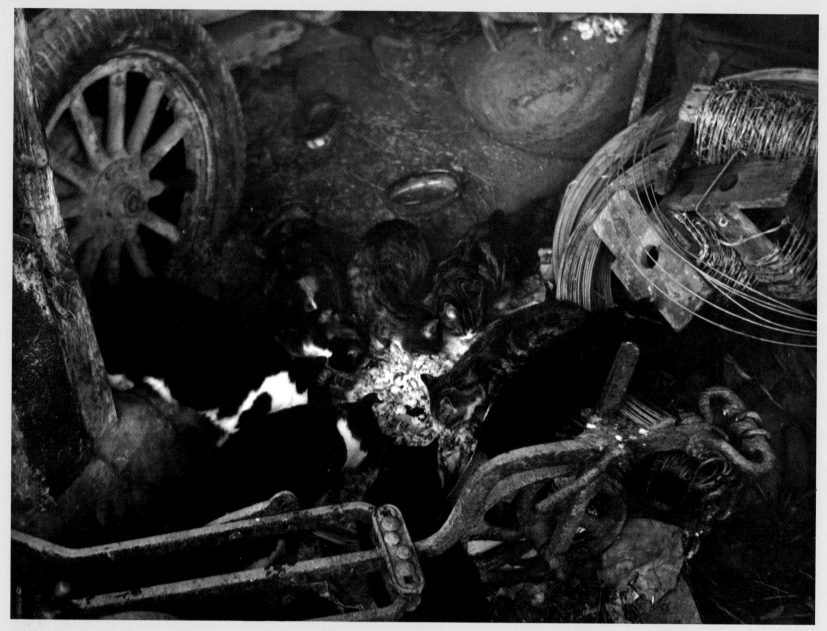

97
Farm cats, Firle, Sussex;
February 1958

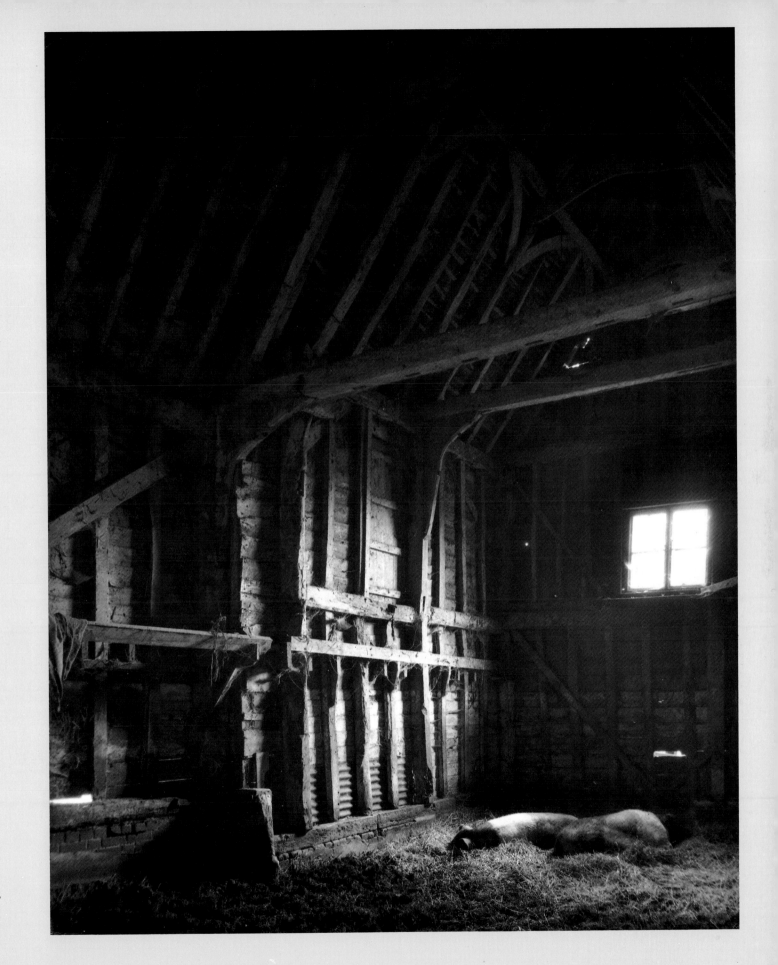

98
Barn, Henley,
Suffolk;
17 May 1953

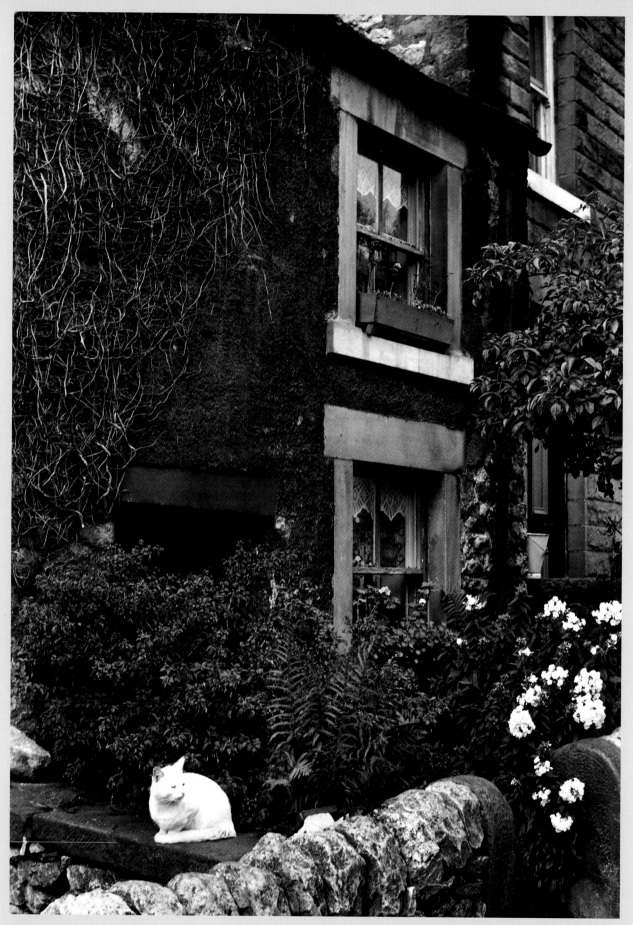

99
Bonsall, Derbyshire;
4 August 1961

100
Allotments,
Saffron Walden, Essex;
5 May 1964

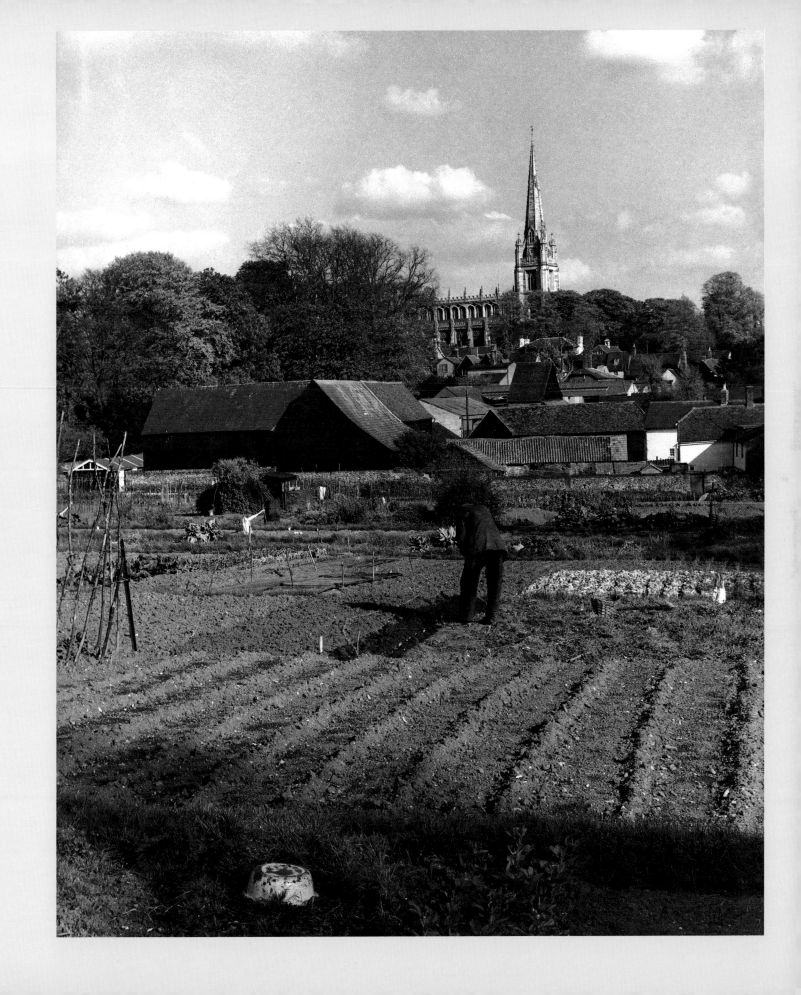

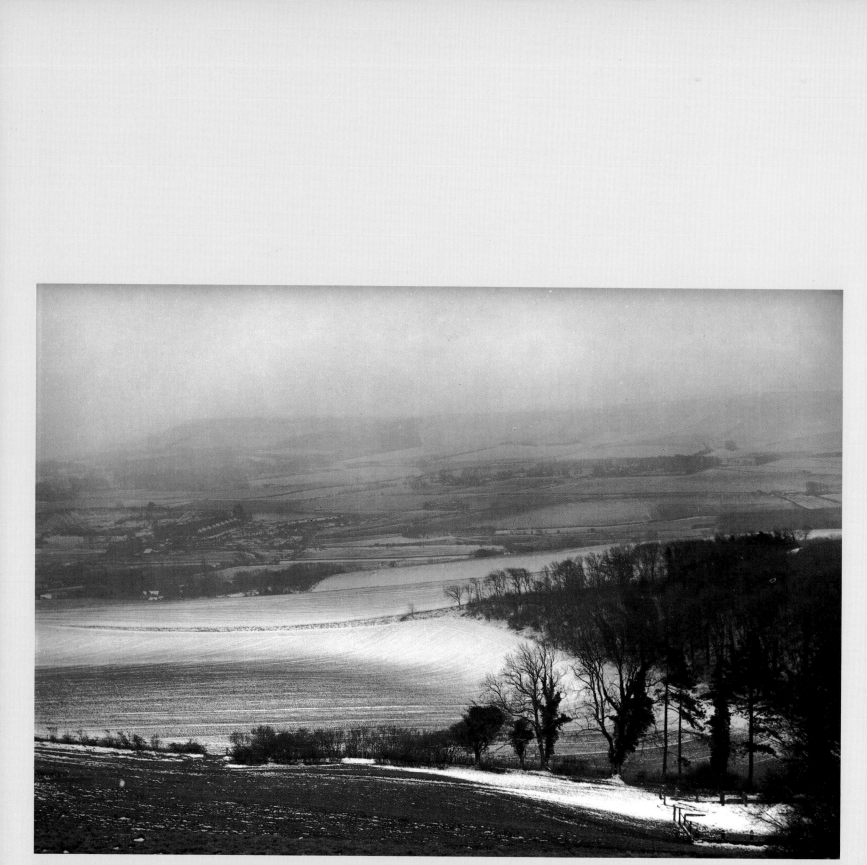

101
Near Glynde, Sussex;
9 March 1955

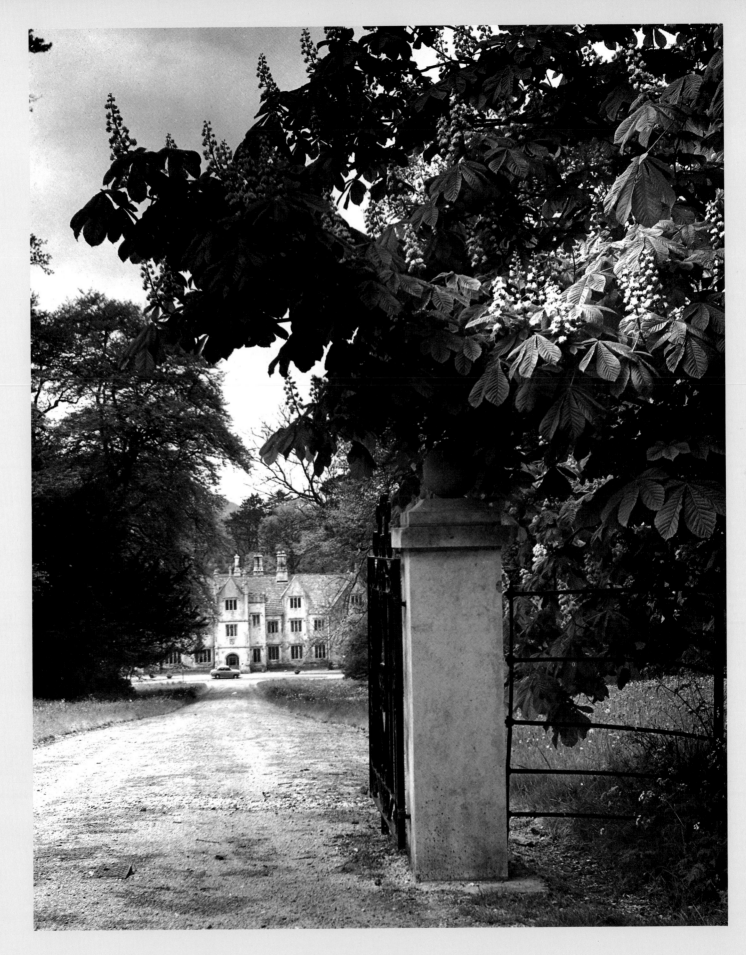

102
*Creech Grange,
Dorset;
17 May 1956*

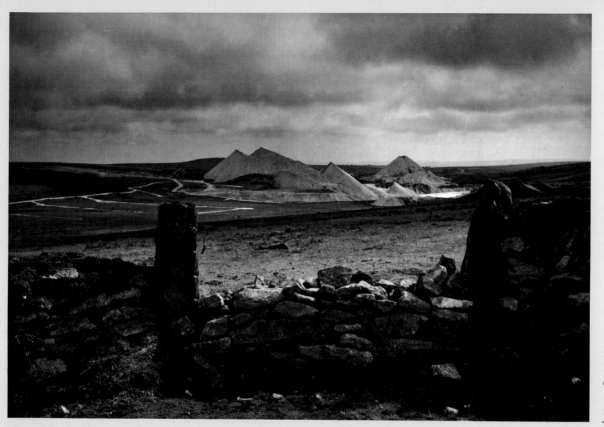

103
*China clay works
on Bodmin Moor,
Cornwall;
31 May 1956*

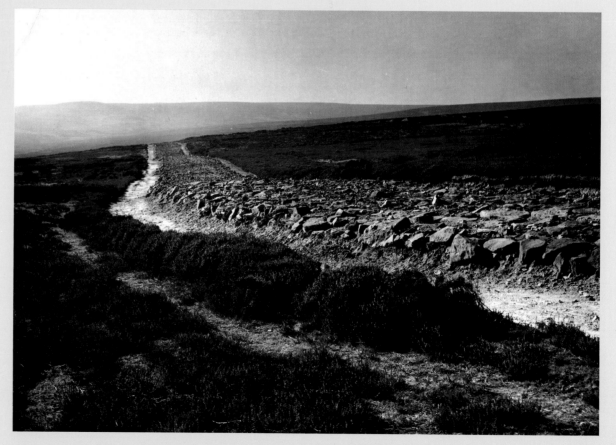

104
*'Wade's Causeway',
the Roman road on
Wheeldale Moor,
East Yorkshire;
14 October 1956*

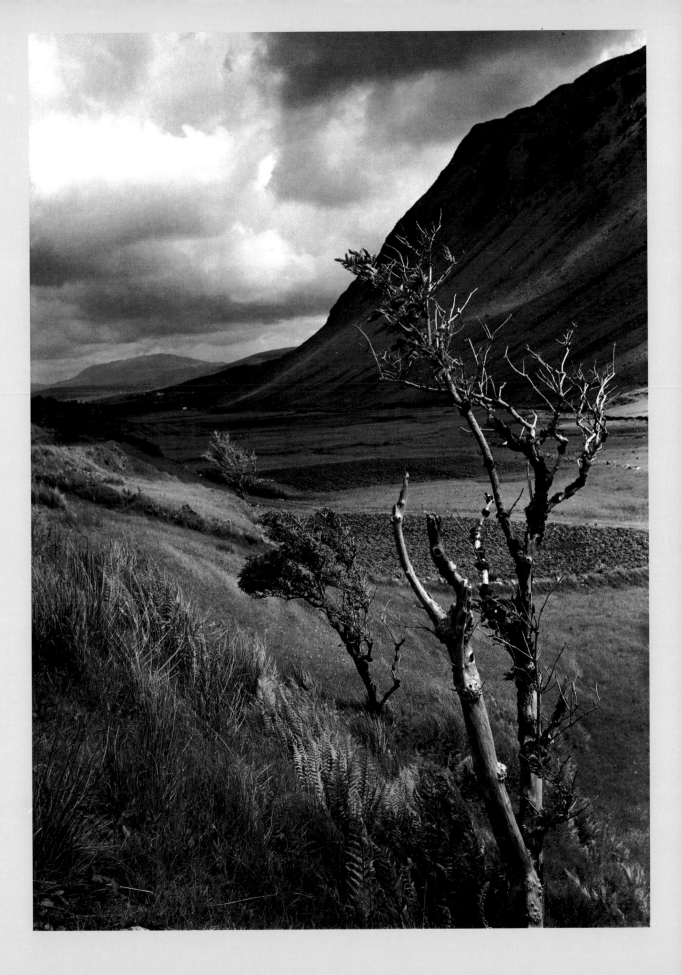

105
In Co. Donegal,
Ireland;
16 June 1965

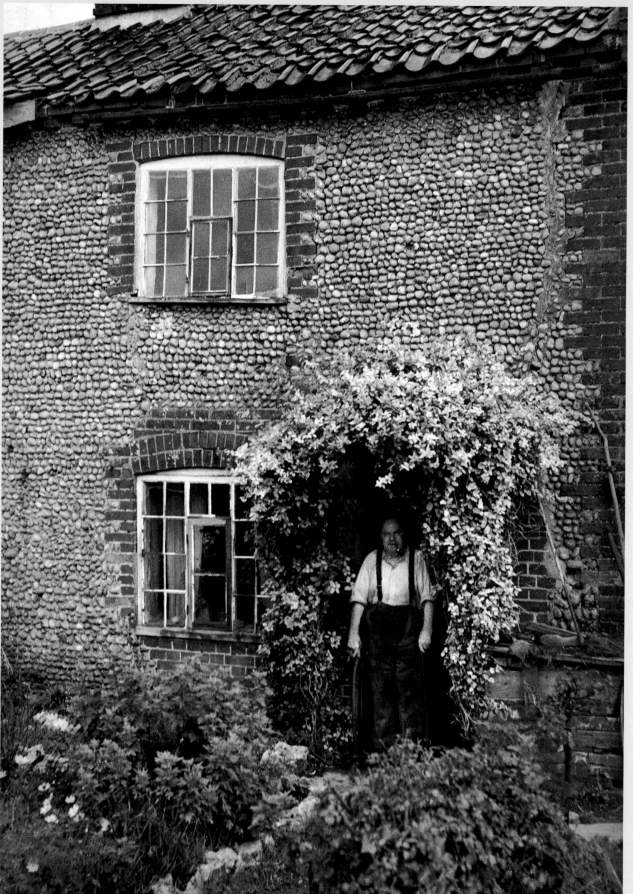

106
Uggeshall, Suffolk;
22 September 1955

107
Walberswick, Suffolk;
September 1960

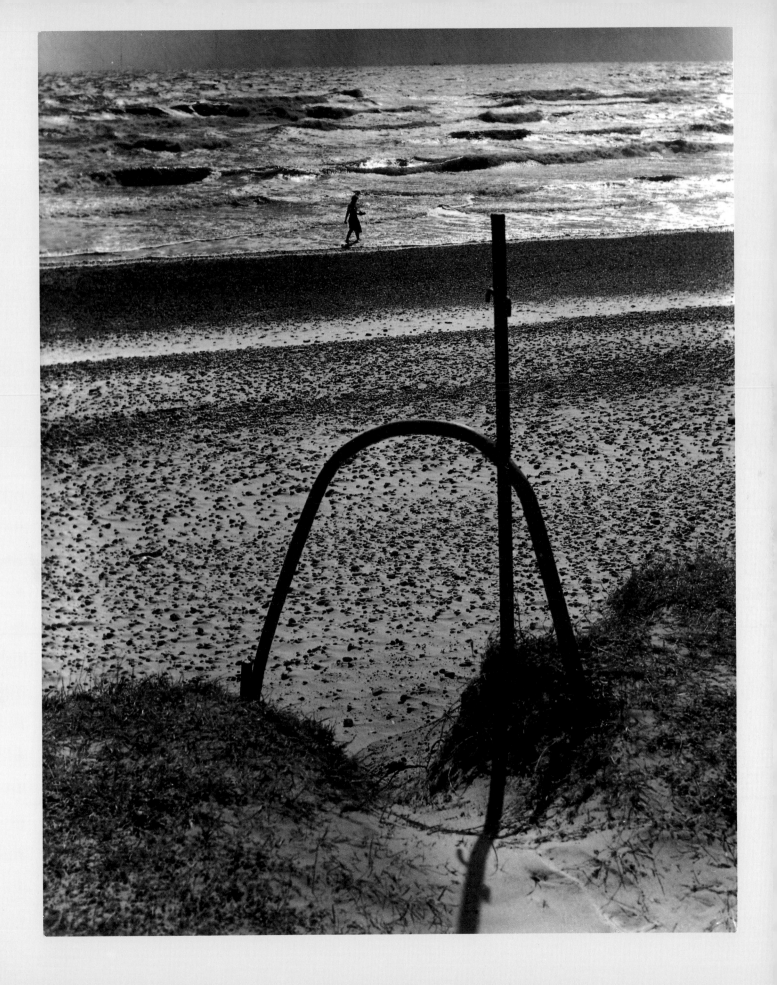

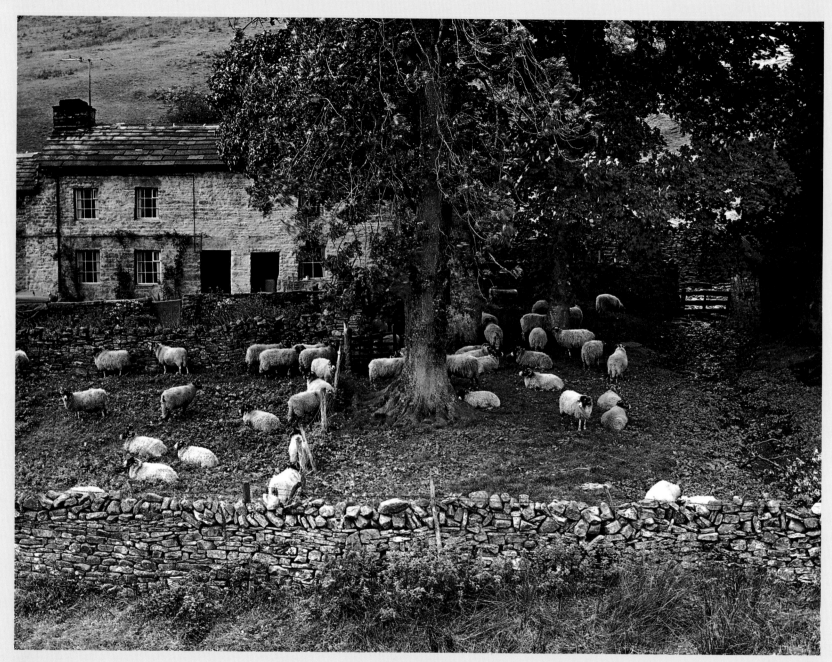

108
Cotterdale, West Yorkshire;
25 September 1969

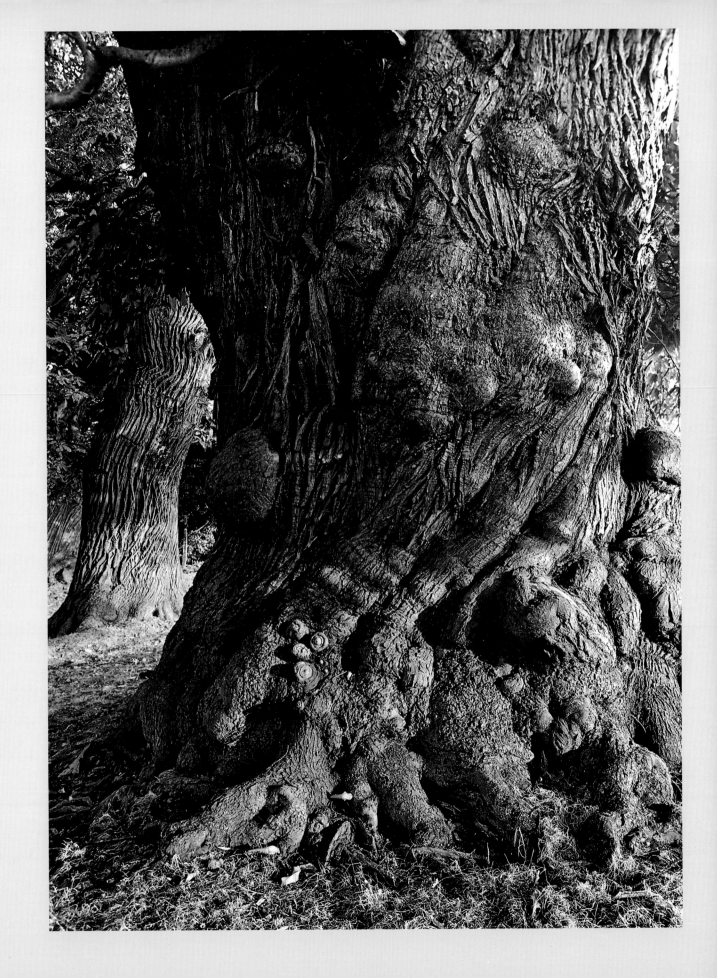

109
In the chestnut avenue,
Croft Castle,
Herefordshire;
30 September 1959

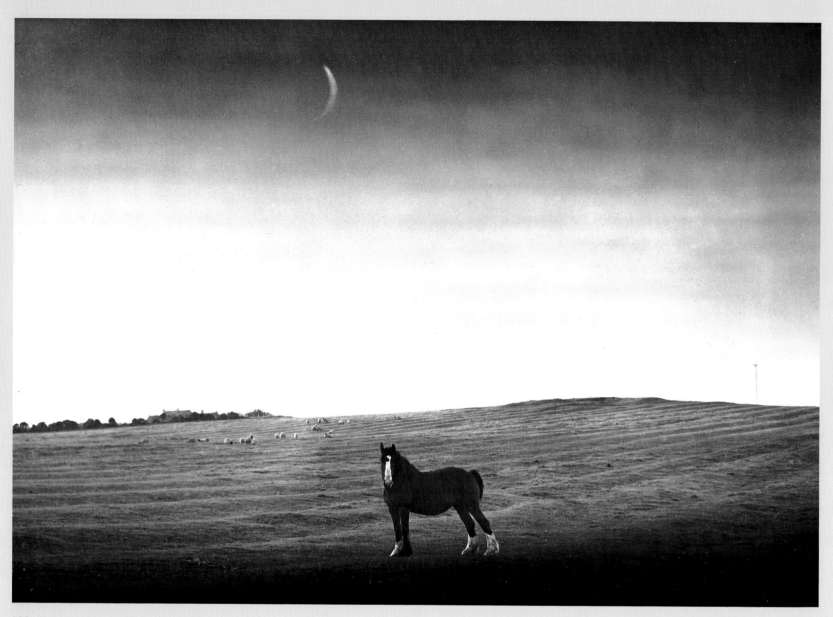

110
Goldsborough Pasture, East Yorkshire;
14 October 1956

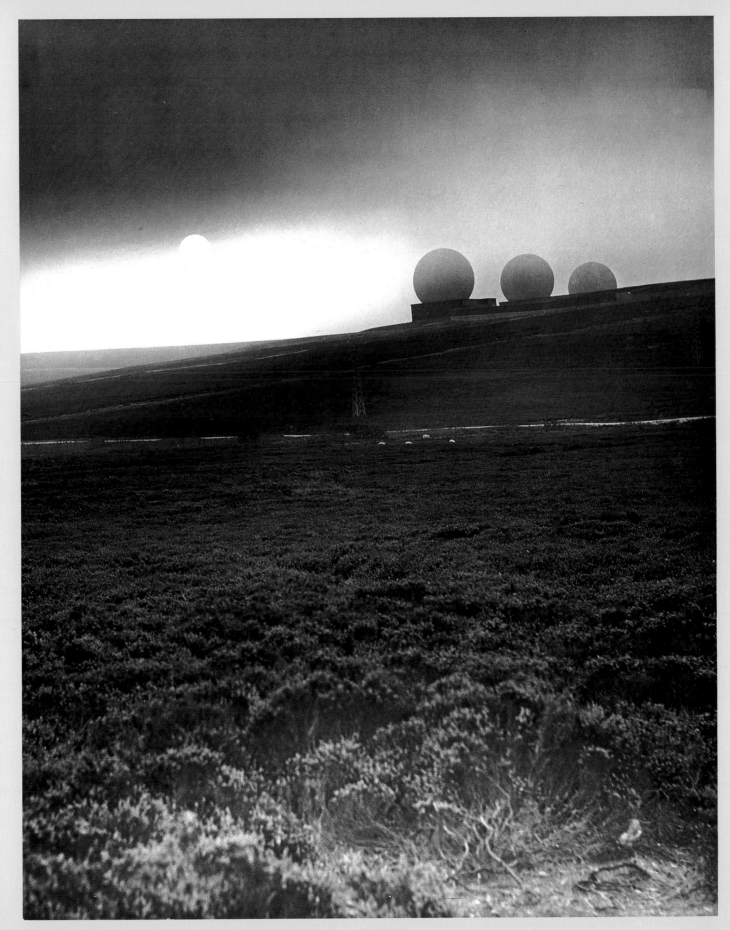

111
Fylingdales Moor,
East Yorkshire;
25 September 1969

INTERIORS

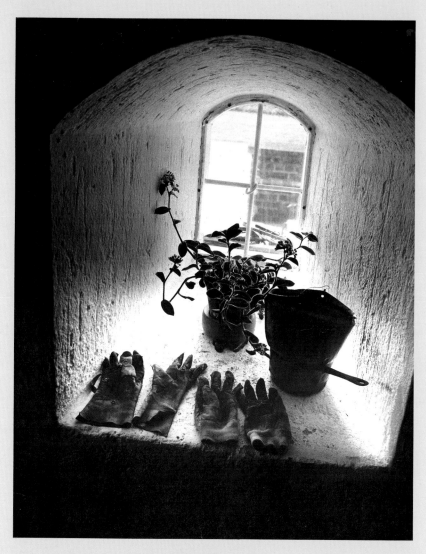

112
A window at Egeskov,
Denmark;
15 August 1960

113
Mrs Hockey's,
Chiselborough, Somerset;
September 1936

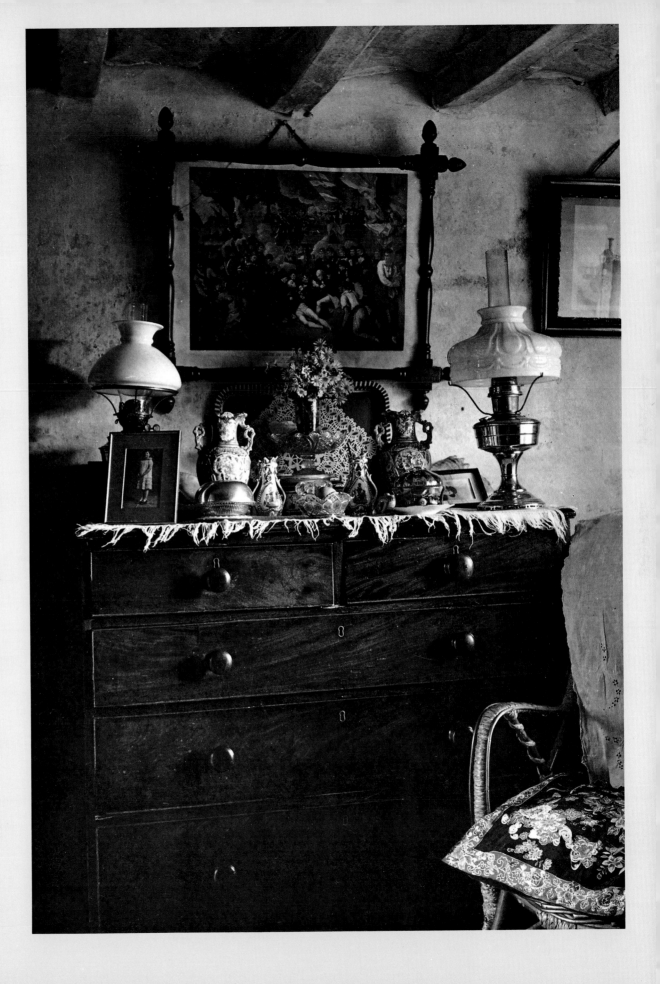

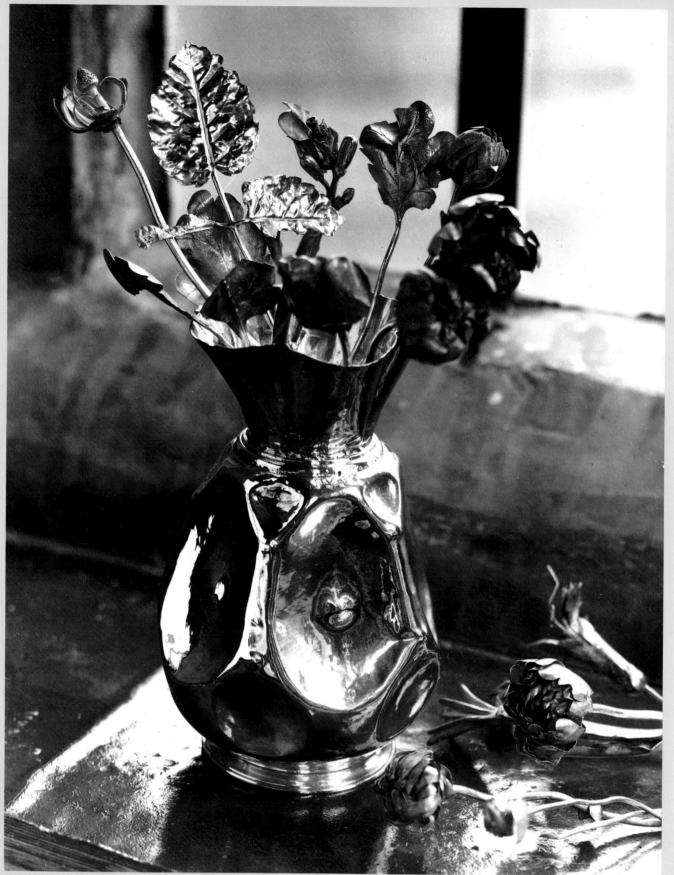

114
*Silver flowers
in the Venetian
Ambassador's Room,
Knole, Kent;
5 October 1960*

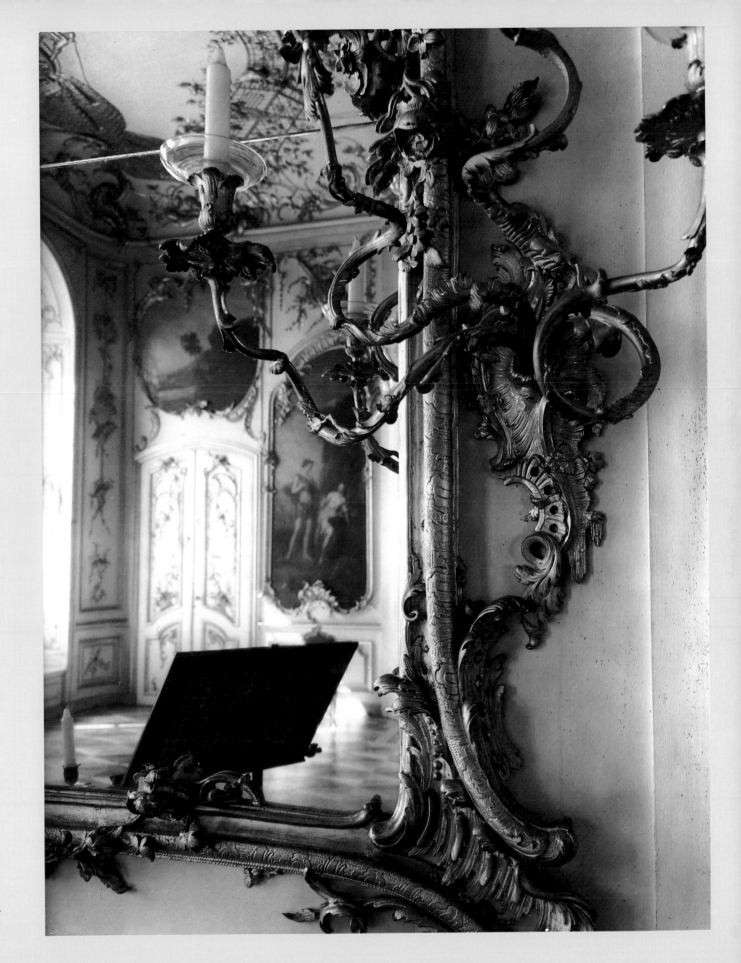

115
The Music Room,
Sanssouci,
Potsdam, Germany;
23 August 1960

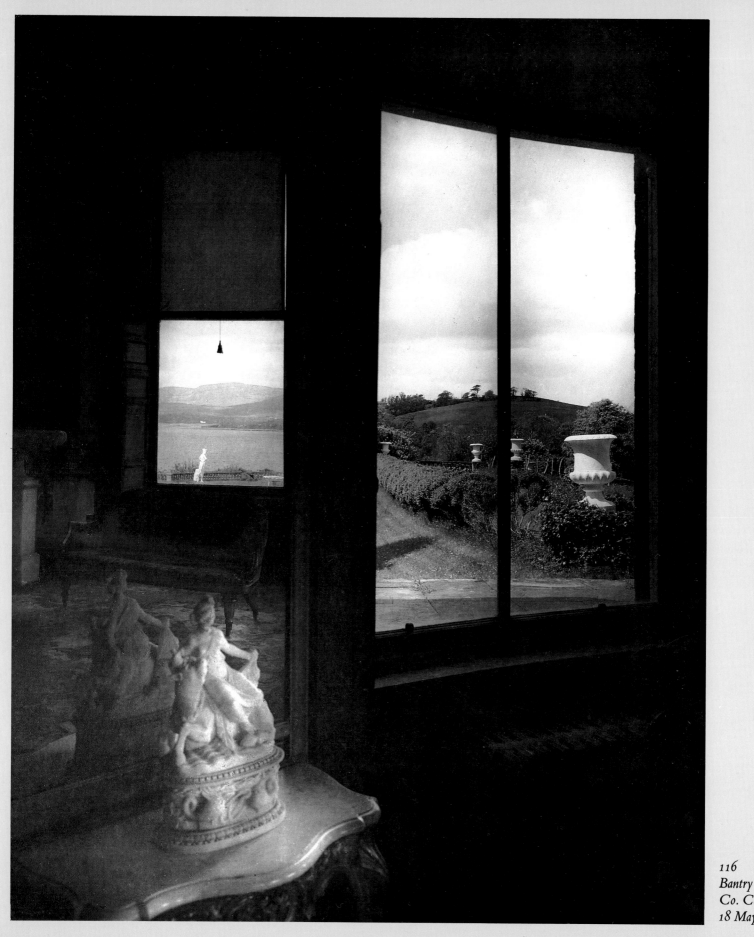

116
Bantry House,
Co. Cork, Ireland;
18 May 1965

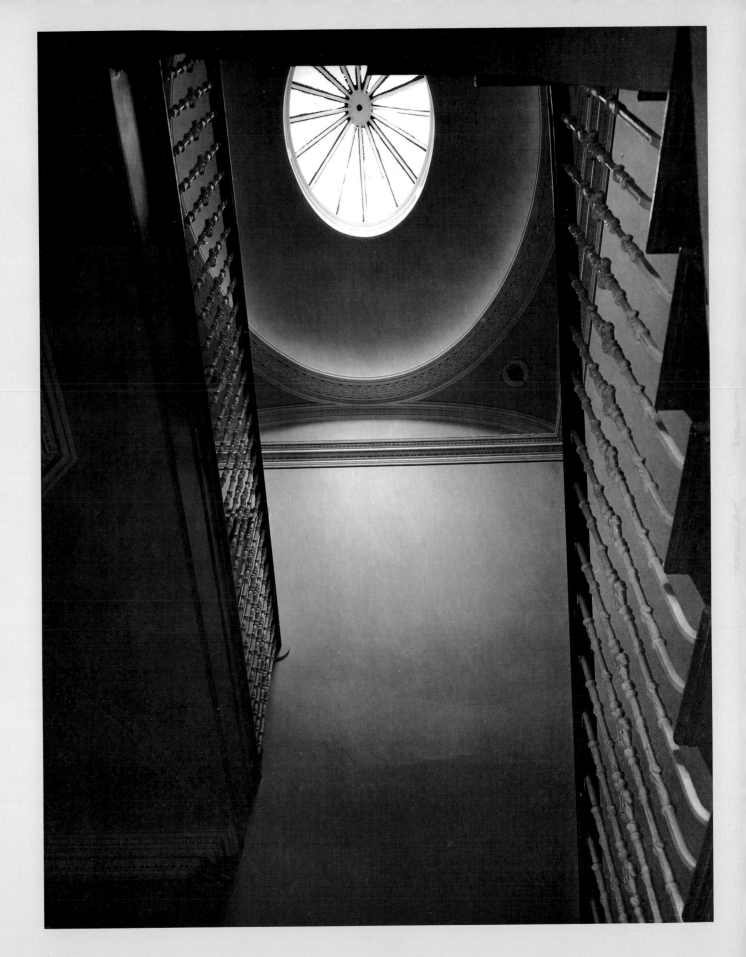

117
Stair,
30 Regent Terrace,
Edinburgh;
17 October 1964

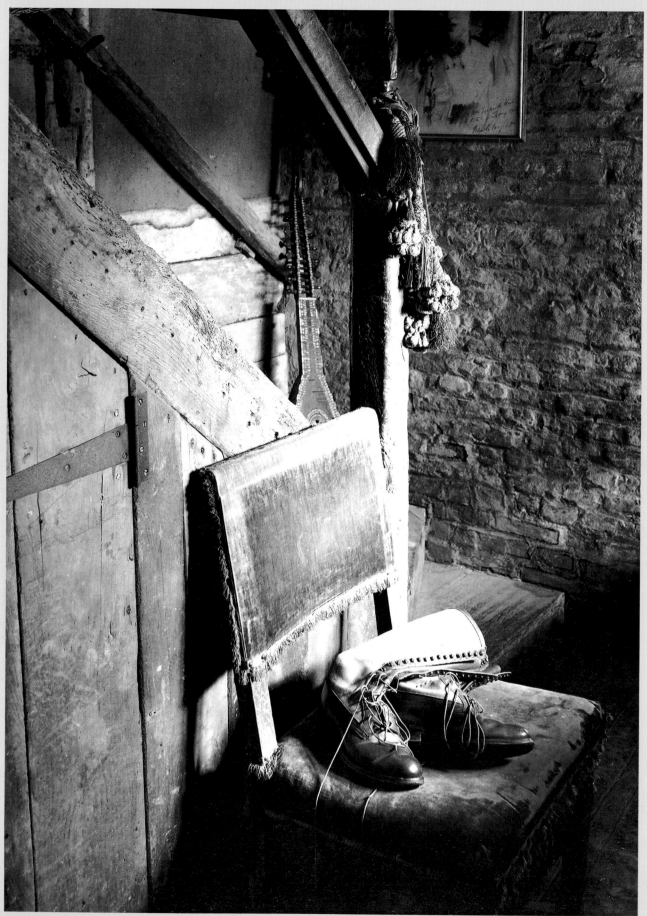

118
*V. Sackville-West's
boots, Sissinghurst,
Kent;
June 1962*

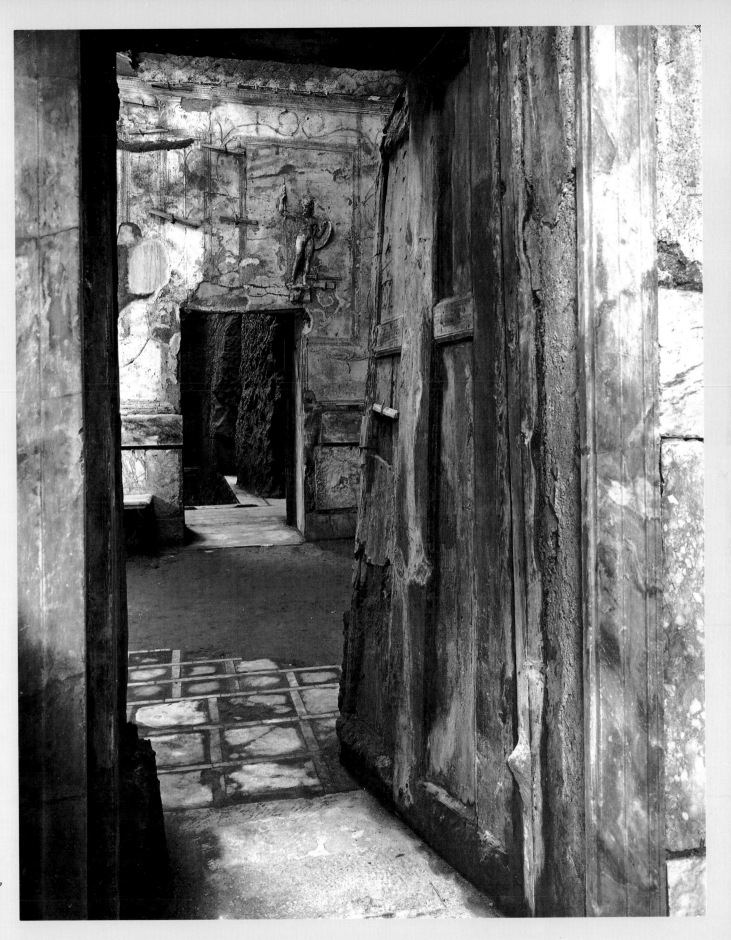

119
The Suburban Baths,
Herculaneum, Italy;
1 November 1959

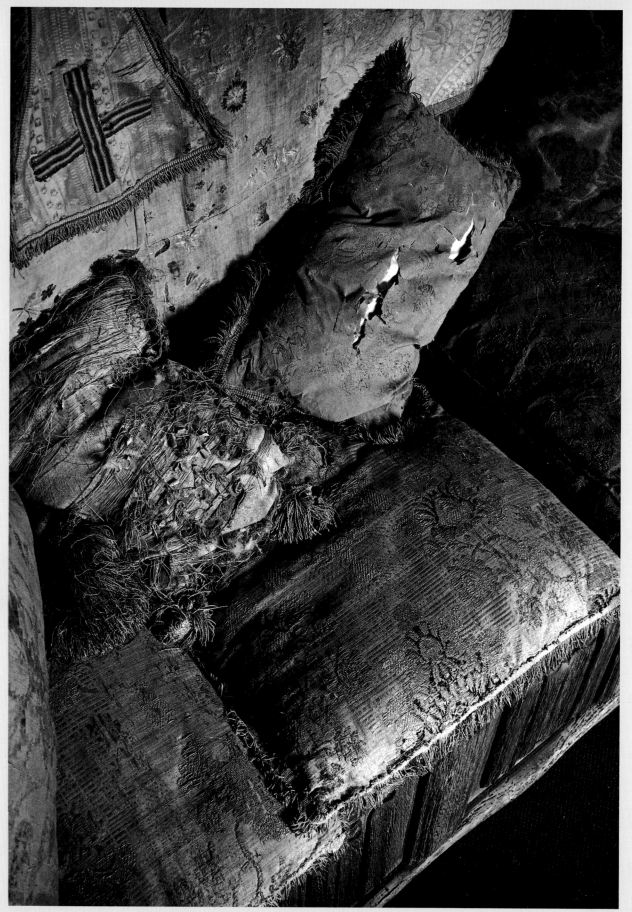

120
Cushions at Sissinghurst,
Kent;
June 1962

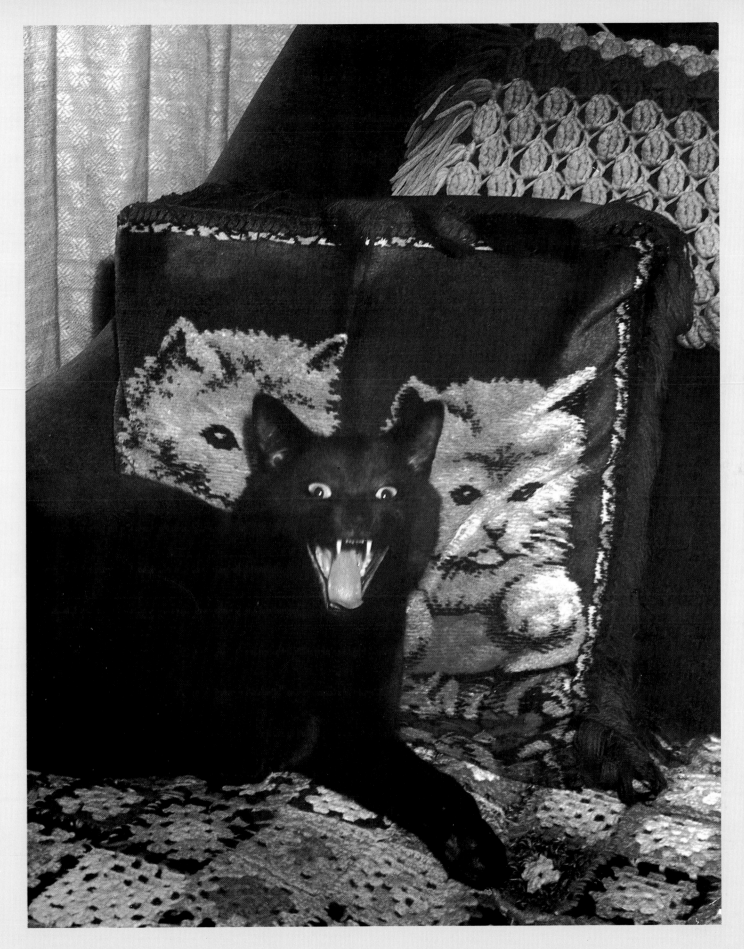

121
Archie;
22 February 1971

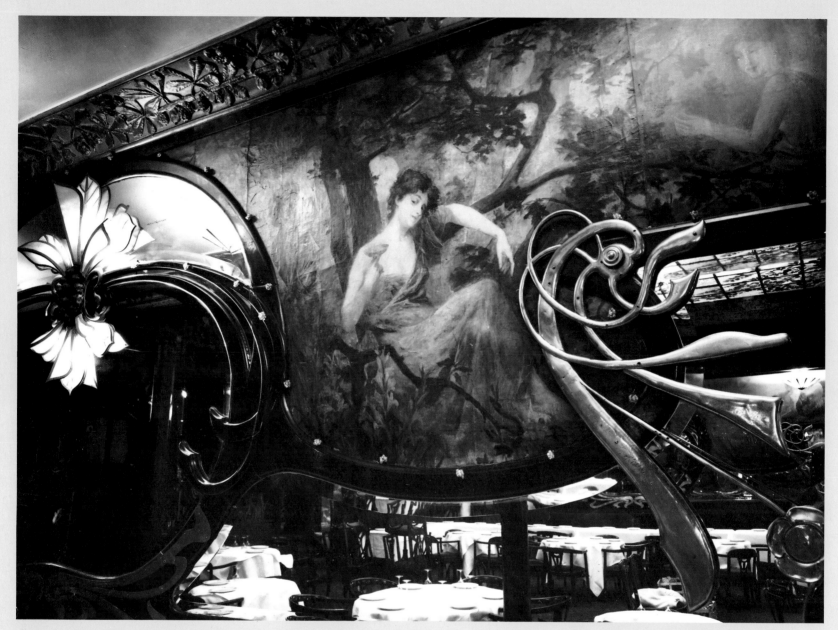

122
Maxim's, Paris;
21 September 1966

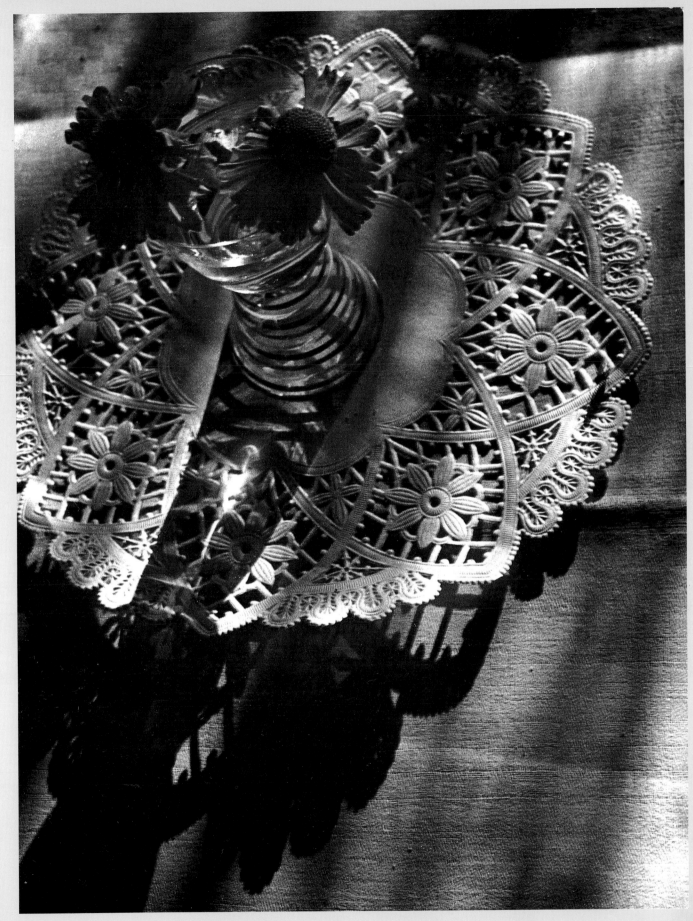

123
Flowers and paper doily;
September 1935

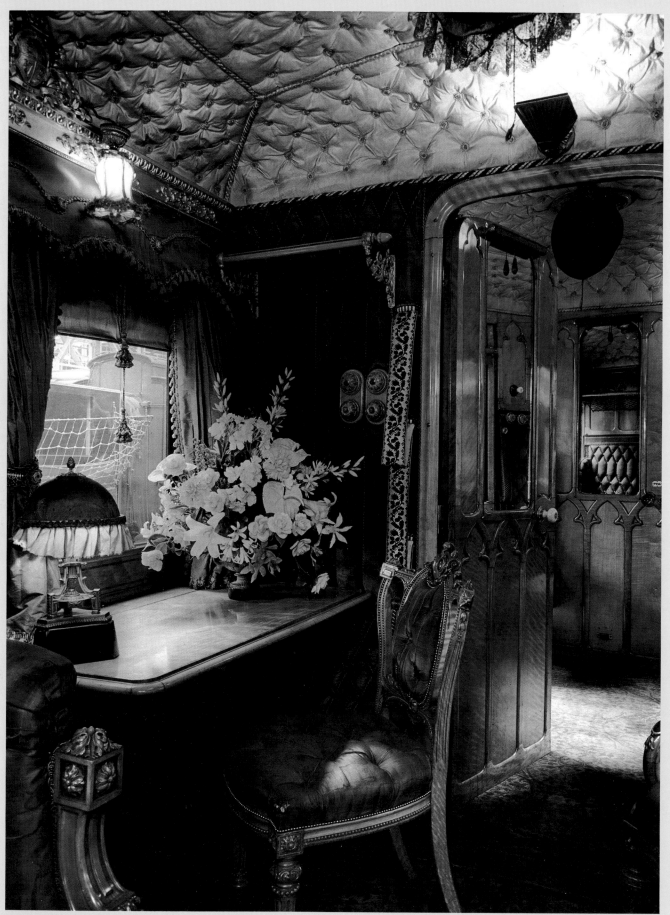

124
Queen Victoria's
railway carriage;
12 August 1966

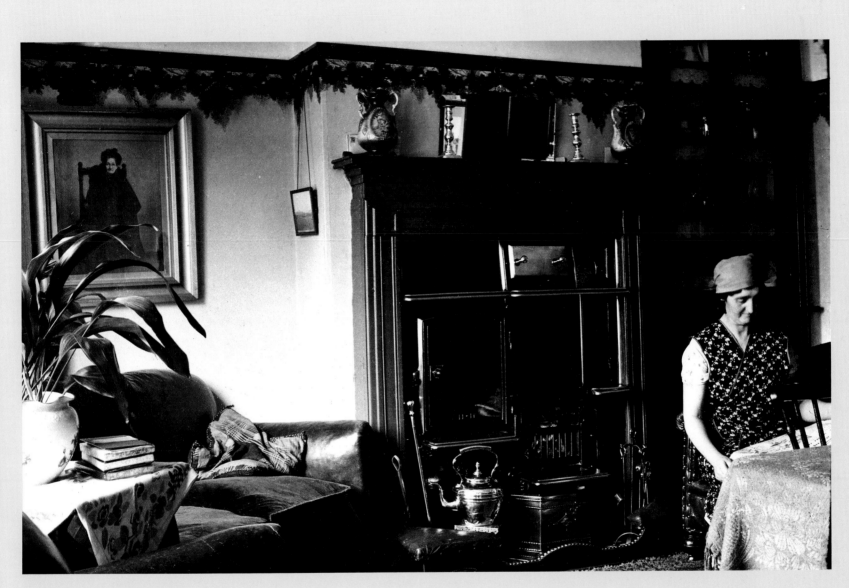

125
Miner's interior (Mrs Denwood's),
Scotswood-on-Tyne, Northumberland;
August 1936

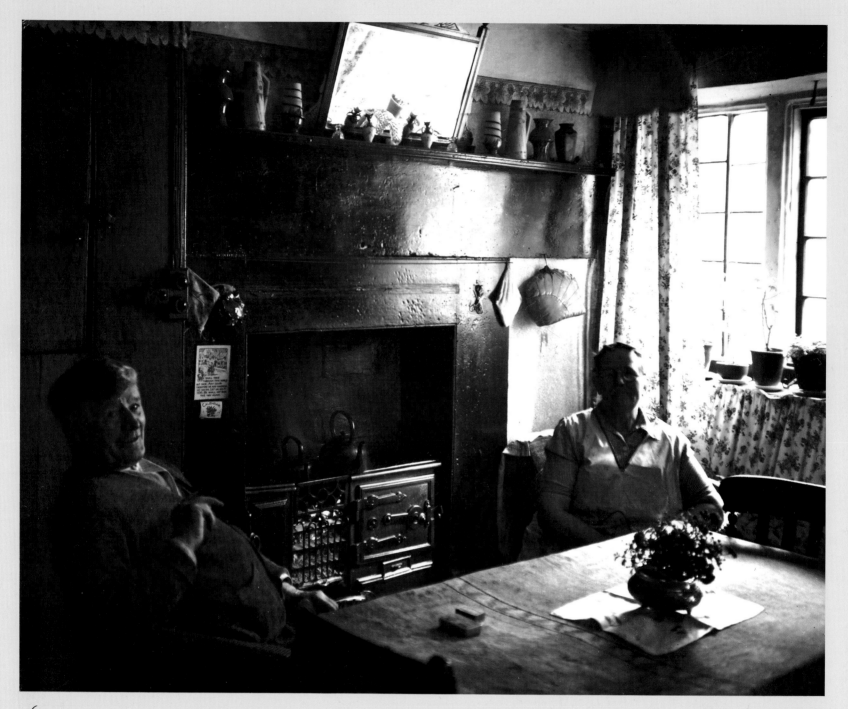

126
Mr and Mrs Joyce, Nunney, Somerset;
1 October 1953

127
Bar of a country inn,
Shobdon, Herefordshire;
22 April 1959

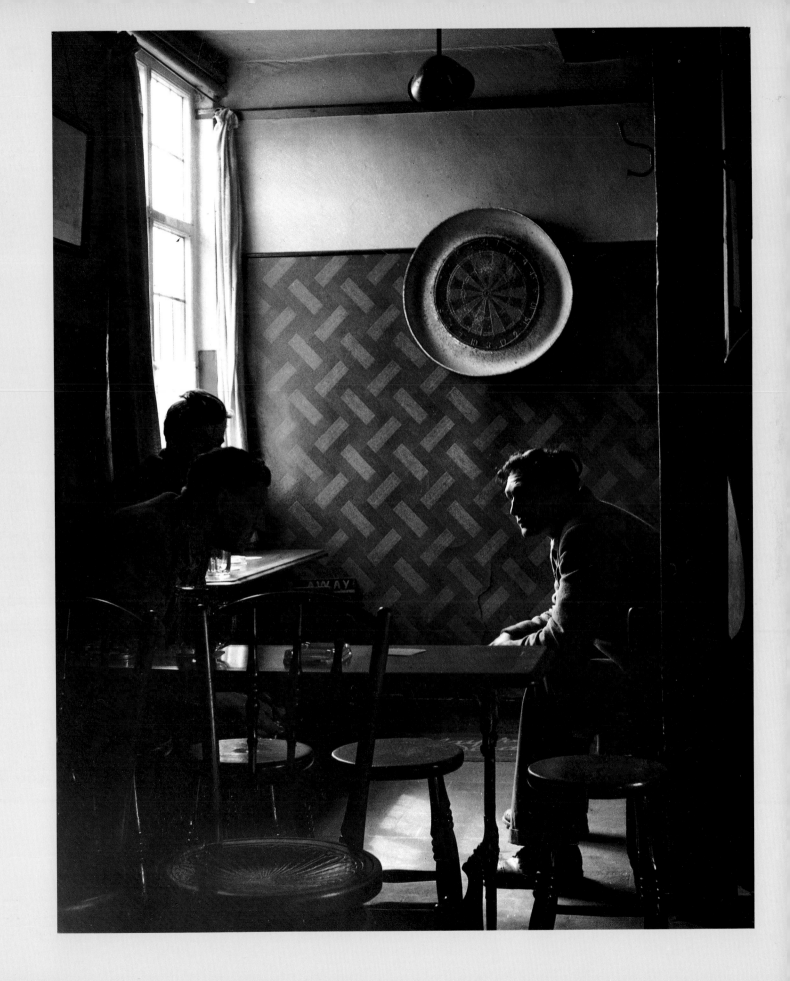

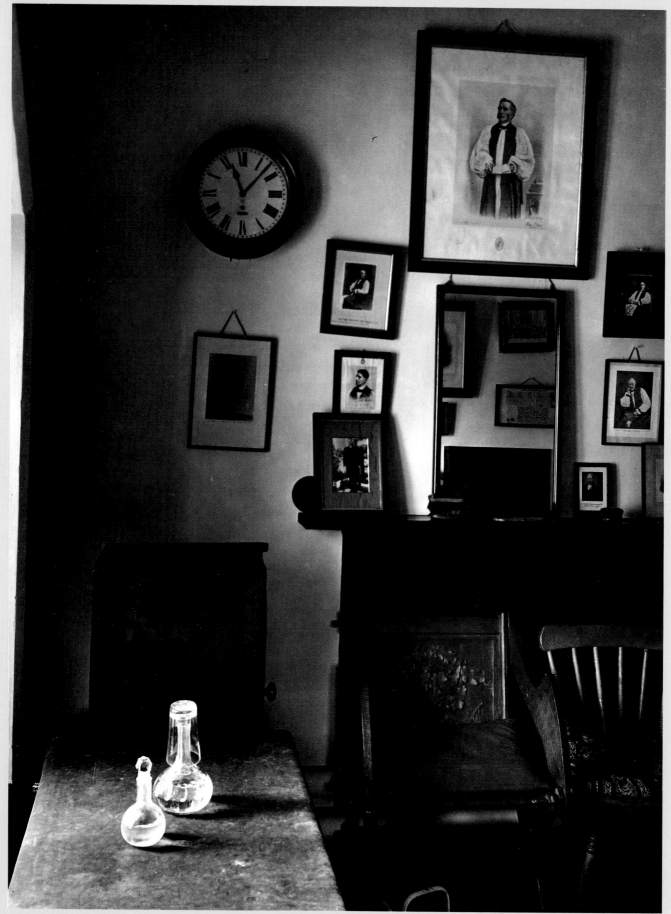

128
The vestry of the parish church, Carlow, Ireland; May 1965

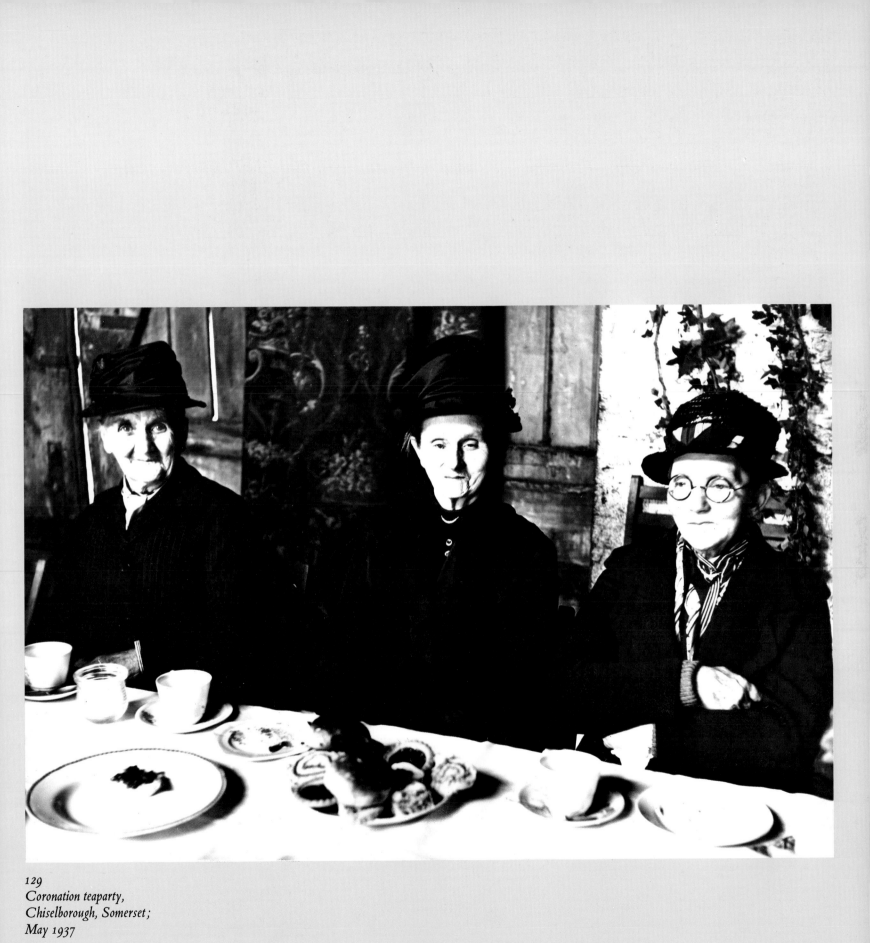

129
Coronation teaparty,
Chiselborough, Somerset;
May 1937

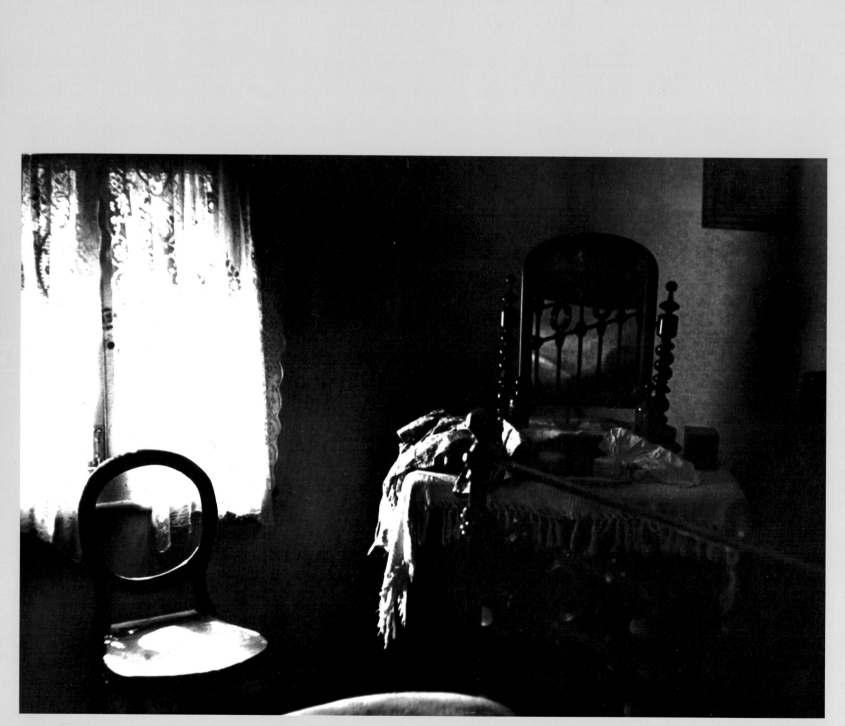

130
Camden Town bedroom, London;
1935

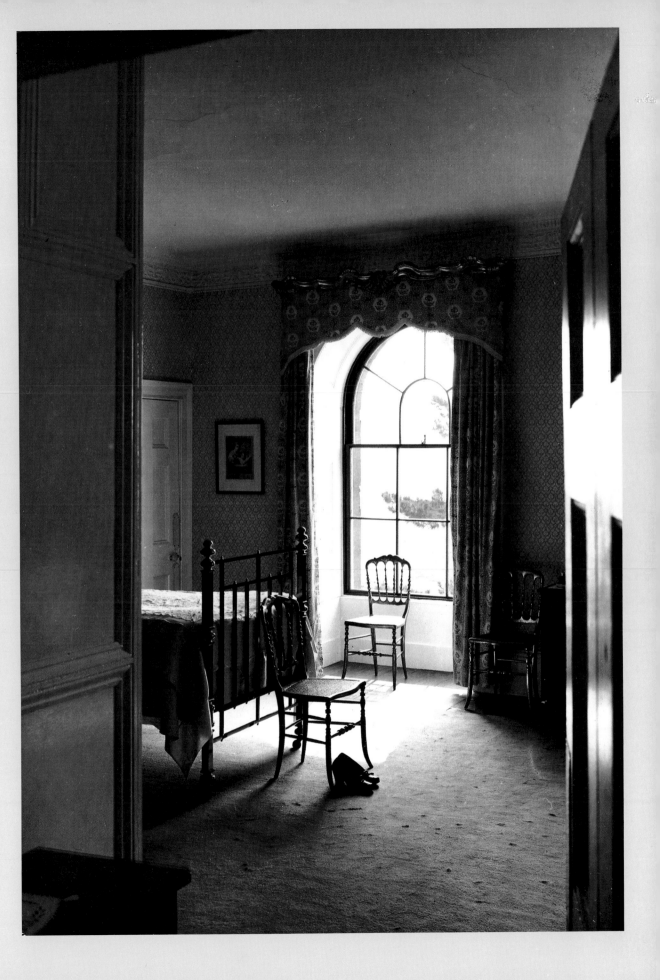

131
*A bedroom at Berrington Hall,
Herefordshire;
29 April 1959*

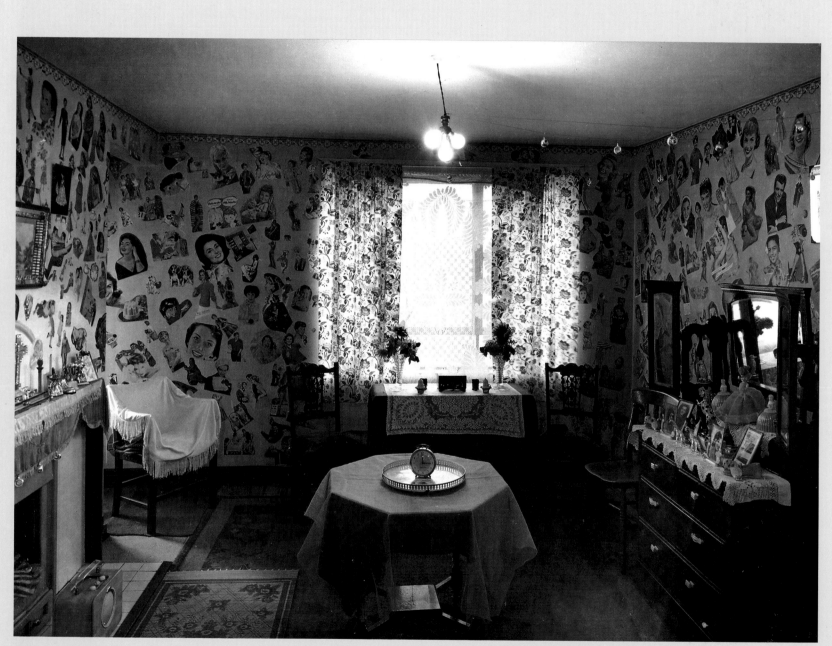

132
Mr Tyler's council flat,
Poplar, London;
4 February 1961

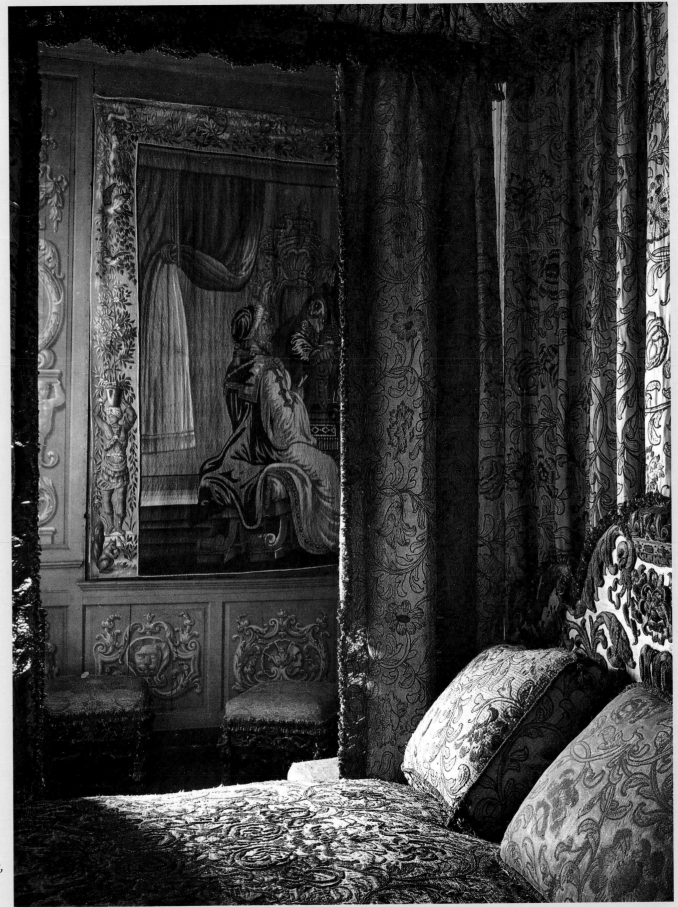

133
The King's Bedroom, Knole,
Kent;
5 October 1960

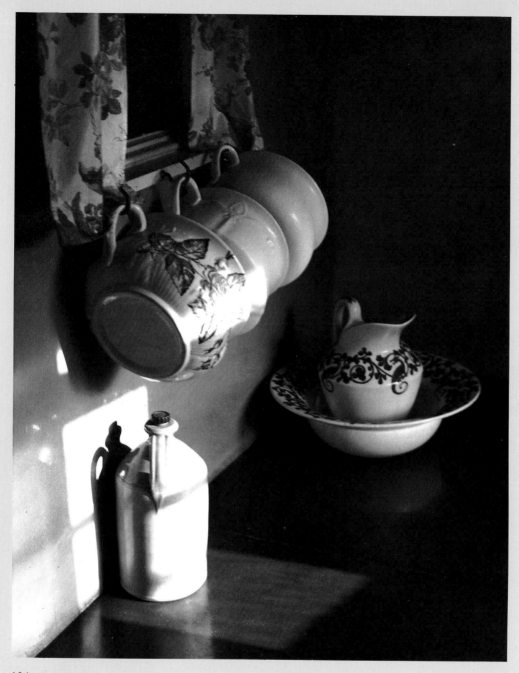

134
On the landing of a country inn,
Tetford, Lincolnshire;
18 May 1965

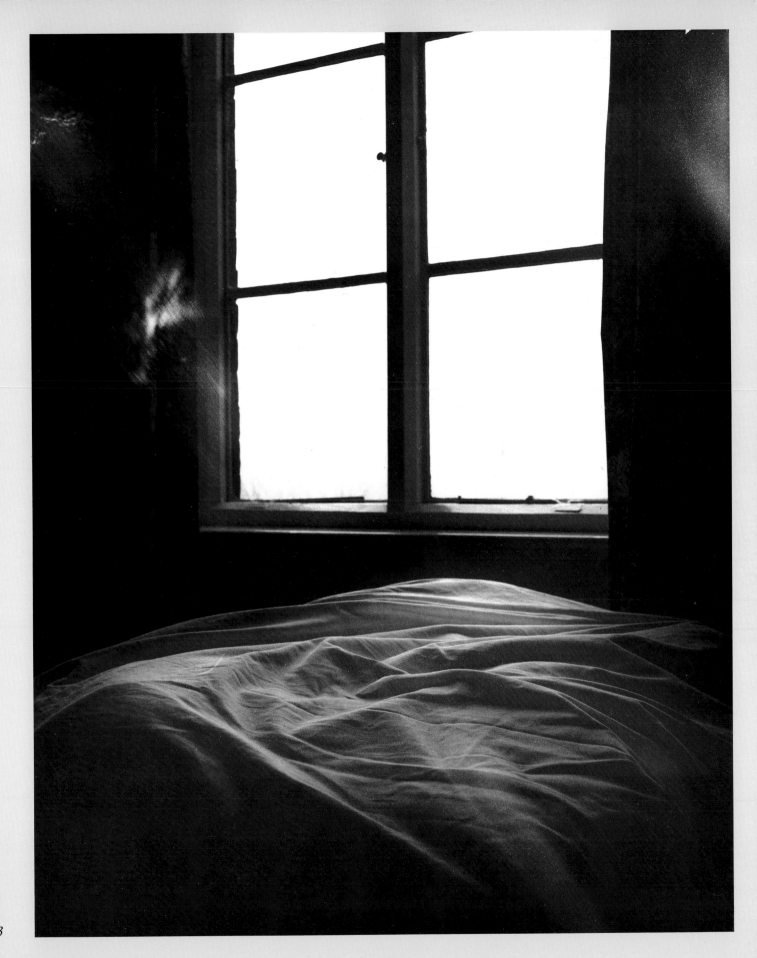

135
Bleak bedroom;
29 January 1963

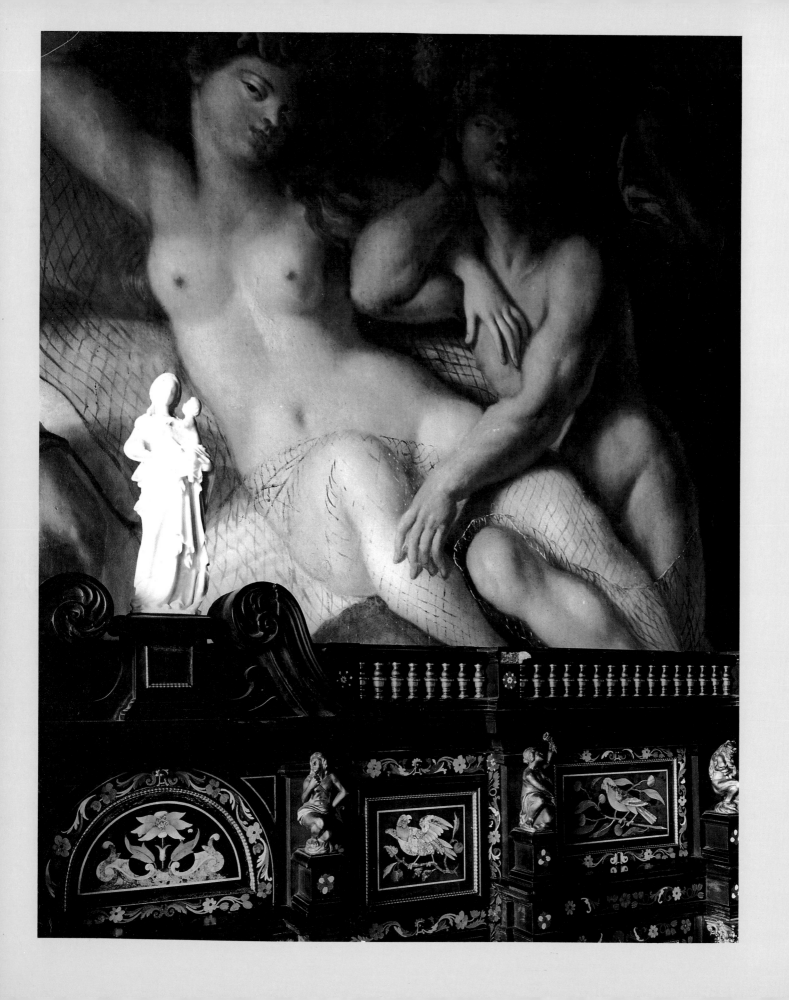

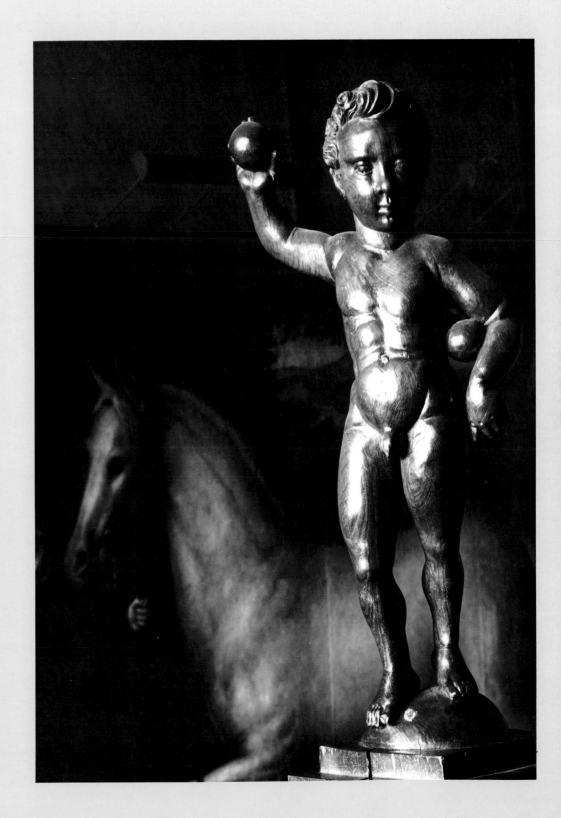

136
The Heaven Room, Burghley House,
Northamptonshire;
19 May 1966

137
Stair finial, Hatfield House,
Hertfordshire;
2 June 1969

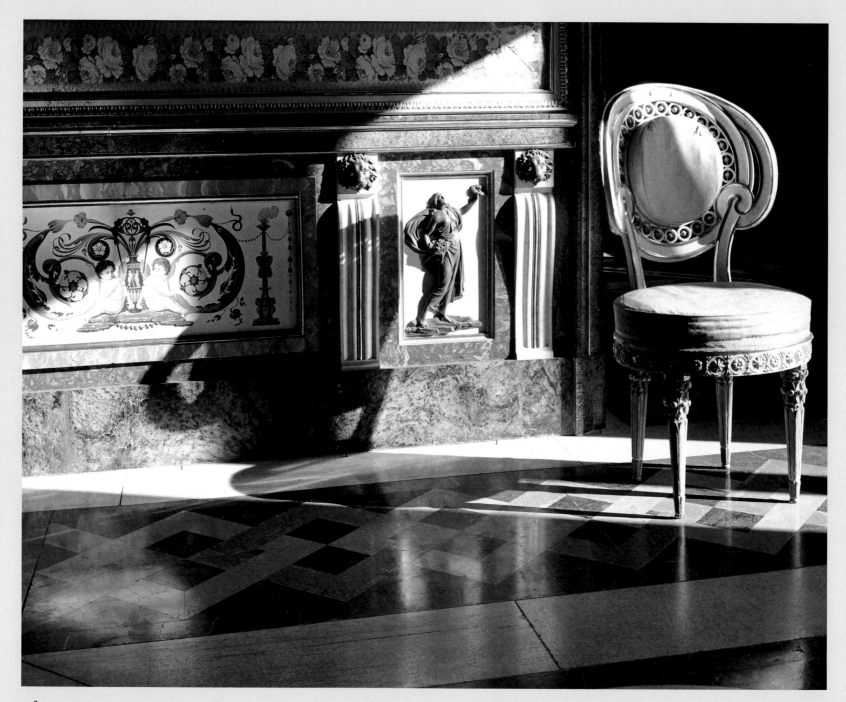

138
The Sala Corunna, Casita del Labrador,
Aranjuez, Spain;
21 April 1960

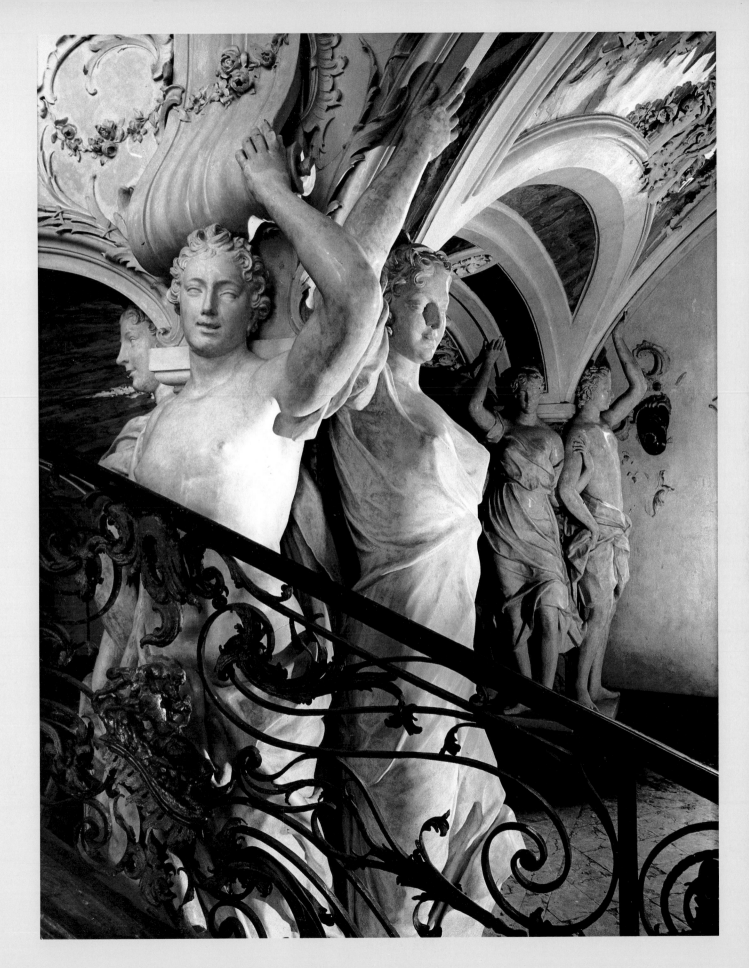

139
The staircase,
Brühl, Germany;
12 August 1960

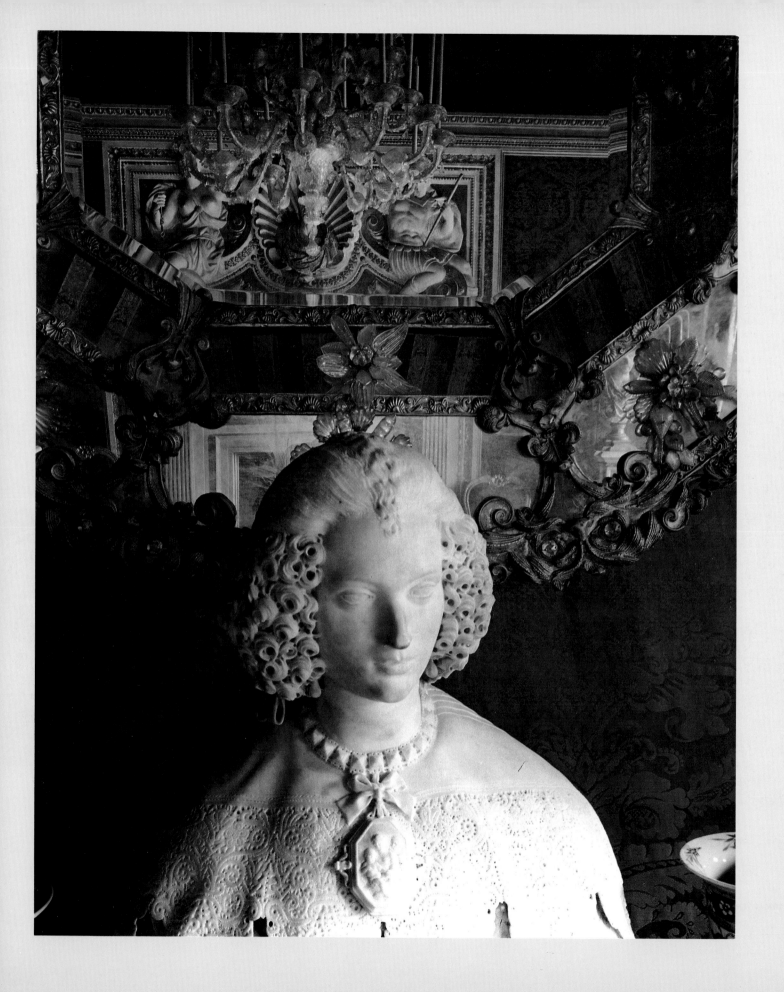

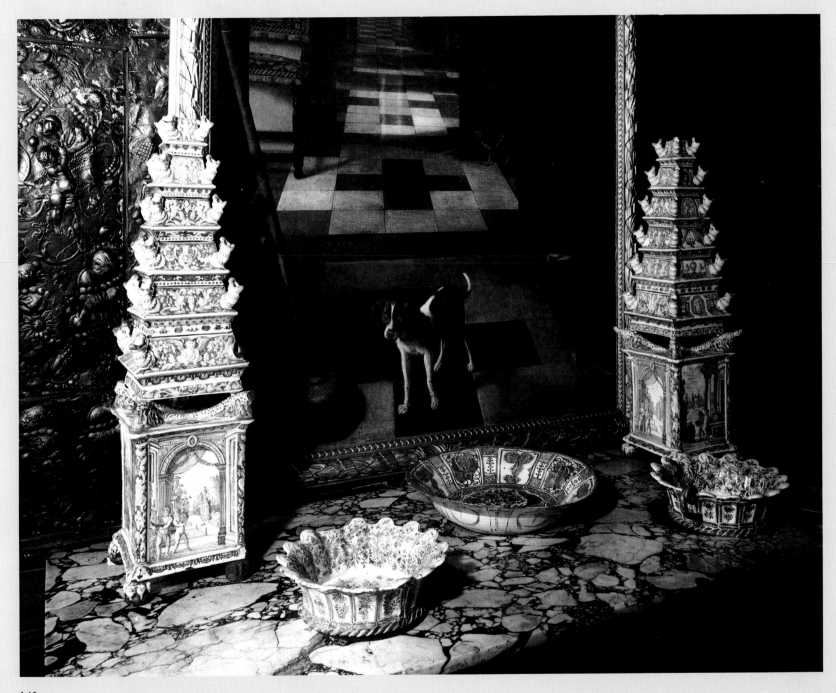

140
Palazzo Labia, Venice;
24 March 1960

141
Dyrham Park, Gloucestershire;
22 March 1967

142
The Library,
Trinity College,
Cambridge;
4 August 1964

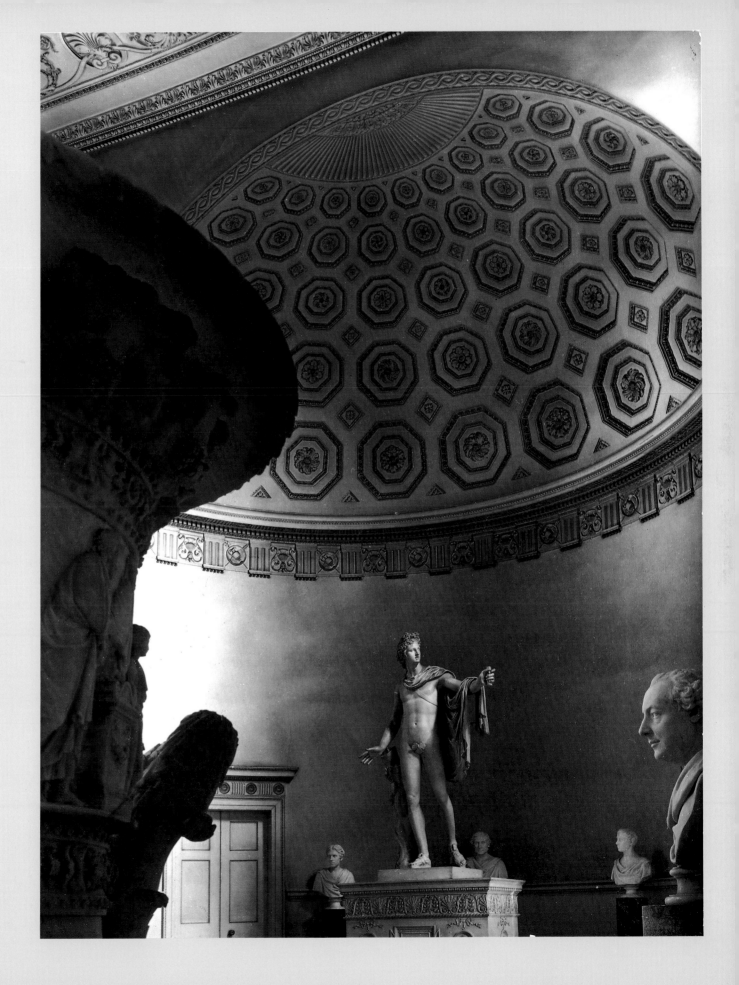

143
*The Hall,
Syon House,
Middlesex;
18 June 1959*

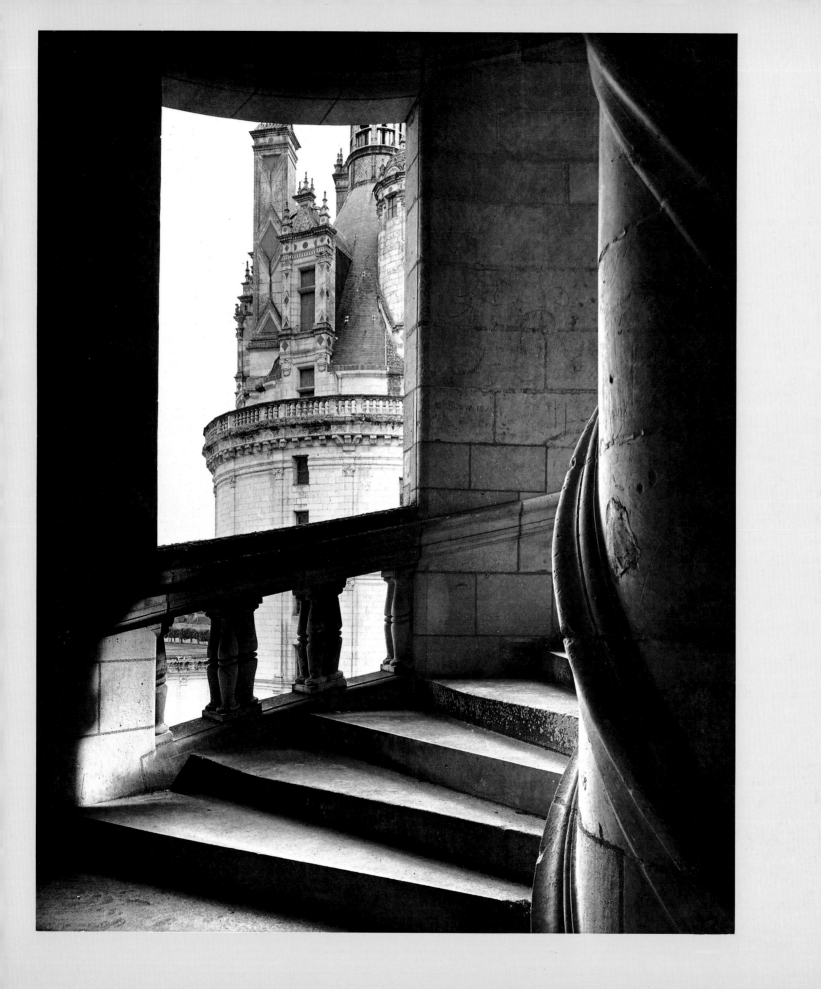

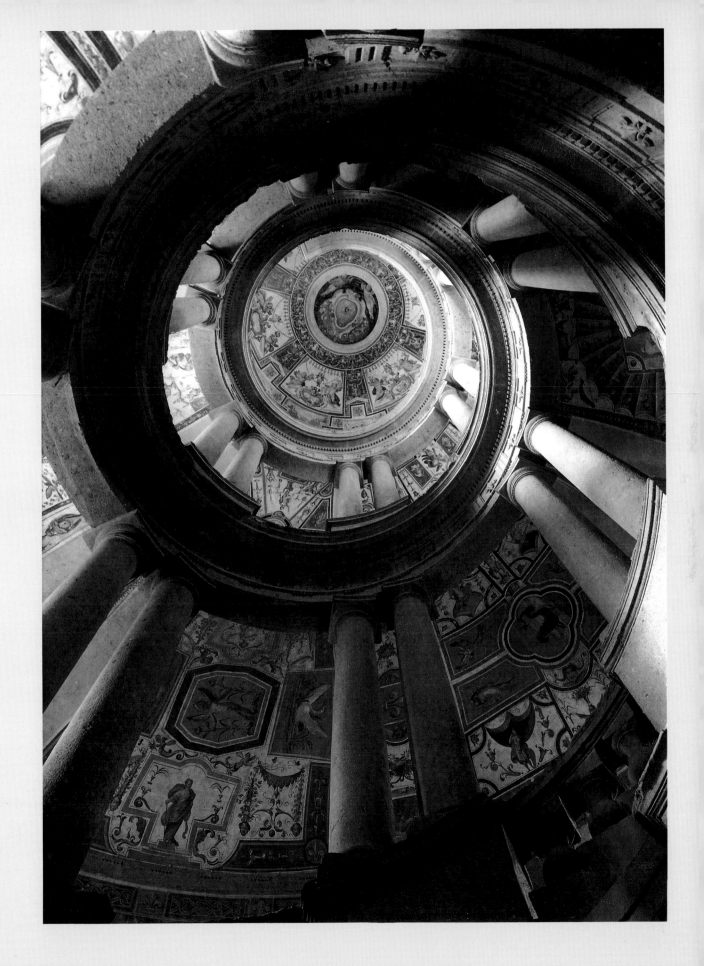

144
A turret stair,
Château de Chambord,
France;
9 July 1960

145
Staircase,
Villa Farnese,
Caprarola, Italy;
8 April 1960

PATTERNS AND TEXTURES

146
The Petit Château,
Tanlay, France;
5 July 1960

147
Frost patterns on a window,
16 January 1966

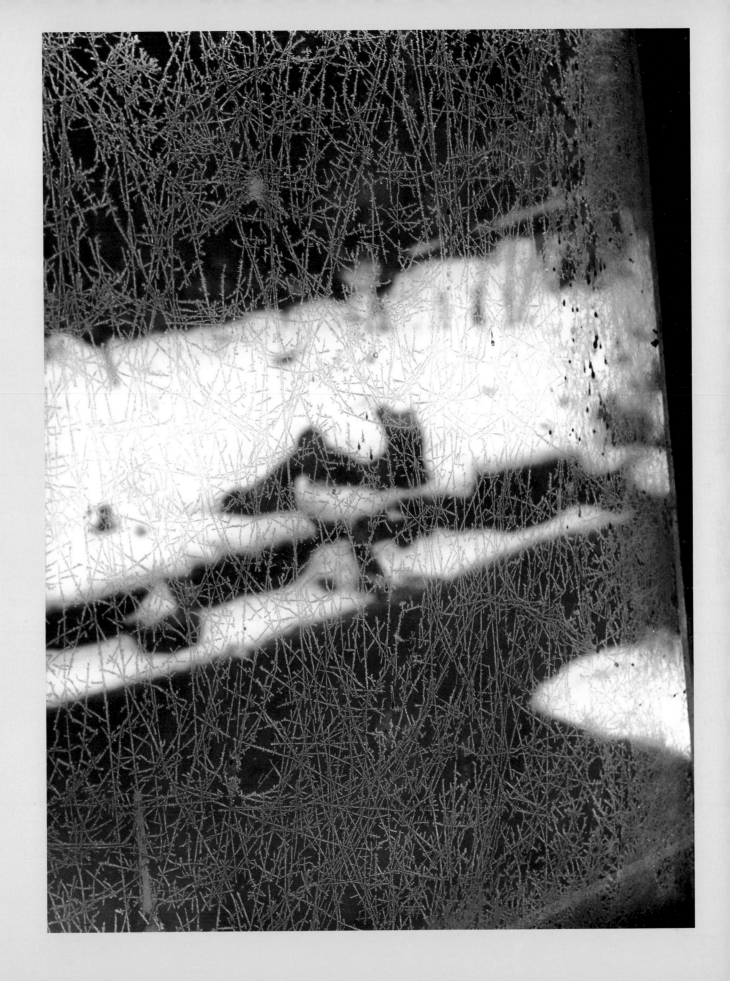

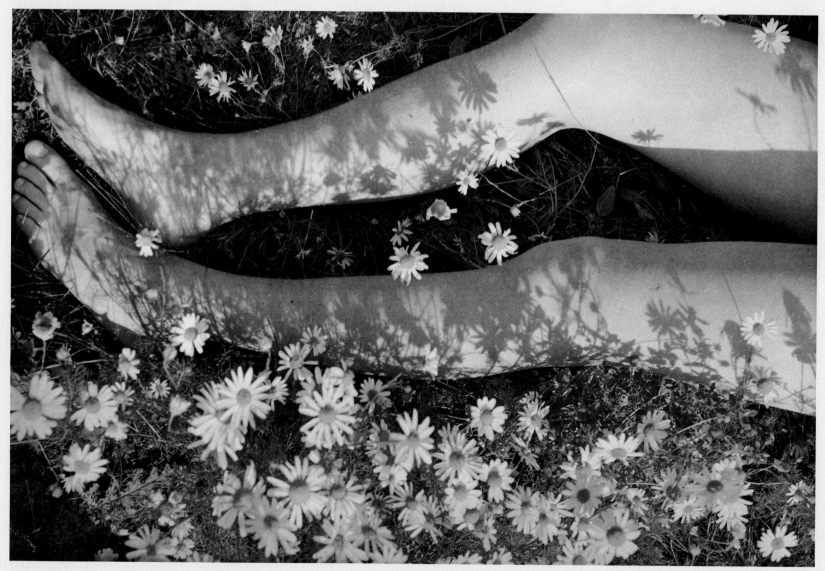

148
Legs in a field of dog daisies;
29 July 1935

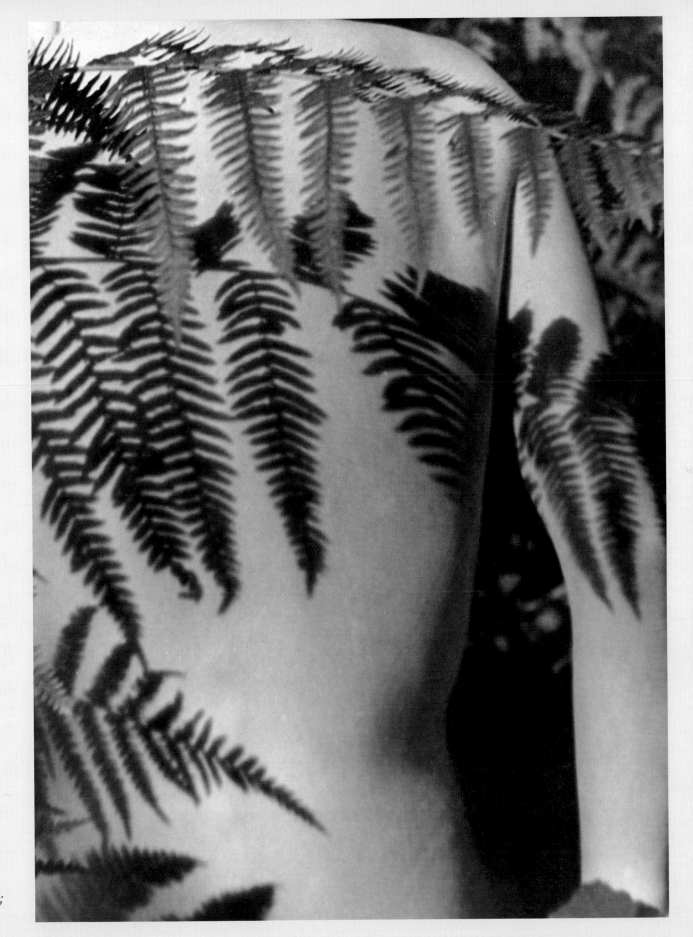

149
Fern patterns on a girl's back;
29 July 1935

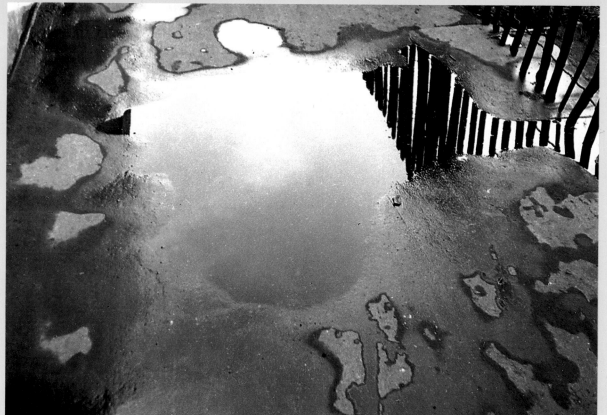

150
Puddle;
December 1939

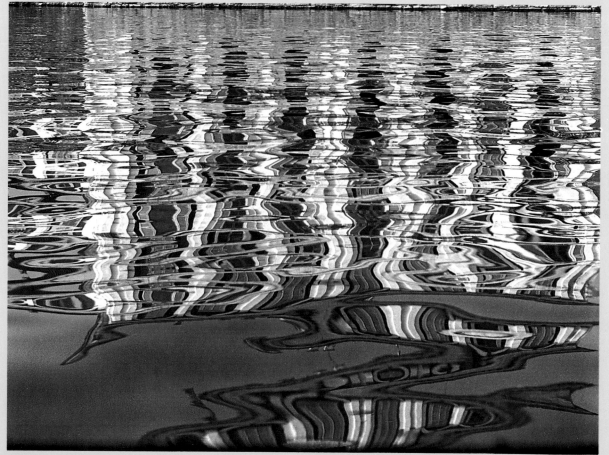

151
Lago Maggiore,
Italy;
19 March 1959

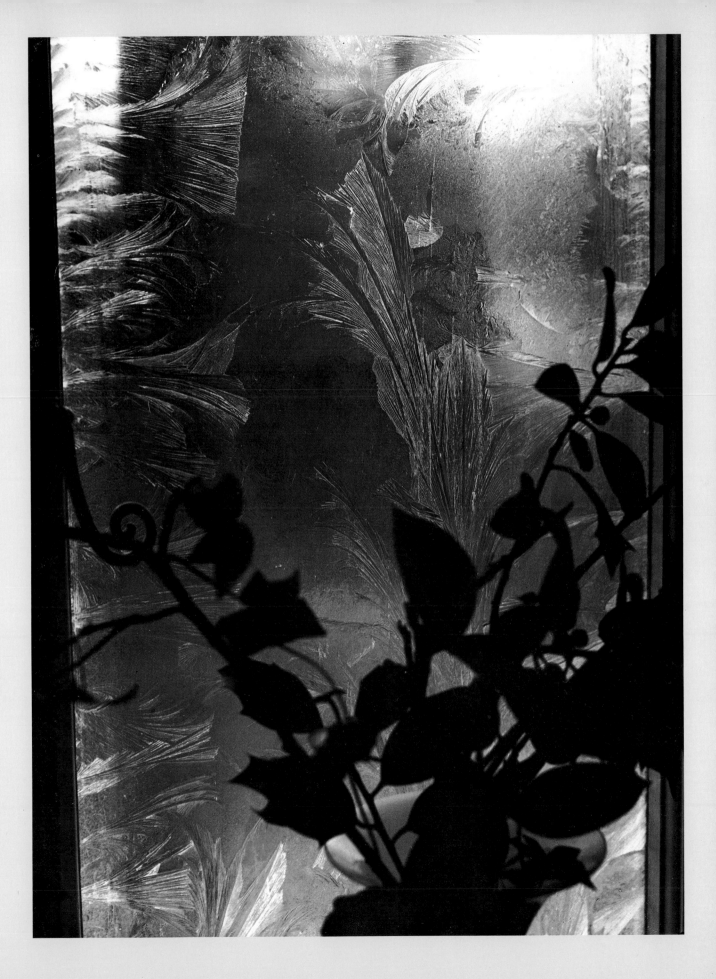

152
Frost ferns
on the workroom
window;
6 December 1965

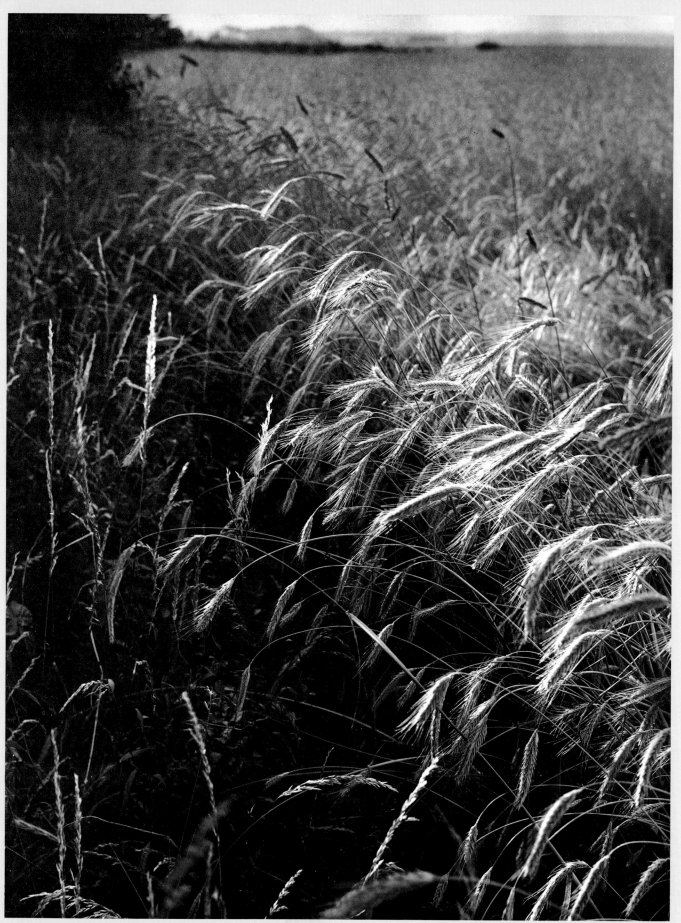

153
Edge of a cornfield;
July 1959

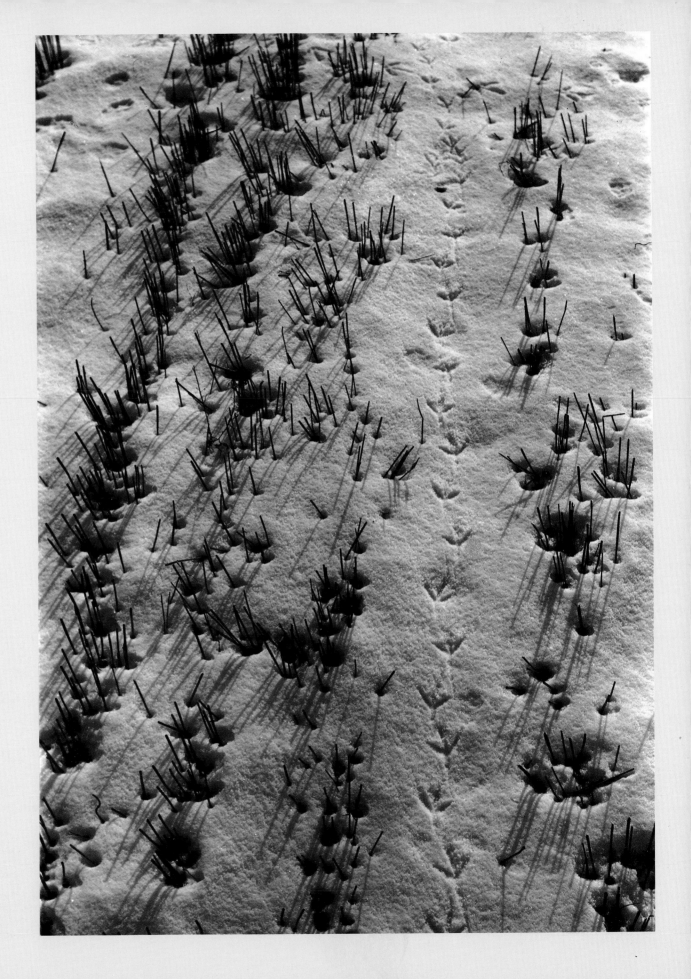

154
Snow;
17 January 1963

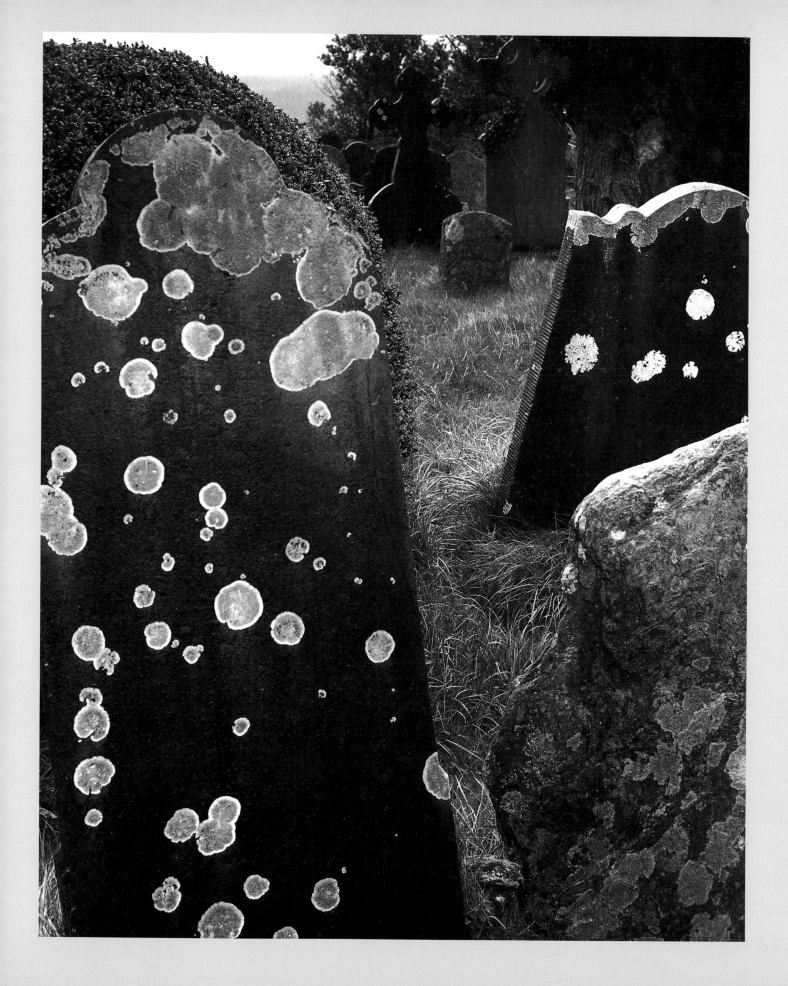

156
Brickwork, Pompeii,
Italy;
9 October 1959

155
Tombstones at Glendalough,
Co. Wicklow, Ireland;
6 May 1965

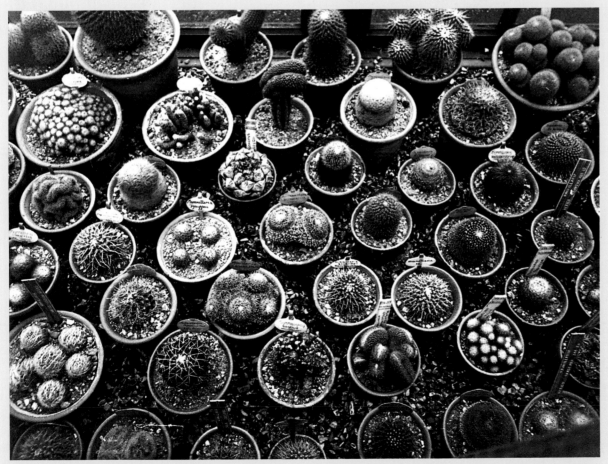

157
Cacti;
May 1937

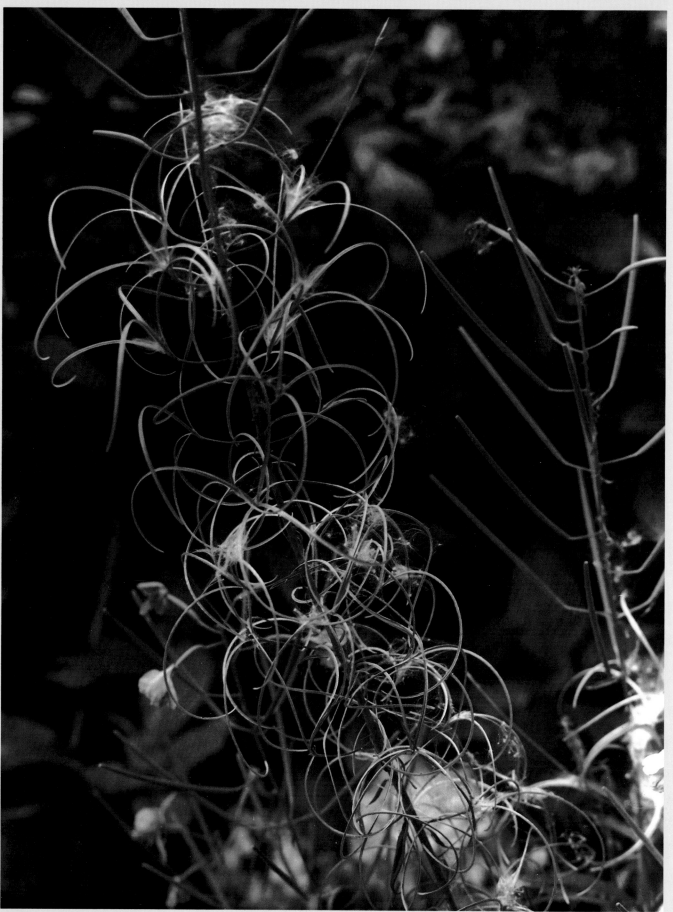

158
Rosebay;
September 1962

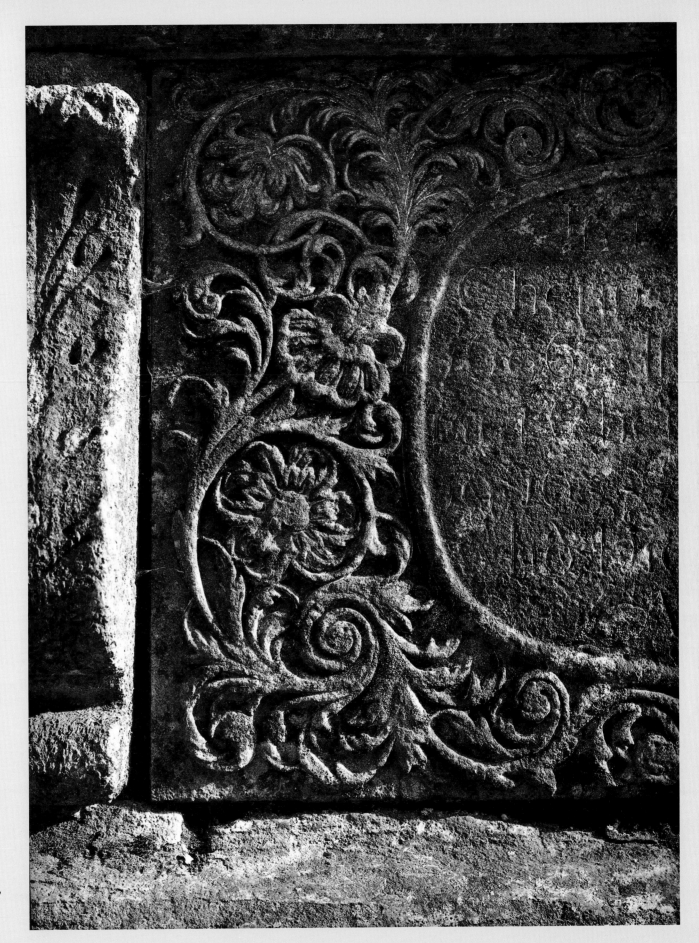

159
Tombstone (1696),
North Cerney churchyard,
Gloucestershire;
23 April 1957

PARKS AND GARDENS

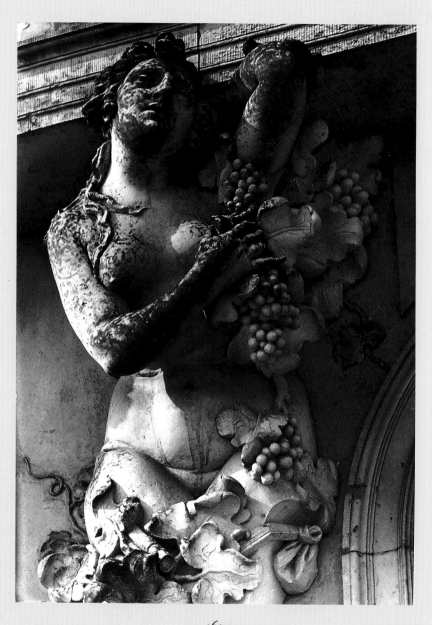

160
Caryatid,
Sanssouci, Potsdam, Germany;
August 1960

161
The Dell Garden,
Bodnant,
Caernarvonshire, Wales;
June 1962

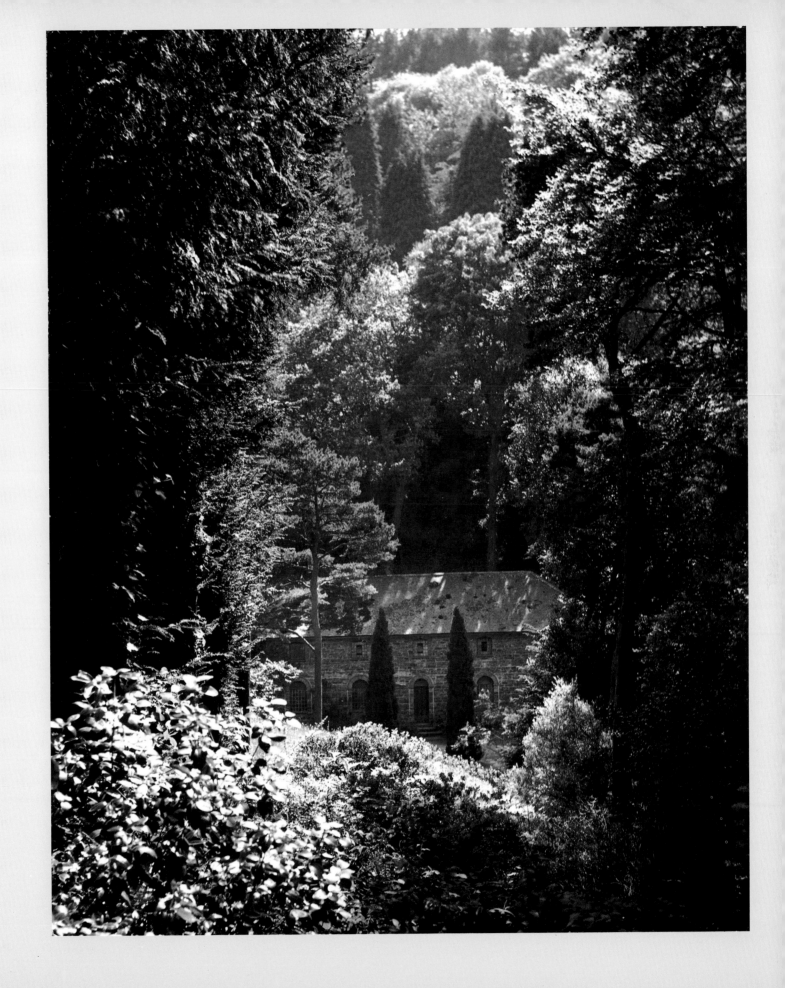

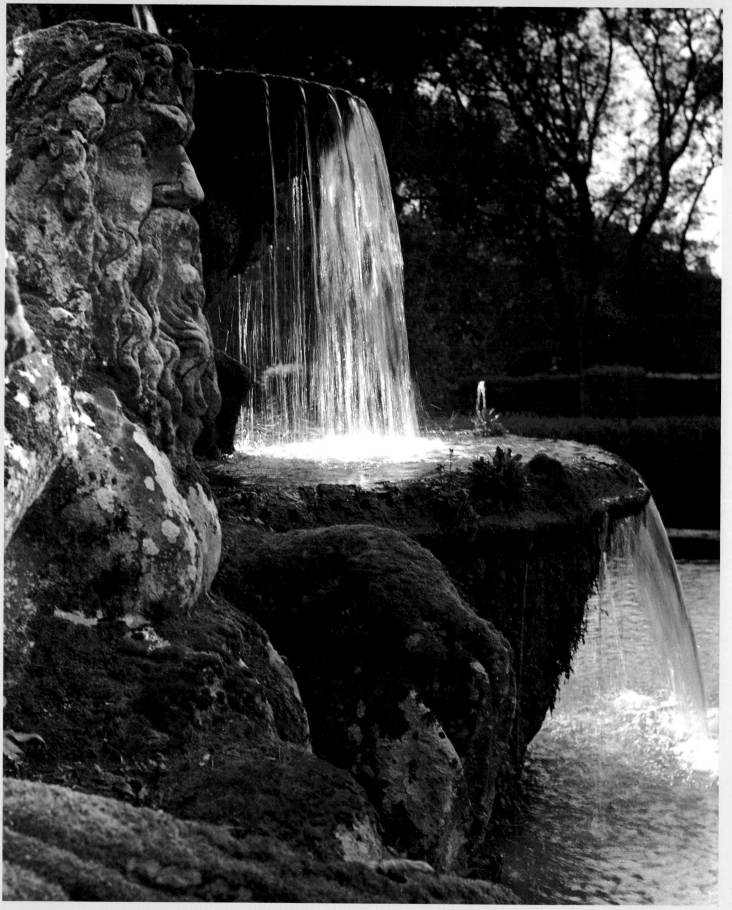

162
Fountain of
the Giants,
Villa Lante,
Bagnaia,
Italy;
31 March
1960

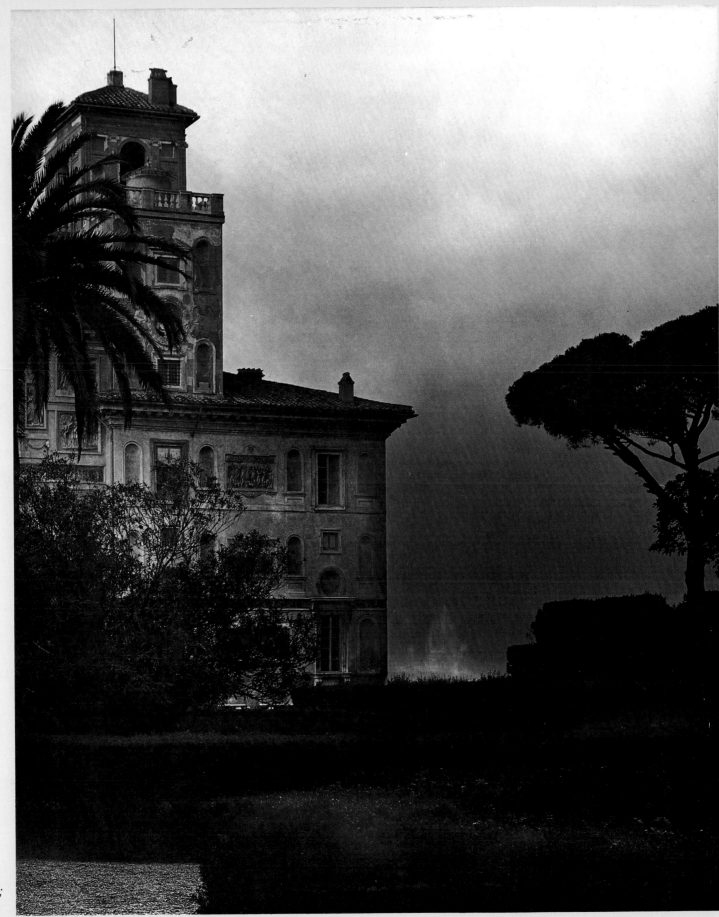

163
*Villa Medici,
looking towards
St Peter's, Rome;
8 November 1970*

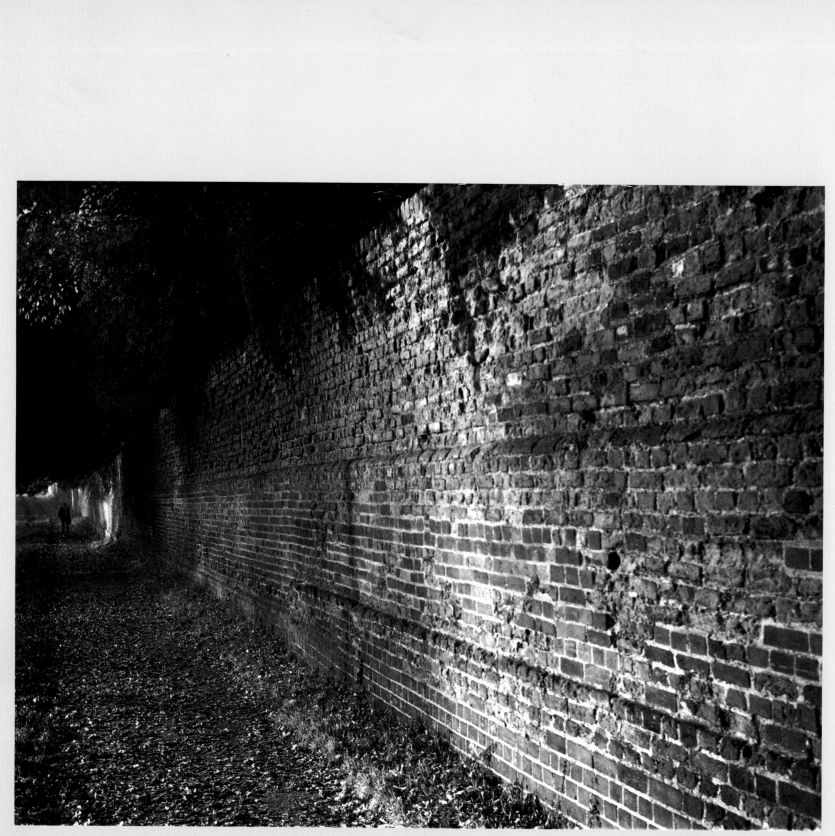

164
Wall of Audley End Park,
Saffron Walden, Essex;
14 November 1964

165
Gates of Hardwick Hall,
near Bury St Edmunds,
Suffolk;
10 October 1955

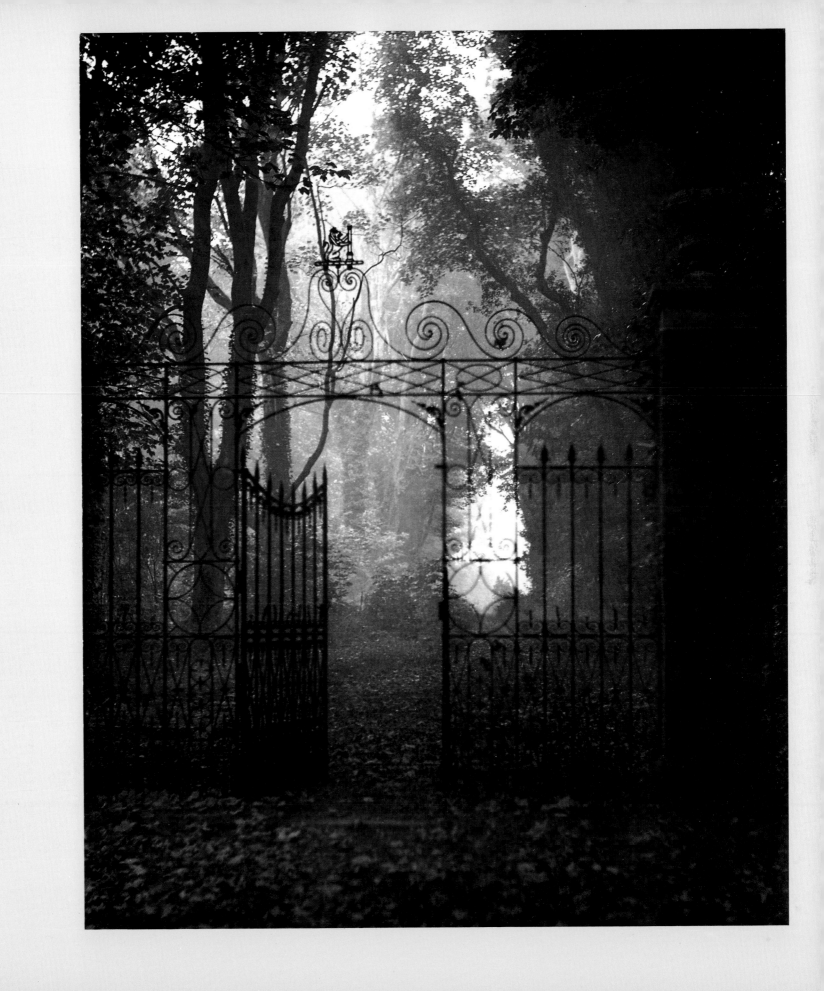

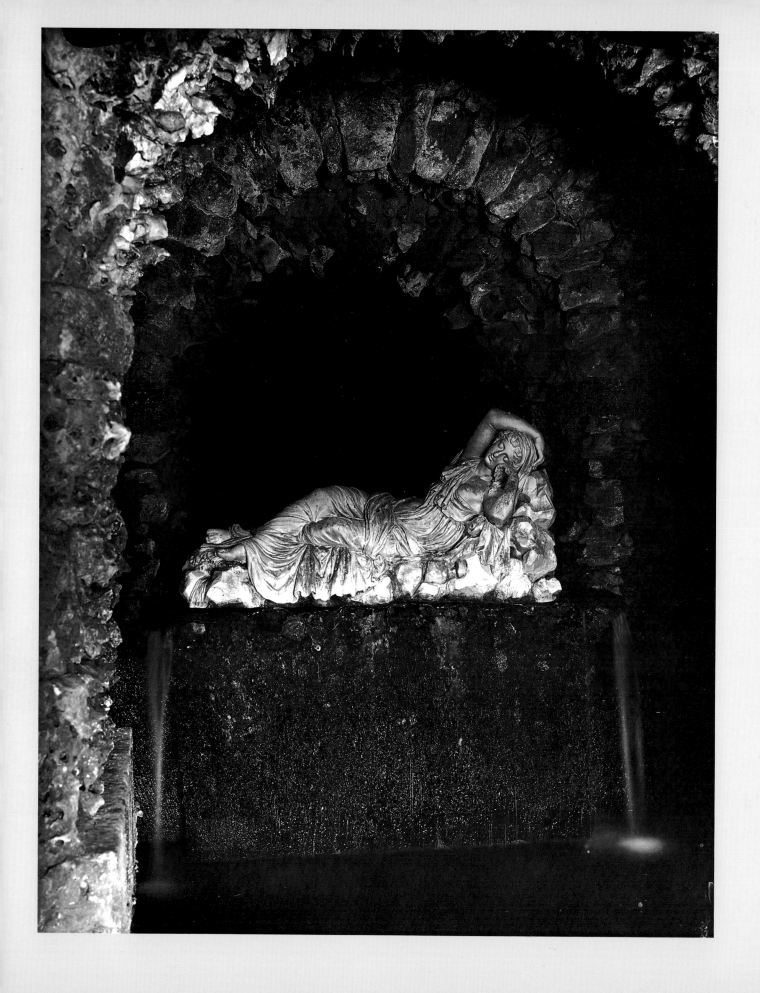

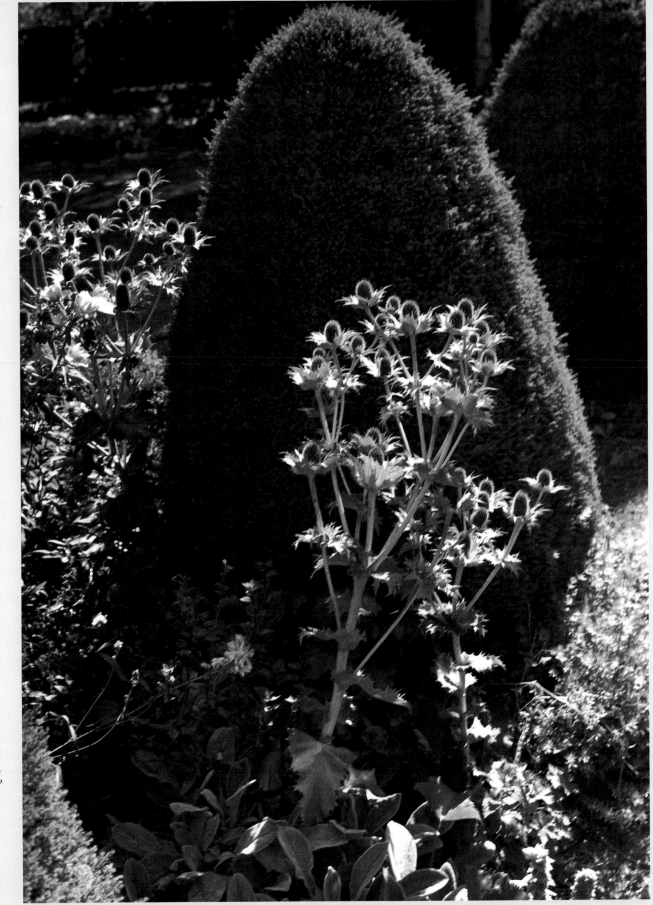

166
'Nymph of the Grot', Stourhead,
Wiltshire;
28 May 1956

167
East Lambrook Manor,
Somerset;
22 August 1968

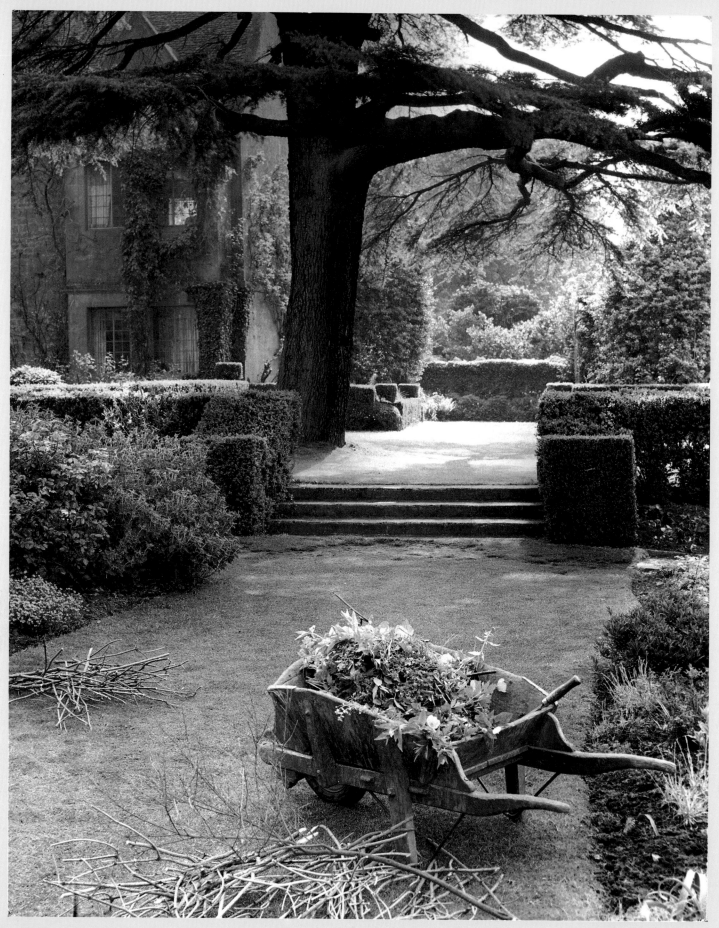

168
Hidcote,
Gloucestershire;
2 June 1962

169
Chiswick House,
Middlesex;
2 September 1965

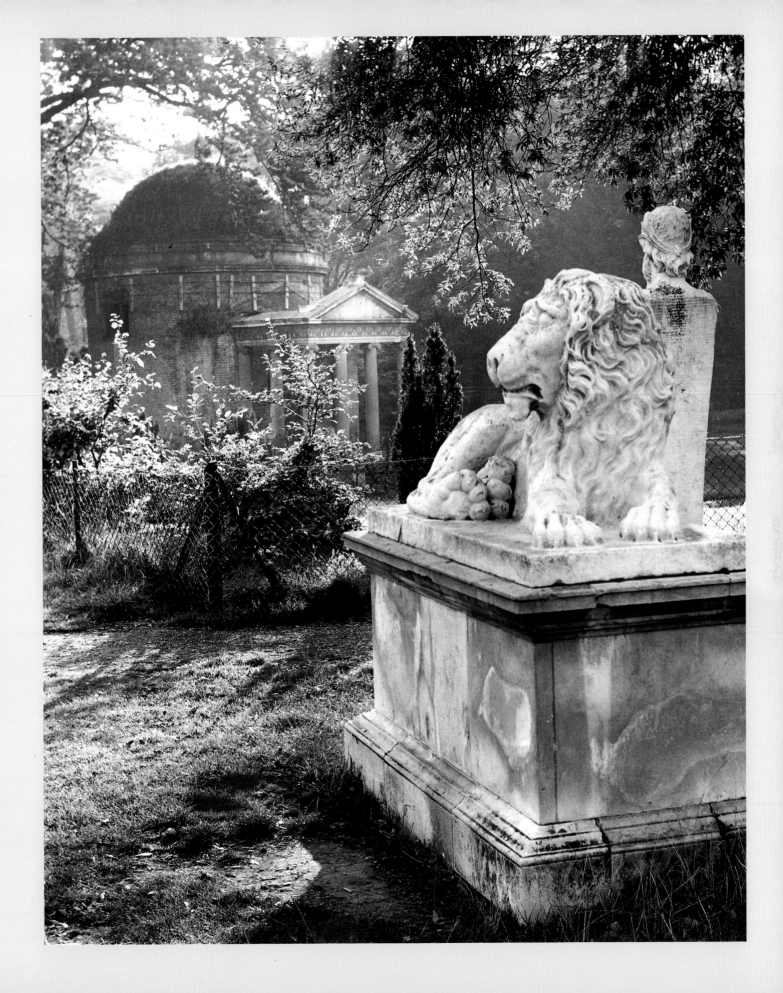

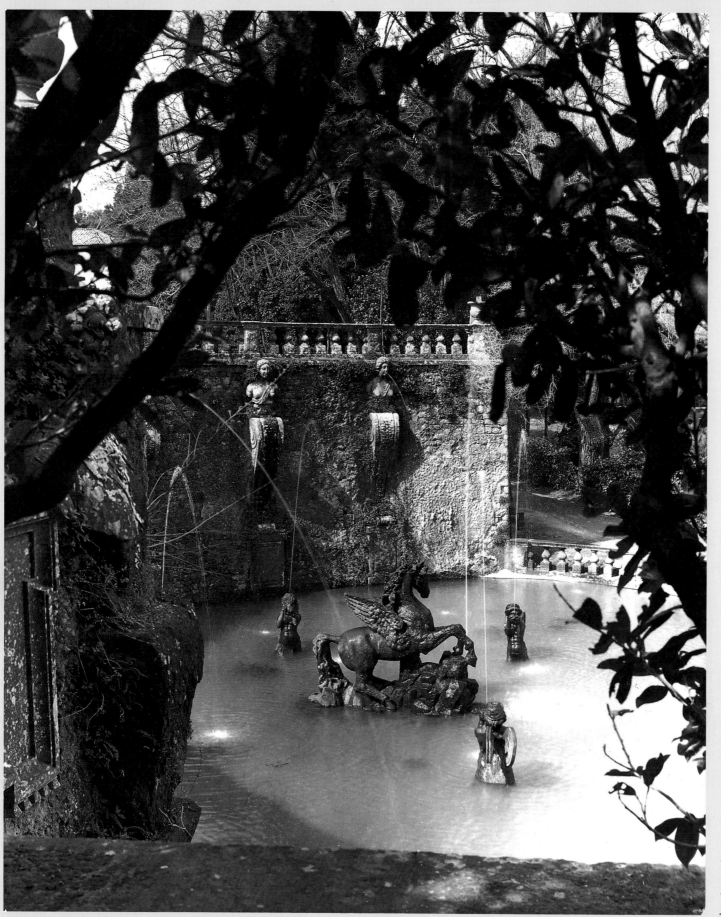

170
Pegasus Fountain,
Villa Lante,
Bagnaia, Italy;
3 April 1960

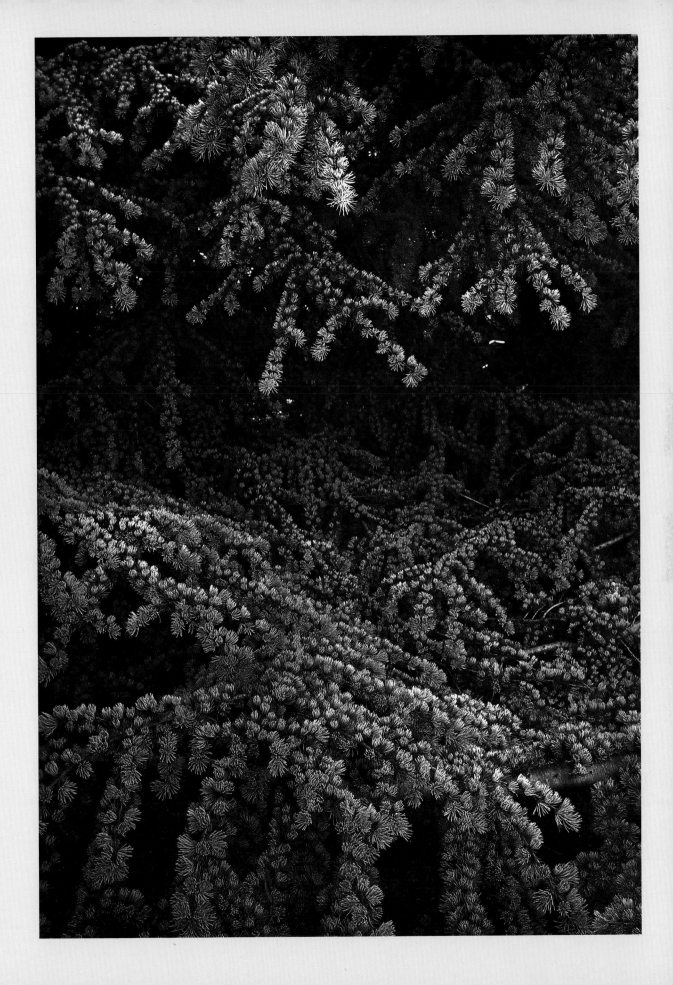

171
Cedar, Bodnant,
Caernarvonshire,
Wales;
June 1962

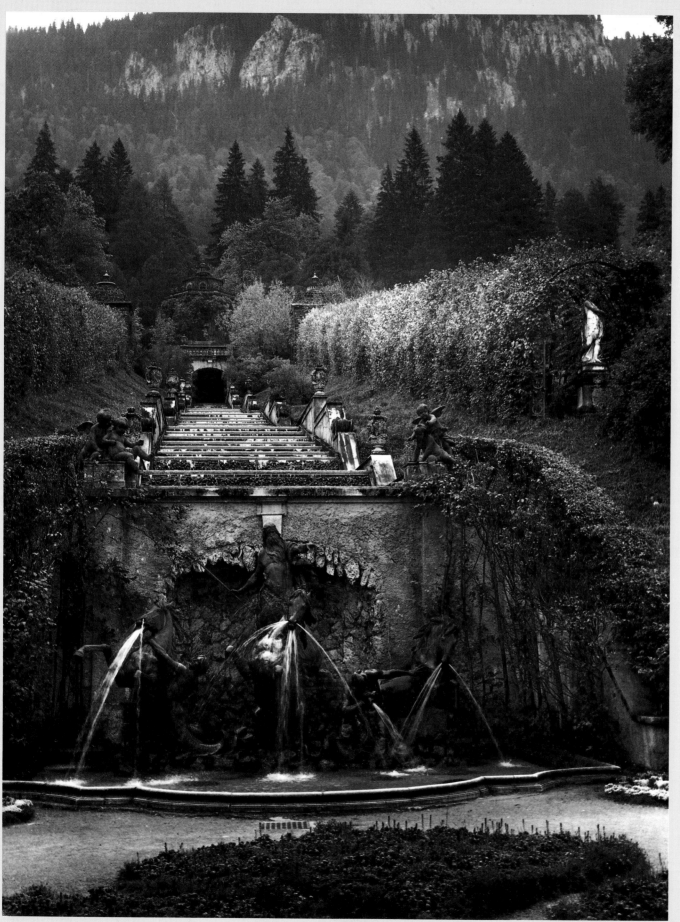

172
Linderhof, Bavaria;
October 1966

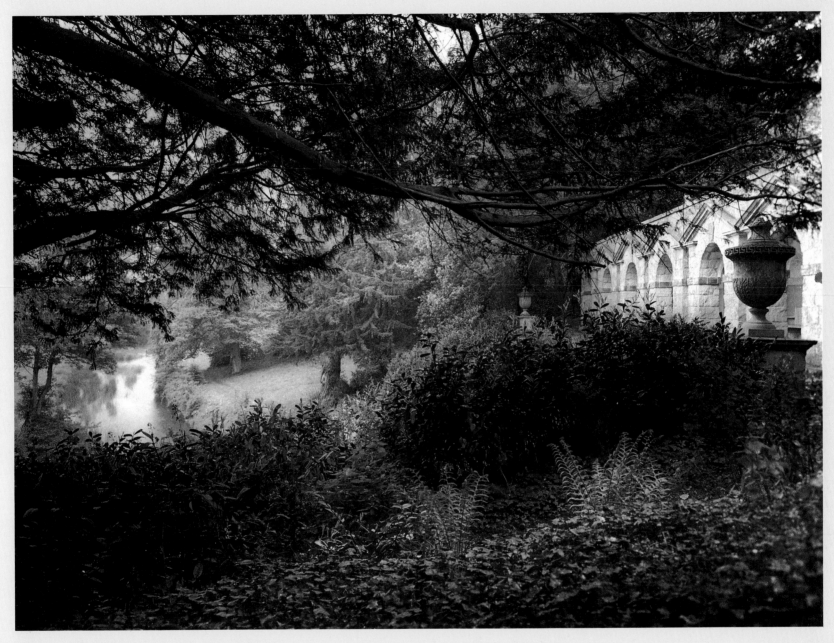

173
Rousham, Oxfordshire;
28 May 1966

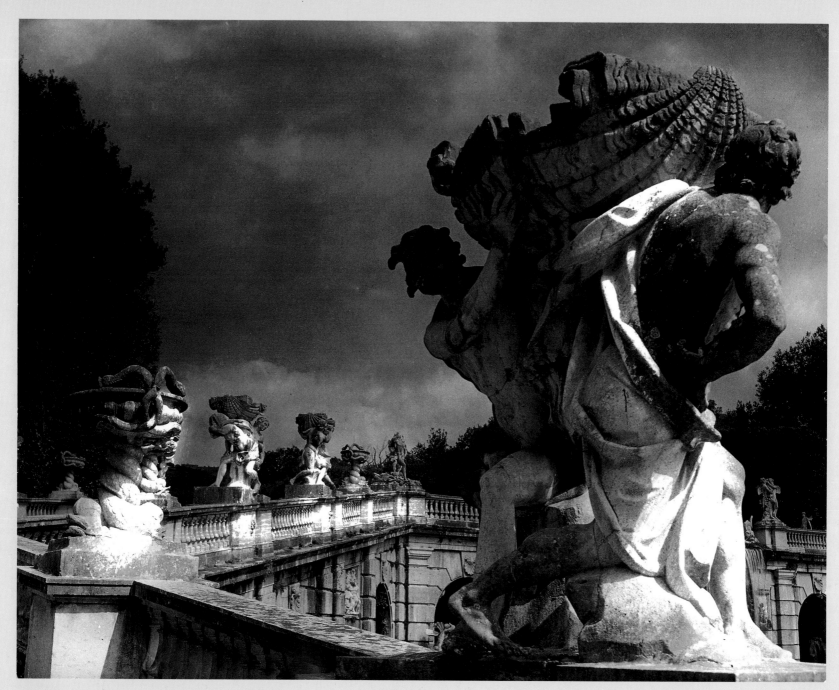

174
Balustrade and sculpture above the cascade of Aeolus,
Caserta, Italy;
20 March 1963

175
Isola Bella, Lago Maggiore, Italy;
10 March 1960

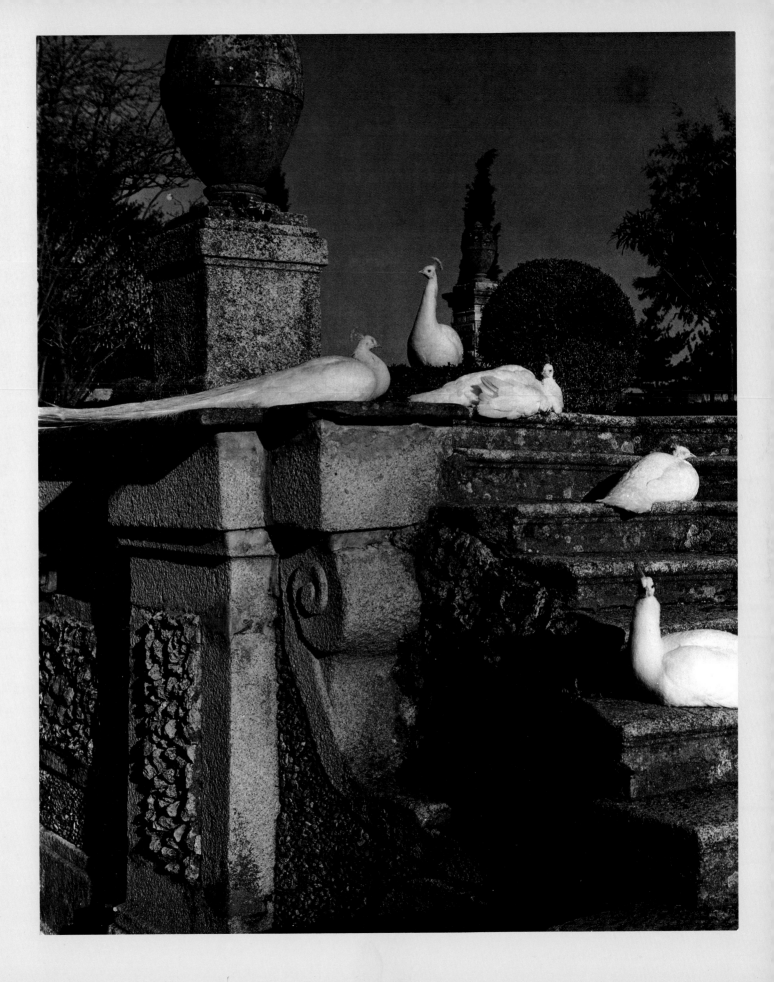

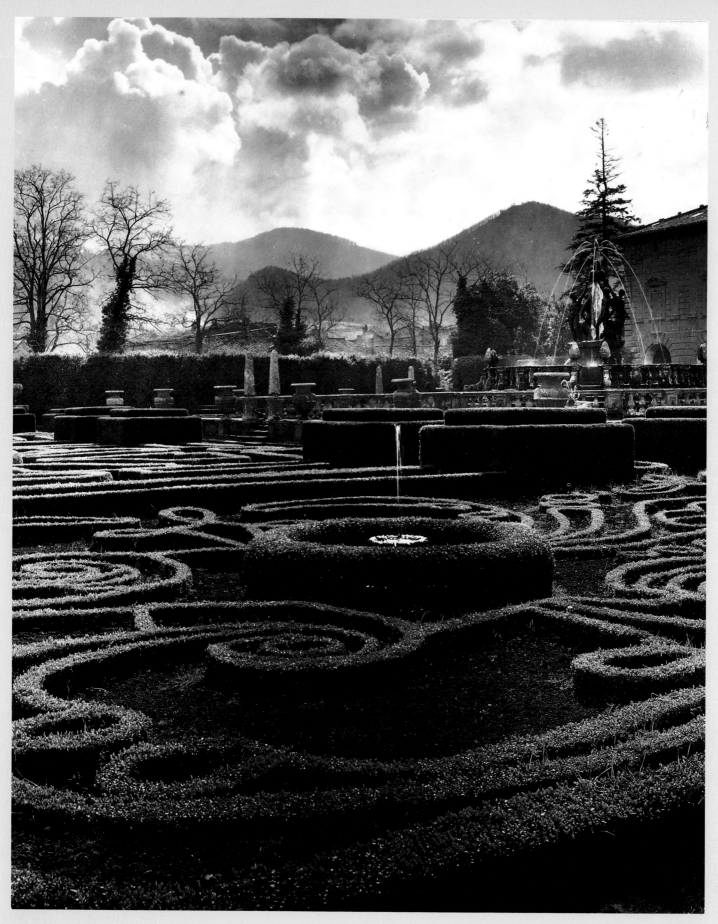

176
*Quadrato of the
Villa Lante,
Bagnaia, Italy;
3 April 1960*

177
Villa Farnese, Caprarola, Italy;
5 April 1960

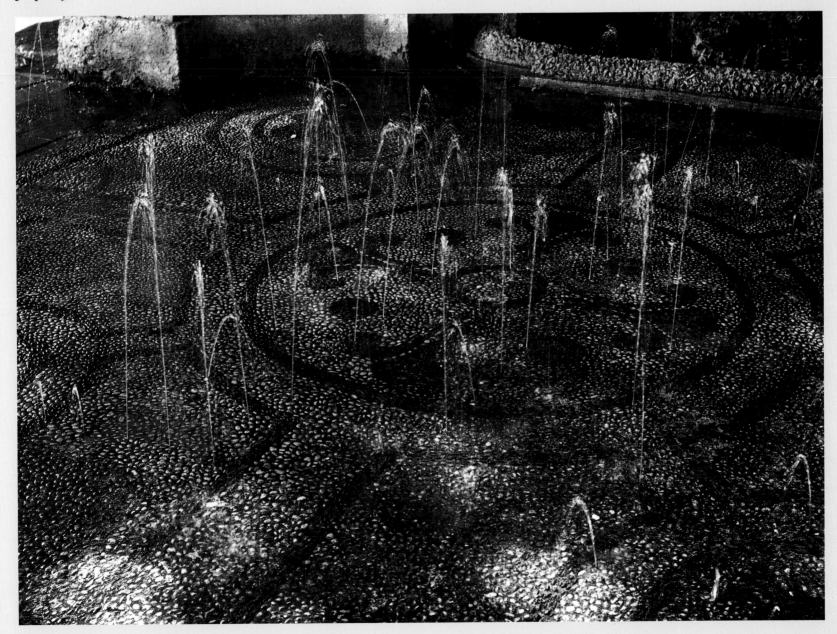

178
Casa de Pilatos,
Seville, Spain;
25 April 1960

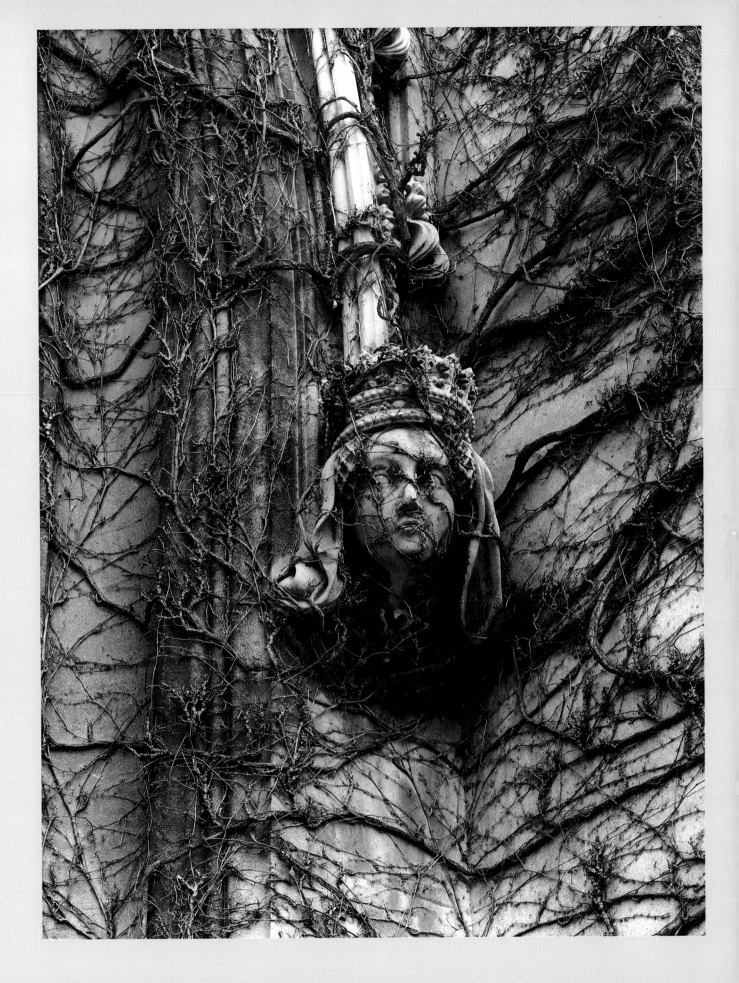

179
New Court,
St John's College,
Cambridge;
14 August 1964

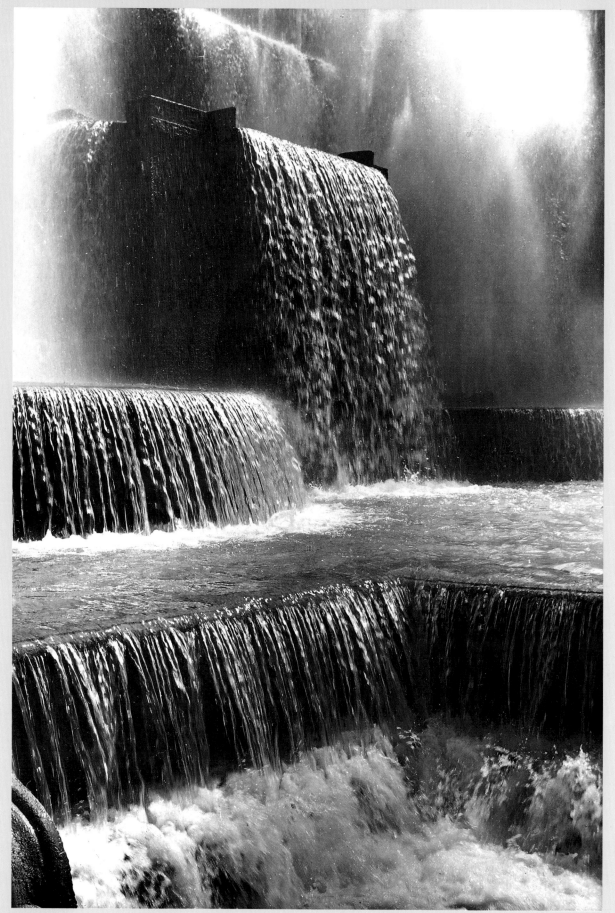

180
Neptune Fountain,
Villa d'Este, Tivoli;
6 April 1960

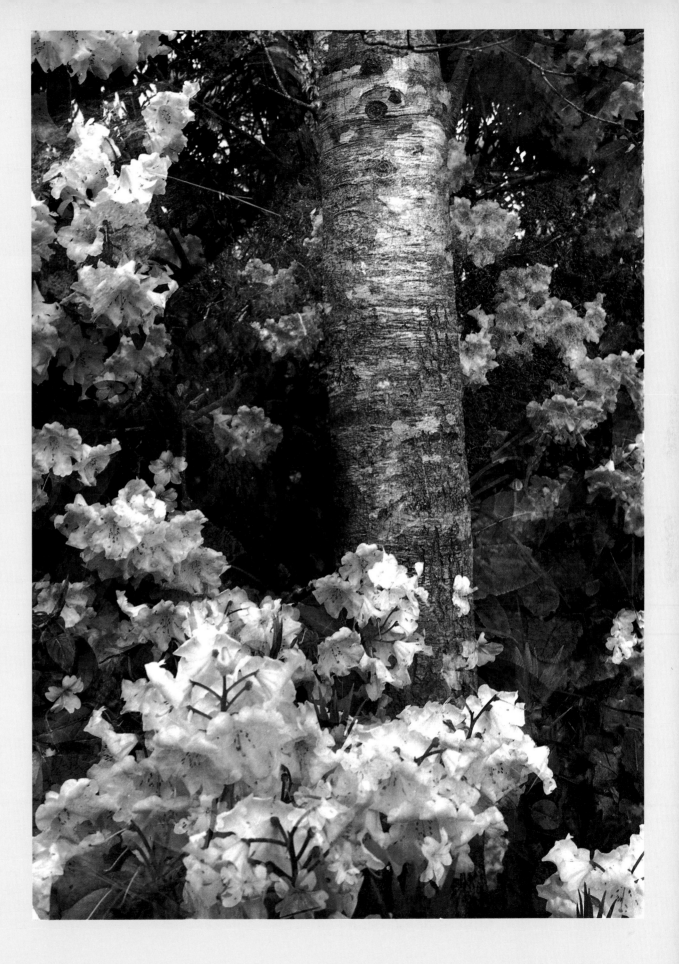

181
Caerhays, Cornwall;
13 May 1966

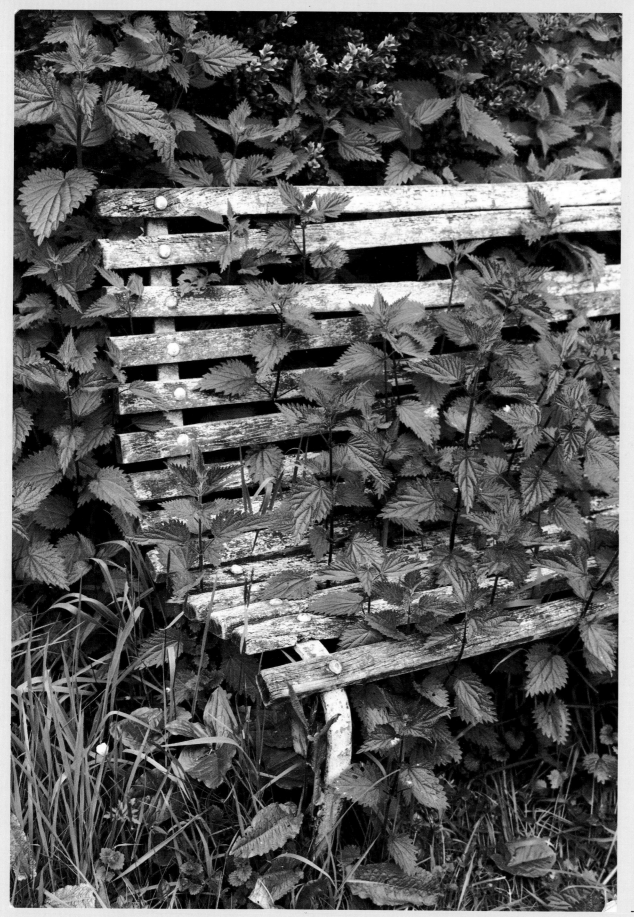

182
Garden seat, Rousham,
Oxfordshire;
June 1966

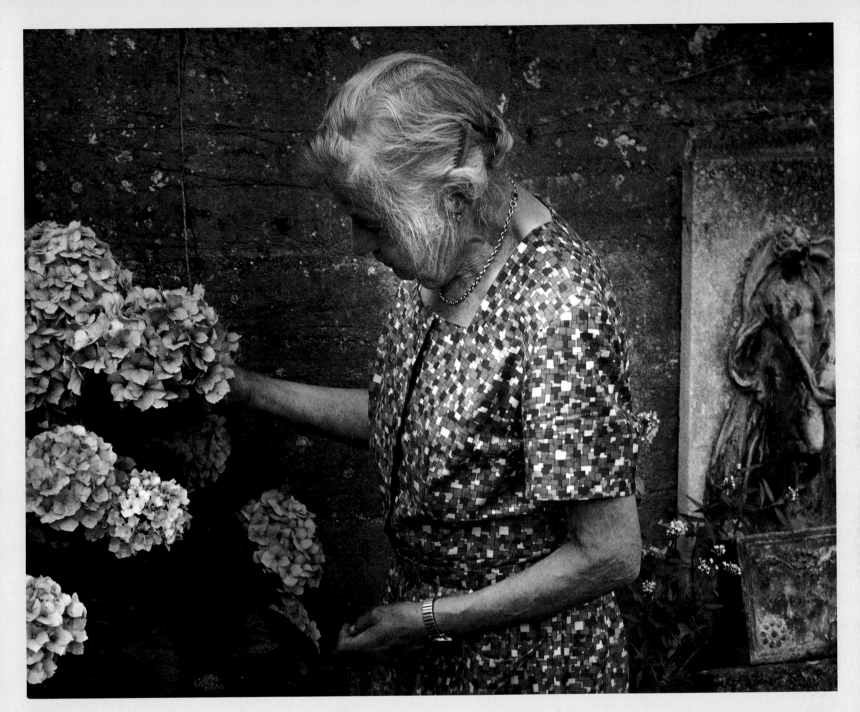

183
Mrs Margery Fish,
East Lambrook Manor,
Somerset;
22 August 1968

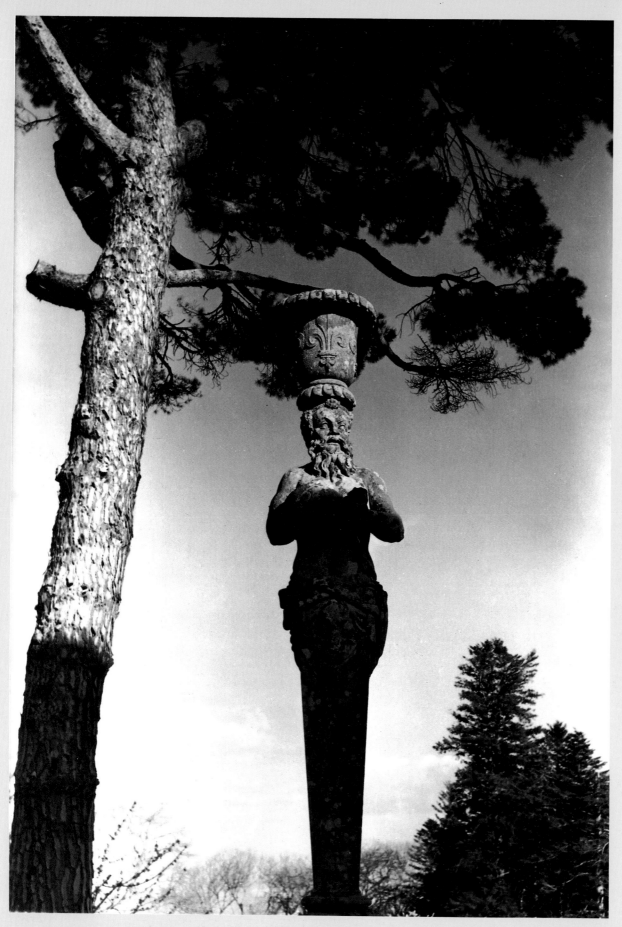

184
Villa Farnese,
Caprarola, Italy;
5 April 1960

185
Satyr looking down
on the terrace,
Villa Garzoni, Collodi,
Italy;
May 1963

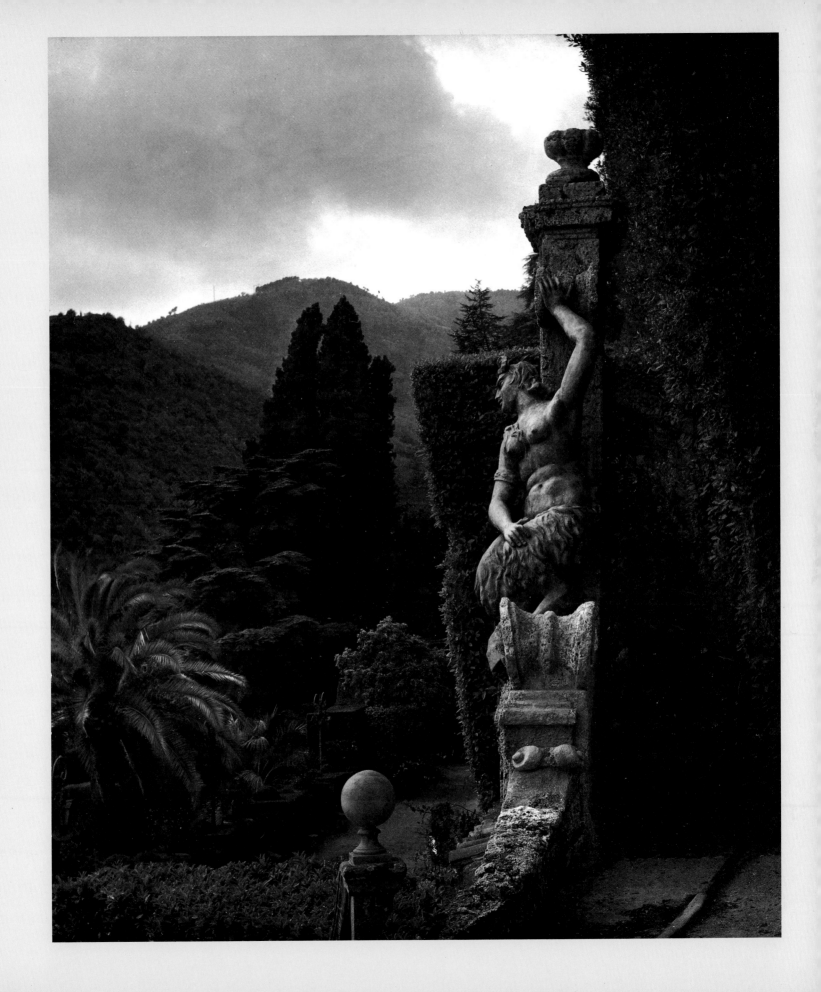

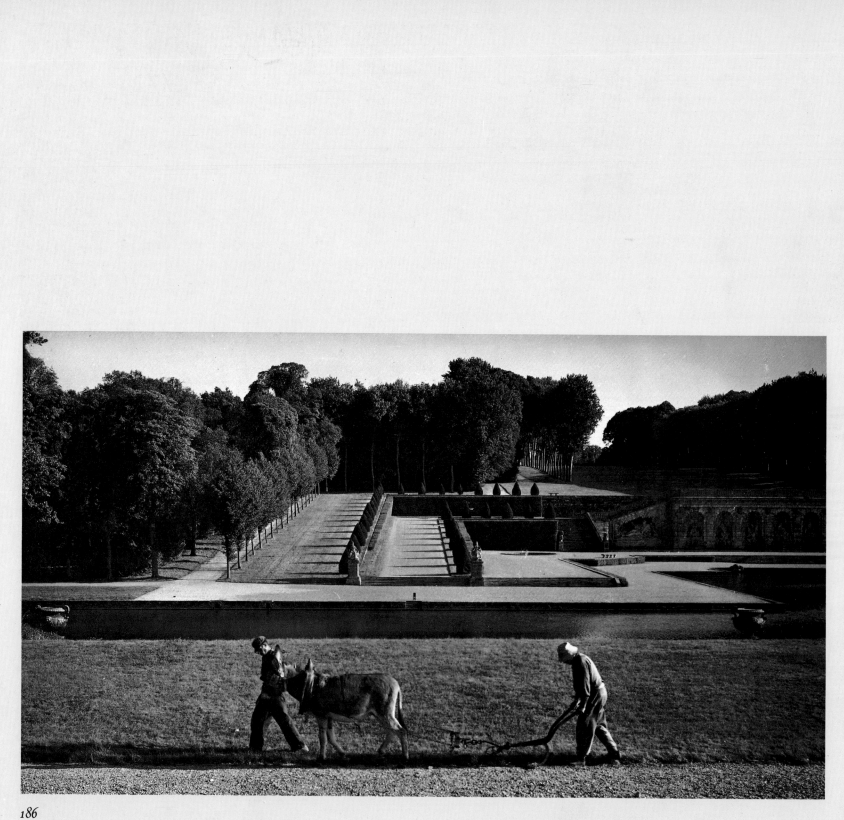

186
Vaux-le-Vicomte, France;
26 August 1959

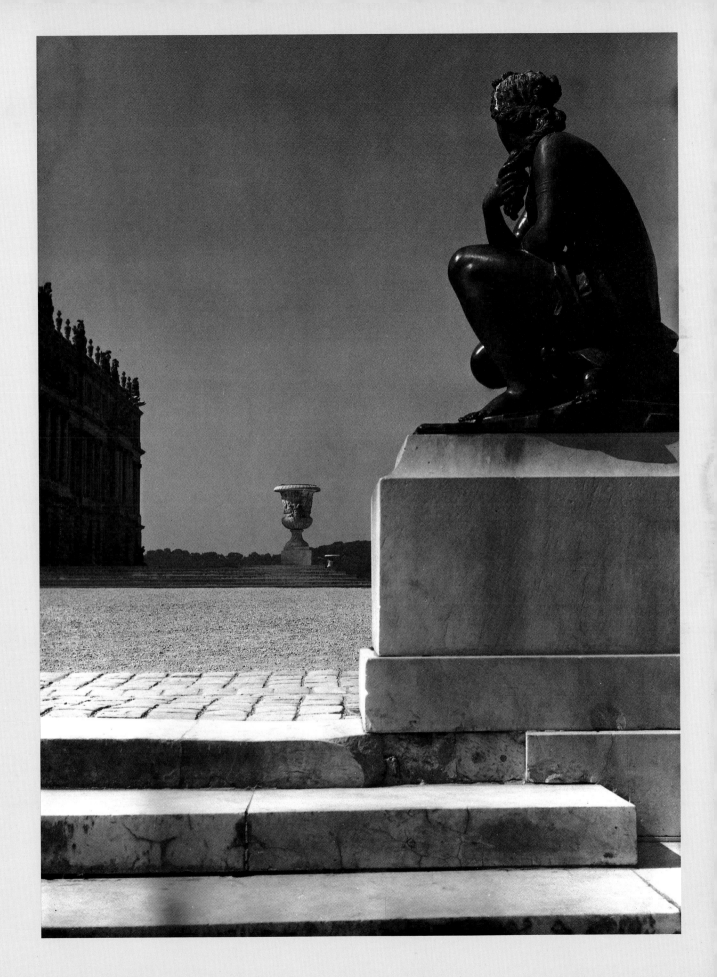

187
Versailles, France;
July 1962

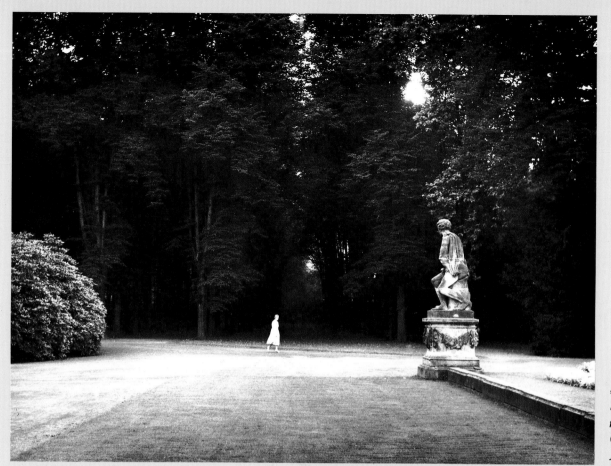

188
Schloss Benrath,
near Düsseldorf,
Germany ;
August 1960

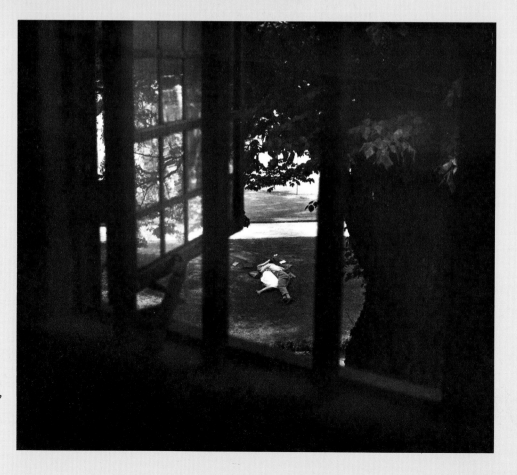

189
From a window of the Library,
Trinity College,
Cambridge ;
12 May 1959

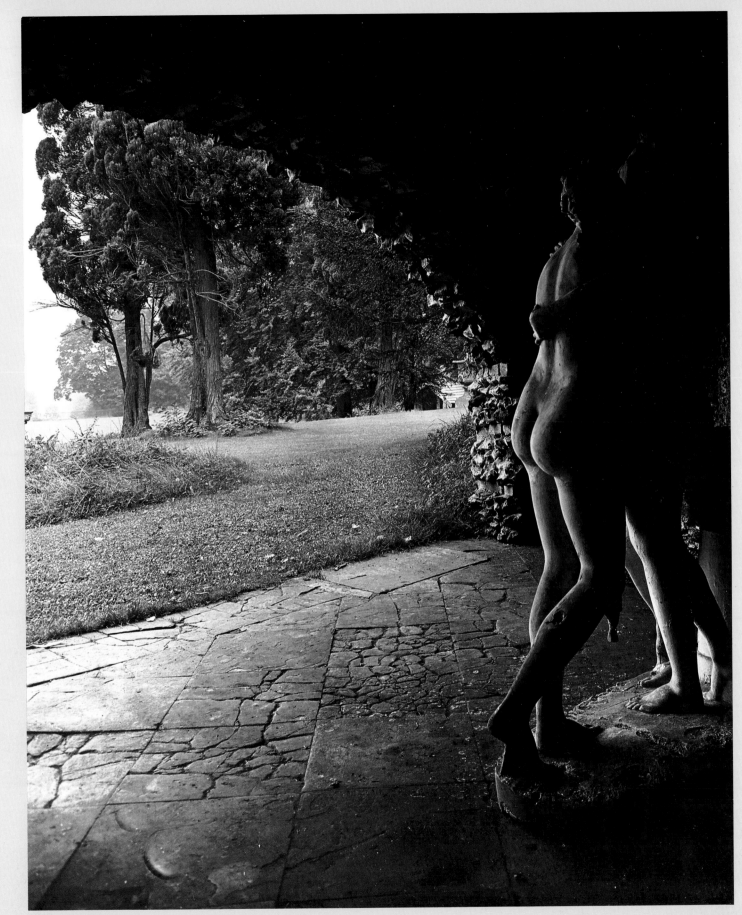

190
The Grotto,
Clandon Park,
Surrey;
5 September
1958

CLASSICAL

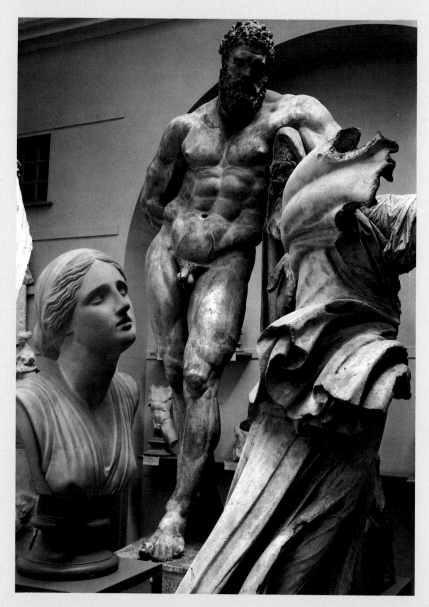

191
Casts in the Archaeological Museum,
Cambridge;
June 1964

192
The Stabian Baths,
Pompeii, Italy;
2 November 1959

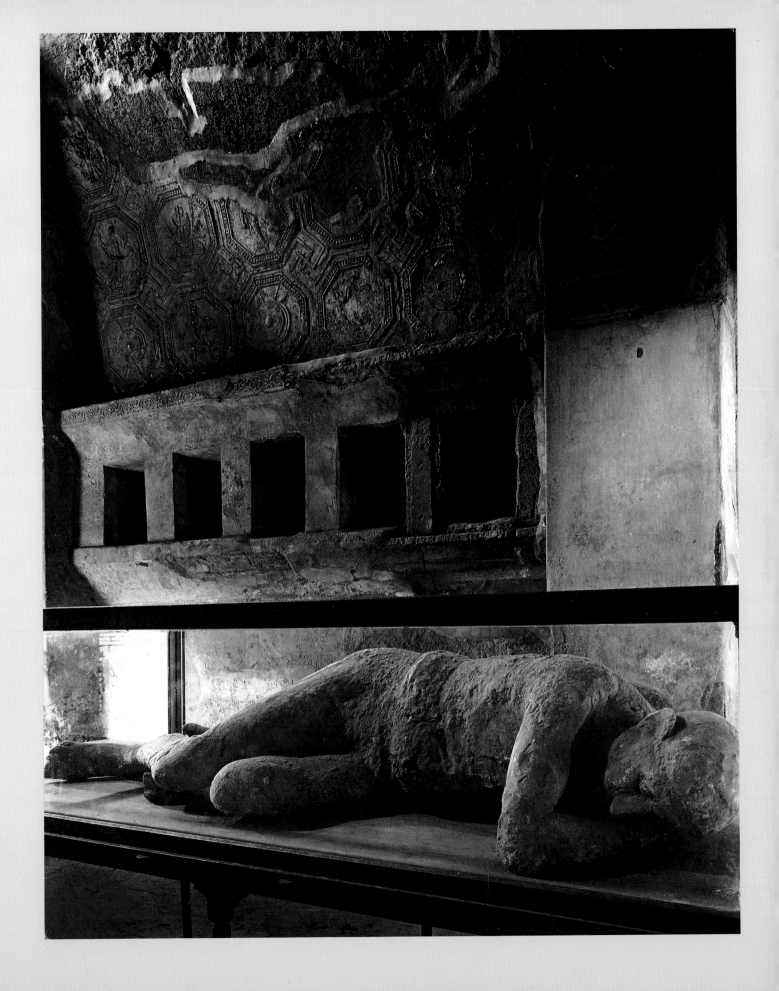

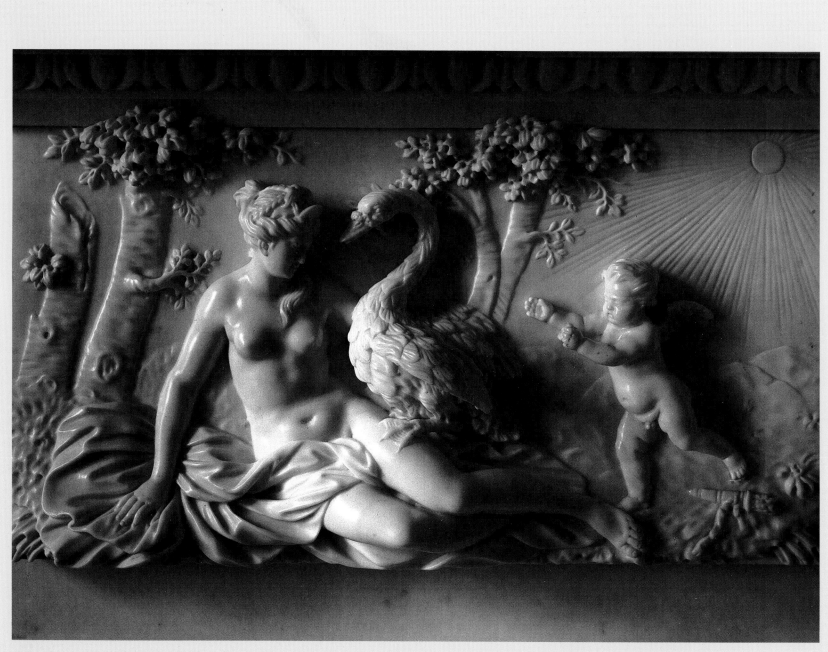

193
Detail of the Music Room fireplace,
Russborough, Co. Wicklow,
Ireland;
19 October 1960

194
Detail of a stele,
National Museum, Athens;
30 March 1962

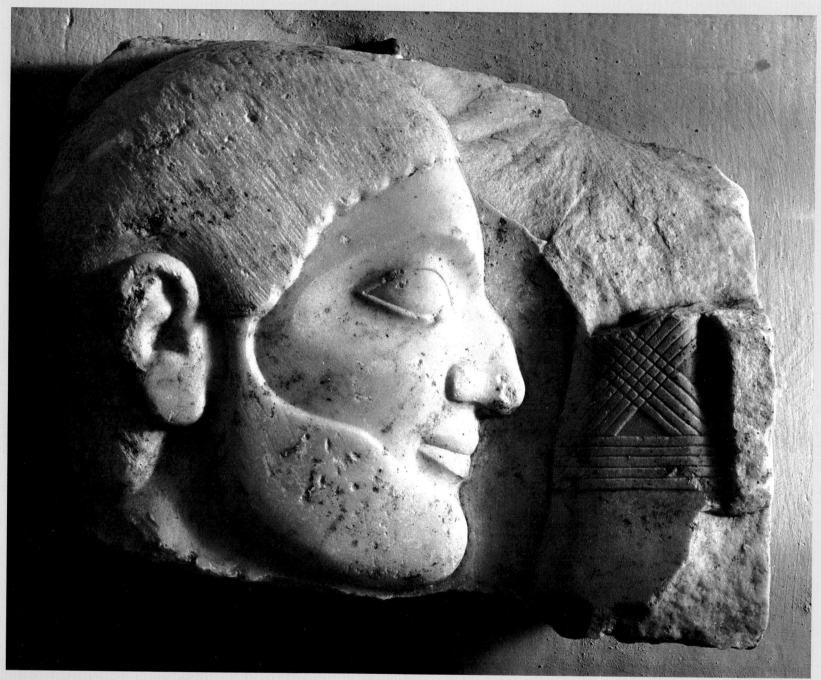

195
Head of a boxer,
Kerameikos Museum, Athens;
10 March 1962

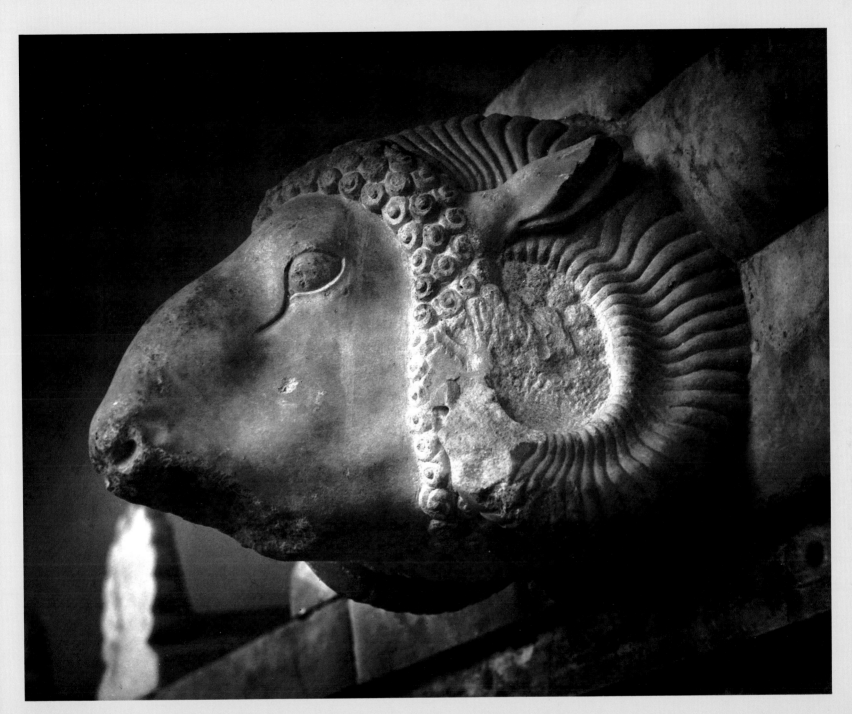

196
Head of a ram from a pediment,
Eleusis Museum, Greece;
26 March 1962

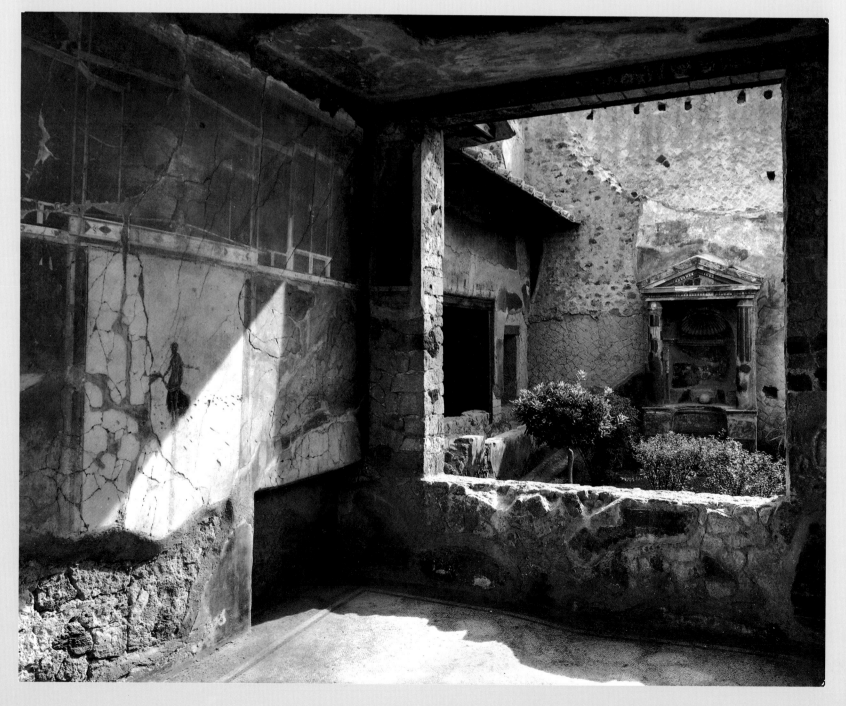

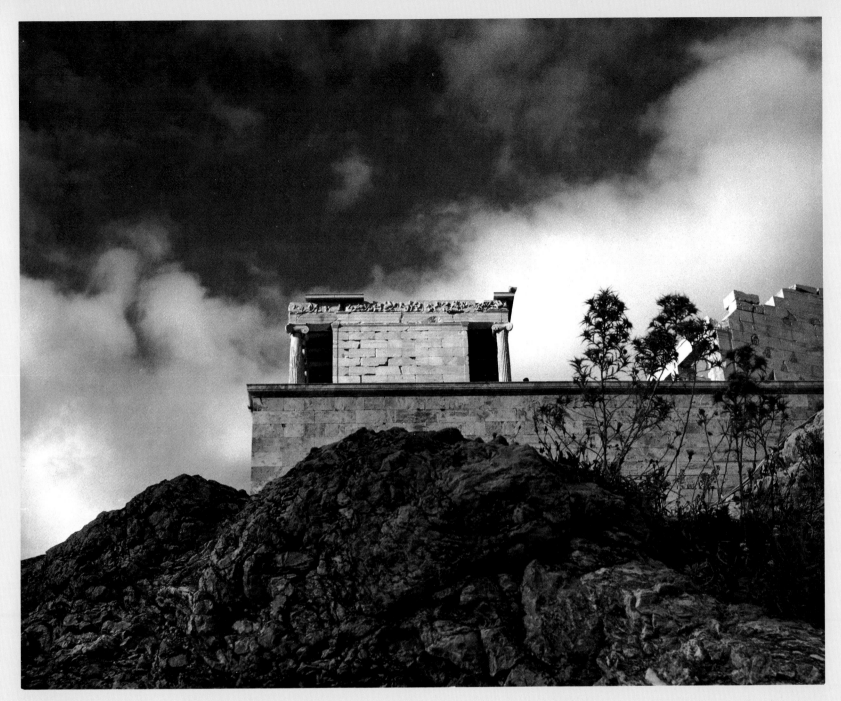

198
Temple of Nike, Athens;
March 1962

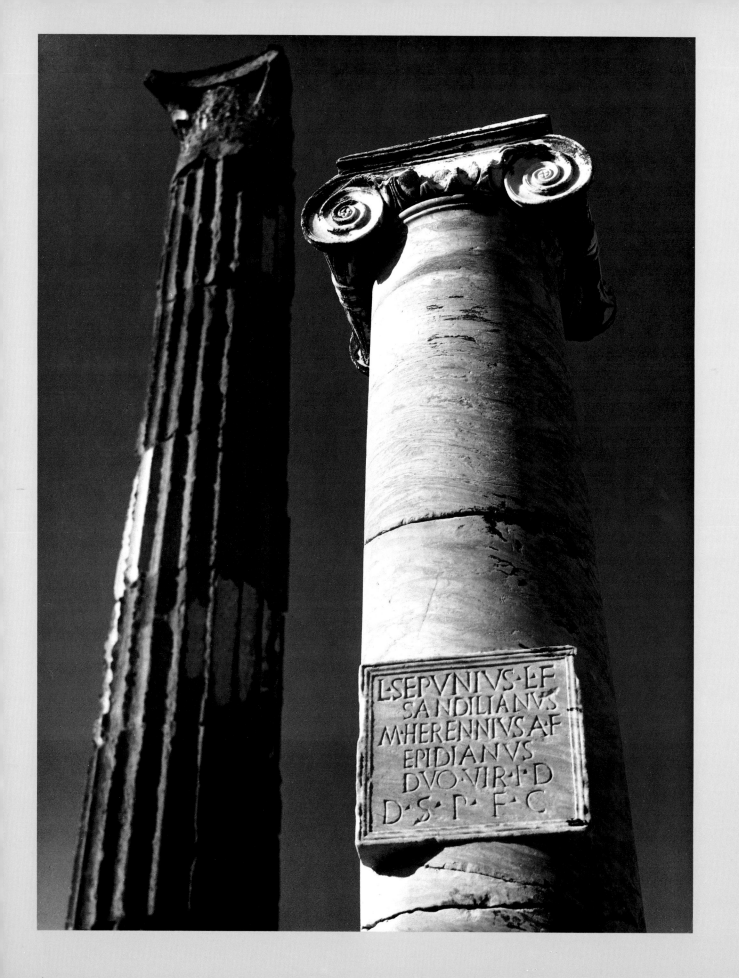

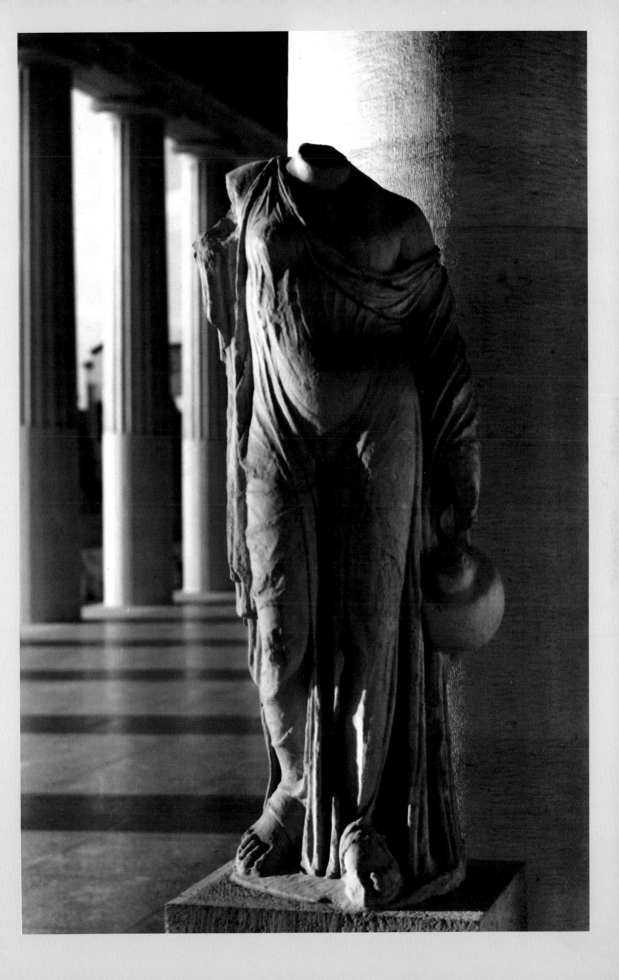

199
Columns of the Temple
of Apollo, Pompeii,
Italy;
26 October 1959

200
Agora Museum,
Athens;
March 1962

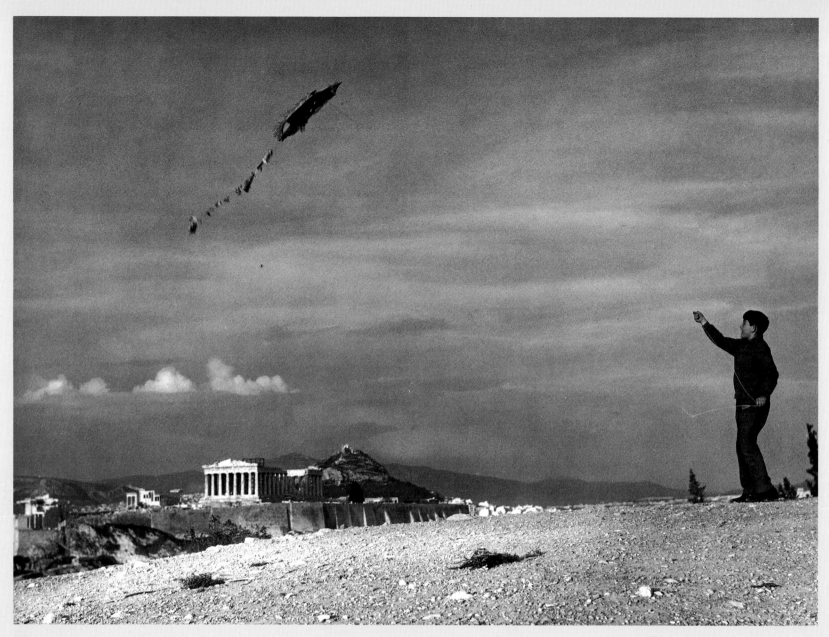

201
Athens;
March 1962

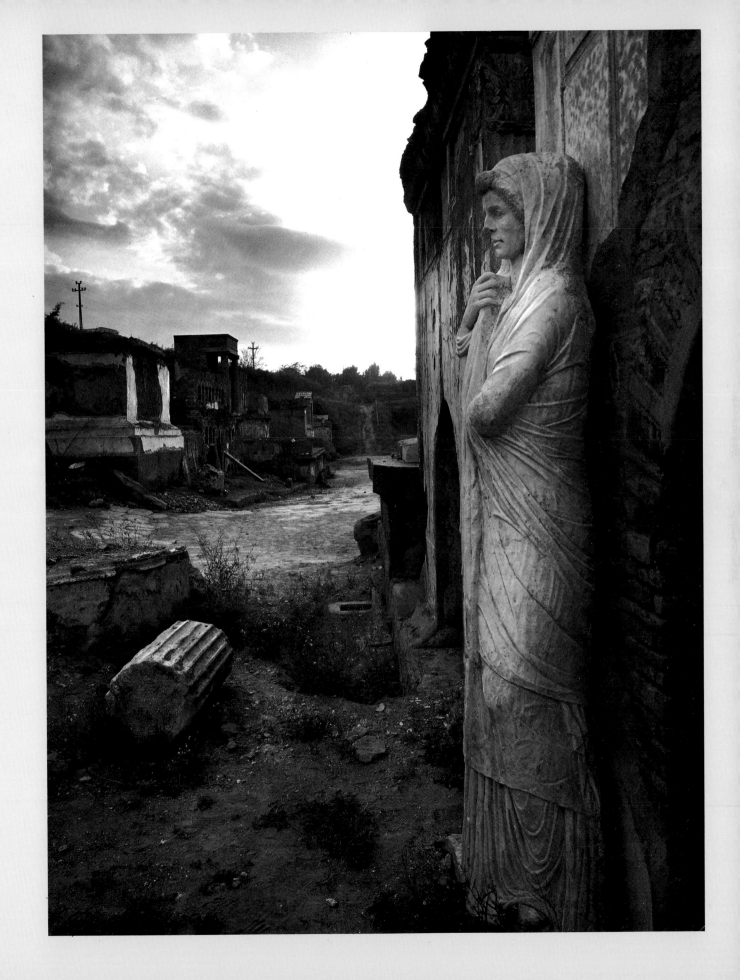

202
The Necropolis,
Pompeii, Italy;
sunset,
21 October 1959

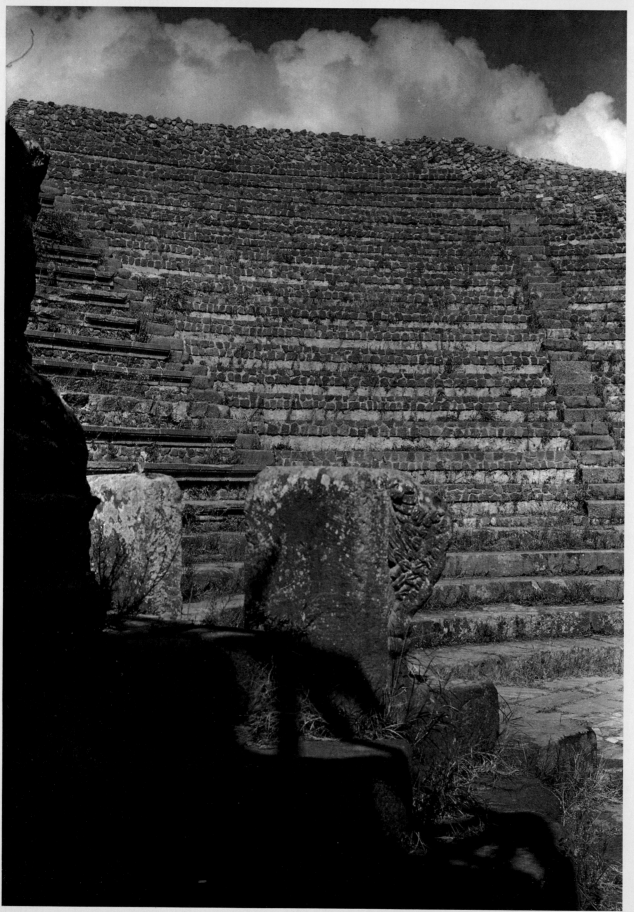

203
The large theatre,
Pompeii, Italy;
9 October 1959

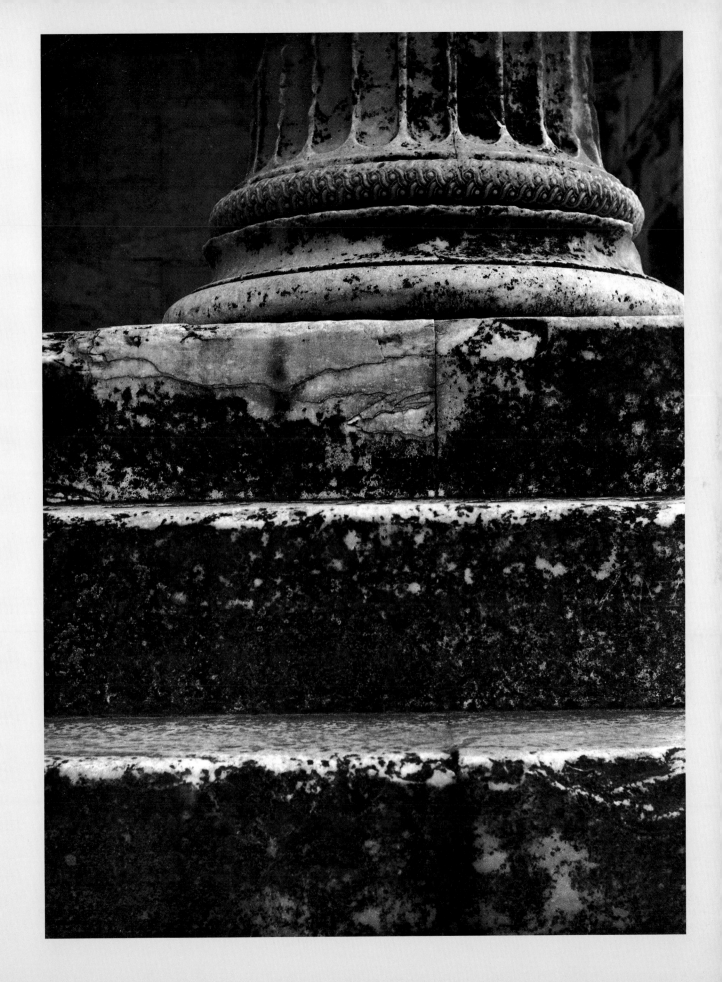

204
*Base of a column of
the Erechtheion,
Athens;
March 1962*

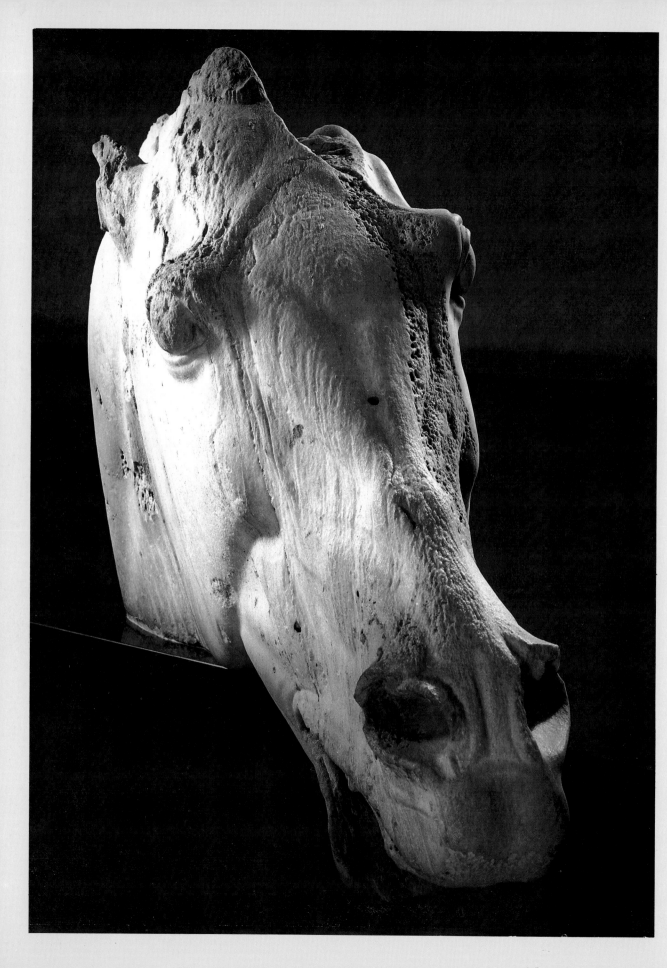

205
Head of a horse
from the east pediment of
the Parthenon, Athens,
now in the British Museum,
London;
25 February 1955

206
Detail of a stele,
Kerameikos Museum,
Athens;
6 March 1962

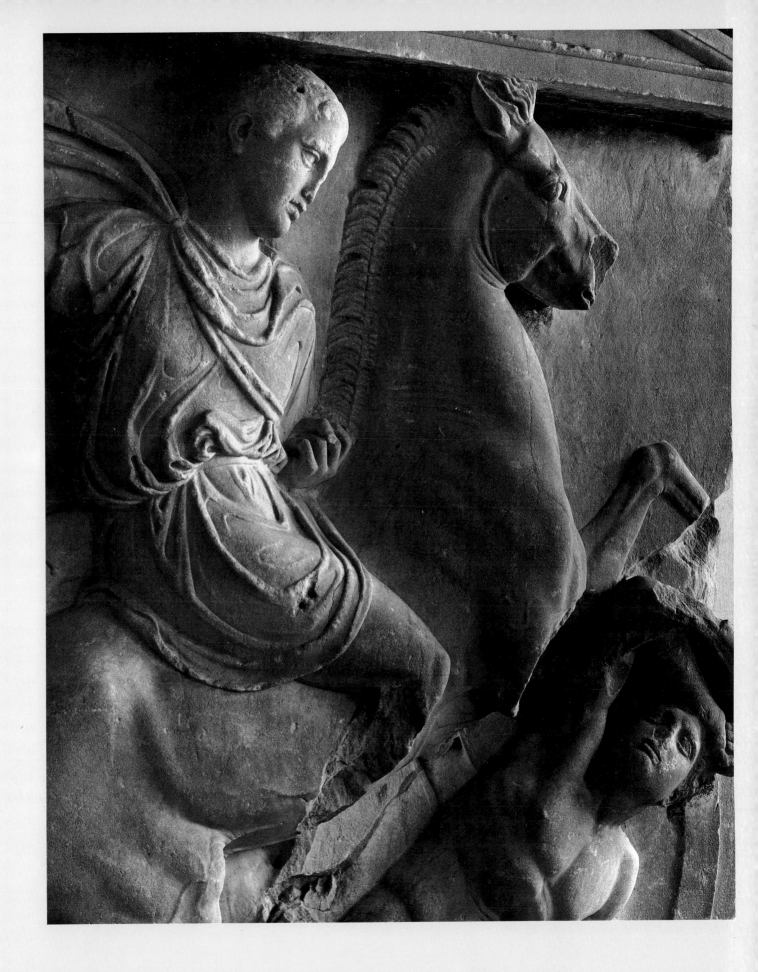

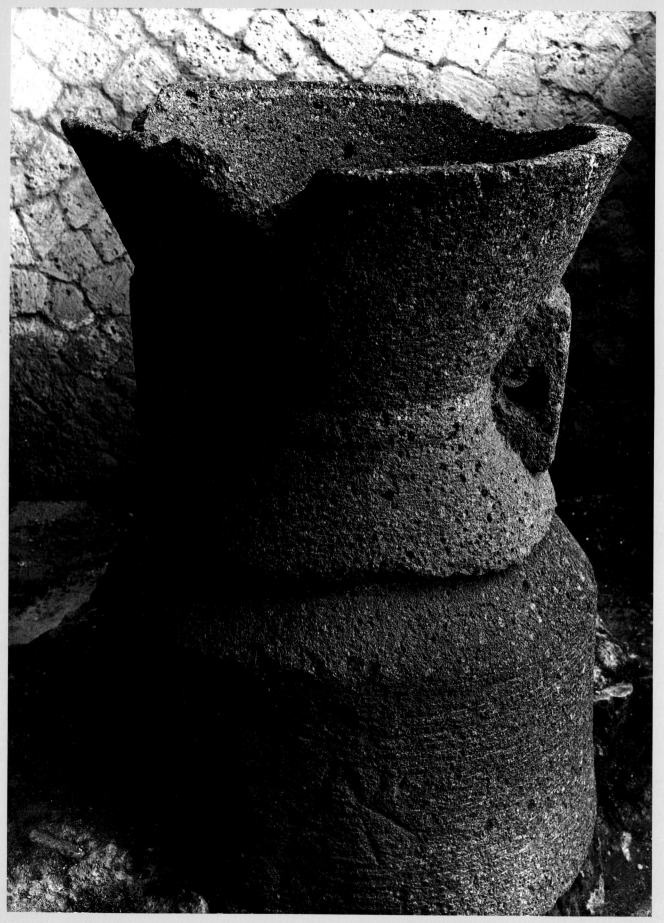

207
Baker's quern,
Pompeii, Italy;
23 October 1959

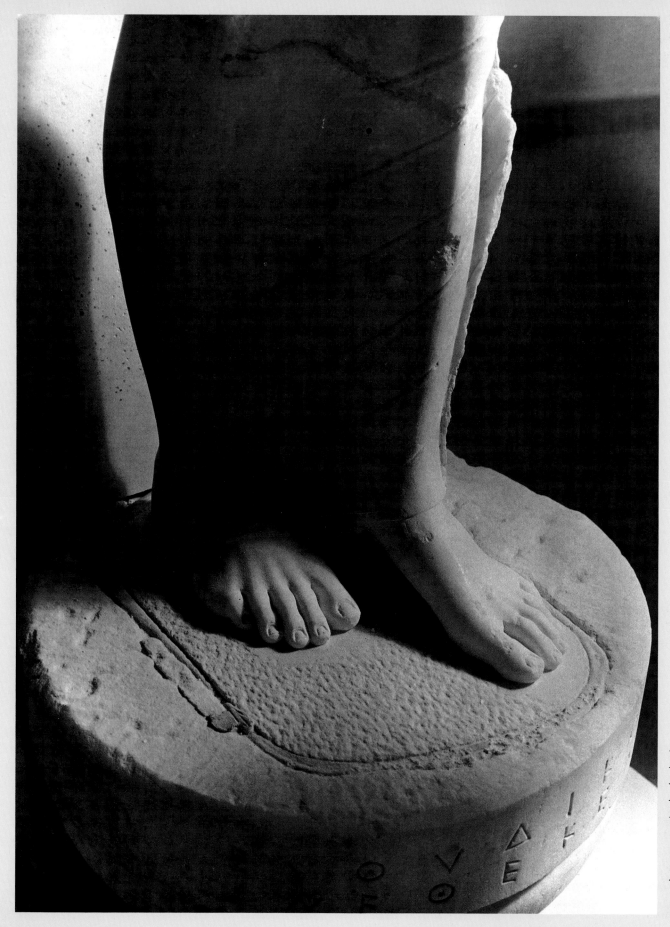

209
Feet of Apollo,
Acropolis Museum,
Athens;
10 March 1962

210
Colossal head of
Juno from Pompeii,
now in Naples Museum;
10 March 1959

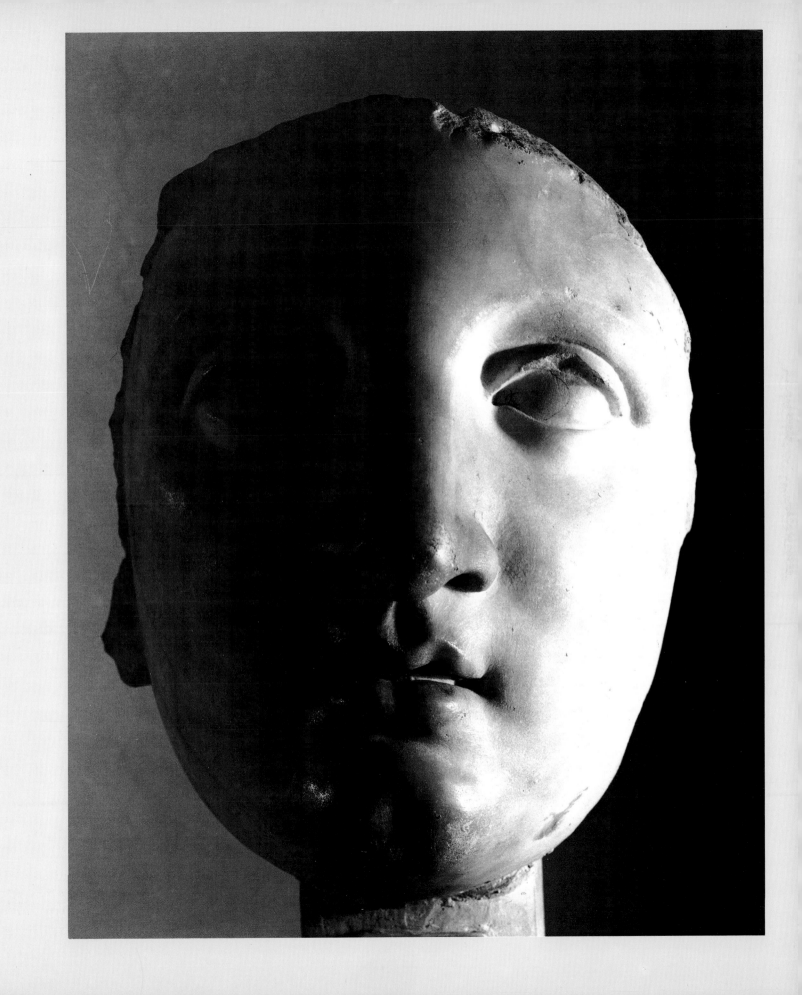

ECCLESIASTICAL

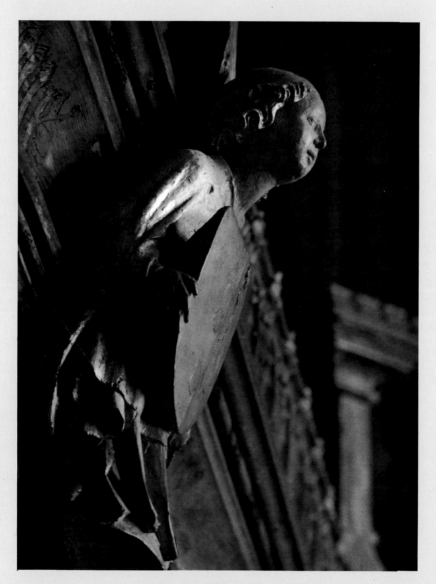

211
Detail from the tomb of Henry IV,
Canterbury Cathedral;
May 1971

212
The nave seen from the choir,
Hereford Cathedral;
10 October 1969

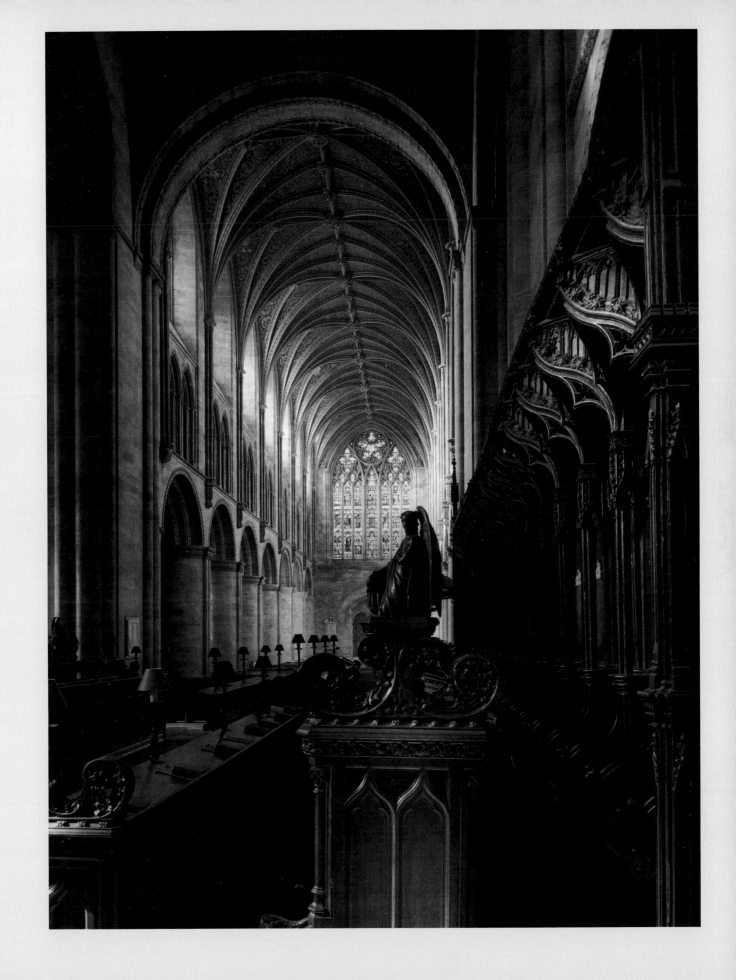

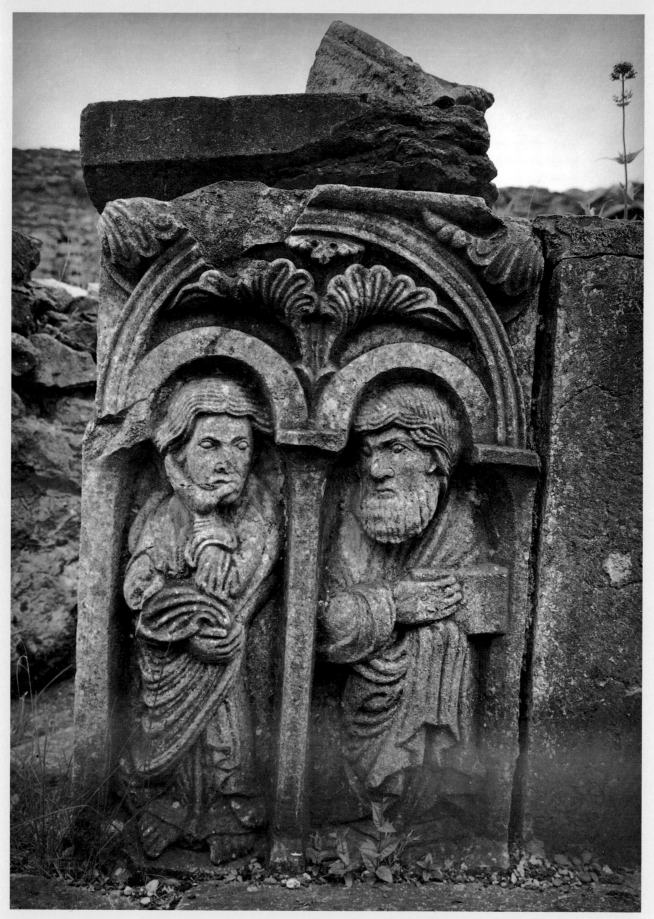

213
*Panel of the monks'
lavatorium,
Much Wenlock Priory,
Shropshire;
2 June 1959*

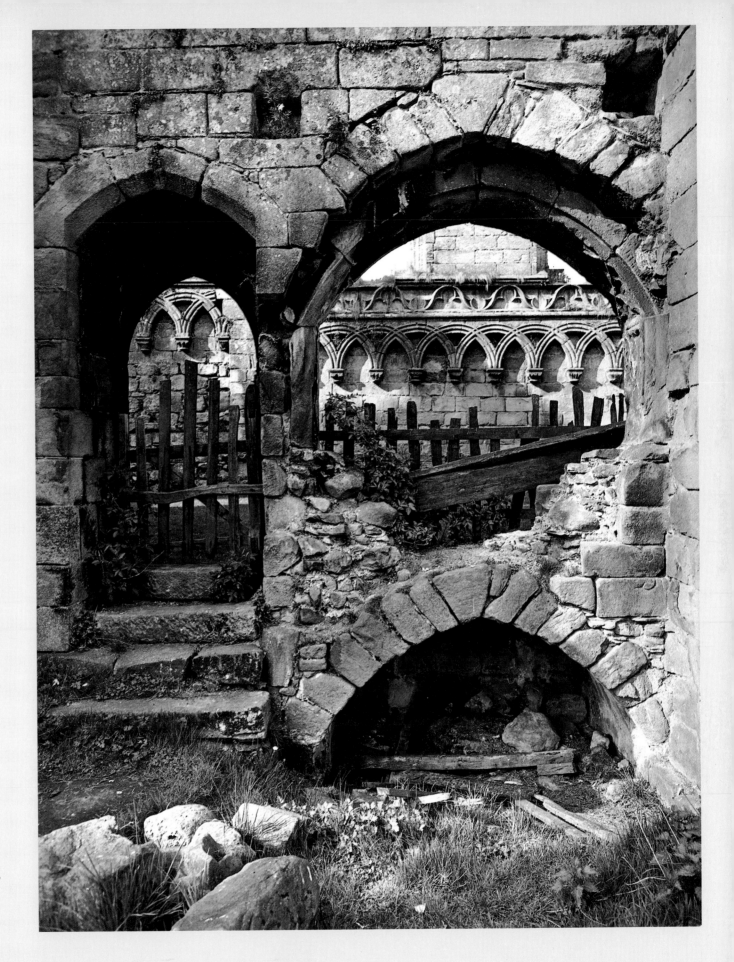

214
View into the chancel,
Bolton Abbey,
Yorkshire;
6 May 1959

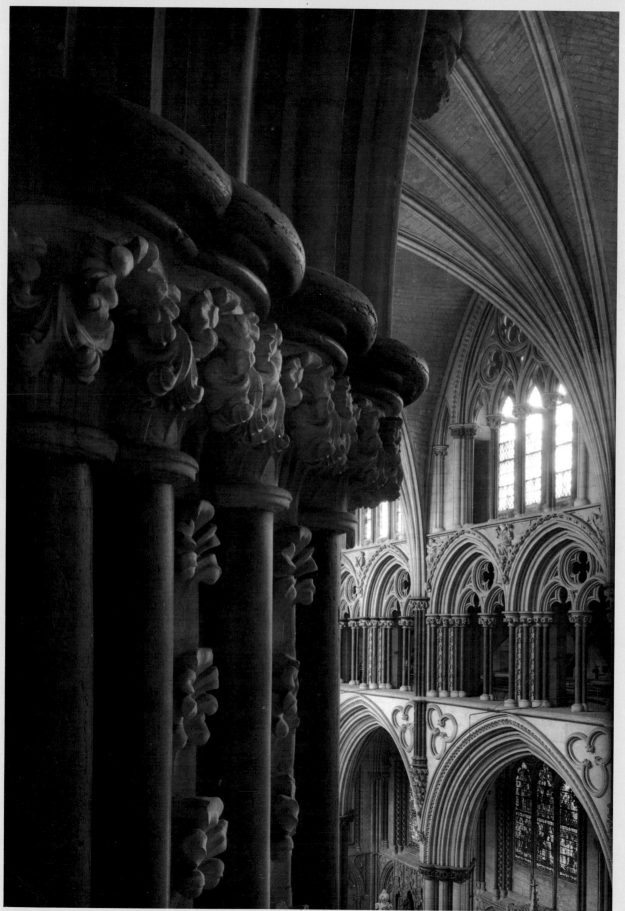

215
*The Angel Choir from
triforium level,
Lincoln Cathedral;
15 June 1960*

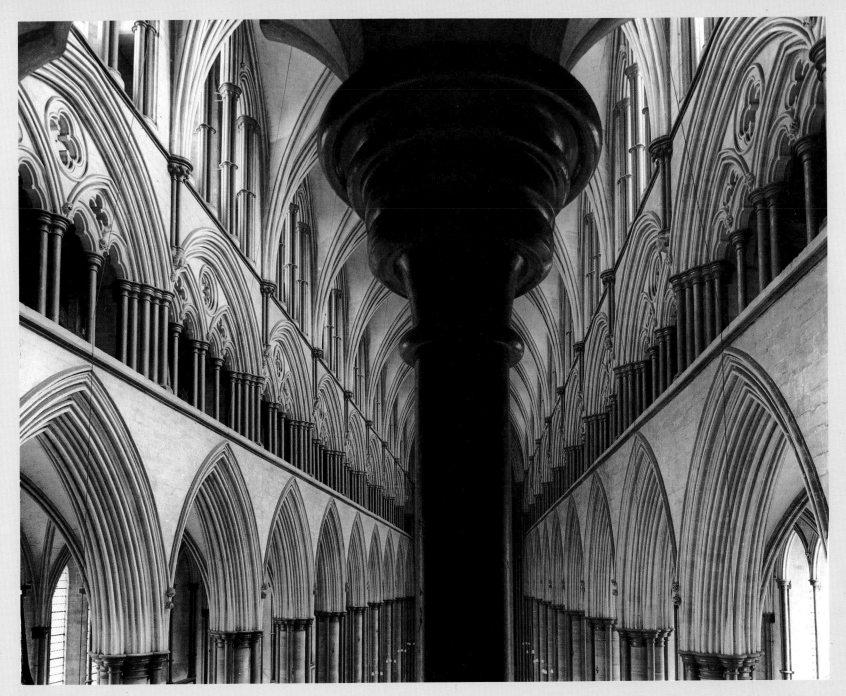

216
*The nave from west to east,
Salisbury Cathedral;
20 August 1959*

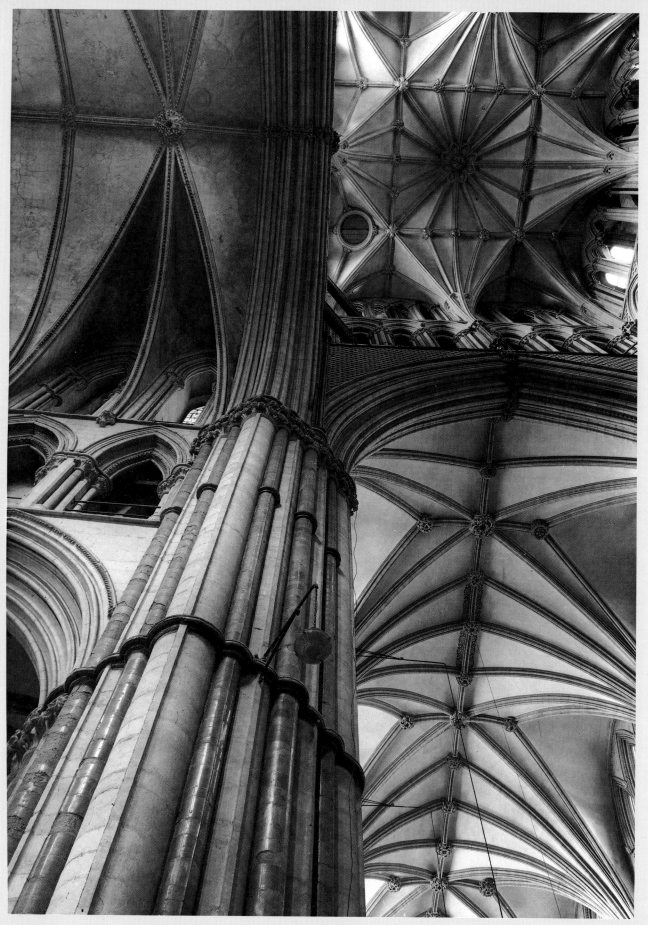

217
*Crossing,
south transept
and nave,
Lincoln Cathedral;
14 June 1960*

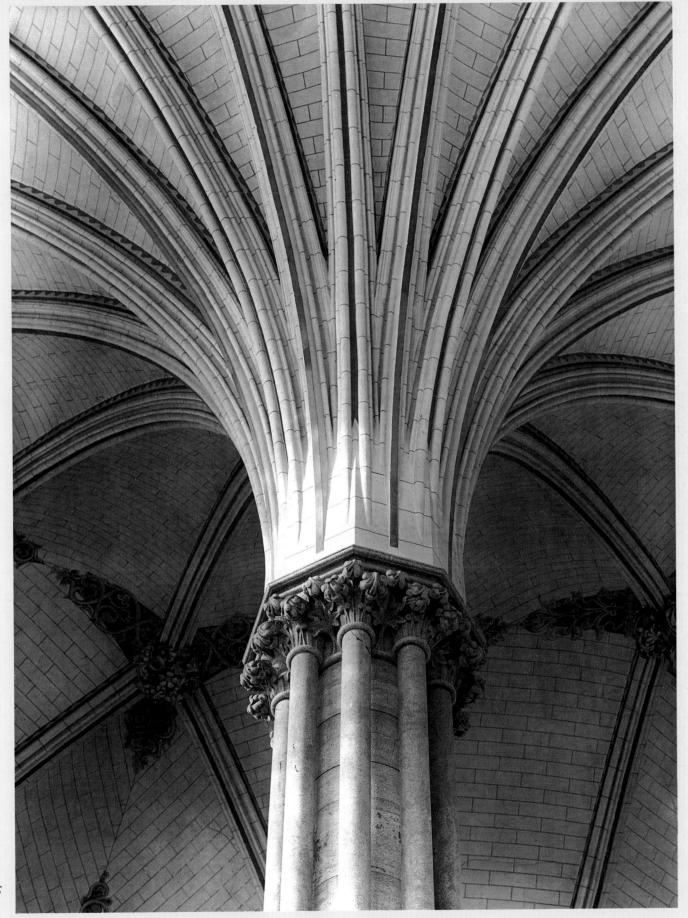

218
Chapter House,
Salisbury Cathedral;
9 March 1959

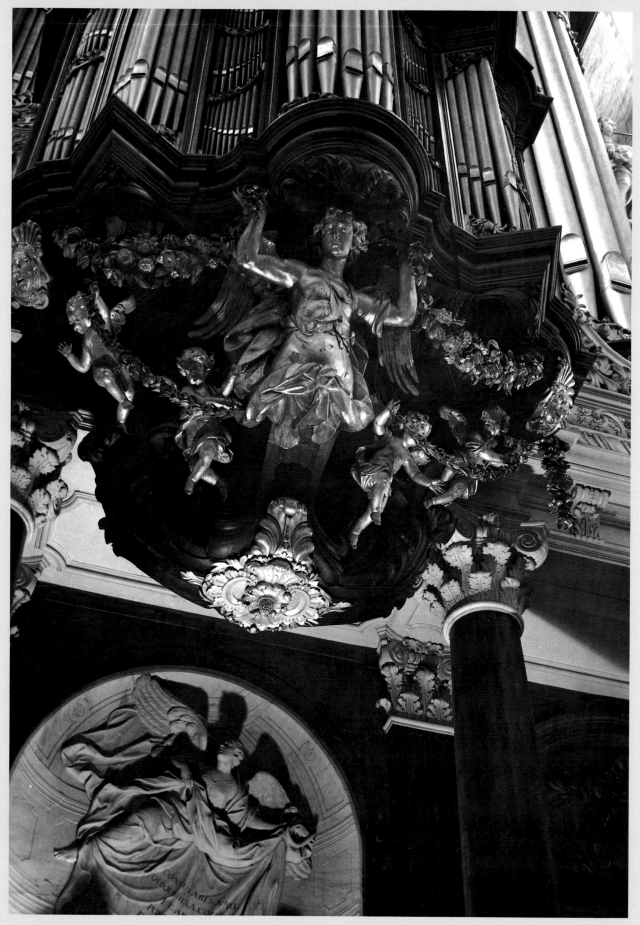

219
The organ,
Grosse Kerke,
Haarlem, Holland;
14 September 1958

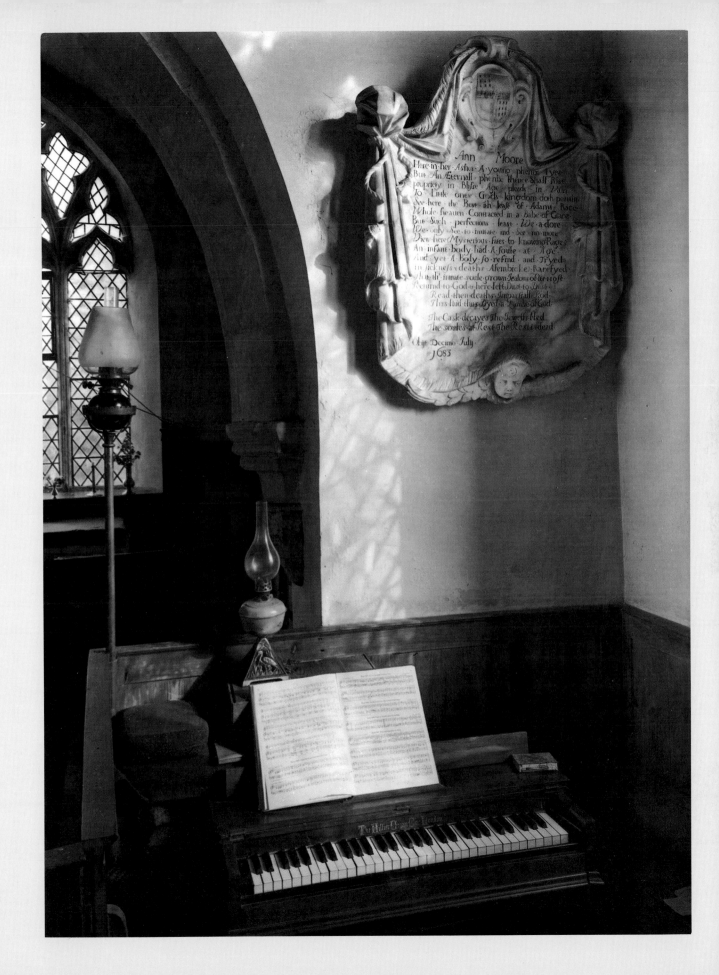

220
Plumpton parish church,
Northamptonshire;
28 October 1956

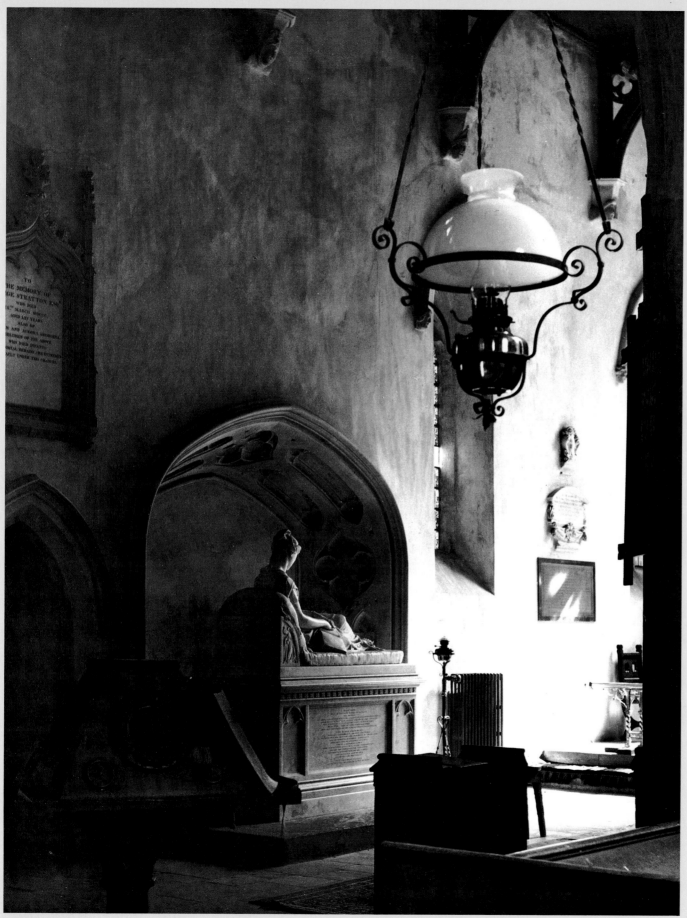

221
Monument to
Mary Anne Boulton
in Great Tew
parish church,
Oxfordshire;
11 May 1961

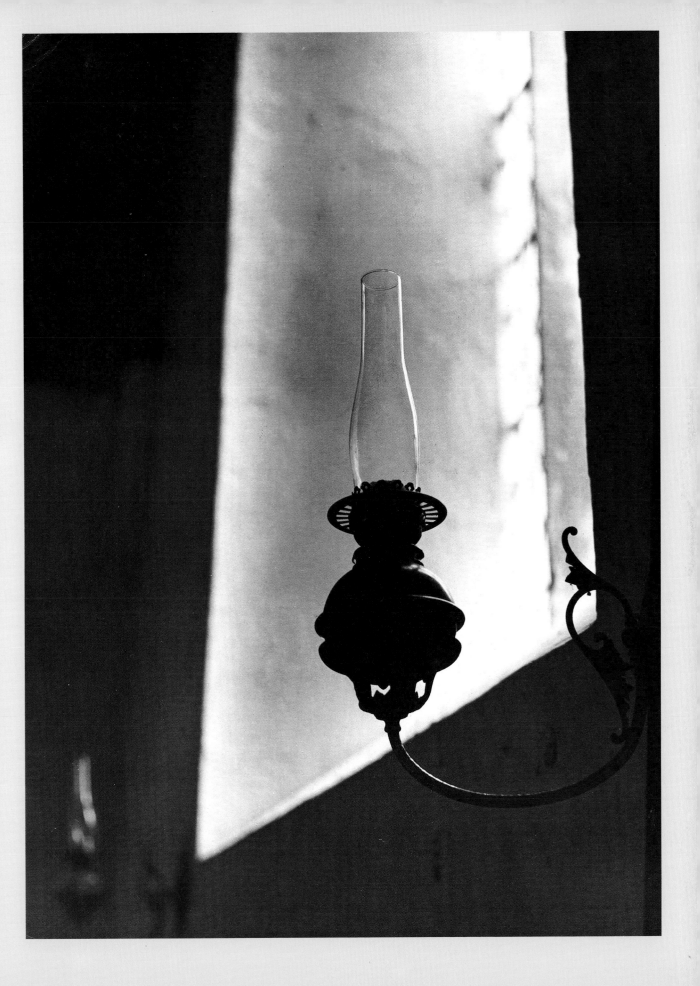

222
Church lamp,
Tintern,
Monmouthshire,
Wales;
22 June 1959

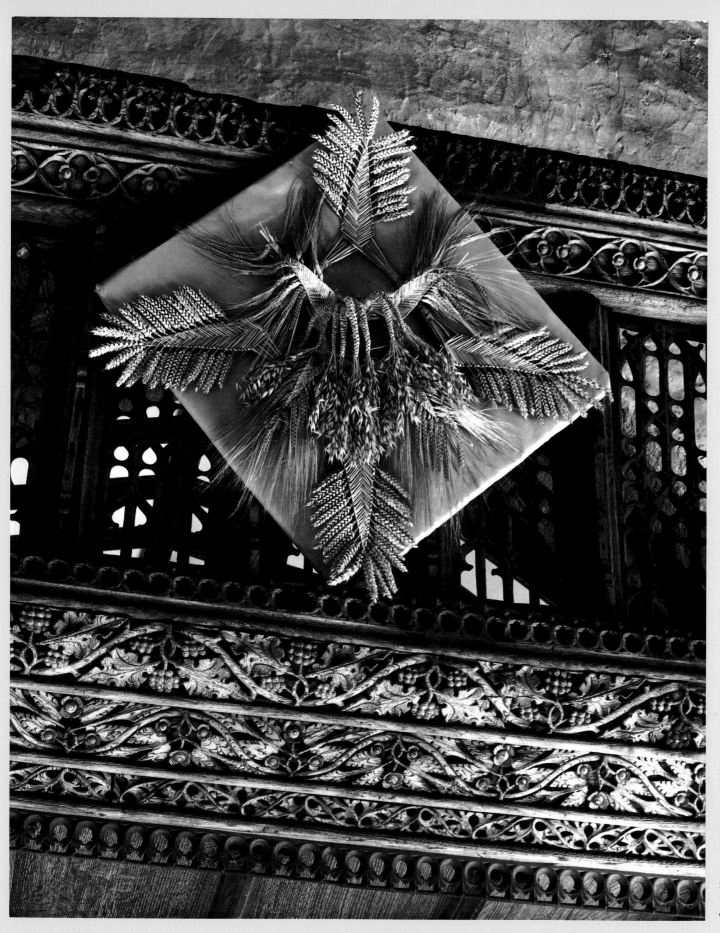

223
Corn dolly,
Patricio parish
church,
Monmouthshire,
Wales;
8 October 1969

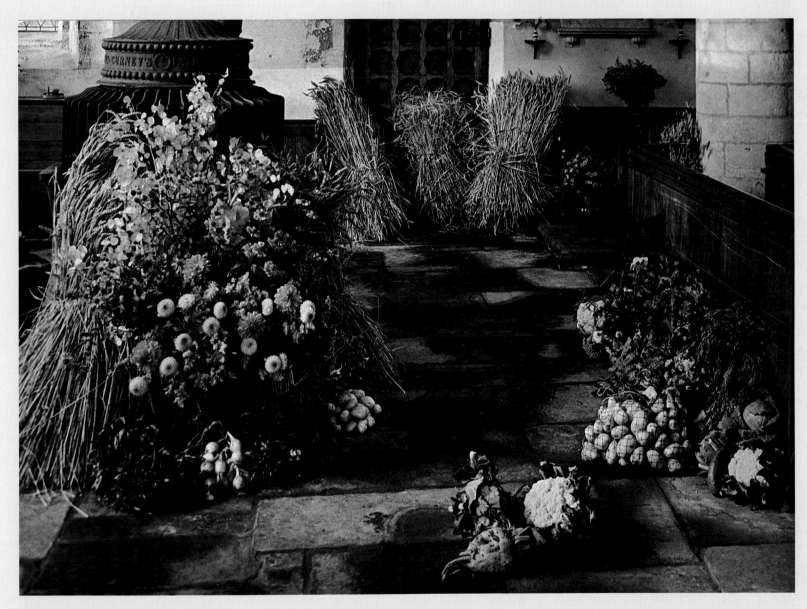

224
Harvest Festival,
Sutterton parish church, Lincolnshire;
28 September 1956

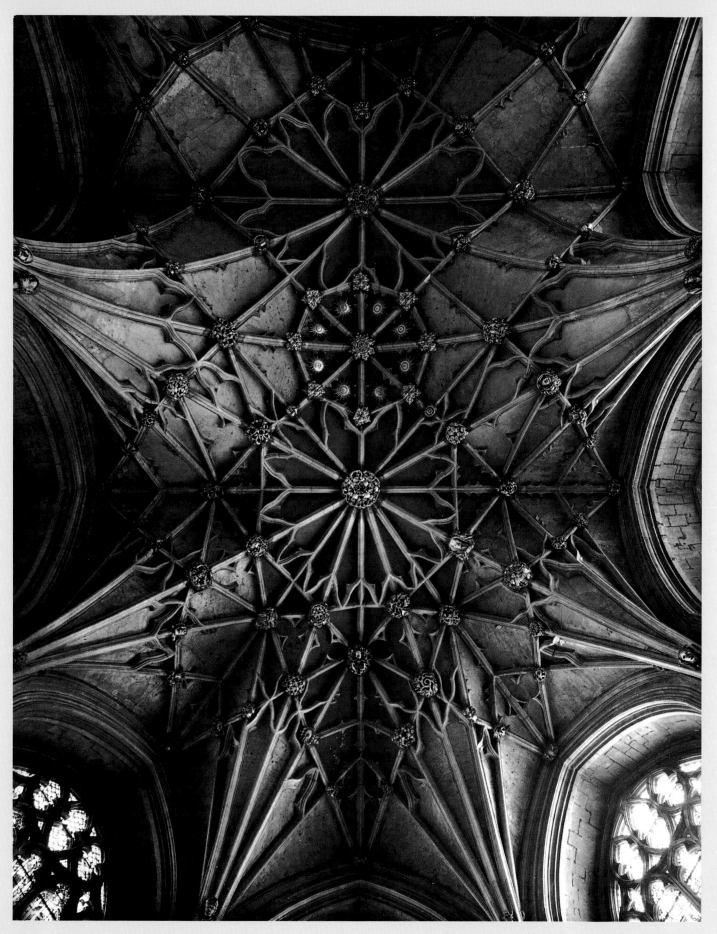

225
Chancel vault,
Tewkesbury Abbey,
Gloucestershire;
27 August
1958

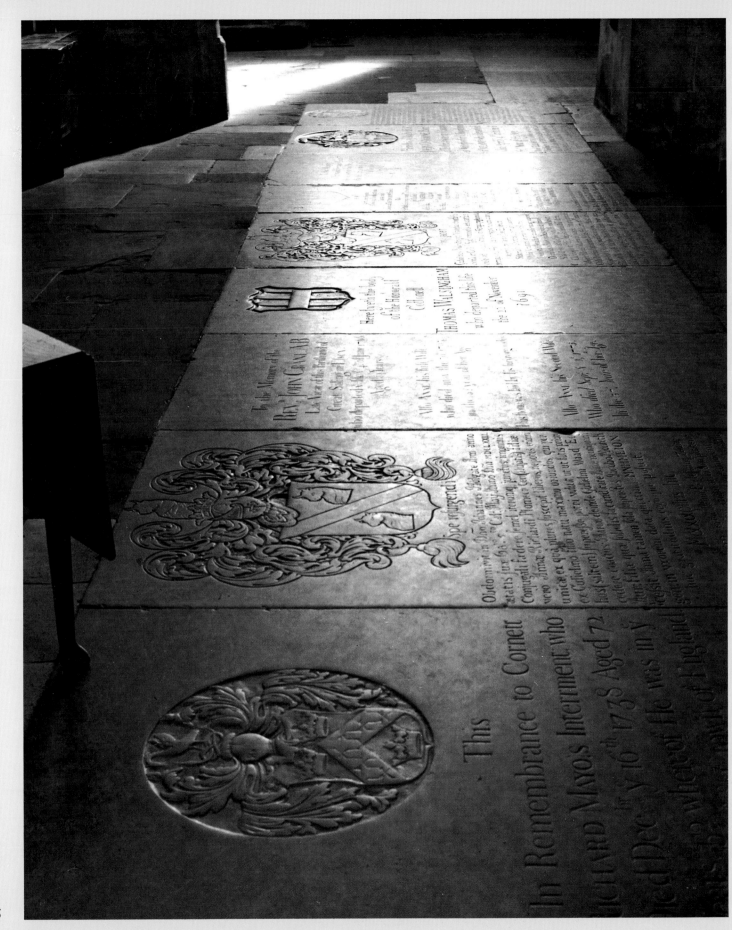

226
Tomb slabs,
Saffron Walden
parish church,
Essex;
22 October 1965

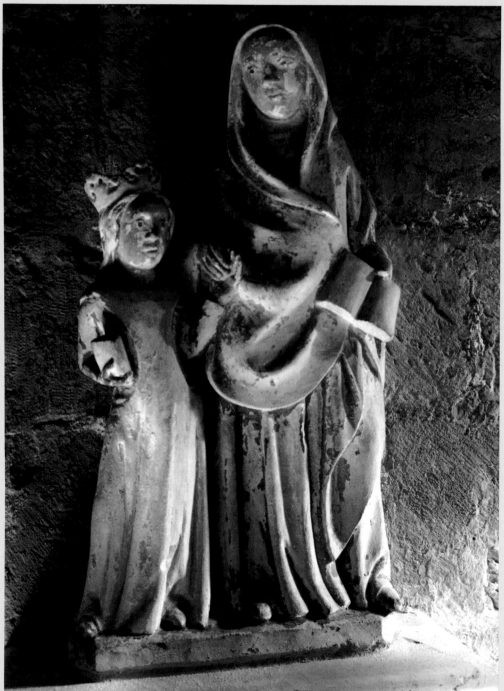

227
St Anne and the Virgin,
York Minster;
7 October 1960

228
Didmarton parish church,
Gloucestershire;
1 July 1961

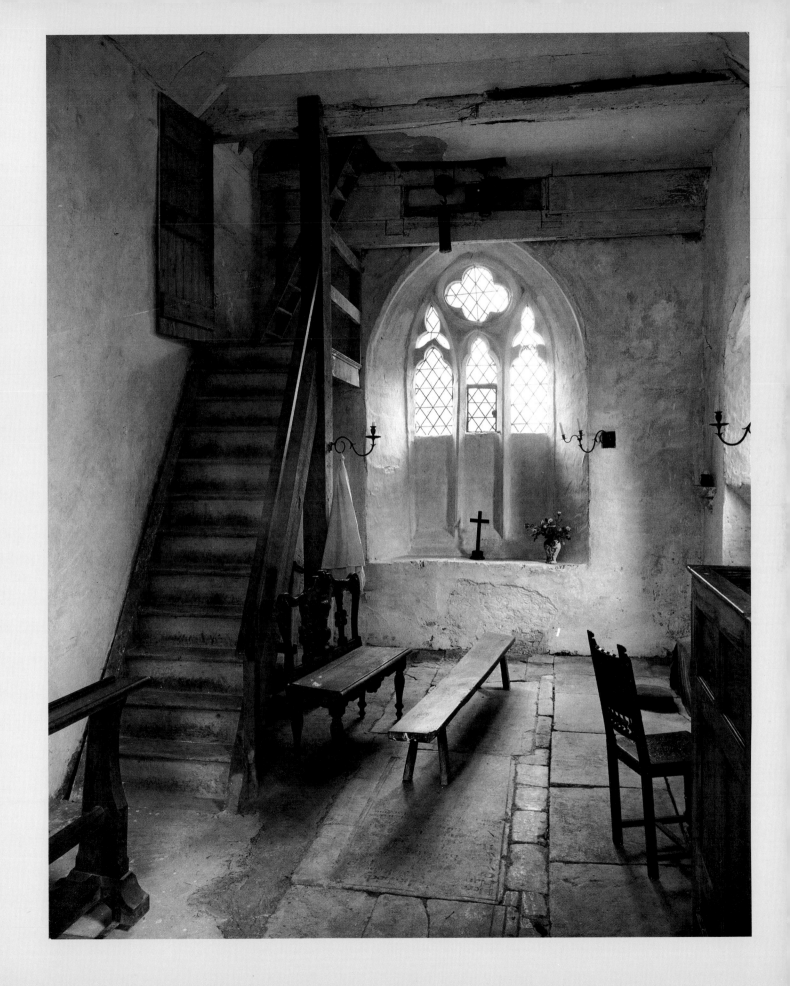

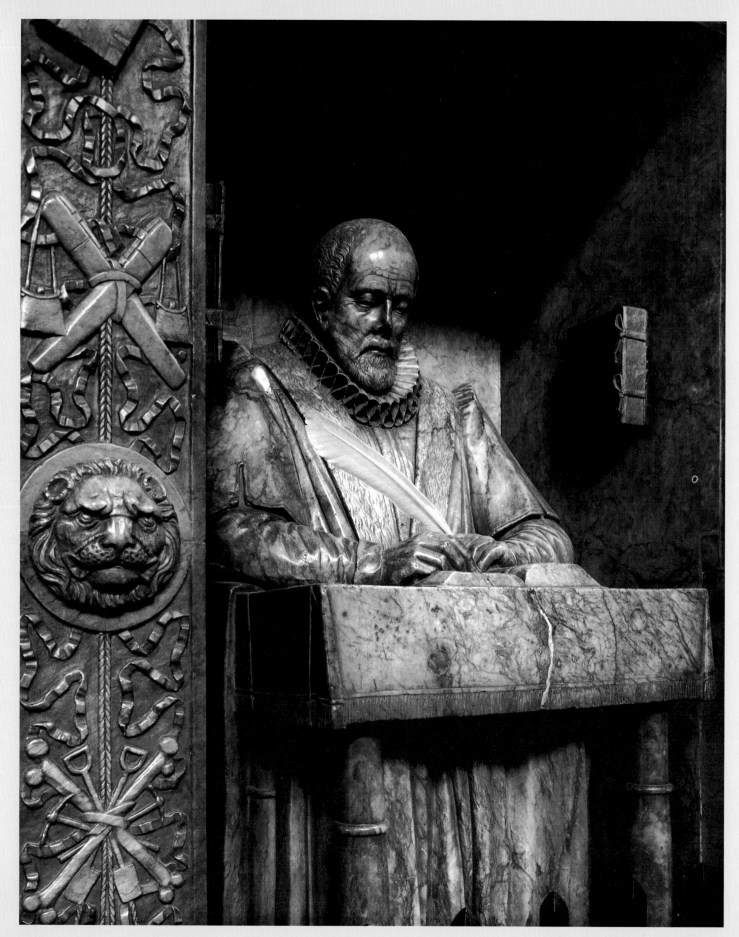

229
Monument to
Sir John Stow
in St Andrew
Undershaft,
London;
30 May 1968

230
*Bronze railings
of the octagon
gallery,
Aachen Cathedral,
Germany;
September 1964*

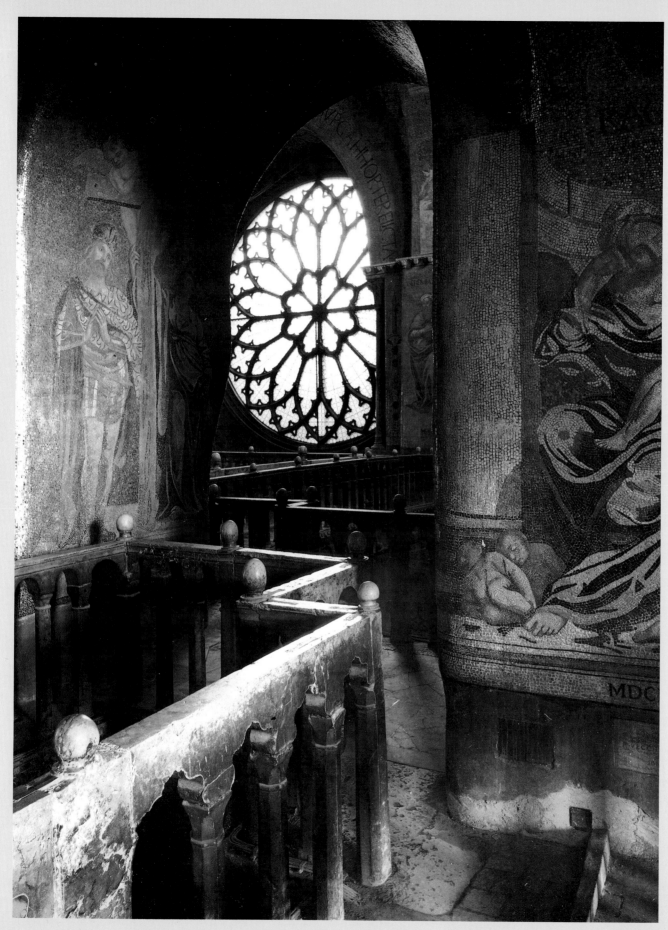

231
*Looking south
from the gallery,
St Mark's,
Venice;
25 September
1961*

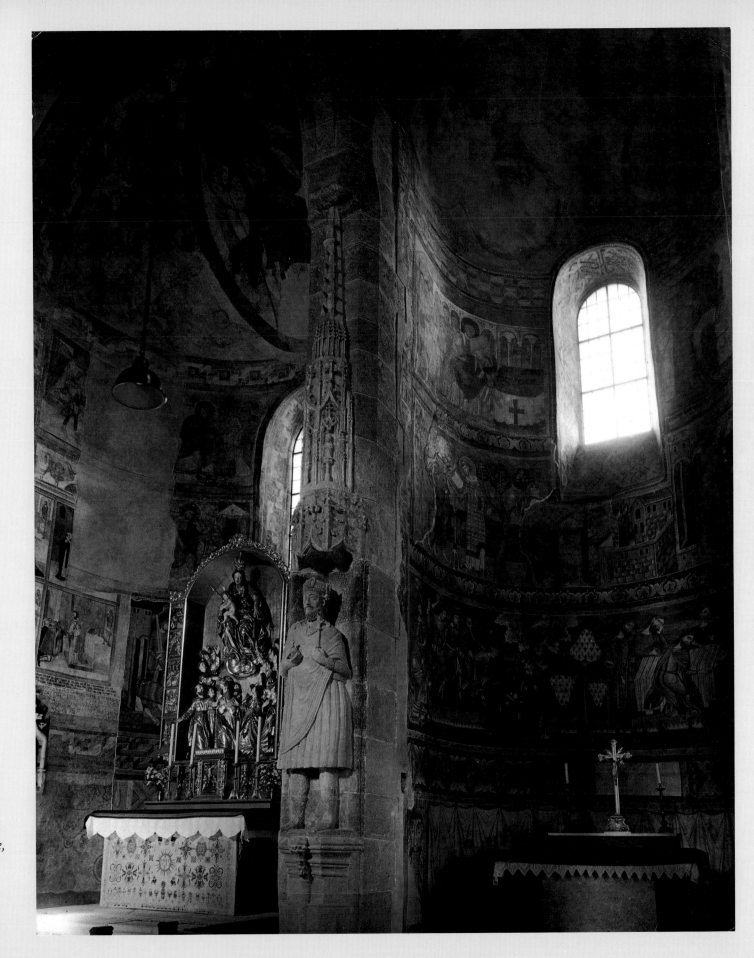

232
East end of
the church of
St Johann,
with the statue
of Charlemagne,
Müstair
in Grisons,
Switzerland;
22 September
1964

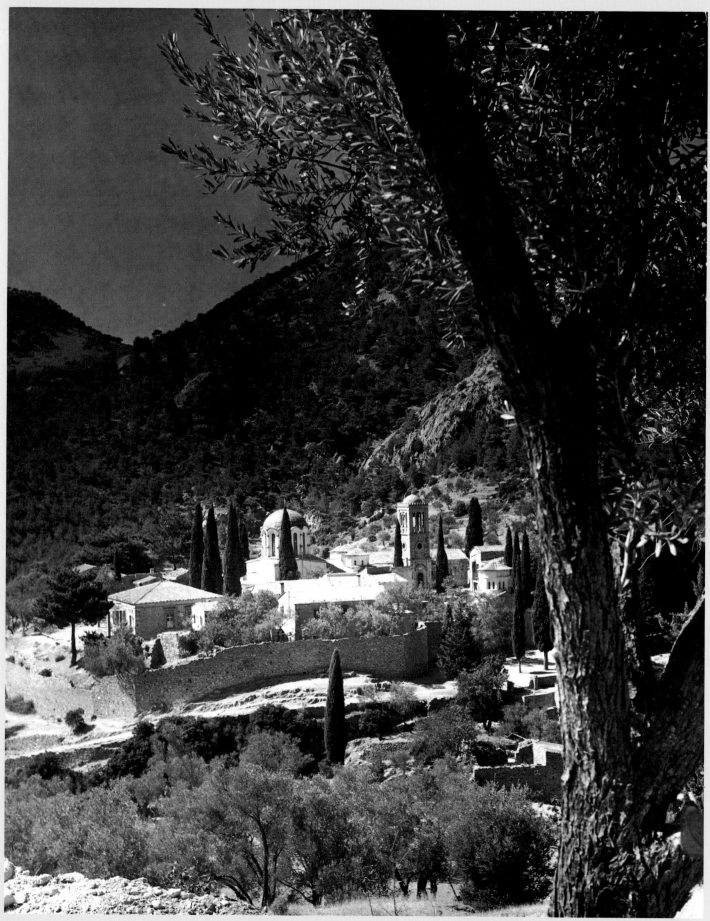

233
*Nea Moni
monastery,
Chios, Greece;
4 September 1969*

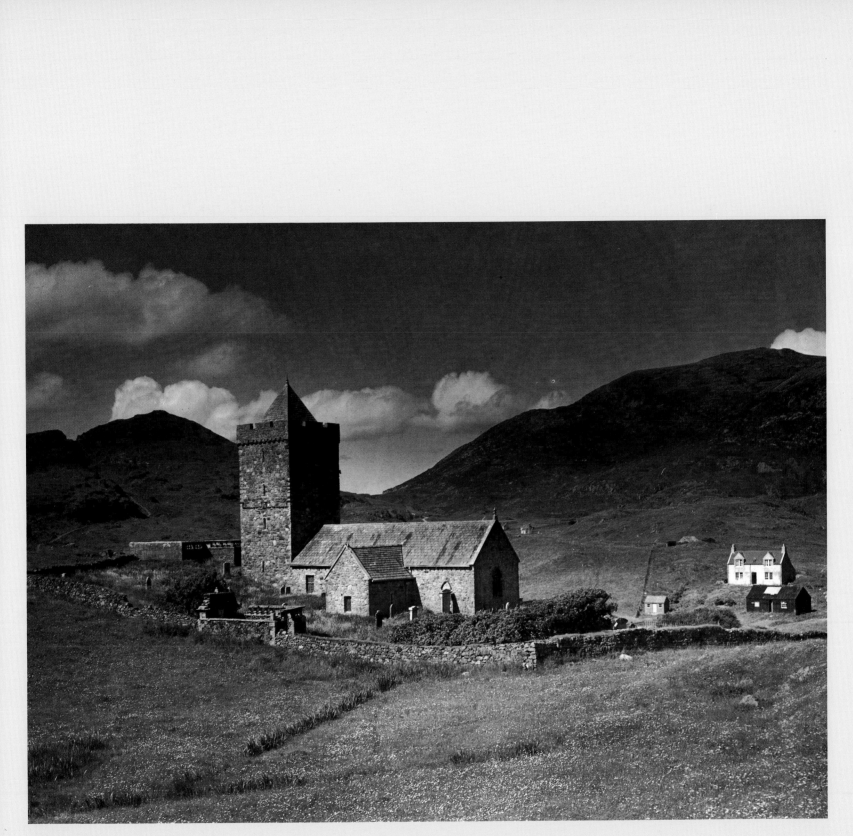

234
St Clement's Church,
Rodil, Harris,
Outer Hebrides;
August 1956

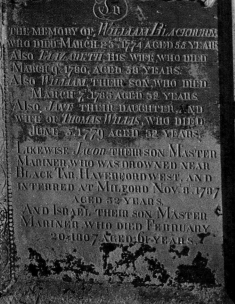

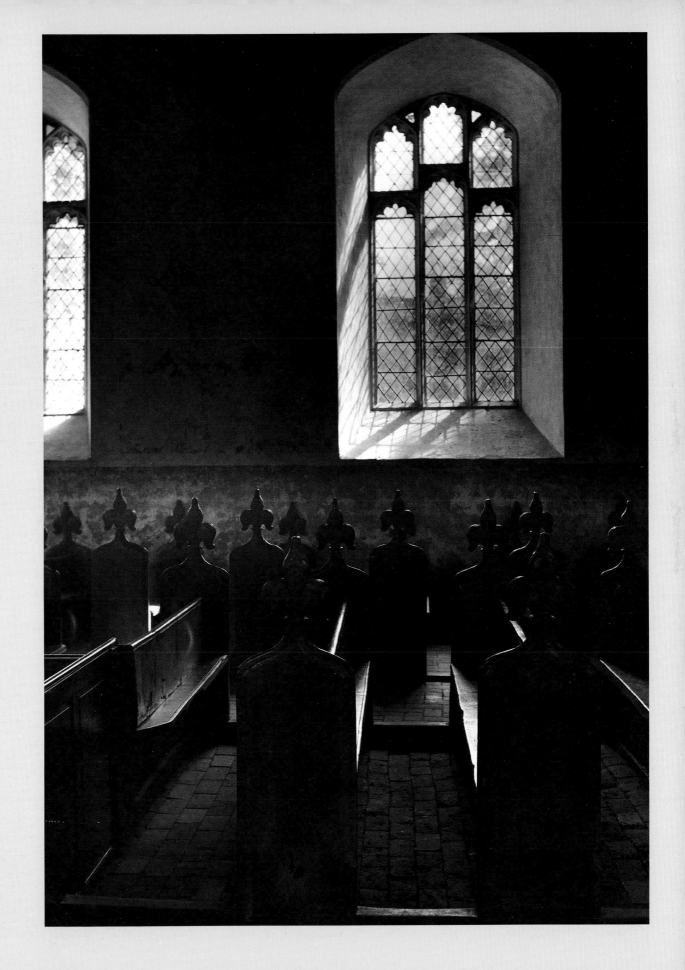

235
Churchyard, Whitby,
East Yorkshire;
14 October 1956

236
Westhall parish church,
Suffolk;
July 1959

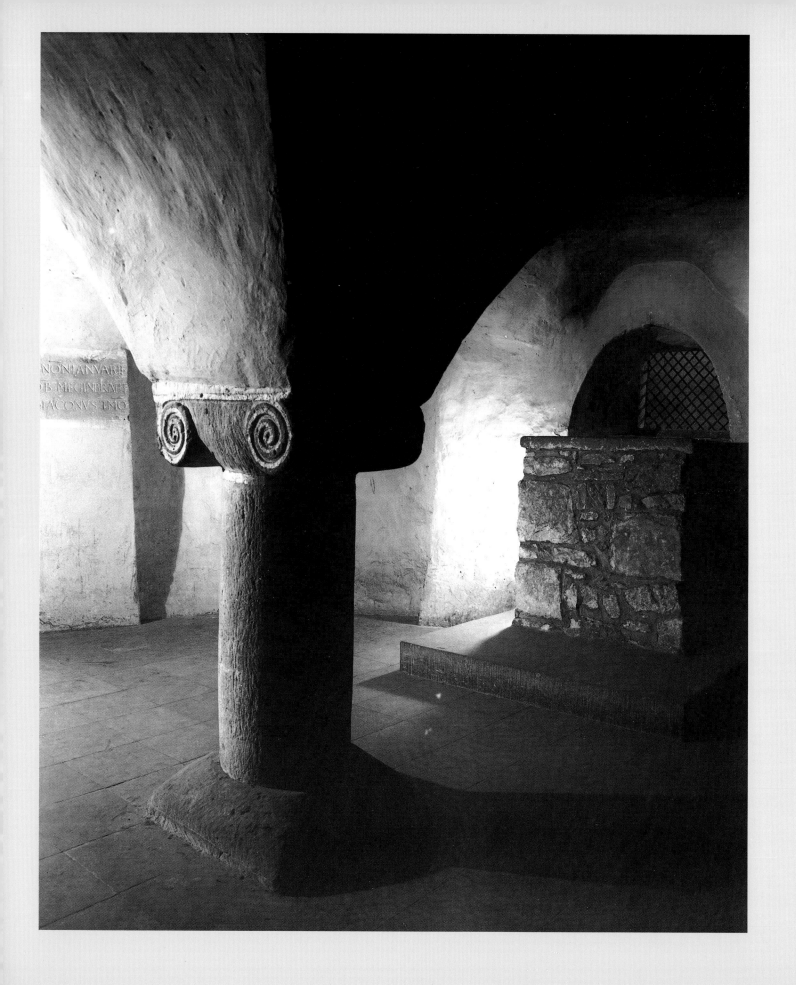

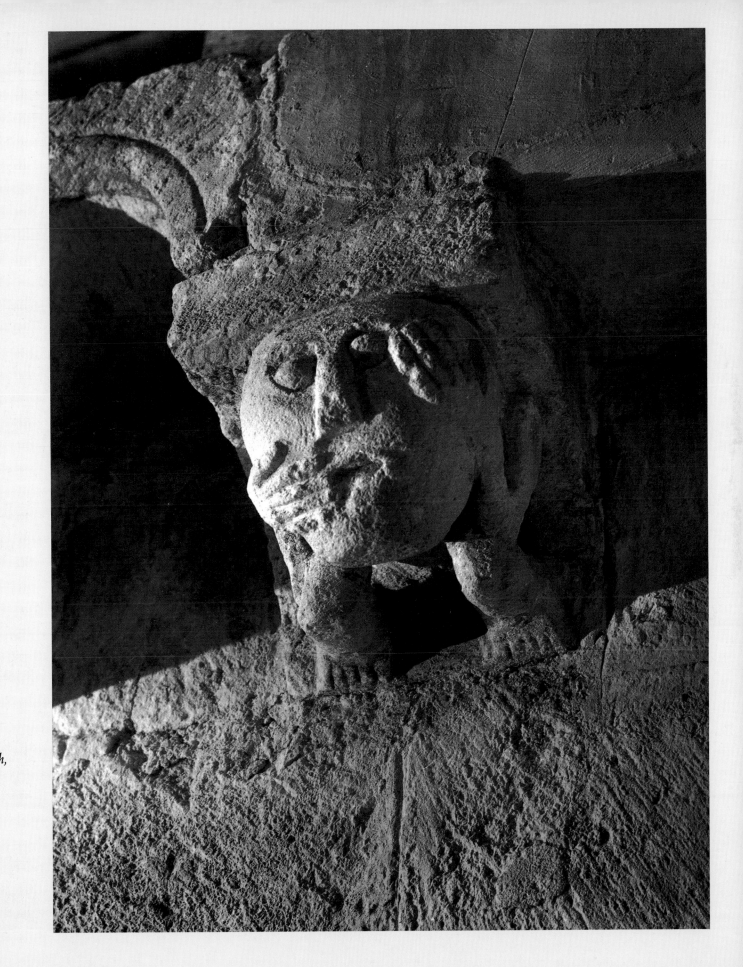

237
The crypt of
St Michael's Church,
Fulda, Germany;
19 September
1964

238
Capital in the
Library,
Chichester
Cathedral;
11 June 1958

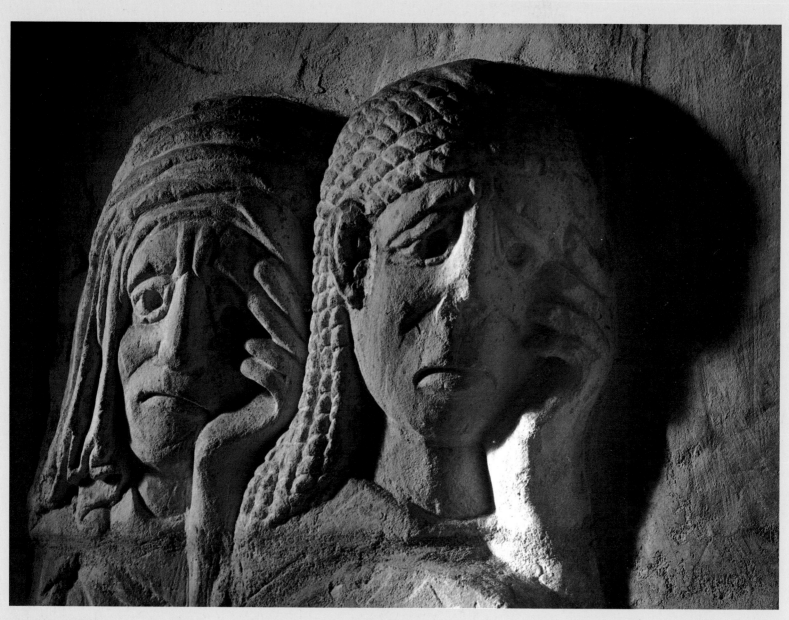

239
Detail from 'The Raising of Lazarus',
Chichester Cathedral;
13 June 1958

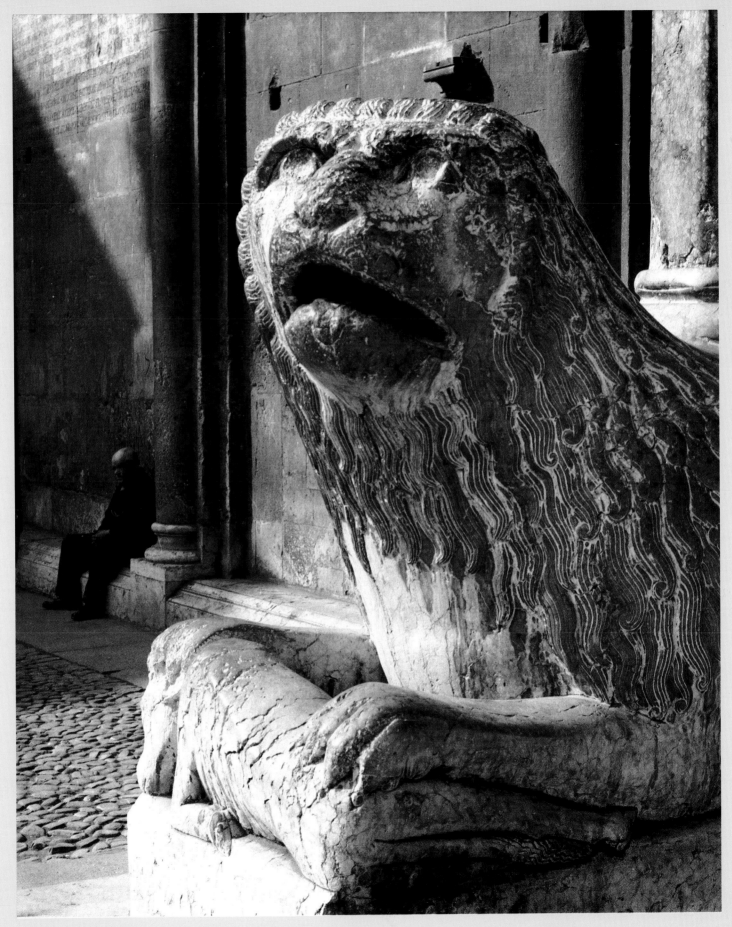

240
By the door of the
Duomo,
Modena, Italy;
April 1963

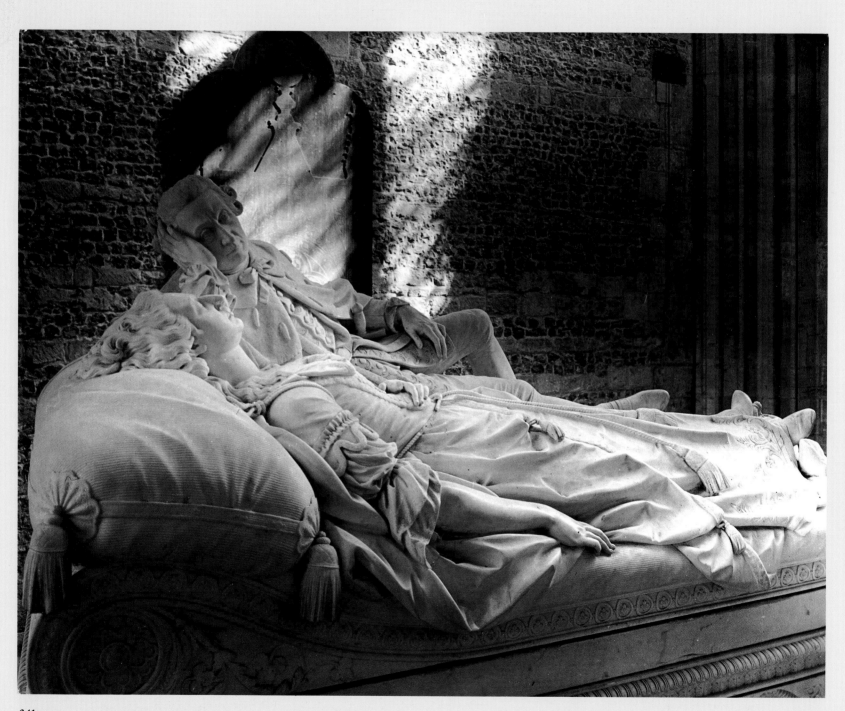

241
Monument to Baron Joseph Dormer
and his wife in
Milton Abbey, Dorset;
3 June 1959

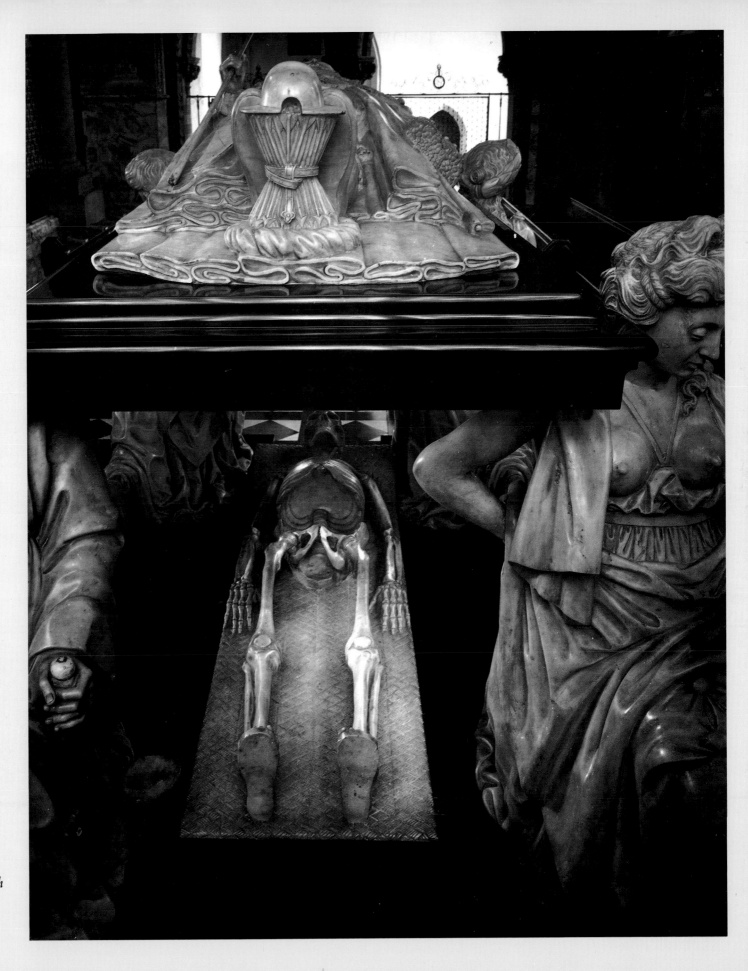

242
Tomb of
Robert Cecil
in Hatfield parish
church,
Hertfordshire;
June 1970

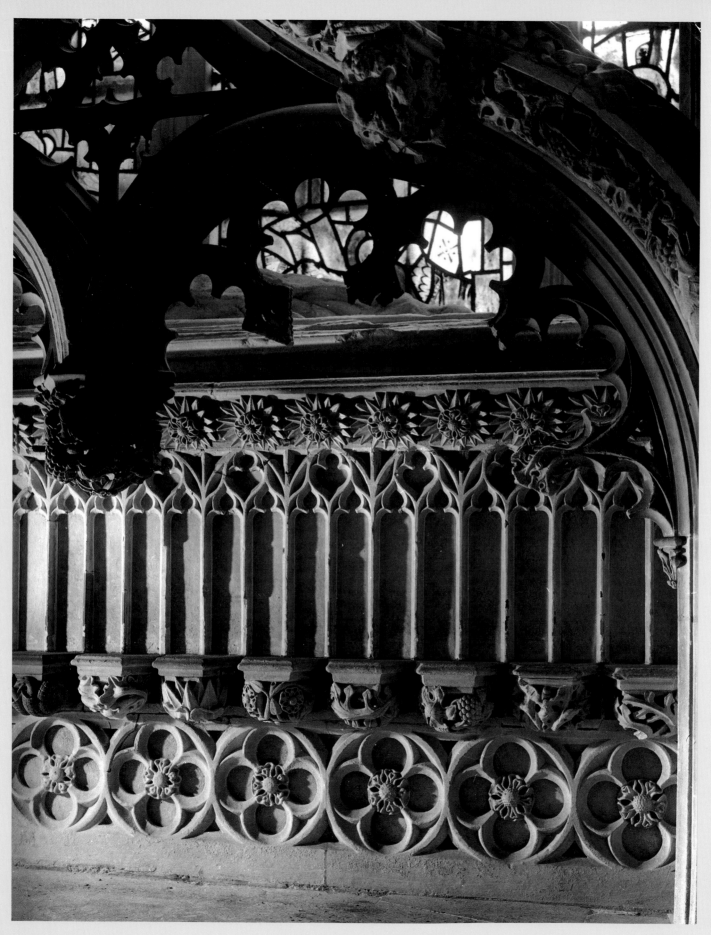

243
Bishop Alcock's
chantry,
Ely Cathedral;
August 1960

244
The choir school,
Lincoln
Cathedral ;
14 June 1960

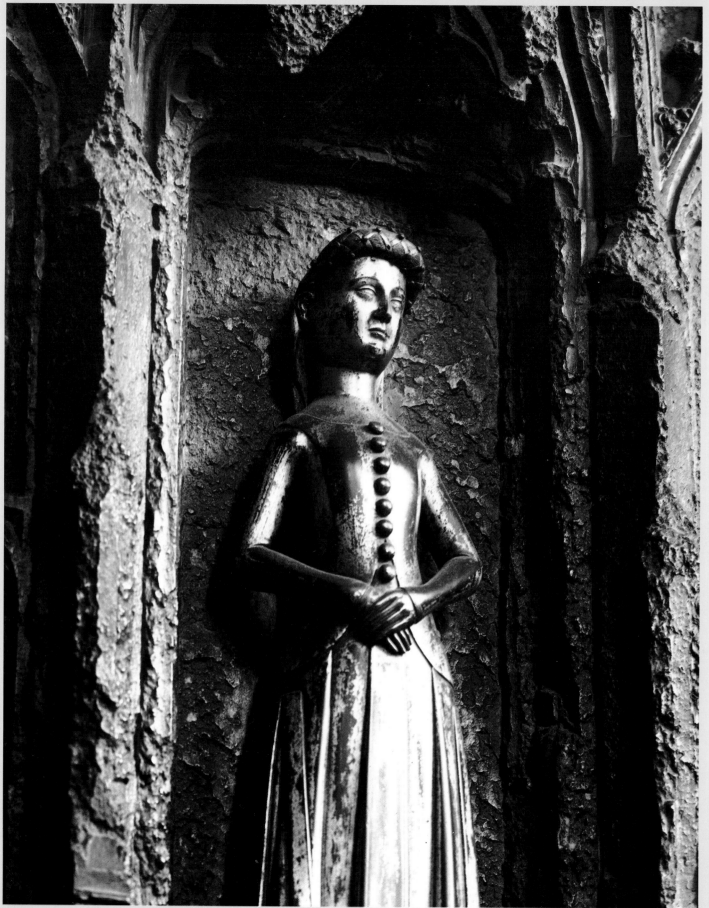

245
Weeper on the tomb
of Edward III,
Westminster Abbey,
London;
July 1970

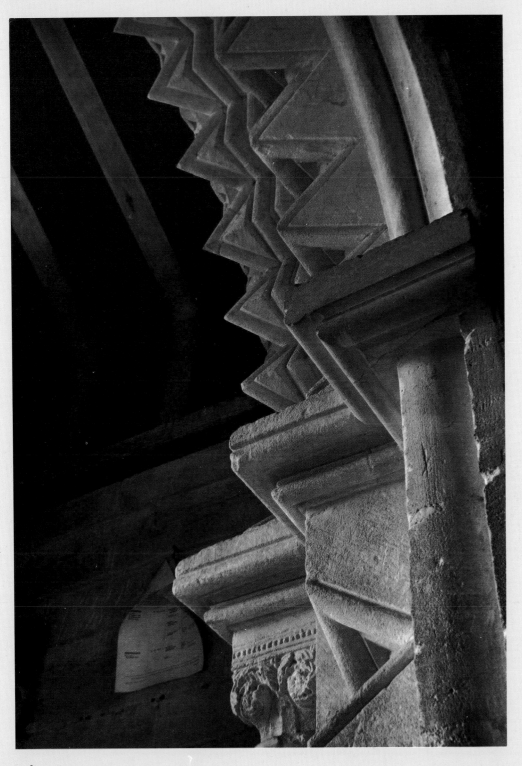

246
South porch, Little Barrington parish church,
Gloucestershire; Easter 1957

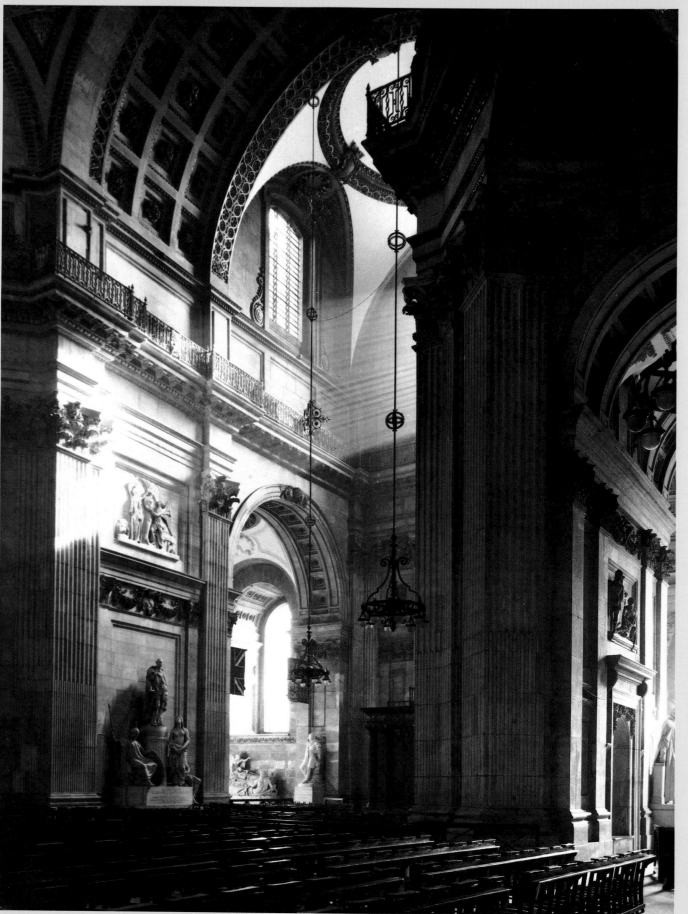

247
*St Paul's Cathedral,
London;
25 October
1955*

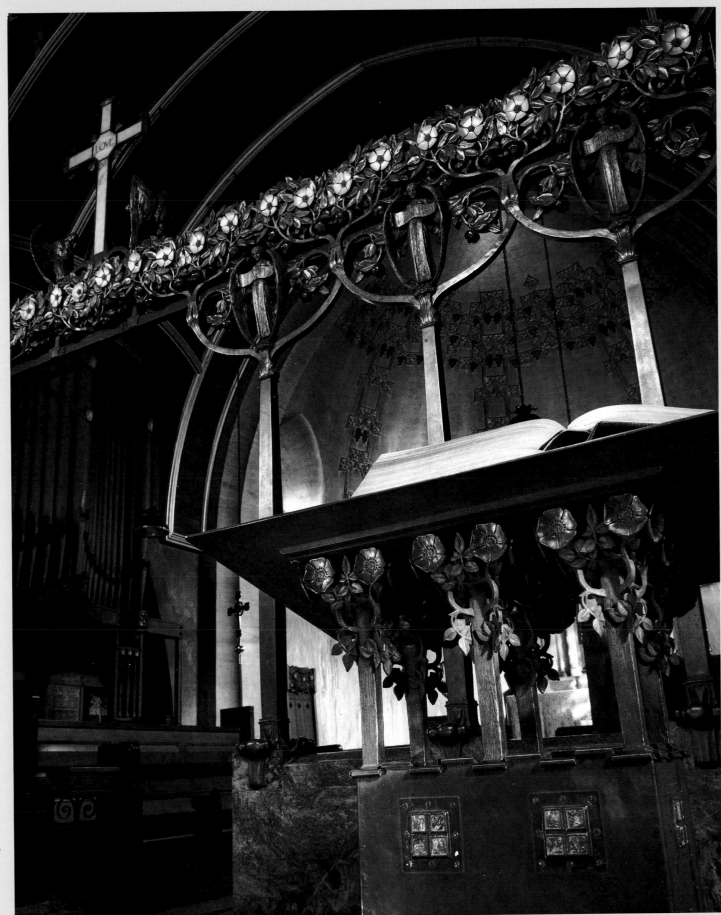

248
Lectern and screen,
St Mary's,
Great Warley,
Essex;
13 February 1967

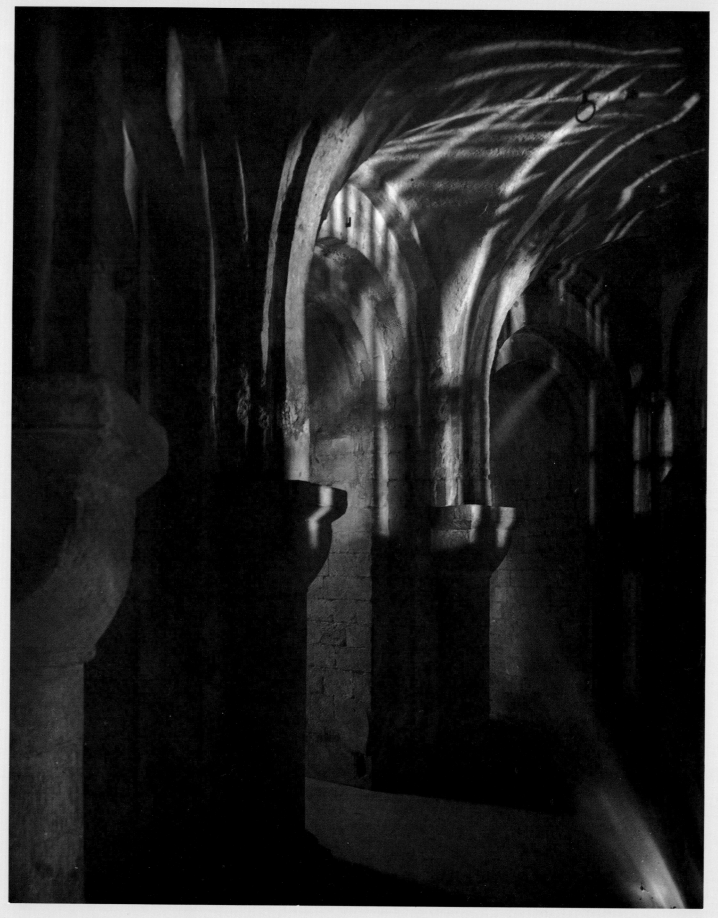

249
*Ambulatory of
the crypt,
Canterbury
Cathedral;
6 June 1968*

250
*Leebotwood
parish church,
Shropshire;
2 August 1961*

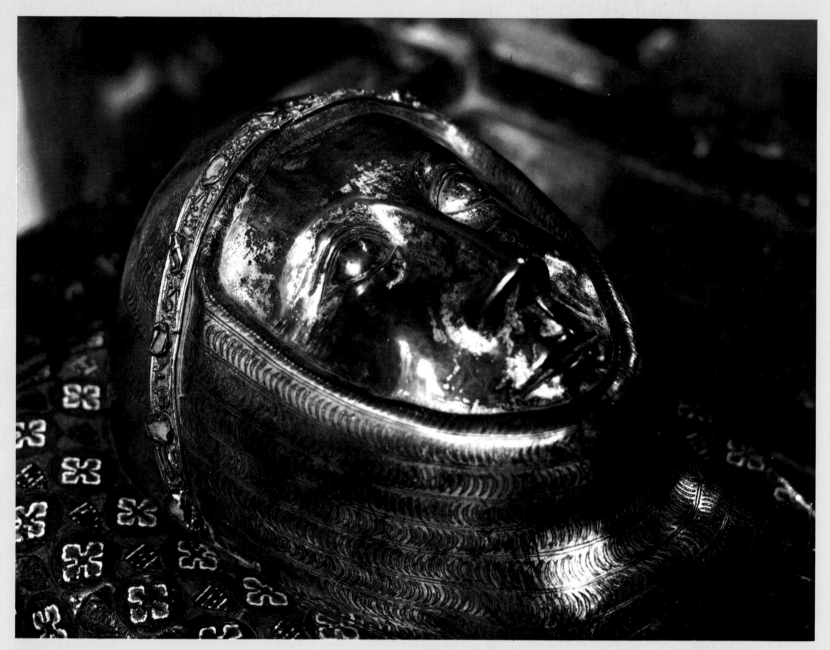

251
William of Valence,
in Westminster Abbey, London;
22 November 1966

252
Robert, Lord Hungerford,
in Salisbury Cathedral;
10 March 1959

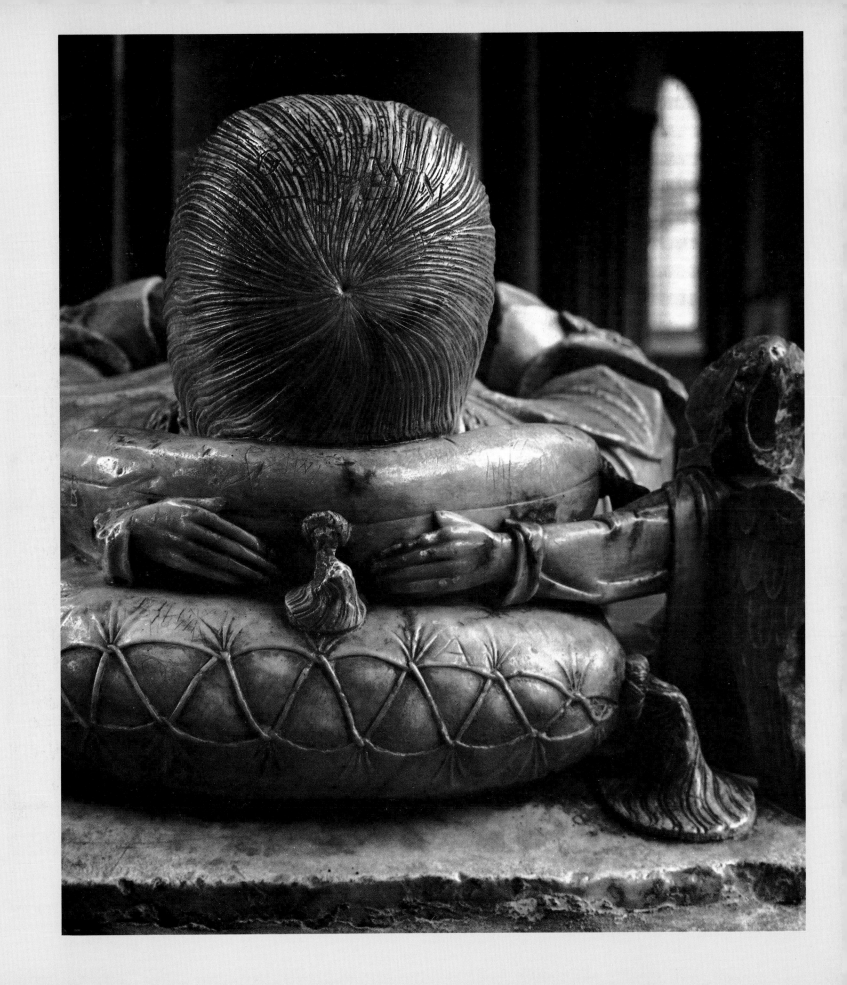

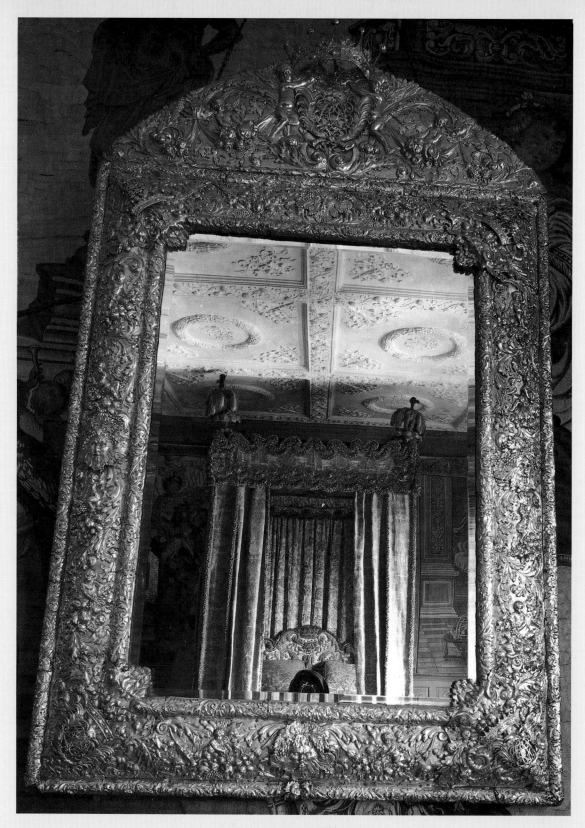

253
In the King's Bedroom, Knole, Kent;
5 October 1960